Living Buddhist Statues in
Early Medieval and Modern Japan

Living Buddhist Statues
in Early Medieval and
Modern Japan

Sarah J. Horton

First published in 2007 by
PALGRAVE MACMILLAN™
175 Fifth Avenue, New York, N.Y. 10010 and
Houndmills, Basingstoke, Hampshire, England RG21 6XS
Companies and representatives throughout the world.

PALGRAVE MACMILLAN is the global academic imprint of the Palgrave Macmillan division of St. Martin's Press, LLC and of Palgrave Macmillan Ltd. Macmillan® is a registered trademark in the United States, United Kingdom and other countries. Palgrave is a registered trademark in the European Union and other countries.

ISBN-13: 978–1–4039–6420–5
ISBN-10: 1–4039–6420–3

Library of Congress Cataloging-in-Publication Data

Horton, Sarah J.
 Living Buddhist statues in early medieval and modern Japan / Sarah J. Horton.
 p. cm.
 Includes bibliographical references and index.
 ISBN 1–4039–6420–3 (alk. paper)
 1. Gods, Buddhist—Japan. 2. Buddhist cults—Japan. 3. Sculpture, Buddhist—Japan. 4. Buddhism—Japan—Customs and practices. I. Title

BQ4660.J3H67 2007
294.3'42180952—dc22 2006050738

A catalogue record for this book is available from the British Library.

Design by Newgen Imaging Systems (P) Ltd., Chennai, India.

First edition: October 2007

10 9 8 7 6 5 4 3 2 1

Printed in the United States of America.

To my mother and father

CONTENTS

ILLUSTRATIONS

ABBREVIATIONS

For complete citations of publications, see the Bibliography.

Ch. Chinese
DNBZ *Dai Nihon Bukkyō zensho*
DNKK *Dai Nihon kokiroku*
ESZ *Eshin Sōzu zenshū*
GR *Gunsho ruijū*
J. Japanese
KYIK *Kokuyaku issai kyō*
NKBT *Nihon koten bungaku taikei*
NST *Nihon shisō taikei*
Sk. Sanskrit
SNKBT *Shin Nihon koten bungaku taikei*
T *Taishō shinshū daizōkyō*
ZGR *Zoku gunsho ruijū*
ZST *Zōho shiryō taisei*
ZZGR *Zoku zoku gunsho ruijū*

ACKNOWLEDGMENTS

I am deeply indebted to many people without whose support I could not have completed this book. First, I wish to thank the Japan Society for the Promotion of Science in conjunction with the Social Science Research Council for awarding me the grant that enabled me to spend a year in Kyoto conducting research from 2004 to 2005. Ōtani University sponsored my stay in Kyoto, and the faculty and staff there assisted me in countless ways. I am particularly grateful to Robert Rhodes for all his kind efforts in helping me conduct my research.

I am also indebted to Griffith Foulk, Mimi Yiengpruksawan, and William Bodiford for carefully reading the manuscript and providing many invaluable suggestions for improvement.

In addition, I am grateful to Stanley Weinstein for the training I received as a graduate student at Yale. I would also like to thank the Japan Foundation for supporting a year of dissertation research from 1997 to 1998, and Ryūkoku University for sponsoring my stay. My interest in the material that came to be included in this book developed at that time.

I also wish to express my gratitude to Professor Yamada Meiji and the members of the Buddhist Text Translation Society at Ryūkoku University for their friendship and enthusiasm for all things Buddhist; Toide Mami and Nakashima Konomi for their encouragement of my interests and for their friendship; and last but not least, my parents for their support, and my father for his careful editing of my work.

CHAPTER ONE

Introduction: Living Buddhist Statues

The importance of Buddhist statues in Japan can hardly be overstated. In fact, until the Edo period (1603–1867), almost all statues in Japan were Buddhist. This does not mean that they were all images of a being identified as a buddha, but rather that they depicted figures related to Buddhism. In Japan, as in China, the legend of the introduction of Buddhism revolves around statues. When the Japanese were introduced to the Buddhist images imported from Korea and China in the sixth century, without any doctrinal understanding of Buddhism, they were impressed by what they took to be powerful foreign deities. Modern scholarship has tended to attribute the spread of Buddhism across Asia to the teachings of missionaries, but material culture has arguably played a greater role. As one scholar explains, "[I]t is important to think not so much of a disembodied dharma [doctrine] descending on another culture from above, but rather of a more material movement—of monks, texts, relics, and icons—along trade routes and across deserts, mountains, and seas."[1] In the case of Japan, in particular, that material movement came largely in the form of statues.

Statues have numerous similarities to drawings, paintings, and other two-dimensional images. However, the central image (*honzon*) of most Japanese temples is a statue, and Japanese stories about Buddhist images that affected people's lives feature statues much more frequently than paintings. Even in the case of so-called secret buddhas, which are usually hidden from view, statues are far more common than paintings.

Medieval Japanese collections of Buddhist stories contain numerous instances in which a person is said to have "gone to the temple and prayed before the buddha" (*hotoke* or *butsu*). When phrases such as this are rendered into English in academic publications, however, they often

end up saying that the person "prayed before the buddha statue" or "prayed before a painting of the buddha."[2] Translators feel a need, perhaps unconsciously, to supply an extra word—"statue," "image," or "painting"—that is not there in the original. It seems that in English and other Western languages that are heir to the Judeo-Christian tradition, there is a built-in urge to distinguish between an "actual" buddha in the flesh as it were, and the mere image of a buddha in the form of a sculpture or painting. The Japanese language does have a word that translates as "buddha image" (*butsuzō*), which the compilers of Buddhist stories could have used if they had wanted to, but in most cases they referred to the objects of worship in temples simply as "buddhas." Either the distinction between "images" and "actual beings" that English speakers are wont to make did not occur to them or they chose not to make it.

Moreover, these Japanese stories almost never provide any description of the physical appearance of the statue. They may refer, at best, to the size of the statue and to the light it seems to exude. No mention is made of the mudra formed by its hands, its facial expression, the type of garments that are carved upon it, or any of the other myriad details that preoccupy art historians and scholars of Buddhism when they attempt to discern the "meaning" of a statue.

As continues to be the case today, throughout Japanese history many statues were not clearly visible to the worshipper. In modern Japan, observant visitors to temples will note that most of the statues, often including the central image on the main altar, cannot easily be seen. They are dimly lit, if at all, by candles. Sometimes a brocade curtain hangs in front of the face. Often the statues are ensconced in cabinet shrines (*zushi*), further contributing to the darkness. Moreover, the doors to a *zushi* are frequently closed; some are opened at regular intervals, others never opened at all. Nevertheless, people pray even to these images that cannot be viewed. They know the deity is there, and they often know, through a sign, temple brochure, or popular knowledge, what the statue is believed to be capable of doing for the worshipper.

The absence of physical descriptions of statues in popular medieval texts such as collections of tales suggests, contrary to the commonly held view that the significance of a statue can be discerned from its appearance, that the details of a statue's appearance have often been unimportant. But this is not to say that the statues themselves did not have a crucial role. They were members of Japanese society, just as much as, and in many cases more so than, individual humans.

In this book, I explore the ways in which Japanese worshippers have treated and continue to treat Buddhist statues as living beings with whom they engage in reciprocal relationships. My focus is on the early medieval period in Japan, extending from about 1000 CE to 1250 CE, but I also compare the practices and beliefs evidenced in historical records and popular literature of that time with behaviors and attitudes observable in contemporary Japan. The religious beliefs and practices in Japan today, needless to say, are not necessarily the same as those in early medieval Japan, and I make no such assumption in this book. Nevertheless, there are historical and cultural influences that can be traced directly from that time to the present, not the least of which are buddhas that have been worshipped continuously in the same location for a millennium. It is not unreasonable, then, to take contemporary Japanese ways of understanding and dealing with Buddhist images as a hypothetical frame of reference for the critical, historical study of the use and meaning of images in medieval Japan. The early medieval period is especially important because it is then we begin to find numerous clues to the religious activities of the common people, rather than merely the elite.

This book is grounded in research into the history of early medieval Japanese Buddhism, which is my particular area of professional scholarly expertise. However, my interpretation of the historical data presented herein has been immensely enriched by my observations of and experiences at numerous rituals and festivals in Japan where Buddhist statues played a central role. I am not trained as an ethnographer, but my knowledge of Buddhist doctrine and ritual, and of modern spoken Japanese, has made it possible for me to learn a great deal by attending such events. Of my years in Japan, the two that I spent in Kyoto provided the greatest opportunity to play the role of participant observer at Buddhist rites. Although as a foreigner I was far from inconspicuous, I never announced my presence as a researcher. Rather than conducting interviews, I noted the attitudes and comments of people around me, particularly the nonclerical worshippers. Thus, for example, at the clothes-changing ceremony of a bodhisattva that occurred on an oppressively hot summer day in 2005, I was able to observe elderly women exclaiming that the bodhisattva looked "delighted and refreshed to be in new, clean clothes." Such responses to Buddhist images are not unusual in Japan. Indeed, among believers, they may be the norm. This book presents a number of case studies, from both early medieval and modern times, of Japanese Buddhists who treated statues as though they were living.

Biographies of Statues

If statues are considered to be living, then they must have a life history, or biography. To explain this, Richard Davis, author of *Lives of Indian Images*, proposes combining the approach of the anthropologist Igor Kopytoff, who looks at objects through a "cultural biographical" lens, and that of the literary critic Stanley Fish, who emphasizes what he calls "interpretive communities," or the negotiation of meaning between the reader and the text. Davis suggests we view images similarly, substituting the term "communities of response" for "interpretive communities."[3] The worshipper and the image enter into a dynamic relationship and jointly produce meaning.

An appealing aspect of this approach is the freedom it allows for change. Scholars have tended to stress the moment of construction of an image, implying that the only authentic function and meaning is that which was intended at the very beginning. The moment of birth, however, is only one small part of a person's biography. Humans change, often dramatically, in appearance, behavior, and societal role over the course of their lives. This is no less true of statues. Davis explains, "I portray them [Indian images] as fundamentally social beings whose identities are not fixed once and for all at the moment of fabrication, but are repeatedly made and remade through interactions with humans."[4] As with a human, a statue's moment of birth constitutes only one small part of its biography.

A Japanese Buddhist monk and sculptor, the late Nishimura Kōchō (1915–2004), provided a fascinating case history of a statue with a complex biography.[5] In 1931, a fire seriously damaged a ninth-century, six-meter statue of Kannon Bodhisattva at the Kyoto temple Tōji.[6] Nishimura, commissioned to participate in the restoration process, was among those who witnessed the discovery of three layers of faces on the statue. The image, it turned out, had already been repaired twice, with a different face added each time. A Kamakura period (1185–1333) repair, which took place after a major earthquake toppled the statue, resulted in a popular Kamakura-style face. A further repair in the Edo period (1600–1867) added a face in the style of that time atop the previous one.

Those participating in the project to repair the Tōji Kannon were confronted with a difficult decision: which face should they restore to the image? Arguments could be made for each. The government had designated the statue a National Treasure (Kokuhō) when it possessed the Edo face. Of the three, the Kamakura face remained in the best condition.

The original Heian period (794–1185) face was in some ways the most "authentic," for it was the oldest. Finally, the decision was made to restore the Kannon's Heian face.[7] But the modern artisans, who did not fully know the processes and materials used by Heian sculptors, inevitably showed contemporary influence in their work, resulting in what must be recognized as yet a fourth face for this Kannon Bodhisattva.

Another complication in the biography of statues derives from the fact that, in Japan, the current central image of a Buddhist temple is often not physically the same as the statue originally created, although the *identity* of the deity is considered to be unchanged. For example, the Kannon statue at Hasedera temple in Nara prefecture, known since at least the tenth century for its miracles, dates from 1538. Although it is said to be iconographically identical to the original, and even to be carved from the same immense block of wood, it is indisputably not the original. In some cases, such as the Yatadera temple Jizō Bodhisattva discussed in chapter five, even the iconography of the replacement image does not match that of the original.

How does the replacement of one statue with another inform the biography of an image? From a Buddhist point of view, it does not necessarily constitute a problem. More often than not, Buddhist biographies do not begin with the birth of the subject, but rather with his previous lives. Many Buddhist statues in Japan, I propose, also possess biographies that include a sort of transmigration from one physical form to the next. Indeed, the replacement of one statue with another does not appear to matter to devotees of the Hasedera Kannon or the Yatadera Jizō. Those few worshippers who are aware that the statue is not the original still believe it to be fundamentally the same. Thus, the community of devotees is responsible for the continued life of the image. The reciprocal relationship between statues and their worshippers is well expressed by James H. Foard, who notes that "[a]s their [believers'] lives have changed, so have those of their icons."[8] What ultimately makes an image alive is the fact that people treat it as such.[9]

Symbolism, Veiled Presences, and Open Display

Many people in the West equate Japanese Buddhism with Zen, which conjures up for them a picture of people sitting calmly in meditation, without devotion to a deity. It is a strange irony that the idea that true Buddhism (or Zen) is not a religion and that it has nothing to do with the worship of images was promoted in the West by Japanese scholars

such as D.T. Suzuki (1870–1966), who wrote:

> As to all those images of various Buddhas and Bodhisattvas and Devas and other beings that one comes across in Zen temples, they are like so many pieces of wood or stone or metal; they are like the camellias, azaleas, or stone lanterns in my garden. Make obeisance to the camellia now in full bloom, and worship it if you like, Zen would say. There is as much religion in doing so as in bowing to the various Buddhist gods, or as sprinkling holy water, or as participating in the Lord's Supper. All those pious deeds considered to be meritorious or sanctifying by most so-called religiously minded people are artificialities in the eyes of Zen.[10]

The Zen tradition in China and Japan, it is true, is famous for its iconoclastic rhetoric, but, as Suzuki admits, "all those images" are in fact present and worshipped in Zen temples, just as they are in the temples of all other schools of Buddhism in Japan. Ever since the Meiji period (1868–1912), when Buddhism in Japan came under attack for being a "superstitious" religion that impeded modernization in the Western mode, academic apologists in that country have tended to present the worship of images as a popular deviation from "pure" Buddhism, or the "original" teachings of the Buddha in India. To the extent that this paradigm accepts Buddhist images as legitimate, it holds that they have a largely symbolic function as devices for reaching out to the uneducated or that they are objective supports for the practice of meditation. This view of Buddhist images has found a widespread following, even among Asian art historians and scholars of Buddhism in the West.

A recent article in *Time* magazine illustrates the Western tendency to interpret Buddhist art symbolically. It tells of a New York couple who impulsively bought a Tibetan religious painting and later became collectors and connoisseurs of Tibetan art. After their first purchase, they "hung the painting [of White Tara] in their bedroom. They didn't yet grasp its symbolism—White Tara represents truth, health, and longevity—but it radiated *something* that they felt deeply."[11] The author of the article does not cite a source for this information, but White Tara occupies a much more central and complex role in Tibetan Buddhism than merely "representing" truth, health, and longevity: such images are often hung inside Tibetan homes, for example, to provide protection from evil spirits. But the impulse to explain an image, especially a Buddhist one, by referring to its symbolism often proves irresistible. Buddhist texts sometimes do assign symbolic meanings, usually quite

complex ones, to images, but these symbols have not necessarily been understood by, visible to, or important to worshippers.

The emphasis on symbolism is connected with the idea that Buddhist images are solely for the uneducated, those unable to understand complex doctrinal texts. This theory, however, flies in the face of the historical evidence. The Chinese monk Xuanzang (600–664), for example, a highly educated Buddhist and one of the most skillful translators in Buddhist history, spoke in his diary, *Record of Western Travels* (Ch. *Xiyouji*; J. *Saiyūki*), of miraculous images he saw on his journey through India. In one instance, he wrote:

> To the south-west of the great stupa 100 paces or so, there is a figure of Buddha in white stone about eighteen feet high. It is a standing figure, and looks to the north. It has many spiritual powers, and diffuses a brilliant light. Sometimes there are people who see the image come out of an evening and go round the great stupa. Lately a band of robbers wished to go in and steal. The image immediately came forth and went before the robbers. Affrighted, they ran away; the image then returned to its own place, and remained fixed as before. The robbers, affected by what they had seen, began a new life, and went about through towns and villages telling what had happened.[12]

His narrative testifies to his belief in and devotion to miraculous images. The diaries of Xuanzang and an earlier Chinese pilgrim, the fifth-century Faxian, related the story of an Indian king who ordered a wooden image of the historical Buddha Śākyamuni to be carved while Śākyamuni himself was temporarily absent. The statue was placed in the Buddha's usual seat at the monastery, and when the Buddha returned, the image rose to greet him.[13] If these two highly educated monks could unwaveringly believe such a story, devotion to miraculous images cannot have been a phenomenon restricted to the uneducated.

Some might argue that only Mahāyāna Buddhists believe in such tales and that followers of Theravāda, a non-Mahāyāna tradition, do not engage in this type of "idol worship." In *The Long Search: Footprints of the Buddha*, a movie widely used in introductory courses on Buddhism, the Sri Lankan monk Balangoda Ānanda Maitreya emphasizes this point when he tells his British interviewer that the huge buddha statues found in the temple they are visiting are the equivalent of a spiritual "kindergarten" for the simple-minded laity.[14] But hundreds of examples can testify to the misleading, polemical nature of this statement, including

the consecration ceremony of a new Buddhist statue in Sri Lanka itself. When the craftsman paints in the eyes, the crucial step in the consecration process, he carefully uses a mirror to avoid directly meeting the statue's gaze. After he has finished, the craftsman's gaze itself becomes dangerous, and he must destroy the first thing he sees after he exits the room.[15] If the image were truly regarded as merely a teaching device, why would the craftsman's gaze be deemed dangerous?

An additional question is why one would need to fear a buddha under any circumstances, since this is a deity of ultimate compassion. In Japan, too, worshippers are sometimes afraid of images. If the statue is treated improperly, they believe, it may become angry and seek revenge. If pressed to provide an orthodox Buddhist explanation for the fear of Buddhist images, one could argue that the statue's anger is actually a tool to save the worshipper from committing even more heinous offenses in the future. Such rationalization, however, is unnecessary. As Davis eloquently points out, "these objects may be animated as much by their own histories and by their varied interactions with different communities of response as by the deities they represent and support."[16] This being the case, statues may engage in actions that would never be performed by buddhas themselves.

Deitrich Seckel, a pioneer in the field of Buddhist art history, stated that Buddhist art has three functions: representation, communication, and realization.[17] Realization in this particular case means enlightenment. A practitioner's ultimate goal, he concluded, is achieved by using statues in a meditational context.[18] In fact, Buddhist images, whether drawn or sculpted, have served as holy objects or living presences much more frequently than as objects of meditation or visualization. Robert Sharf, speaking specifically of mandalas, explains that contrary to popular belief, they are not necessarily or even usually the objects of meditation. Mandalas are sacred objects that supply a presence. "As such," Sharf emphasizes, "rather than serving as an aid for visualizing the deity, the presence of the mandala before the practitioner actually abrogates the need for visualization at all."[19]

The problems with an overemphasis on the symbolism or the meditative function of an image become especially apparent in light of the phenomenon of secret buddhas, the topic of chapter six. Secret buddhas (*hibutsu*) are Buddhist images that are completely hidden from view and revealed only at set intervals, if at all. I learned about them the hard way in 1997. A Japanese guidebook to temples in and around the city of Kyoto informed me that Hokkaiji temple housed a venerable statue of Yakushi Buddha. Determined to see that image, I boarded a train, transferred to a bus, got

lost, and finally found my way to the temple. Upon entering the hall, I saw only a dark, recessed area behind a lattice barrier. A sign informed me that the statue will remain hidden forever. It was a secret buddha, one that drew hundreds of worshippers every year, none of whom could actually view it. This Yakushi, it turns out, is renowned for its power to grant new mothers plentiful breast milk. For this reason, hundreds of small bibs, inscribed with prayers from mothers, were tied to the lattice barrier. I later discovered that documents describing Hokkaiji temple's Yakushi statue can be found in libraries and archives, and a few photographs are also available. But for the average worshipper, this Yakushi Buddha's appearance remains forever unknown, and largely irrelevant.[20]

My guidebook had stated that the temple housed the statue, but not that the statue could not be viewed. Immensely frustrated, I brought this up with numerous Japanese friends who were familiar with temples; all declared that they had never before thought about the phenomenon of secret buddhas. When I inquired why a person would journey to pray to a hidden image, I was told that prayers are more effective in the presence of a deity, regardless of whether it is visible. After that, I began to notice not only that secret buddhas are extremely common but also that even statues nominally open to view in temples often cannot be clearly seen. In addition to the statues being recessed in a dark inner altar area, which neither casual visitors nor serious devotees are allowed to enter, a curtain frequently hangs in front of the image's face.

There are, of course, places where Buddhist images are expressly placed to be viewed: museums. The location of religious objects in art museums rather than halls of worship is peculiar to the modern era. It has been common in Japan since the Meiji period, when the term "art" (*bijutsu*) was coined and "Buddhist art" (Bukkyō bijutsu) became Japan's answer to the classical and Renaissance art that was used in the West to claim cultural superiority. In Japan, however, the distinction between a temple and a museum is not always so clear to visitors. In Japanese museums, people sometimes leave coins in front of statues or paintings of deities, an act often performed by worshippers in Buddhist temples. Similar behavior can even be found among followers of Japanese Buddhism in the West. The Denver Art Museum, for example, houses a statue of Nichiren, the revered founder of the Japanese school of Buddhism that bears his name. On a trip to the museum in 1999, I witnessed followers of the American Nichiren school holding a dramatic worship ceremony, which included loud drumming, in front of the glass-enclosed image. I was informed by participants that they performed this ritual regularly, with the permission of the museum.

Some sociologically savvy scholars of Buddhism and Asian art historians who are attuned to the "original" ritual functions of Buddhist images have decried the treatment of Buddhist images as "art" in museums. They complain that the statues are cut off from the original religious and institutional contexts—on an altar in a temple, for example—in which their meanings must be interpreted.[21] Objections to the treatment of religious objects in museums are understandable but overstated. In Japan, large groups of high school students on field trips are often reluctantly herded through temples. For them, the setting of a temple is no more relevant than that of a museum. Conversely, as noted above, visitors to museums often exhibit considerable reverence. Moreover, it is now common for Japanese temples themselves to have museums in which they exhibit some of their valuable objects, including statues. This is in part because, in recent years, statues have been stolen from unguarded temples and because a museum setting allows for modern climate control and other methods of preservation.

It is easy to idealize the past and the "original" function of images, but things are not so simple. Many of the statues that we can read about today no longer exist because they were forgotten or neglected. A statue in a museum, at least, is less likely to meet this fate. In any case, a new chapter in the biography of a statue begins when it enters a museum. It may indeed take on the kind of didactic function and symbolic meaning that it never had on an altar in a temple. As art in a museum, Buddhist statues become emblematic of Japanese culture not only for foreigners but also for the Japanese themselves. That topic, however, is largely beyond the scope of this book.

Eye-Opening Ceremonies

Eye-opening ceremonies (*kaigen shiki*), in which Buddhist statues are consecrated before being placed on an altar, have frequently been cited by scholars as the source of an image's living status.[22] Most worshippers, however, are unaware whether a particular statue has undergone such a ceremony or even that such a ceremony exists. The rite is mainly the concern of Buddhist temple priests, and the resulting change to the image, in any case, is usually not visible to the naked eye. Many a roadside statue has been worshipped as alive without such a ceremony. Even a statue properly enshrined in a temple may not have experienced this rite. A contemporary Buddhist sculptor in Kyoto who has sculpted images for numerous temples informed me that some temples take consecration ceremonies very seriously, whereas others are unconcerned.

Worshippers at Buddhist temples cannot distinguish which statues have gone through the ritual and which have not, and this does not affect their relationship with the deity. As stated above, the interaction between believer and image is the ultimate source of an image's life.

In the biography of a statue, the eye-opening ceremony is comparable to a baptism in Christianity. The ordinary observer is unable to discern a difference in the subject before and after the ritual—and in the case of infant baptism, the subject himself may be unaware of the shift. But the performance is nevertheless deeply meaningful to those who request, witness, and conduct it. Here, I briefly outline the content of Japanese eye-opening ceremonies and the role they have played in the history of Japanese Buddhism.

As its name indicates, the ceremony usually involves a ritual action performed on the statue's eyes. This is the act of completion of an image, after which it is considered sacred and animated. Depending on the manner in which the eyes were constructed, the ceremony may involve painting in the pupils, pricking the eyes with a pin, or anointing the eyes with a liquid such as oil. Eye-opening ceremonies are not limited to objects that actually have eyes, such as statues and paintings; memorial tablets (*ihai*), Buddhist altars, stupas, mandalas, and other objects that do not take a human form also undergo similar eye-opening ceremonies.

The ceremony differs from one school of Japanese Buddhism to the next, but the goal does not change. Nishimura Kōchō compares the relationship between a Buddhist statue and a buddha to that between a television set and a broadcasting station.[23] Each buddha has a permanent residence. Nishimura does not name the locations of those residences, but other texts specify that they are Pure Lands. The buddha beams signals to the statue, just as a broadcasting station sends signals to televisions. Televisions must be in working condition to receive the signal. Moreover, they must be plugged in and turned on. Conducting an eye-opening ceremony is akin to plugging in a television, explains Nishimura. Turning the switch on, however, is done by the believer, in the act of joining the palms (*gasshō*) in prayer.[24] In addition, similar to the way in which a television screen needs to be dusted and cleaned periodically, the image requires offerings such as flowers and incense.

Unwilling to push the simile too far, Nishimura admits that at some point it breaks down. When a television becomes old and impossible to repair, it can simply be thrown away. But a statue, especially one that has been worshipped for hundreds of years, must have the spirit removed before it can be retired as an object of worship. This is accomplished through a sending-away ceremony (*hakken shiki*), conducted when an

image is to be repaired, cleaned, moved, or displayed in a museum. Nishimura states that removing the spirit of an image that has long been worshipped can prove extremely difficult and tells of his own occasional failure to do so.[25] Almost no mention is found in Japanese texts of sending-off ceremonies, which, like funerals, were understandably not reasons for celebration.

But Japanese works abound with references to eye-opening ceremonies, particularly those performed on newly minted images. Historically, the most famous eye-opening ceremony in Japan was performed for the Great Buddha at Tōdaiji temple in Nara in 752. An enormous celebration, complete with music and dancing, marked the occasion. The emperor, his wife, more than ten thousand monks, and a South Indian monk who led the ceremony are said to have been among the participants. Cords more than two hundred meters long were fastened to the brush, so that while the emperor himself stood on a ladder to reach the eyes of the eighteen-meter-tall buddha, those on the ground could grasp the ends of the cords. To adapt Nishimura's simile, it was as if they were connected by an electrical cord to the current coming from the image. The same brush was used in rededication rites of the statue in 1185, when it was again wielded by the emperor of the time. It now rests in the Shōsōin, Tōdaiji temple's famous repository of treasures.

David Freedberg suggests, with regard to religious images in general, that formal ritual acts of consecration are relatively unimportant:

> In an extended sense they are all consecrated—by removing them to shrines (often specially constructed), by washing them, anointing them, crowning them, or garlanding them. This may seem too broad a sense of the notion of consecration to be useful, and many of these acts do not take place prior to the animation or operativeness of the image; but to see it in this way serves to emphasize the continuity between spontaneous action and ritual practice.[26]

These remarks hold true for the Japanese Buddhist tradition as well. The Buddhist eye-opening ceremony makes an interesting case in point for the scholarly discussion of living images, but it does not exhaust the subject.

Buddhist Statues in Modern Japan

As noted above, images are enlivened by those who worship them. They can fall asleep if not worshipped but can always be reawakened. This can

take place in the traditional manner, through eye-opening ceremonies and worship by individuals, but in today's society it can also occur through publications and the electronic mass media. All it takes are authors with a talent for conveying their enthusiasm to large audiences.

In Japan today, few people profess an interest in Buddhism, in Buddhist statues, or indeed in religion at all. Often unable to identify a statue as a particular deity, many are even unsure whether the deity is Buddhist or Shintō.[27] In the past decade or so, however, there has been a marked increase in interest in all things Buddhist, although this is not necessarily manifest in more frequent visits to temples or increased financial donations to Buddhist organizations. Rather, it is apparent in books and television programs that discuss Buddhism on an introductory and personal level.

In the early twentieth century, one of the few guidebooks that featured Buddhist statues was Watsuji Tetsurō's *Pilgrimage to Ancient Temples* (*Koji junrei*), published in 1918.[28] Watsuji took an approach that was innovative in his day: he conveyed his own personal impressions of and reactions to the statues he visited. A huge success, his book became the model for many later works. One such modern example is the extremely popular series of books and public television programs entitled *Record of Seeing the Buddhas* (*Kenbutsuki*), in which the two protagonists, author Itō Seikō and illustrator Miura Jun, embark on a series of journeys to temples where famous statues are enshrined. The title itself demonstrates the complex nature of their approach: the word *kenbutsu* as it is usually written means "sightseeing" (*ken* = "seeing," *butsu* = "things"), but Itō and Miura have coined a homonym using a different Sino-Japanese character and come up with a phrase that means "seeing the buddhas" (*ken* = "seeing," *butsu* = "buddha").[29] Thus, they make an implicit connection between tourism and religious pilgrimage.

Miura, in particular, takes a humorous yet personal approach to the statues, comparing them to subjects as diverse as women in Gaugin's paintings, movie stars, rock stars, and former girlfriends. A recently published guide to unusual religious sites echoes this attitude by referring to temples as theme parks, pointing out that in the past, before the appearance of Disneyland, television, and video games, Buddhist temples and Shintō shrines were centers of entertainment, including drinking, eating, and games. The guide's authors suggest a return to viewing temples in that way.[30]

Another modern personal account of visits to deities is provided by a bestselling book titled *Little Buddhist Statues, Big Buddhist Statues* (*Chiisai butsuzō, ōkii butsuzō*), by a popular fashion model named Hana, who

describes visits to some of her favorite Buddhist statues. Similar to Itō and Miura, she personalizes images by likening them to her own friends and acquaintances, imagining what they might be thinking. Her reactions to statues are visceral. She feels sorry for those enclosed behind glass, worrying that they cannot breathe.[31] When gazing at a statue of Amida Buddha that is fabled to be based on a likeness of the character Hikaru Genji, star of the eleventh-century novel *Tale of Genji*, Hana reveals, "Even though I almost never feel a thrill of excitement when I pass a guy on the street, I wonder why I sometimes feel that with a buddha statue."[32]

Itō and Miura also describe certain Buddhist images as sexy and profess physical attraction to them. Such an attitude might seem like a modern blasphemy or perversion, but precedents abound in Buddhist literature. A ninth-century Japanese collection of tales, for example, contains the story of a lay believer who is attracted to and falls in love with a statue of the female deity Kichijō. He subsequently has a dream in which he is in bed with this deity.[33] Similar cases also occurred in China.

The Buddhist sculptor Nishimura Kōchō, introduced above, was a fervent believer in the miraculous power of statues and took a more orthodox approach. He related, for example, an anecdote about the Kannon statue at Tōji temple, which was damaged in the disastrous fire of 1931. During the restoration process, a large hole was discovered in the center of the image's forehead, where a statue frequently bears a crystal. Buried deep inside was a gold reliquary wrapped in paper. The paper around the container did not burn in the conflagration, nor did the container itself melt or become distorted in any way. The lid opened smoothly to reveal a relic enshrined inside. Why had the relic container and the paper surrounding it remained undamaged? Nishimura's explanation was that the spirit (*tamashii*) of the image, engulfed by fire, fled into the relic.[34] To the devotee, the statue itself, not merely the deity it "represents," is alive and possesses a spirit that is capable of making decisions. This Kannon statue sought to save itself from the fire in the best way it knew.

Textual Sources: Tales, Temple Histories, and Illustrated Scrolls

Although this book is concerned with Buddhist images, it is primarily on textual sources that the historian must rely for information about the ways in which people related to images in the early medieval period.

The main genres of texts that shed light on the subject are collections of tales (*setsuwashū*), temple histories (*engi*), and illustrated scrolls (*emaki*).

Collections of Tales

Ghosts, demons, buddhas, kings, and beggars are among the many figures that appear in a loosely defined genre of medieval Japanese literature known today as "tales" (*setsuwa*). Tales appear in scattered fashion in various early medieval Japanese novels, histories, collections of poems, and independent works, but the most useful sources for the modern historian are the so-called collections of tales (*setsuwashū*). Because they frequently feature Buddhist statues as protagonists, collections of tales provide the most useful material for investigating the popular roles of Buddhist images in early medieval Japan. The misnomer "folk tales," though frequently employed, implies that such stories were the province of commoners. In fact, it is only because aristocrats were interested in the stories that they have survived to this day in any written form.[35]

Although the stories are not limited to religious topics, a majority of those in collections of tales do have religious import. Some scholars argue that the genre derived from handbooks used by Buddhist preachers.[36] Others refer to *Collection of Tales from Uji* (*Uji shūi monogatari*), an early thirteenth-century text, to explain the origins of the genre. A passage in that work tells of Minamoto no Takakuni (d. 1077), a high-level courtier, who escaped the unbearable summer heat and humidity of Kyoto by going to his villa in the city of Uji. There he would lie on a cool mat, fan himself, and "call in passers-by, low-class people as well as high, and invite them to tell tales of days gone by, while he reclined in his room and wrote down the tales in large notebooks, just as they were told."[37] Drawing as they do on numerous unnamed sources, such collections of tales cannot be deemed historically reliable as records of actual events. It was, however, important to the storytellers that their tales, though somewhat fantastic, be fundamentally believable, so they often used the names of real people and places. Moreover, the stories do accurately reflect the religious beliefs and practices of people at the time of their compilation. The information that can be gleaned from them concerning the interaction of ordinary people with Buddhist statues is especially valuable, because commoners were almost entirely excluded from official court records and other histories.

I shall briefly discuss, as examples of the genre, two major Japanese collections of tales: (1) *Miraculous Stories of Karmic Retribution of Good and Evil in Japan* (*Nihonkoku genpō zen'aku ryōiki*, usually abbreviated as *Nihon ryōiki*), and (2) *Tales of Times Now Past* (*Konjaku monogatari*). The oldest

extant collection of Buddhist tales in Japan, *Miraculous Stories of Karmic Retribution* was compiled by the monk Kyōkai in the early ninth century. The text displays the heavy influence of similar works deriving from mid-seventh-century China. Kyōkai specifically mentioned the *Records of Supernatural Retributions* (Ch. *Mingbao ji*), explaining that since the Japanese are interested in the miraculous events of other countries, they should also learn about those in their own.[38] Kyōkai cited the oral tradition of the masses as his source, and he does seem to have been more familiar with tales than with orthodox Buddhist texts, for he mentioned few of the latter apart from the *Lotus Sutra* and *Nirvana Sutra*.[39]

The stories contained in *Miraculous Stories of Karmic Retribution* are more concerned with benefits in this life than with the world after death. They are obviously intended to encourage good and discourage evil, in part by showing the consequences of evil deeds. But the results of these deeds need not be suffered helplessly: relatively simple measures can be taken to change or adjust one's karma. Among these are devotional acts, such as copying or reciting the *Lotus Sutra*. Another means of counteracting negative karma is the worship of buddhas and bodhisattvas, most frequently performed at temples "in front of the Buddha." Often the buddha is named, as in the "Kannon of <Name> Temple." Many of the temples can be identified today, although most of the images no longer exist. The reliance of *Miraculous Stories of Karmic Retribution* on actual statues in real temples sets it apart from the Chinese collections on which it is based; in those works, images were generally not identified as belonging to a specific temple. The statues in Kyōkai's work, moreover, distinguish themselves by behaving in most dramatic ways: they scream, cry, bargain with passersby, and are anything but content with sitting still as abstract icons or didactic symbols.

Tales of Times Now Past is thought to have been recorded in the early twelfth century by an unidentified compiler or compilers, probably monks. The text comprises more than one hundred stories in thirty-one chapters: the first five chapters cover India; the next five, China; and the remaining twenty-one, Japan. Of the chapters situated in Japan, ten focus on Buddhism. A variety of materials was used in the compilation, but because it draws heavily on widely known legends, *Tales of Times Now Past* is especially valuable. It speaks of all classes and types of people, from monks to laymen, aristocrats to commoners, samurai, farmers, doctors, prostitutes, thieves, animals, monsters, and—those lowly creatures—ordinary women! The tales tend to be simple and straightforward, often repeating a standard formula, but they can be very amusing, depicting the human condition in all its comedy and tragedy.

Temple Histories (engi)

Temple histories, like collections of tales, convey information that modern scholars evaluate as partly historical and partly legendary. Usually sponsored by the temples themselves, the histories began to appear in the late ninth century, to document a temple's founding and development. As time passed, however, they became increasingly embellished and incorporated entertaining stories about miracles performed by the central image. Temple histories thus became a successful device for encouraging pilgrimages and donations to the temple. Many temples that even today house famous images, such as Hasedera temple in Nara prefecture and Kiyomizudera temple in Kyoto, found their initial popularity in early temple histories. As James Foard writes, "These legends became the basis for explaining the temple grounds to visitors, and formed part of the repertoire of the itinerant preachers associated with the temple. For the general populace, then, an *engi* explained more than a temple's origins; it established it as a sacred spot, giving expectancy to the devotions performed there."[40] As the histories became more common and elaborate, they were sometimes transformed into illustrated narrative scrolls (*emaki*).

Illustrated Narrative Scrolls (emaki)

The twelfth century saw the appearance of illustrated narrative scrolls, a dramatic and appealing genre. Though scrolls were not limited to religious topics, some related the history of a particular temple or its central image, and others centered on a specific sutra, monk, or religious ceremony. Most contain both text and illustrations, though a few make use of only pictures. None of the authors is known.

The scrolls, made of joined pieces of silk paper, are unrolled gradually, from right to left, as the story is read. As a means of storytelling, illustrated scrolls are quite effective, conveying the movement of a narrative when the same characters reappear in various scenes as the scroll unrolls. For this reason, they were an ideal medium for presenting Buddhist statues as living.

Types of Deities

Japanese texts that introduce Buddhist iconography typically divide images into four categories: buddhas, bodhisattvas, wisdom kings (*myō-ō*), and "deities" (*ten*, a Chinese translation of the Sanskrit *deva*). These

divisions were firmly established in Japan by the twelfth century, as demonstrated by a number of iconographic manuals.[41] In modern Japan, a fifth category of "other" is sometimes proposed, which includes statues of famous monks.

The usefulness of this taxonomy lies in its ability to explain the multiplicity of Buddhist beings in the Mahāyāna tradition. It is inadequate for the purposes of modern scholarship, however, for it is primarily prescriptive rather than descriptive, and it lacks firmly established boundaries for each category. There is, for example, a substantial overlap between buddhas and bodhisattvas, as both are thought capable of coming to the assistance of devout supplicants. The world of Buddhist deities is nowhere near as simple as the four-category system would suggest. Nevertheless, I will briefly outline the four categories, since modern Japanese Buddhist texts ubiquitously refer to them.

Buddhas comprise the first group. In Sanskrit, the word *buddha* means "Awakened One." A buddha is generally understood as a being who has seen the world as it really is, achieved nirvana, and thus been released from the cycle of birth and death, which from a Buddhist point of view inevitably entails suffering. The first buddha for our time period was Śākyamuni, known by various names, including Siddhartha and Gautama. He lived in India and what is now Nepal around the fourth century BCE.[42] But in Mahāyāna, the type of Buddhism prevalent in East Asia, anyone who comes to the same realization as Śākyamuni also becomes a buddha. Because buddhas are modeled on Śākyamuni, technically they all are male.

A common misunderstanding in the West is that the buddha is a fat, jolly figure of the sort frequently found in Chinese restaurants. This portly character is actually a Chinese deity who did not make an appearance until around the twelfth century CE. Modeled on an eccentric Chinese monk, he is associated with good luck, and hence his image has become part of the décor in many business establishments. He also came to be identified with Maitreya, the buddha of the future. In East Asia, however, he is only one small part of the Buddhist pantheon.

Iconographically, a buddha usually wears a simple robe and no jewelry, and sits in meditation, with eyes partially closed, his face serene. The Western stereotype that many buddhas' faces (excepting, of course, the jolly Chinese Maitreya) are impassive and cold is inaccurate. A comparison of different buddha images reveals a wide range of facial expressions and individual characteristics, suggesting that some were modeled on real people. Nevertheless, because buddhas, having reached nirvana, are often understood no longer to have contact with the world of living

beings, they arguably play a less central role in East Asian Buddhism than the more active members of the next category: bodhisattvas.

Considered buddhas-in-the-making, bodhisattvas have begun their journey on the Buddhist path, assured of nirvana at some point in the future. They are still active in this world and therefore are usually the ones to whom prayers are directed. Bodhisattvas are sometimes understood to postpone nirvana intentionally so that they can remain accessible to sentient beings.

The prototype for the bodhisattva is the prince, often called Siddhartha, who later became the Buddha Śākyamuni. Bodhisattvas thus are frequently depicted as royalty, with crowns, jewelry, and elaborate clothing. Jizō Bodhisattva, usually portrayed as a monk with simple robes and a shaven head, is the main exception to this rule. Most bodhisattvas are male; however, as we will see, one of the most popular bodhisattvas, Kannon, is frequently regarded as female.

Bodhisattvas give the impression of activity. Many are not in a state of meditation but rather are watching human activity, ready to help those in need. Their posture reflects this dynamic nature: buddhas most often sit in the lotus position, legs folded into each other, but bodhisattvas can assume any number of postures, including standing, crouching, or leaning back in a state of repose.

Wisdom kings, the third category, are esoteric Buddhist deities who usually appear angry and frightening. Esoteric Buddhism, by definition, emphasizes secret teachings that only the initiated can practice. Tibet is the most famous site of esoteric Buddhism, but the esoteric tradition has influenced almost all schools of Buddhism in Japan as well. Sometimes regarded as contrary to the principles of Buddhism, which according to some sutras is to be a completely open teaching, equally available to all, esoteric Buddhism is held by believers to provide a fast path to enlightenment and to require a high level of secrecy because the teachings and practices are easily misunderstood and potentially dangerous to those without the proper training.

It is easy to misinterpret the angry countenance of many esoteric deities. The anger, according to the tradition, is actually directed toward that which would prevent a person from attaining enlightenment. Wisdom kings are also said to be buddhas. Every buddha has both a peaceful aspect and an angry aspect, with the wisdom kings displaying the latter. This reveals one of the many weak spots in the four-category taxonomy: if wisdom kings are actually buddhas, do they not belong in the first category?

"Deity," a generic category that includes what the scholar Mimi Yiengpruksawan has aptly termed "the benevolent riffraff of the

Mahāyāna universe," is made up largely of protectors of Buddhism, often borrowed from the Hindu tradition.⁴³ In a temple, they frequently surround buddhas and bodhisattvas, sheltering them from harm. Technically, this is the only category that can include females.

A second, considerably older, system of classifying Mahāyāna deities attempts a doctrinal explanation of the relationships among them. This is the theory of the three bodies of the buddha, an orthodox Mahāyāna doctrine that has been around since the fourth century. The first and most important of the three bodies is the "dharma body," a kind of cosmic buddha force, from which all Buddhist deities emanate. The "enjoyment body," the second type, is that which appears in the purified lands where buddhas reside. The "manifestation body," finally, refers to buddhas such as Śākyamuni who appear in the ordinary world of human beings, the world of birth and death. In this way, all buddhas are manifestations of this cosmic buddha principle: bodhisattvas are manifestations of buddhas, deities are manifestations of bodhisattvas, and so on. This is best depicted in pictorial form, as skilfully accomplished in esoteric mandalas.

Ultimately, however, neither of these taxonomic systems has gained much acceptance on the ground in Buddhist Japan. Worshippers have been as likely to regard all Buddhist deities as manifestations of Kannon Bodhisattva, for example, as to accept the orthodox idea that as a bodhisattva, Kannon must be a manifestation of a buddha. Moreover, most Japanese Buddhists have been less concerned with categorizing a particular deity than with establishing what can be expected from him, and especially from a specific statue at a specific temple.

Topical Outline

This book focuses on the two most popular buddhas and the two most popular bodhisattvas in Japan, historically speaking. The buddhas are Śākyamuni and Amida; the bodhisattvas are Kannon and Jizō. My choice of particular statues to discuss is based on two factors: their relevance to the topic of living images and the likelihood that visitors to Japan might actually visit them. Many can be found in Kyoto, undeniably the historical center of Japanese religion.

In chapter two, I treat several images of Śākyamuni, the historical Buddha. The subject of chapter three is Amida Buddha, the buddha famous for his Pure Land. Chapters four and five deal with Japan's two ubiquitous bodhisattvas: Kannon and Jizō. Chapter six discusses secret

buddhas. In the next four chapters, I begin by presenting examples of the interaction between statues and people in modern Japan. I then provide a brief outline of the textual bases for devotion to that deity. Finally, I discuss the ways in which people in early medieval Japan related to specific images.

CHAPTER TWO

Śākyamuni: Still Alive in This World

Śākyamuni in Modern Japan

The Buddha's Birthday

Most schools of Buddhism in Japan today observe what are known as the "three Buddha ceremonies" (*san butsu-e*), elaborate rituals commemorating Śākyamuni Buddha's birth (*gōtan*), awakening (*jōdō*), and entry into final nirvana (*nehan*), or death. All three rites are observed by Buddhist clerics in many temples and monasteries, but the one that is best known, loved, and attended by the population at large is the celebration of the Buddha's birthday.

According to traditional scriptural accounts found in the Buddhist canon of Śākyamuni's birth, his mother, the queen Māya, had a dream in which a white elephant penetrated her side; when she awoke, she was pregnant with the future Buddha. Later, she gave birth standing in a grove of trees that were in full flower, the baby emerging from her side (rather than the birth canal, which was considered polluted). Śākyamuni's first act, immediately upon his birth, was to take seven steps, point one hand up and the other down, and declare, "From heaven above to earth below, I alone am the honored one." Heavenly deities appeared and bathed him in fragrant water, an act of worship.

The ritual observation of the Buddha's birthday in Japan is attested in records that date back to the eighth century, but my focus here is on the form it takes today. Commonly known as the Flower Festival (Hana matsuri), the celebration of the Buddha's birthday takes place on April 8 in modern Japan.[1] That is a time when cherry blossoms are nearing full bloom in many parts of the country, and people today associate the

name Flower Festival with the season. Many do not know that the term actually derives from the traditional practice of setting up a small gilt image of the newborn Śākyamuni, standing with one hand pointing to the sky and the other to the earth, in a large bowl beneath a trellis decorated with flowers, as a recreation of the grove of flowering trees in which he was born. Those attending the ceremony, which today include many parents and grandparents with small children in tow, ladle water or sweet tea over the baby Buddha. Some can be heard to remark that he looks "cute." Sometimes, there is a large white papier-maché elephant figure, as much as two meters high, standing on a set of wheels. In some variations of the rite, the birthday Buddha statue, in a small, colorful shrine, is placed on the back of the elephant, which is then pulled around the temple and the neighborhood by children, a practice that onlookers can associate with the use of portable shrines (*mikoshi*) in Shintō festivals (*matsuri*). At one birthday ritual I observed at Kyoto's Nishi Honganji temple in the spring of 2005, a person in a panda suit appeared and posed for photos with children in front of the elephant. At Mibudera temple, also in Kyoto, children from the temple's nursery school wore gold paper crowns. A temple monk explained that these made them resemble princes, just like Śākyamuni, who was born a prince.

The Buddhist clerics who organize Flower Festival gatherings at their temples are more or less aware of the religious significance of the elephant, the flower trellis, the posture of the baby Buddha image, and the act of bathing the image. Scholars of Buddhism, of course, can explain the symbolism of the ritual by referring to the canonical account of Śākyamuni's birth. Most of the people who attend, however, are only vaguely aware of these symbolic elements, although they do know that the festival is a celebration of the Buddha's birthday. What is clear to even the casual observer is that the celebration of the Buddha's birthday in modern Japan is popularly understood as an event that is aimed at children. It is meant to be fun for them, similar to any child's birthday party—hence the pandas and various other amusements and treats that have little or no historical precedent or symbolic meaning. Beyond that, however, the Flower Festival can be seen as a ritual that from an adult point of view celebrates the birth of children and the good fortune and joy they bring. To bathe the baby Buddha is, according to Buddhist doctrine, an act of worship that creates much spiritual merit (good karma). Those who attend the ceremony also in a sense view their own children and grandchildren as little buddhas. When they bathe the image, they are, in effect, ritually reenacting and sanctifying the everyday

chore of caring for their own offspring. That is not to say that they take the baby Buddha lightly or view him as an ordinary child. The water or sweetened tea poured over the image is believed by many to possess the power to heal and ward off illness, so it is a common practice for the participants to take home a small container of it, usually prepared separately, for good luck. At the Flower Festival I attended at Nishi Honganji temple, I was given a teabag to prepare the tea at home.

Statues of the baby Buddha are unusual in that most are set up and worshipped only once a year, on the occasion of the Flower Festival. The rest of the time, they usually are simply stored away in the temple and ignored. Baby Buddhas, moreover, are generic. Few that reside at particular temples for use in the Flower Festival ritual are famous, although some antique ones have found their way into permanent displays in museums. Perhaps because they remain forever the infant, baby Buddhas usually do not acquire complex biographies in the way that other Buddhist statues do.

Many monasteries also celebrate the Buddha's birthday, in a highly formal, ritualized manner, but also as if the image were living. For example, in addition to bathing the statue, they feed it. At Zen monasteries belonging to the Sōtō school, images of Śākyamuni are waited upon in ceremonies marking the three major events of his life.[2] For the Buddha's birthday, the statue is of the type used in the Flower Festival: a small metal image with one finger pointing up and the other down. The procedure for worship is outlined in *Standard Observations of the Sōtō Zen School (Sōtōshū gyōji kihan)*, a collection of ritual procedures based on medieval Chinese and later Japanese models. The instructions in this text are still followed today. On April 8,

> [a]fter breakfast, communal labor cleaning takes place as usual. Hall prefect and buddha hall postulant pick various flowers (in regions where snow is deep and flowers have not yet bloomed, make flowers from five-colored paper), decorate flower trellis (flower pavilion). Place a bowl in middle of pavilion, pour fragrant decoction into it. (According to Keizan's Rules, fragrant decoction is made by decocting five trees: peach, plum, pine, oak, and willow, and other fragrant wood. At present, sweet tea is steeped and used to bathe buddha.) Set image of newborn Buddha inside bowl, attach two small ladles on top of altar as decorations, and provide items of offering. Next, write Verse of Bathing Buddha on two placards and hang them within hall on two pillars to left and right.[3]

After the preparations are complete, the monks chant:

> We deeply bow our heads to the Most Holy Blessed One,
> In the heavens above and this earth below,
> Most revered among human beings.
> We now, with this water of merit,
> Bathe the pure dharma body
> of the Tathāgata.[4]

Then, after several representative monks have bathed the Buddha, other offerings, including sweets and tea, are given to the statue of the newborn Śākyamuni. The monks chant directly to the Buddha, who stands before them:

> We humbly beg your attentive concern and beseech your true compassion.
> On the eighth day of this month, we respectfully celebrate the occasion of the birth of our Great Benefactor and Founder of the Doctrine, the Original Teacher, Great Teacher Śākyamuni Buddha. We have humbly prepared incense, flowers, lamps, and candles, decoction, sweets, tea and rare delicacies, and have extended them in offering.[5]

The instructions continue in great detail about how the food and other offerings should be presented to the statue:

> At this point, buddha hall postulant in east row first raises up decoction vessel in both hands, passes it to incense-burning acolyte. Incense-burning acolyte first turns body around to right until facing decoction vessel, then bows with *gasshō* (this is called greeting bow with *gasshō*), and receives vessel in both hands.[6] Buddha hall postulant, using right hand, turns over lid, pinches it between index finger and middle finger, and removes it. . . . Abbot infuses decoction with incense, turns body to left, hands it to guest-inviting acolyte, makes send-off bow with *gasshō*. Buddha hall postulant in west row makes greeting bow with *gasshō* at same time. Guest-inviting acolyte receives decoction vessel, turns body to left, hands vessel to buddha hall postulant, makes send-off bow with *gasshō*. Buddha hall postulant raises up vessel, places it in offering on Sumeru altar (Usually hall prefect on top of altar receives and places it in offering).[7]

Next, buddha hall postulant in east row raises food vessel and passes it to incense-burning acolyte. Ensuing passing of the food vessel is same as that for the decoction vessel provided in the above extract.[8]

The argument is frequently made, as discussed in chapter one, that only laypeople feel the need to engage in rituals centered on a statue. As the above example demonstrates, the truth is quite the opposite: monks are especially likely to treat statues as though they are alive, although they do so in more highly structured settings. Zen monasteries contain numerous statues of buddhas, bodhisattvas, guardian deities, and ancestral teachers who are nourished with offerings of tea and decoctions on a daily basis, as well as in more elaborate monthly and annual rituals.

The Seiryōji Temple Śākyamuni: A Statue with Guts

In modern Japan, the Śākyamuni statue most enlivened by the attention and worship it receives is the "living-body Śākyamuni" (*shōjin Shaka* or *ikimi Shaka*) at Seiryōji temple in the Sagano area of Kyoto. Said to have been carved as an exact likeness of the historical Śākyamuni during his own lifetime, this secret buddha can be seen only on the eighth of every month, the holy day (*ennichi*) of Śākyamuni. His fame is such that although the temple's official name is Seiryōji, most people call it the Śākyamuni Hall in Sagano (Sagano Shakadō).

The status of this statue as a living-body buddha stems in part from the remarkably accurate internal organs, made of Chinese silk, inside his life-sized hollow wooden body. These went undisturbed from the construction of the statue in 985 until their discovery almost a thousand years later, in 1953, when the temple monks who brought the statue down from its pedestal in preparation for an official inspection noticed that several Tang dynasty Chinese coins tumbled from its back. A full-scale investigation by scholars and government representatives commenced in February of the following year. It revealed, beneath a wooden panel on the statue's back, a cavity more than 7 centimeters deep and 14 × 30 centimeters wide filled with over two hundred objects. Most striking were the internal organs, including a white stomach, purple kidneys, a violet gall bladder, and a red heart.[9] A statue with such organs is rare; this is the earliest of the few known examples in Japan and China.[10] After creating replicas of the organs, which are now on display at the temple, monks returned the originals to the inside of the buddha to avoid jeopardizing his living status.

The presence of the organs tells us more about the moment of the image's birth, however, than about its long life. Because this Śākyamuni was known as a living-body buddha long before the organs were discovered, their existence cannot constitute the only reason he has been so revered over the centuries. A guide to statues in Kyoto published in 1943, before the discovery of the items inside the statue, spends four pages on Seiryōji's Śākyamuni, emphasizing its legendary provenance as the statue that came to Japan from India through China.[11]

This legend is the main reason for the statue's longevity and status as a living buddha. Seiryōji's Śākyamuni is, according to Japanese lore, the very statue that was carved during the Buddha's own lifetime. As mentioned in chapter one, several early Buddhist texts explain that when Śākyamuni temporarily left India, the local ruler, often identified as a certain King Udāyana, missed him intensely and commissioned an exact likeness of him. In the version of the story the fifth-century Chinese pilgrim Faxian records in his diary, the king was named Prasenajit, and the statue rose to greet Śākyamuni when he returned:

> When the Buddha went up to the Heaven of Thirty-Three, and preached the Law for the benefit of his mother, (after he had been absent for) ninety days, Prasenajit, longing to see him, caused an image of him to be carved in Gośārsha Chandana wood, and put it in the place where he usually sat.[12] When the Buddha on his return entered the temple, this image immediately left its place, and came forth to meet him. Buddha said to it, "Return to your seat. After I have attained to *parinirvāṇa*, you will serve as a pattern to the four classes of my disciples," and on this the image returned to its seat.[13]

Xuanzang, an eighth-century Chinese pilgrim, related a similar narrative in his diary, also noting that

> [t]his king [Udāyana], thinking of him with affection, desired to have an image of his person; therefore, he asked Mudgalyāyanaputra, by his spiritual power, to transport an artist to the heavenly mansions to observe the excellent marks of Buddha's body, and carve a sandalwood statue.[14]

The version heard by Xuanzang involves even greater miracles. The statue is carved in the heaven itself, in front of the Buddha, so that it will be an exact likeness.[15]

The Japanese version of the legend builds on these stories, weaving a complex narrative to account for the statue's presence in Japan. One of the earliest appearances of the story is in the *Collection of Treasures* (*Hōbutsushū*), a late twelfth-century collection of tales; it is elaborated upon in a sixteenth-century illustrated scroll recounting the history of Seiryōji temple (*Saga Shakadō engi*). The *Collection of Treasures* begins with a historically verifiable incident in which, after viewing the image on a visit to China, the Japanese monk Chōnen (938–1016) requested a copy be made for him to take back to Japan. The text continues with the following mythical narrative: the night before Chōnen was to depart, the original statue appeared to him in a dream, telling Chōnen that he wanted to go to Japan. Chōnen had no choice but to accede to the wishes of the image, who was, for all intents and purposes, the Buddha himself. In the morning, to make the new statue match the old one exactly in appearance, as though it had long been enshrined in a temple, Chōnen immersed it in incense smoke. He then returned to Japan with the original.[16] According to this text, then, the statue in Japan today is the image carved during Śākyamuni's own lifetime. Knowledge on a popular level of this story, more than any other factor, accounts for the widespread devotion to Seiryōji temple's Śākyamuni. Today, the temple's brochures relate the legend in detail.[17]

The *Collection of Treasures* also tells the legend of how the statue came from India to China in the first place. The story centers on an evil king who, after Śākyamuni's death, wanted to destroy all the buddhas and bodhisattvas in the land. A government minister, deciding that he must protect Śākyamuni, became a monk and took the statue east, to the oasis city of Kusha. During the day he carried the living image, but at night the statue carried him.[18] Similar stories of a Buddhist statue carrying a human on its back, indicating complete trust and reliance between the image and the person, occasionally appear in the history of Japanese Buddhism. In chapter six, I discuss another such tale, involving the Amida Buddha at Zenkōji temple.

After some time, the *Collection of Treasures* explains, the statue made it known that he wanted to return to India. The citizens of Kyoto, deeply distressed, pleaded with him to remain. At last he agreed to do so.[19] He still lives in this temple solely because of his compassionate response to the urgent requests of devotees. His life is inseparable from that of his believers.

The 1515 illustrated scroll presents a more elaborate version of the story, accompanied by compelling pictures.[20] For example, rather than have Chōnen switch the statues before his departure, the scroll grants

them greater agency, depicting the statues changing places of their own accord. Each is drawn in the act of climbing onto the empty lotus pedestal of the other, in adjacent rooms.[21] The scroll also shows the statue walking along a rocky mountain path with Chōnen on his back.[22]

In the spring of 2005, I attended a public ritual in the main hall of Seiryōji temple, in front of the statue. In this annual Body-Cleaning Ceremony (Minugui shiki), the statue is cleansed with fragrant water and white cloth. The leaflet distributed to those attending the ceremony framed its importance in terms of an odd miracle attributed to the image.[23] About seven hundred years ago, a devout young girl who regularly performed retreats at Seiryōji temple married the emperor. Her mother, however, engaged in numerous evil acts, and when she died intense thunder and lightning tore through the sky. The daughter, understanding that her mother had been reborn in hell, continued visiting the Seiryōji Śākyamuni to pray for her. Śākyamuni appeared to the daughter in a dream one night, informing her that her mother had indeed been reborn in hell, but that owing to the daughter's faith, the mother had now been reborn as an animal. If she wanted to see her mother, Śākyamuni continued, she should visit Seiryōji temple early in the morning, when seven head of oxen pulled wood to the temple. The fourth, a yellow ox, would be her mother.

The daughter recognized her mother and arranged for her to have special food and a shed. But Śākyamuni once again appeared in a dream, explaining that an ox should live out the life of an ox to burn off past karma and achieve a better rebirth. By pampering it, the daughter was actually adding to its bad karma. With a heavy heart, the daughter sent the ox, her mother, back to hard labor. When the ox finally died, it was cremated wearing a shroud the daughter had sewn from the white cloth used to clean the body of the Seiryōji Śākyamuni. Purple clouds appeared in the sky and a wonderful fragrance wafted through the air, attesting to the miracle of the mother's birth in Amida's Pure Land. Some of the ox's skin found under the cremated bones was used to make a drum, and some to construct a hanging decoration for the temple (keman). The leaflet explained that the Body-Cleaning Ceremony now takes place every year, with that very drum and decoration on display, on the day the ox died and went to the Pure Land. Those who make a shroud of the white cloth distributed to some who attend the ceremony, the leaflet concluded, will be assured of birth in Amida's Pure Land. In this way, the temple neatly demonstrates how the miraculous powers of the Śākyamuni statue can cause birth in Amida's Pure Land. During the ceremony, monks and laypeople chant Amida's name for extended periods.

Worshippers are aware that the image is Śākyamuni, but they see no conflict in reciting Amida's name to him.

Seiryōji's other main celebration, the Lighting of the Pines (Taimatsu), is more directly associated with the historical figure of Śākyamuni himself. It occurs every year on March 15, traditionally held by the Japanese to be the day the Buddha was cremated. Three huge pillars made of bound pine branches, each about three meters tall, are set on fire, the sparks illuminating the cold night sky. As they burn down, flaming limbs and ashes fall dangerously close to the onlookers. This exciting ritual unfolds directly in front of the main hall, whose doors are opened for the occasion, as an offering to its central image. The doors of the shrine where Śākyamuni lives are also opened, enabling him to gaze from his altar in the main hall at the unruly celebration outside. Inside the hall, many people gather, admittedly to get warm, but also to see the statue and pray before it. Again, these prayers consist primarily of recitation of Amida's name and declarations of faith in him.

Many organized tours of the city of Kyoto include a visit to Seiryōji temple. If it happens to be the eighth of the month, visitors are able to view the statue. If not, they pray in front of the doors of its closed shrine. Worshippers usually kneel on a woven mat floor before a low gate that divides the inner from the outer worship chamber. Many clutch a small circle of prayer beads in their folded hands. All visitors are given a brochure outlining the legend of the Śākyamuni statue and recounting its journey from India to Japan, indicated in the designation "Śākyamuni transmitted through three countries" (*sangoku denrai Shaka*). Temple literature and Kyoto guidebooks emphasize the statue's "exotic" appearance. The statue does differ significantly from others carved in Japan in the tenth century, although the average worshipper probably would not be aware of that were it not pointed out. The emphasis on its foreign appearance is intended to authenticate its provenance as the miraculous image that was brought to Japan from India and China.

In the first volume of the *Record of Seeing the Buddhas* series, Itō Seikō and Miura Jun tell of visiting Seiryōji temple in hopes of meeting the image, having called in advance to ascertain that it could be viewed that day. Upon their arrival, however, despite their celebrity status, they were informed that owing to preparations for a ritual the following day, to be held in front of the cabinet shrine that houses the Buddha, they could not see Śākyamuni. Disappointed, they entered the hall anyway and found people setting up a microphone and video camera directly in front of the closed shrine. Miura imagined the scene that might take place, with the Buddha emerging to greet a breathless audience, performing as a rock star.[24] In an

illustration, Miura pictures himself in the audience exclaiming, "The word 'superstar' must have been coined just for Śākyamuni!"[25] The point is well made: elaborate preparations for the viewing of a secret buddha are similar to those for the appearance of a celebrity. Indeed, perhaps it is not too much of a stretch to call this statue a celebrity in its own right. Few people have remained popular, with incidents from their lives continuously retold, over the course of more than a thousand years.

The fashion model Hana, meanwhile, personalized and animated the image in a different manner. She observed that the statue's hairstyle resembles that of a character in the popular comic *Moomin Valley*, thus equating the statue with a fictional character who nevertheless would seem real to her book's young female audience. Then she imagined the statue remarking on how she had grown since he had last seen her years ago. Hana ended by professing awe at the statue's arduous journey across Asia to Japan, exclaiming that this miracle lives on in the heart of the Japanese people.[26]

Textual Bases for Devotion to Śākyamuni

Does Śākyamuni differ fundamentally from other buddhas? As the so-called historical Buddha, he is often regarded by those who seek an "authentic" Buddhism, especially in the West, as a mere human, someone who was born, reached enlightenment, died, and is no longer accessible. Statues of him, according to this view, simply serve as reminders of his example. Though this argument is found most markedly in the modern Theravāda tradition, it is not unknown to those who discuss Japanese Buddhism.

Śākyamuni was a historical figure who lived around the fourth century BCE in what is now India and Nepal. Beyond that, however, very little is known with any certainty. For the first several hundred years after his death, Buddhism remained an oral tradition. No extant written records of his teachings (sutras) predate the second century BCE. Only scattered biographical details appear in early texts; full-length biographies came much later. The earliest, fragmentary accounts depict a figure decidedly dissimilar to other human beings. As we have seen, for example, he is said to have been born from his mother's right side and to have been able to walk and speak immediately at birth. In addition, unlike biographies that the modern world would tend to consider reliable, those of Śākyamuni place great emphasis on his past lives. From the beginning of the written tradition of Buddhism, Śākyamuni was no ordinary person.

Śākyamuni is the narrator of almost all sutras, even those in which he himself does not appear. He also stars in hundreds of sutras. In East Asia, the *Lotus Sutra* is the text most responsible for promoting worship of Śākyamuni Buddha. The "Lifespan of the Tathāgata" chapter of the *Lotus Sutra* explains why Śākyamuni was extraordinary: his life on earth was an expedient device (Sk. *upāya*), a drama enacted to enable unenlightened people to relate to him. In actuality, the text explains, he achieved enlightenment in the beginningless past, and his earthly form was simply the manifestation of an eternal being. The *Lotus Sutra* goes on to assert that Śākyamuni will live on infinitely, at a cliff called Vulture Peak (Sk. Gṛdhrakūṭa):

> For asamkhya kalpas [aeons]
> Constantly have I dwelled on Holy Eagle Peak [Vulture Peak]
> and in various other places.
> When living beings witness the end of a kalpa
> and all is consumed in a great fire,
> this, my land, remains safe and tranquil,
> constantly filled with heavenly and human beings.
> The halls and pavilions in its gardens and groves
> are adorned with various kinds of gems . . .
> My pure land is not destroyed,
> yet the multitude see it as consumed in fire,
> with anxiety, fear, and other sufferings
> filling it everywhere.[27]

Vulture Peak is the site from which Śākyamuni is believed to have pronounced some of his most famous teachings, including the *Lotus Sutra* itself. Identified in modern-day India as a cliff just outside the city of Rajgir in the northern state of Bihar, it is a major pilgrimage site. The passage quoted above explains that Vulture Peak itself is the Pure Land of Śākyamuni.

Although little known in the West, the concept of Pure Lands is fundamental to Mahāyāna Buddhism, appearing very early in the development of that tradition. At its most basic, a Pure Land (*jōdo*), also sometimes referred to as a Buddha land (*butsudo*), is the place where a buddha resides. By his very presence, he creates a purified area around him. Pure Lands stand in contrast to polluted lands (*edo*), or worlds in which ordinary human beings dwell. Therefore, as generally understood, a Pure Land is free of all the negative aspects, such as pain and suffering, of the world of humans. However, numerous competing understandings of Pure Lands

have appeared in Mahāyāna Buddhism. Some hold that a Pure Land cannot be perceived by an unenlightened person. For example, in the *Vimalakīrti sūtra*, a seminal Mahāyāna work, the Buddha states that only the person whose mind is pure is able to see the purified area around a buddha.[28] It then follows that this world can be a Pure Land to the enlightened person.

In all interpretations, a Pure Land is a place where one can be in the presence of a buddha. By definition, all buddhas have Pure Lands, but only a few have received special attention. Amida's Pure Land became most popular in East Asia, so that the term "Pure Land" today is effectively synonymous with that of Amida. This was not, however, always the case.

Rather than the beautiful jeweled trees and palaces in Amida's Pure Land, rocks and cliffs adorn the Pure Land of Śākyamuni, who is seated on a throne, surrounded by devotees, amidst a mountainous landscape. In paintings, one of the cliffs often takes an unusual hooked shape, which is thought to be the shape of a vulture's head, the feature that gave rise to the mountain's name. Śākyamuni at Vulture Peak became a popular theme in China, especially in illustrations accompanying copies of the *Lotus Sutra*. But emphasis on Vulture Peak as his Pure Land took center stage only in Japan.

Śākyamuni in Early Medieval Japan:
Creating a Pure Land

Images of Śākyamuni preaching at Vulture Peak appeared in Japan almost from the time of the official entry of Buddhism in the sixth century. The scene is depicted, for example, on the petals of the lotus pedestal atop which sits the Great Buddha of Tōdaiji temple. Although the Great Buddha itself suffered damage in fires and was reconstructed repeatedly, much of the original pedestal remains. The sermon on Vulture Peak also appears on the seventh-century Jewel-Beetle Zushi and in murals at Hōryūji temple.

In early medieval Japan, the idea was taken a step further, and Śākyamuni's Pure Land was actually re-created at several sites, in line with the long-standing Japanese habit of grafting sacred spots from other countries onto their own landscape. To recreate a Pure Land, a buddha must be present. If a buddha is re-created, so is a Pure Land. The two are mutually dependent. Śākyamuni's prominence in early medieval Japan was due in large part to the belief that images of him

were a living buddha, and that the area around them therefore constituted a Pure Land.

Early medieval texts frequently refer to Vulture Peak as the dwelling of Śākyamuni, demonstrating the popularity of this notion. In her late tenth-century *Pillow Book* (*Makura no sōshi*), for example, Sei Shōnagon exclaimed, "The Numinous Mountain (Ryōzen) is where Śākyamuni lives. Oh, how poignant!"[29] Not limited to aristocrats, belief in Vulture Peak as Śākyamuni's Pure Land also appears in the twelfth-century *Songs to Make the Dust Dance*, a collection of popular songs which contains several verses lauding Vulture Peak. For example,

> Under the forest of *śāla* trees,
> he [Śākyamuni] appeared to have died,
> but on the edge of the mountain called Vulture Peak (Ryōjusen),
> like the moon [he is] always shining.[30]

An illustration of Śākyamuni at Vulture Peak was found inside the Seiryōji Śākyamuni, suggesting that this statue was understood to be Śākyamuni in his Pure Land, but the emphasis on the Seiryōji image's legendary origin as the original Indian sculpture took precedence over any other claim to fame. However, two other famous statues—neither of which is extant—were revered in early medieval Japan explicitly as Śākyamuni in his Pure Land.

The Daianji Temple Śākyamuni

The first Japanese Śākyamuni statue widely worshipped as Śākyamuni at Vulture Peak lived at Daianji temple in the city of Nara. Although the statue is no longer extant, the biography of this seventh-century image has been recorded in some detail. Its physical details are almost completely unknown, however, suggesting either that worshippers were unable to see it clearly or that its appearance was unimportant to them. *Miraculous Stories of Karmic Retribution* (822) described two separate instances in which the Daianji Śākyamuni worked miracles for his devotees.

In the first story, a farmer killed a deer to feed his family, unaware that it belonged to the emperor, who then ordered that the entire family be imprisoned. Since the family had heard that the Daianji temple Śākyamuni answered prayers, they begged a monk to petition this buddha. They also requested, "When we are led to court, please open the southern gate of the temple so that we may pay homage to the buddha. Also we beg you to ring the bell when we are taken to court so that the

sound of the bell may follow us." This was done. When they arrived at court, they learned that a new prince had been born and the emperor was granting amnesty to prisoners. The farmer's family was freed.[31] In this example, the family was forced to offer prayers from outside the south gate and would not have been able to see Śākyamuni well, if at all. Nevertheless, their prayers were answered.

In the second story, the protagonist is an indigent woman:

> Having heard that the three-meter Buddha of Daianji was ready to grant wishes immediately, she bought flowers, incense, and lamp oil, and went to make a petition before the Buddha, saying, "As I did not produce good causes in my previous lives, I am suffering from extreme poverty in my present body. Please give me some wealth to save me from dire poverty." She never ceased to pray for days and months.[32]

She subsequently discovered some money next to a bridge, with a label indicating that it belonged to Daianji temple. She promptly returned the money to the temple, and the temple monks placed it in a safe to ensure it would not again be misplaced. The woman continued to worship the Śākyamuni, offering lighted lamps, incense, and flowers. Then she found yet more money, again labeled as belonging to Daianji temple, this time in her garden—and again she returned it. When the monks opened the safe, they were perplexed to discover that the exact amount she had found was missing. Next, she came across the money on the threshold of her house, and again returned it. Finally, "the monks consulted and said, 'Since this is the money Buddha gave her, we won't keep it in our safe anymore.' They returned the money to her. . . . Indeed, we know this took place by the miraculous power of the three-meter Śākyamuni and the woman's utmost devotion."[33]

Although she made offerings to the Buddha, we do not know whether she could see him, or whether he might even have been in a hall that she was not allowed to enter, in which case she would have placed the offerings in front of the building. Neither of these stories describes the image, other than mentioning that it is three meters tall. Details of its appearance were not important to these devotees, who knew only the purported efficacy of the Daianji Śākyamuni. In both stories, although the Śākyamuni of the elite Daianji temple aids commoners, in neither is it likely that they ever entered the hall and saw the statue.

Neither of these stories refers to the Daianji statue as Śākyamuni at Vulture Peak. Apparently, he was not constructed with this in mind,

although a birth story in the tenth-century *Three Jewels* (*Sanbōe*), a collection of Buddhist stories compiled three hundred years after the statue was carved, does make this connection:

> In the reign of Emperor Tenji a three-meter image of Śākyamuni Buddha was made and installed in the temple. The emperor passed an entire night in silent prayer, and the next morning two Celestials appeared and worshipped before the image. They made offerings of magical flowers and passed some time in reverent prayer. Then they told the emperor, "This image is a perfect likeness of the real Buddha of Vulture Peak," and then they rose into the sky and disappeared. When the image was dedicated, purple clouds filled the sky and magical voices were heard singing in the heavens.[34]

Even the great monk Kūkai (774–835), founder of the Shingon esoteric school of Buddhism in Japan, was a devotee of Śākyamuni at Vulture Peak and spoke with reverence of the Daianji temple Śākyamuni in his will, stating that Daianji's West Pagoda, where the statue was installed, was the "Fundamental Peak" (Konpon no mine), a reference to Vulture Peak.[35] Kūkai was asserting that the hall at Daianji temple in which the image lived was equivalent to Śākyamuni's Pure Land.

The elite of the eleventh and twelfth centuries, under the growing influence of the *Lotus Sutra*, particularly revered the Daianji Śākyamuni, to the extent that a twelfth-century sculptor remarked that Śākyamuni statues everywhere were copied from the one at Daianji temple.[36] In 1017, the aristocrat Fujiwara Sanesuke recorded in his *Shōyūki* that he had worshipped this Śākyamuni.[37] Fujiwara Munetada, in his diary *Chūyūki*, also mentioned worshipping the statue in an entry for the year 1089.[38] In the 1106 *Journal of the Seven Great Temples* (*Shichidaiji nikki*), the low-level aristocrat Ōe no Chikamichi stated his opinion that "with the exception of the Daianji Śākyamuni image, the statues of the Buddha and his twelve generals [at Yakushiji], which can be viewed, are superior to [the images at] all other temples."[39] In Chikamichi's follow-up, the 1140 *Record of Pilgrimages to the Seven Great Temples* (*Shichidaiji junrei shiki*), he exclaimed that the Daianji Śākyamuni was no different from Śākyamuni on Vulture Peak, and he described it as three meters tall.[40]

Myriad other magnificent Buddhist statues dating to the same period also live on today in Nara's temples and museums. For example, the central image at Yakushiji temple, mentioned above, is extant and widely regarded as a masterpiece of Japanese Buddhist art. Yet in the

twelfth century, Dainaji temple's Śākyamuni was called the greatest of all. Some scholars have interpreted this to mean that the Daianji Śākyamuni was one of Japan's finest pieces of Buddhist art. This may be true. But "greatest" probably did not refer solely, or even primarily, to what we now regard as artistic quality. More likely, it described the image's power, just as a "great" human is not necessarily the most physically appealing but rather possesses a charisma to which others are attracted. The size of the Daianji Śākyamuni would certainly have contributed to its power, but whether it was a great work of art is unknown. It was, however, without question a "great" image.

Hundreds of years after its construction, the statue's power to inspire faith was based largely on the conviction that he was the real Śākyamuni of the *Lotus Sutra*. Thus the community of response, including worshippers and compilers of legends, kept this image alive for at least five hundred years. At some point, however, it was allowed to die.

The Śākyamuni of Vulture Peak Hall

A statue in early medieval Japan that dwelled in a setting more explicitly designated as Śākyamuni's Pure Land was enshrined in Vulture Peak Hall (Ryōzen'in) in the Yokawa sector of Mt. Hiei, the mountain that was home to Enryakuji temple, the great center of Japanese Tendai Buddhism.[41] The year 1007 saw the founding of the Śākyamuni Fellowship (Shakakō), whose sole purpose was to keep watch over a living statue of Śākyamuni in shifts of twenty-four hours a day, year round. The image's status as the actual Śākyamuni necessitated that it be guarded and served just as the Buddha's own disciples would have served him during his lifetime. Members of the fellowship, who included both monastic and lay believers, brought it food and water, warmed it in winter, fanned it in summer, and took care of its various needs. Strict rules governed the activities of the group.

Some scholars have speculated that this statue may have been a copy of the living-body buddha at Seiryōji temple. Almost certainly, however, it was modeled on Daianji temple's image. According to the *Record of the Mountain Temple Halls* (*Sanmon dōshaki*, fourteenth century), the monk Genshin (942–1017) commissioned the famous sculptor Kōjō to create a life-size image of Śākyamuni for Vulture Peak Hall.[42] Other texts establish that Kōjō had earlier created an image modeled on Daianji's Śākyamuni for a temple in Kyoto. It stands to reason, therefore, that Kōjō's carving of Śākyamuni for Vulture Peak Hall was also based on that at Daianji temple.[43]

Genshin was the founder and leader of the Śākyamuni Fellowship. Although he is known today almost exclusively for his composition of *Essentials for Pure Land Birth* (*Ōjōyōshū*), a text that contributed to the popularization in Japan of practices aimed at achieving birth in Amida's Pure Land, Genshin was also, and perhaps more importantly, active in many fellowships and associations at Yokawa, including a Jizō Fellowship. In addition, he was a lifelong devotee of the *Lotus Sutra*, and therefore of Śākyamuni Buddha, the hero of that text.

The names of members of the Śākyamuni Fellowship are known to us today from an extant sign-up sheet, full of erasures and additions, which is judged by scholars to be the original. Under daily headings for an entire year, one to four people (totaling 547 for the year) volunteered to keep watch over Śākyamuni for a 24-hour shift; 121 of these are laypeople, constituting about one-fifth of the Śākyamuni Fellowship. Among them were not only high aristocrats but also mid-level bureaucrats and others of even lower status, who may have been local governors and landowners.

Women, both monastic and lay, participated in the Śākyamuni Fellowship. The names of twelve nuns appear on the list. The lay women, all either aristocrats or their close associates, included Rinshi, Fujiwara Michinaga's primary consort; Teishi, an imperial consort whose servant was Sei Shōnagon, the author of the *Pillow Book* (*Makura no sōshi*); and Shishi, sister of Emperor Ichijō (980–1011).[44] Mt. Hiei in general, and Yokawa in particular, had been off-limits to women since the time of Saichō (767–822), the founder of the Tendai school, to preserve the temple's purity. The *Biography of the Great Teacher Eizan* (*Eizan Daishi den*, c. 822) stated that in the fourth month of 822, when Saichō knew he was about to die, he instructed his disciples that "[w]omen may not come near the temple and certainly may not enter its sacred precincts."[45] That this rule was later broken so women could worship a statue of Śākyamuni speaks to the importance of that living image.

On the third day of the seventh month of 1007, Genshin composed the founding charter for the Śākyamuni Fellowship, called the *Daily Procedures* (*Mainichi sahō*). It is to this text that the sign-up sheet was appended. Ten days later, he composed *Procedures for Vulture Peak Hall* (*Ryōzen'in shiki*). The second document echoed the first but added a few points, outlining each of the rules in greater detail. Serious infractions must have prompted its composition. Any such transgressions would have been especially problematic within the context of such a strict group.

Although complex religious exercises such as meditation were not included in the Śākyamuni Fellowship's activities, the rules were laid

out in great detail. Adhering to them while staying awake for twenty-four hours after what would have been in many cases a long journey to Mt. Hiei from the city of Kyoto, even if accompanied by servants, would have been no easy task. *The Daily Procedures*, for example, states:

> [We] must not, in front of the Buddha, walk around aimlessly, sit or lie down, read sutras in a loud voice, etc. Since even when performing an assigned task, [we] must not speak loudly, [we] must all the more cease all unnecessary speaking and laughing. If [we] have something to do, [we must] go outside the hall to do it.[46]

Both the *Daily Procedures* and the *Procedures for Vulture Peak Hall* referred only to "the Buddha"; they never used the word statue. Since it is a relatively short document and reveals much about the statue's role in the Śākyamuni Fellowship, I present the *Procedures for Vulture Peak Hall* in its entirety.

Procedures for Vulture Peak Hall

Preparing the three actions [of body, mouth, and mind], we should enter [the hall].

Numinous Eagle Peak (Ryōjusen) is the place where the Tathāgata Śākyamuni is always living, the land where all of firm belief take refuge. All deities of heaven and all good spirits always protect it. Therefore, the sentient beings in the three worlds are covered with multitudinous benefits. Now, this jeweled hall traces that mountain [Vulture Peak]. Therefore, [only] those with a pure body and mind should be allowed to enter. Those who are impure and licentious, without dignity, etc., absolutely may not enter.

1. Every day, we should pay respect and make offerings [to the Buddha].

After the signal at the time of the rabbit [5 to 7 a.m.], [offer] rice gruel, one or two types of vegetables with sauce, and chopsticks. At the time after the signal at the hour of the serpent [9 to 11 a.m.], [offer] four or five measures of fragrant rice, and one or two types of soup made with salt, vinegar, etc. Fruit, when available [, should be offered]. At daybreak, [offer] water; at twilight, [offer] votive lights (with a measure of new oil).

In addition, as appropriate to cold or heat, such things as a brazier or a folding fan should be offered. (The brazier and fan should be ready in the hall; the charcoal, however, should be brought by the person whose turn it is.)

2. In the afternoon and evening, we should keep watch and guard [the Buddha].

From the early morning of that day to the early morning of the following day, [we should] keep watch, and perform the various tasks as they have been designated, such as rolling up the blinds and lowering the awnings, opening the door, cleaning, etc.

We must not approach the Buddha at undesignated times. Walking or sitting, we must maintain firm resolve, and we must not behave roughly. We absolutely must wait for the entrance of the next person, and then leave.

3. We should recite sutras, think on the Buddha, and love and revere [the Buddha].

When we make offerings twice, in the morning and in the evening, [we must] bow to the Buddha three times. In the afternoon, we must always recite three times the "The Lifespan" [chapter of the *Lotus Sutra*] thrice. In the evening, we must recite and think on Śākyamuni's name, thrice, over one hundred times. However, we must not recite with a loud voice. All the more, we must cease all unnecessary speech and laughter.

If we have something particular to do, we must go outside the hall to do it.

Moving, not moving, sitting, or lying down, we must always love [the Buddha], at these times preparing our minds by looking at the "The Lifespan."

In India, [there are] images of the Buddha at numerous miraculous sites. If someone earnestly desires to see such an image, the true body of the Buddha will appear, comforting, and the practitioner fulfills his vows. This is so even now. You must not doubt this for a moment.

4. When we make offerings at special times, [those who] love the Buddha should be included.

Those who know their indebtedness to the Buddha, and those who seek enlightenment, should do such things as sometimes taking flowers and offering them to the Buddha, and conducting music and song. [Concerning] paying respect to the Buddha in this way, the *Lotus Sutra* says: "If a person offers one flower or [stick of] incense, lowers his head and raises his hands, all will become buddhas."

The *Collected Treasures Sutra* (J. *Hoshakkyō*) says, "Ah, the great holy man, the great master Śākyamuni, has passed away. Now, we can only hear his name; we cannot see his form."[47]

5. Stating our heart-felt intent, from time to time, we should make these vows.

Facing the Buddha and paying obeisance [to him], we should reflect in our hearts and speak out loud "[I,] a certain person, a provisionally named monk who is a disciple (or, perhaps, a white-robed disciple) of a distant land [from India] in the Final Era, face the Great Master Śākyamuni, saying, 'The Great Master was in this world over forty years. He saved those with karmic connections, but soon returned [to Nirvana] without remainder. Since then, to the fourth year of the Kankō era [1007], it has been 1963 years. Or, Master Xingchan of Shuanglin temple of Anwu County explained that 1990 years [have passed].' " The above articles are as outlined.

Now, our inhalations do not await our exhalations, nor do our exhalations await our inhalations. How much more, when we reach our decline, is it impossible in the morning to wait for the evening?

Let us strive with body and mind; we must not be lax. Fortunately, through reliance on the compassionate vows of the Great Master, we have chanced to become disciples of the Dharma that he left us. We have already entered the mountain of treasures. We must not return empty-handed.

Kankō 4 (hinoto hitsuji) [1007], seventh month, thirteenth day.[48]

Although Genshin was a highly educated monk, this text is notable for its single-minded emphasis on devotion to a statue. Members read and recited the "Lifespan of the Tathāgata" chapter of the *Lotus Sutra*, the *locus classicus* for the belief that Vulture Peak is Śākyamuni's Pure Land. Genshin's statement that "[i]f someone earnestly desires to see such an image, the true body of the Buddha will appear, comforting, and the practitioner fulfills his vows" demonstrates his sincere conviction that Śākyamuni was made present at Vulture Peak Hall. Moreover, Genshin's emphasis on the necessity of each person maintaining a pure mind and body is reminiscent of the *Vimalakīrti sūtra*'s explanation that the land around a person who is pure is also pure. A delicate balance, which could be disrupted by not following the strict procedures, had to be maintained for Vulture Peak Hall to truly be the site of Śākyamuni's preaching of the *Lotus Sutra*.

The best description of the appearance of Vulture Peak Hall is found in the *Biography of the Monk Genshin* (*Genshin Sōzu den*), thought to have

been written before 1061, within fifty years of Genshin's death, with input from a member of the Śākyamuni Fellowship who was still alive. It stated:

> [Genshin] erected a hall. There was enshrined a likeness of the great master and founder Śākyamuni. Every morning, utensils for face-washing were offered, and food for meals was presented. The ten great disciples, including Śāriputra, were painted on the four walls, respectfully surrounding [Śākyamuni]. In what way was it different from the old tradition at Vulture Peak?
>
> Moreover, in that hall, on the last day of every month, [Genshin] lectured on the *Lotus Sutra*, discussing its doctrines.[49]

The hall was, for believers, the very site from which Śākyamuni preached the *Lotus Sutra*; they themselves could mingle there with his famous disciples. But like the Daianji Śākyamuni, the Śākyamuni of Vulture Peak Hall eventually died. The Śākyamuni Fellowship did not survive for long after Genshin's death; perhaps the statue died with it.

The Śākyamuni of Seiryōji Temple, Revisited

The actual birth story of the Seiryōji living statue is almost as dramatic as the mythical one. In the eleventh century, belief in Amida Buddha and practices directed toward birth in his Pure Land were rapidly transforming Japan's religious landscape. Chōnen, born in Kyoto and trained as a monk at Tōdaiji temple in Nara, keenly believed that "traditional" Buddhism was suffering at the hands of schools based in the Kyoto area that focused on Amida. Determined to restore Śākyamuni to prominence, Chōnen vowed to establish, in the city of Kyoto itself, a center of Śākyamuni faith. With this goal, in 983 he traveled to China on the boat of a Chinese merchant. He received a warm welcome from the Chinese and was even granted an audience with the emperor, who presented him with the purple robes, the highest honor for a monk. Chōnen made such an impression that much of the section on Japan in the official *Song Dynasty History* (*Song shi*) is taken up with his visit. He accomplished a great deal during his two years in China, spending most of his time at Mt. Wutai and making pilgrimages to numerous other important Buddhist sites, but one of his most important legacies is the statue that he brought back to Japan.[50]

Items discovered inside the statue, including woodblock prints depicting the five deities of Mt. Wutai, jewels, coins, textile fragments,

and numerous texts, reveal much about its actual birth. A list of objects, with the names of the donors, was also placed inside the image upon its completion in 985. Since many of the objects could no longer be identified in 1953, having long since disintegrated, the list is invaluable. Further details about some objects that were recovered are also helpful. For example, the list explained that each of the silk internal organs contained a precious item, including a gemstone in the heart and incense in the liver.[51] When the statue was consecrated, crystals were placed in the ears, and a tooth of the Buddha and a mirror in its head. The list also related a miracle relating to the statue:

> When the image was made, a tooth of the Buddha was installed in its face. Later, the Buddha's back emitted one blood-spot. It is not known what it portended, but the multitude all saw it. Therefore we have recorded it herein.[52]

The appearance of blood on a statue at the moment enlivening objects were placed within served as proof for onlookers that the statue was indeed living.

The numerous plain textile fragments found in the statue suggest a farewell ceremony in which monks cut off pieces of their simple robes to offer the statue, although the list does not include these textiles. The list does mention the arm bracelet of a one-year-old girl, indicating that laypeople may have been present. The contents of the statue attest to Chōnen's favorable reception in China.

The Chinese were not the only ones to offer items for enshrinement in the image. Chōnen himself gave several objects, including prayer beads, a relic, a mirror, a copy of the *Lotus Sutra*, a leaf from the tree under which the Buddha died, gold, jade, and gemstones.[53] The two most precious items he offered, however, were found inside the statue but are not on the list. One was a written vow, dated 972, taken by Chōnen and his disciple Gishin to build a temple in the western part of Kyoto from which to spread Śākyamuni's teachings. It reads, in part:

> With hearts united in life as in death, while cold and heat alternate in their course, if until the very end we should lose our will, which caused us to establish this bond that we might prosper the Dharma, may neither of us achieve supreme enlightenment. Therefore we have selected a spot on Mt. Atago, where, with hearts united and strength joined, we will build a monastery and raise up the Dharma left behind by Śākyamuni. Then, in our next life, may we be born

together in the inner sanctum of Tuṣita Heaven, where we may see the Buddha and hear the Dharma. In the life after that may we follow Maitreya down to Jambudvīpa, hear the Dharma and gain benefit therefrom, profoundly increase the feeling of the great mercy of the bodhisattva, wander at will through the Pure Lands of the ten directions, and speedily attain to that supreme, true enlightenment which knows no differences. Accordingly we have set down in writing this oath establishing a bond throughout present and future, each holding one copy thereof, which he shall transmit to posterity.[54]

After marking it in red ink with their handprints, each kept a copy. Chōnen's copy ended up inside the Seiryōji image.[55]

Chōnen's most unusual offering is suggested by a slip of paper bearing the handwriting of his mother, which is thought to have been wrapped around a portion of his umbilical cord. He may have carried this with him his entire life, or perhaps his mother entrusted it to him before he embarked on the long and dangerous journey. Either way, he clearly treasured this small item.[56] The enshrining of these offerings in a statue that was intended never to be opened speaks to their value not as symbols but as truly enlivening objects. A relic connected to Chōnen's own birth was incorporated into the birth of the statue.

Another document found in the statue, composed by a Chinese monk at Chōnen's request, provides a short biography of Chōnen, focusing on his travels through China. This text only briefly mentioned the statue into which it was being inserted:

Then he heard that in antiquity King Udāyana had carved a holy image of Śākyamuni in the Heaven of Thirty-Three, that it had appeared in Western Lands, and that a copy had reached China. Since the territory of Japan was remote and, though one might think of an Indian form, yet one might not easily see it, therefore Chōnen gave up his robe and begging-bowl, and with them bought fragrant wood . . .[57]

Chōnen's return to the city of Kyoto was celebrated with a great parade, in which the statue rode on a cart pulled through the city streets. This event was described in detail in Fujiwara Sanesuke's diary.[58] The image was not enshrined in the temple that was to become Seiryōji until after Chōnen's death, but as it became widely known as a living-body

buddha, capable of producing miracles, the temple expanded. Several documents indicate that in the twelfth century, pilgrims hoping to benefit from its powers flocked to the temple. The author of the *Collection of Treasures* mentioned finding the temple crowded with men and women, rich and poor.[59]

Attesting to the popularity of Seiryōji's Śākyamuni are the numerous replicas of him that live in temples throughout Japan. Reproductions began to appear about one hundred years after this living-body buddha arrived in Kyoto. Today, approximately one hundred and twenty such copies are extant. The earliest, at Mimurotoji temple near Kyoto, dates to 1098. One of the most famous copies, executed in 1249, resides at Saidaiji temple in Nara. It was commissioned by the monk Eison (1201–1290), who was concerned, as Chōnen had been before him, that Śākyamuni should occupy a central role in the practice of any Buddhist. Eison therefore instructed one of his disciples to arrange for a copy of the Seiryōji image to be made. Sculptors worked for about eighteen days, directly in front of the Seiryōji statue. Just before the eye-opening ceremony for the new image, relics began appearing in the monks' living quarters, a miracle attesting to the power of the copy.[60]

In the thirteenth century, with the growing prominence of faith in Amida Buddha, more monks became concerned with promoting devotion to Śākyamuni as a means of preserving discipline in the Buddhist order. Likewise, the number of copies of Seiryōji's Śākyamuni increased at this time. Although copies of statues, particularly unusual ones, are not uncommon, the scale of the phenomenon in this case is remarkable. Copies of the copies also began to appear, with some of the once-removed replicas bearing more resemblance to their immediate predecessor than to the Seiryōji Śākyamuni. In this way, the living-body buddha gave birth to children and grandchildren.[61]

The thirteenth-century *Sand and Pebbles* spoke affectionately of the Seiryōji Śākyamuni, explaining that after the temple burned in 1217, sermons were given for fifty days to raise money for its restoration. One of the monks presenting the sermons stated that if the house of one's parents burned down, the children would take responsibility for seeing that it was rebuilt. How much more, he argued, should everyone contribute to the rebuilding of the home of Śākyamuni, our "True Parent." The temple was soon rebuilt with funds raised from the sermons.[62]

As it became increasingly popular, the Seiryōji Śākyamuni's life took an ironic turn. Although it had been constructed and enshrined

expressly to promote worship of Śākyamuni Buddha, a little over three hundred years after its birth it became the focus of worship for devotees of Amida Buddha. The area around the temple had long been inhabited by Pure Land monks. In the thirteenth and fourteenth centuries, when a series of fires destroyed numerous temple halls, these monks sponsored the reconstruction of many of the buildings, rendering the temple increasingly Pure Land Buddhist in nature. This culminated in its official designation in the 1860s as a Pure Land Buddhist temple in the lineage of the monk Hōnen. The situation today, in which devotees gather in front of the Seiryōji Śākyamuni and recite statements of faith in Amida Buddha, would surely have driven Chnen to despair. The statue has come to live a life diametrically opposed to that for which it was intended.

The Buddha's Birthday, Revisited

In early medieval Japan, the Buddha's birthday ceremony was called the Anointment of the Buddha (Kanbutsu-e) and took place primarily in monastic, aristocratic, and imperial circles. Texts as early as the eighth century speak of a celebration on the eighth day of the fourth month, but they offer no details. The first mention of actually bathing the Buddha appears in a ninth-century document, which tells of the ceremony taking place at the imperial palace.[63] Further details emerged in later texts. As one scholar explains,

> Early in the morning special robes for the emperor were laid out, the screens of the Seiryōden (a hall in the inner, private quarters of the imperial court frequently used for court rituals) were lowered, and the emperor's seat prepared. An image of Śākyamuni was placed on a pedestal, from which colored threads trailed into a basin of colored water said to represent the divine waters in which the infant Buddha was first bathed. Ecclesiastical and court dignitaries entered in procession. Then the emperor scattered flowers over the image, and the presiding monk bathed it in five scoops of the colored water. The emperor, his ladies, and other courtiers did likewise.[64]

The tenth-century *Three Jewels* described the ceremony as follows:

> The Anointment of the Buddha was observed in the Seiryōden for the first time on the eighth day of the fourth month of the seventh

year of the Jōwa era [840]. . . . In the *Sutra on the Anointment of Buddha Images* it is said: "All the Buddhas of the ten directions were born on the eighth day of the fourth month. Between spring and summer great numbers of all kinds of living things are born. At that time it is neither too cold nor too hot, and so everything is wholesome and harmonious." And, in the *Sutra on the Anointment of Images the Buddha*: "I shall now explain the practice of anointing images. Among all offertory acts, this is the most excellent. To anoint a Buddha, perfume the water with many lovely scents and bathe his image. As you scoop the water, chant this verse." (Those who find this verse too hard to learn employ monks to chant it and to sing hymns of praise.)

> I anoint all the pure wisdom, all the merit, and all the splendor
> of all the Buddhas;
> May all sentient beings be freed from the Five Pollutions,[65]
> And may they know the purity of the Tathāgata's Body.

This verse was uttered by the Tathāgata Śākyamuni; Gyōki Bosatsu composed this one:[66]

> If I do not now repay
> My obligations to my mother
> Who nursed me with her abundant breasts
> Then when shall I?
> For the years fly by as quickly
> As the passing of one short night.[67]

For the Heian aristocrat who composed this work, the significance of bathing the Buddha lay in the ritual's power to save living beings as well as in its filial implications, stressing as it did the relationship between mother and child.

Several aristocrats, including the great Fujiwara Michinaga, also spoke of bathing the Buddha, and the early eleventh-century *Tale of Genji* briefly mentioned a procession "bearing a statue of the baby Buddha" that occurred on the Buddha's birthday.[68] But, as in modern Japan, statues used in the Buddha's birthday celebrations in the early medieval period were unusual in that although they were treated as living for a day, the rest of the year they were left to languish in storage. Moreover, even for that one day, they were the center of attention for only a handful of the elite. In early medieval Japan, the Śākyamuni statues most

enlivened through their interaction with worshippers were those believed to be the living Śākyamuni at Vulture Peak, the Pure Land from which he preached the *Lotus Sutra*. Today, the Seiryōji Śākyamuni, which also became a celebrity during the early medieval period, is the most celebrated Śākyamuni in Japan.

Connected to Amida Buddha

Amida Buddha in Modern Japan

Two bodhisattvas, statues come to life, dance across a bridge. The first, Kannon Bodhisattva, extends a large lotus pedestal, carved of wood and painted gold. Twenty-three bodhisattvas have already crossed the bridge, each holding a distinctive item such as a musical instrument, a canopy, or a flower garland. They are all on their way to greet a dying person and escort her, seated on the lotus, to the Pure Land of Amida Buddha. This is the famous Welcoming Ceremony (Mukaekō) of Taimadera temple, in Japan's Nara prefecture, which takes place every year on May 14. Crowded around the bridge are hundreds of spectators, many with cameras. No one is actually dying. This is a religious ceremony, a festival, in which observers rehearse the vision they hope to see at their own death.

The bodhisattvas advance to a hall, labeled for this day only "Hall of This Defiled World" (Shabadō), where a small statue, the "dying" person, is placed on the lotus pedestal. Then they triumphantly return to the main hall of the temple, dubbed "Hall of the Land of Bliss" (Gokurakudō) for the day. The atmosphere is one not of sadness but of joy and excitement. Some in the crowd are tourists, some devotees, many both. Welcoming Ceremonies are enacted even today in at least fourteen temples in Japan.[1]

The belief that at death one would be born in Amida Buddha's Pure Land became common in eleventh-century Japan and has remained so to the present day.[2] Amida is by far the most popular buddha in modern Japan. He is closely associated with death and the assurance that upon

death, his faithful followers will be born in his Pure Land. The type of Buddhism that focuses on Amida and birth in his realm is called Pure Land Buddhism. Although relatively unknown in the West, the teachings of Pure Land Buddhism are far more popular in Japan than the abstruse kōan literature and sitting meditation practice of Zen.[3] Amida Buddha, who unlike Śākyamuni is not a historical figure, possesses a Pure Land said to be more wonderful than that of any other buddha. He is believed to appear at the moment of a faithful devotee's death, accompanied by attendant bodhisattvas, to personally escort her to the Pure Land.[4]

Amida's role as a buddha who can save even the most hopeless sinner catapulted him to popularity in the early medieval period, where he has remained ever since. In this chapter, I discuss three manifestations of that popularity: a ceremony involving masks, and two unusual statues. Welcoming Ceremonies, and a living image affectionately referred to as the "Glancing-Back Amida," are still prominent in modern Japan. In the section on early medieval Japan, I discuss the "Burned-Cheek Amida," which still exists, although it does not now receive a great deal of attention.

Welcoming Ceremonies

A useful tool for examining the relationship between humans and Buddhist statues, Welcoming Ceremonies feature a human becoming a statue, lending new meaning to the concept of a living image. The person who is to be a bodhisattva dons robes and a mask, both a luminous gold. The mask itself is considered to be the residence of the deity. In most Japanese performance arts that make use of masks, such as Noh drama, the performer invokes the spirit of the mask before donning it. In Noh, however, the spirit is usually not that of a Buddhist deity. In the Welcoming Ceremony, a bodhisattva inhabits the mask.

The act of Amida and his retinue coming to escort the faithful to the Pure Land is called *raigō* (literally, "coming to greet"). The term is also used to describe a type of painting in which Amida and several bodhisattvas are shown descending, usually from the upper left of the picture, the sky, to the lower right, this world of suffering. Sometimes an elaborate building denoting the Pure Land is depicted in the upper portion of the painting. In the lower right often stands a small house, with the walls omitted by the painter to reveal the dying person waiting inside. Amida is usually accompanied, at a minimum, by the bodhisattvas Kannon (Sk. Avalokiteśvara) and Seishi (Sk. Mahāsthāmaprāpta), one on either

side. They are occasionally depicted riding down on clouds from the Pure Land to this world. Seishi's hands are clasped in prayer, and Kannon extends a lotus pedestal for the dying person to sit upon. Amida emits, from the white swirl of hair between his eyebrows, a bright stream of light that engulfs the dying person.

As *raigō* paintings became more elaborate, the number of bodhisattvas attending Amida increased, eventually settling at twenty-five. Rather than demurely trailing after Amida, these bodhisattvas play musical instruments and dance. Welcoming Ceremonies thus appear to be a three-dimensional enactment of this type of *raigō* painting. It is not known whether *raigō* paintings were based on Welcoming Ceremonies or vice versa. They both became prominent in Japan in the same era, and the influence of one on the other was doubtless mutual.

In modern versions of the Welcoming Ceremony, Amida himself does not join the procession, although he is understood to be present. Most observers, if asked, would probably be surprised to realize that they had not seen Amida. Although he is the central figure, in Welcoming Ceremonies today a statue of Amida usually waits in the hall that has been designated the Pure Land. In this sense, he resembles a secret buddha. His presence is essential, but his actual appearance is incidental.

I have witnessed four Welcoming Ceremonies in Japan: at Taimadera temple in rural Nara prefecture; at Sokujōin Hall, a subtemple of Sennyūji temple in Kyoto; at Kumedera temple, near the city of Nara; and at Hyakumanben Chionji temple in Kyoto. The ceremony at Taimadera temple was by far the most elaborate, though the others were no less touching. Significant differences among the ceremonies exist. Most, for example, make use of a bridge for the procession, but a few do not. Some include various "deities"; others, only bodhisattvas. Yet in all of them, bodhisattvas proceed majestically to the Pure Land with the "deceased" on a lotus pedestal, while onlookers pray. The performance is indeed much like a *raigō* painting come to life.

Twenty-nine temples have been identified as having sponsored Welcoming Ceremonies at one time or another. No doubt many more that did so are simply unknown to us today. Of the twenty-nine, six probably began holding the ceremonies in the thirteenth century.[5] The only one of those six to sponsor the ritual still is Taimadera temple, whose Welcoming Ceremony is a re-creation of the birth in the Pure Land of its most famous resident, Princess Chūjō (Chūjō Hime). The legend of Princess Chūjō survives in various forms, but the general outline, as explained by the temple today, is familiar to most visitors. To escape a failed marriage in which she was tormented by her mother-in-law,

Princess Chūjō entered Taimadera temple and took the tonsure. While there, she prayed to be granted a vision of Amida Buddha. After that, an unknown nun approached her and instructed her to gather the stems of lotus blossoms, which the nun dyed in threads of five colors. Another woman appeared and wove the threads into an illustration of the Pure Land. As they departed, the weaver revealed that she was Kannon, and the nun that she was Amida himself. Thus Princess Chūjō's prayer to see Amida had been granted.[6]

The day of the Welcoming Ceremony at Taimadera is, according to the temple, the anniversary of Princess Chūjō's birth in the Pure Land. The ceremony is thought to closely resemble those held in earlier times. An illustrated scroll that dates to the sixteenth century shows a similar scene. Today, the ceremony begins at four in the afternoon with several young men carrying a palanquin containing a statue of Princess Chūjō across the bridge to the small hall that is, for the day, this world of suffering. There, a small statue is removed from inside her hollow body. The image is probably of Amida Buddha or Kannon Bodhisattva, but it is understood to be Princess Chūjō herself as she is born in the Pure Land. As commonly understood in Japan, birth in the Pure Land is the equivalent of becoming a buddha. Thus, in a sense, it is irrelevant whether the small statue is identified as Princess Chūjō or a buddha or bodhisattva.

After the palanquin, a procession of monks crosses the bridge. They are followed by "celestial children" wearing colorful robes, their faces carefully made up, who cross the bridge with their mothers. This is a recent addition to the Welcoming Ceremony and is not doctrinally important, but Welcoming Ceremonies have adapted to the needs and desires of the community, and temples themselves realize that cute children are always a draw.

Last in line come the bodhisattvas, with Kannon and Seishi bringing up the rear. Once they reach the hall, Kannon and Seishi enter, and the other bodhisattvas form lines on either side of the entrance. The monks in the Hall of This Defiled World chant verses in praise of Amida, while Seishi removes a small statue from the back of the hollow Princess Chūjō image and places it atop the lotus pedestal extended by Kannon. Then, in a brief, odd ritual, Seishi claps his white-gloved hands and waves them over the small statue in esoteric mudras. The temple provides no explanation for this part of the ritual. However, it must in some way be a consecration of the spirit of Princess Chūjō, preparing her for birth in the Pure Land. Then both Kannon and Seishi grasp the pedestal and swing it back and forth several times. The pedestal is finally released to

Kannon, who immediately begins the journey back to the Pure Land. When the bodhisattvas join the return procession around five p.m., with the "dying person" on the lotus pedestal, the sun is setting behind the mountains at the back of the main hall of the temple. They walk to the west, to the light, to the Pure Land.

Taimadera temple is affiliated with both the Shingon school of esoteric Buddhism and Hōnen's Pure Land school. However, the Welcoming Ceremony is sponsored not by the temple but by a group called the Bodhisattva Fellowship (Bosatsukō). Only members of the Bodhisattva Fellowship, an organization separate from Taimadera temple itself, can become bodhisattvas in the Welcoming Ceremony. Members are residents of the town of Taima and the surrounding area, and each is given the opportunity to enact the part of a bodhisattva only once every six years. The main roles of Kannon and Seishi are so demanding that, according to one scholar, only those under age fifty can perform them.[7] Among the many rumors is that participants must drink only boiled or purified water for five months before the event and that those unable to do so must undergo strict purification rituals two weeks before the ceremony. Another rumor is that although the watching crowd is noisy, as soon as the bodhisattva steps on the bridge, he hears nothing at all. Perhaps the most dramatic rumor is that the tension of enacting Kannon or Seishi is so great that for two or three days after the ceremony, the actors are unable to relieve themselves in the toilet.[8]

The activities surrounding Taimadera temple's Welcoming Ceremony provide a vital framework for the occasion. On the day of the event, the streets of the usually quiet rural town of Taima become crowded with tourists, worshippers, and children. Street vendors hawk colorful candy and toys. Most children are not enthusiastic about Buddhist statues and ceremonies, but they get excited about statues that walk. As with the revelation of a secret buddha or the appearance of a celebrity, an important factor in emphasizing the importance of the figure is the buildup to the occasion.

The Welcoming Ceremony of Sokujōin Hall is more of a local event, although it takes place in the metropolitan city of Kyoto. It began only about a hundred years ago, and the masks are likewise relatively recent creations. Posters are pasted on walls in the neighborhood, advertising for children who, for a small fee, can dress as a celestial child and join the procession. Though they are no doubt lectured about the proper behavior of a celestial child, many end up waving from atop the bridge to grandparents and friends.

Sokujōin Hall is known for its Pure Land Buddhist connections, although it officially belongs to the Shingon school of esoteric Buddhism, as does its parent temple, Sennyūji. Its popular name is "Sudden (Pure Land Birth) Temple" (Bokkuri dera), because elderly people who pray to the temple's Amida are believed to be granted a sudden death, without years of decline as a burden to their families. A large statue of Amida, surrounded by twenty-five bodhisattvas, remains in the main hall throughout the ceremony. Although statues of Amida in a *raigō* posture (usually standing with the right foot slightly extended) are quite common, statues of all twenty-five of the accompanying *raigō* bodhisattvas are rather unusual.

At Sokujōin Hall, the *raigō* Amida is seated, and the twenty-five bodhisattvas are smiling, playing instruments, and preparing to dance. Kannon and Seishi, on either side of Amida, are crouched in a ready position to get up and escort the "dead person" to the Pure Land. Eleven of these bodhisattvas, including Kannon and Seishi, were carved in the twelfth century. Fashion model Hana compared the Amida in Sokujōin Hall to a mother: "Sitting to the right of Amida/Mama, smiling ever-so-slightly, Kannon balances a colorful lotus pedestal on her hand. . . . [She is] laughing next to the mother, Amida, who sees what she is doing but pretends not to."[9] Sokujōin Hall's Welcoming Ceremony gives the impression that these twenty-five energetic, playful bodhisattvas are, for the duration of the ceremony, standing and moving.

Although Sokujōin Hall's Welcoming Ceremony does not commemorate the Pure Land birth of any particular person, slips of paper bearing the names of deceased temple members are placed in the Hall of This Defiled World. When the bodhisattvas return to the Pure Land, they take these papers with them, thus delivering deceased parishioners to the Pure Land.

As at Taimadera temple, people crowd around the bridge, many hoping for a good photo opportunity. A unique feature of this Welcoming Ceremony, however, is the five-colored ribbons that hang from posts at intervals along the bridge.[10] Worshippers crowd close to grasp these ribbons, which grants them a physical connection to the action taking place atop the bridge. This use of ribbons, thread, or a rope is common in Japanese Buddhism.

The brochure distributed by Sokujōin Hall on the occasion of the Welcoming Ceremony provides the following explanation of the events taking place:

> Spanning the main hall, which we have made the "Pure Land of Bliss" (Gokuraku jōdo), and the Jizō Hall, which we have made "this

world" (genze) is a fifty-meter long, two-meter high bridge. Atop this, with the great bodhisattva Jizō in the lead, twenty-five bodhisattvas wearing gold masks and robes, accompanied by solemn songs of raigō, process from the main hall to the Jizō Hall, and then back from the Jizō Hall to the main hall. This renders the appearance of being led to the Pure Land of Bliss by means of Amida Buddha's raigō. Therefore, all the good men and women who cover the temple grounds are absorbed in the Pure Land of this world that appears before their eyes.[11]

According to the temple, the Pure Land is created in this world by the presence of bodhisattvas and Amida Buddha.

Hyakumanben Chionji, a small Kyoto temple belonging to Hōnen's Pure Land school, holds a very simple yet highly devotional Welcoming Ceremony. Few tourists attend, perhaps because this version does not include the now-popular procession of celestial children. The bodhisattvas wear simple, almost cartoon-like masks, with dramatic halos made of gold-colored rods fanned to give the effect of rays of light. No bridge is used; participants simply walk, in only one direction, from a small building to the main hall. After the bodhisattvas arrive, at least 50 people, seated in a circle, hold a huge rosary, 110 meters long and weighing 350 kilograms, with 1080 wooden beads. They shuffle the beads from one person to the next, while repeatedly chanting the nenbutsu ("Namu Amida Butsu," which means "Hail to Amida Buddha"). One of the beads, larger than the others, contains a small image of Amida that is visible through a glass window. When that bead comes around, the devotee bows to it, displaying particular devotion. The ritual is not unusual in temples belonging to the Pure Land school, but this particular rosary is said to be the largest in the world.

This Chionji temple Welcoming Ceremony began quite recently and is not well known. Yet those who came to observe were more prayerful and devout than at any other Welcoming Ceremony I witnessed. Many were elderly women, grasping prayer beads in their folded hands, bowing their heads, their lips moving in prayer as the bodhisattvas passed in front of them.

Kumedera temple, which also holds a Welcoming Ceremony, belongs to the Shingon school of esoteric Buddhism. Although the Welcoming Ceremony is a patently Pure Land ritual, several of the temples that sponsor them have no official connection to Pure Land Buddhism. It is not so much that the ceremony serves a doctrinal function, although it does visually present the narrative found in the

nineteenth vow of the *Sutra of the Buddha of Immeasurable Light*, as I later discuss; rather it provides an opportunity for worshippers to form a karmic bond with the bodhisattvas. This temple's official reason for holding a Welcoming Ceremony is to commemorate the healing of a seven-year-old child's eyes by the descent of a buddha named Yakushi. Although this story is completely unrelated to Amida Buddha and his Pure Land, the healing of the child is a cause for rejoicing, and the Welcoming Ceremony is indeed a celebration.

The structure of Kumedera temple's Welcoming Ceremony is similar to that of the ceremonies at Taimadera temple and Sokujōin Hall, although it takes place on a much smaller scale and is attended almost exclusively by local residents. Monks and celestial children walk in procession across the bridge, followed by the bodhisattvas. This is immediately followed by the throwing of *mochi*, pounded rice cakes. Temple administrators stand on an elevated stage in the middle of the temple grounds and toss large chunks of *mochi* into the outstretched arms of the waiting, shouting crowd. Those who catch some *mochi*, take them home, and eat them are said to be guaranteed good health throughout the coming year.

In all Welcoming Ceremonies, because the bodhisattvas are human and the humans are bodhisattvas, the statues/bodhisattvas/actors display highly personal characteristics, despite their masks. A guide, usually garbed in black, walks at the side of each bodhisattva, often grasping his arm. This stems from a very practical concern: masks do not allow for a wide range of vision, and a misstep while walking across the narrow bridge used in many Welcoming Ceremonies, which can barely accommodate two people side by side, could be disastrous. At Taimadera temple, only the two most important bodhisattvas, Kannon and Seishi, who dance as they proceed with heavy, elaborate halos attached to the back of their heads, do not have guides. At the Welcoming Ceremony I witnessed at Taimadera temple in 1997, when the dancing Kannon stepped too close to the side of the bridge, the crowd gasped. In another humanizing incident at this Welcoming Ceremony, the guide of one bodhisattva whose mask was askew was holding the bodhisattva's heavy metal staff for him on his way back to the Pure Land. Even a bodhisattva, it appears, is human.

The human side of the Welcoming Ceremony at Sokujōin Hall is also evident in the participation of children as some of the less important bodhisattvas. A short bodhisattva with a ponytail proceeding across a bridge to the Pure Land grants the scene exactly the right degree of ambiguity. Is the image a bodhisattva, a statue, a human, a child, or all of the above? The Welcoming Ceremony at Kumedera temple in the

spring of 2005 appeared at one point to have lost the delicate balance that enables the worshippers to relate to the bodhisattvas as though they are alive. The day was unseasonably hot and sticky, and the bodhisattvas, though able to proceed from the Pure Land to this world, seemed in danger of passing out from the heat. When returning to the Pure Land, they held their masks in their hands instead of wearing them. At this point the audience's attention was lost; they turned to other pursuits

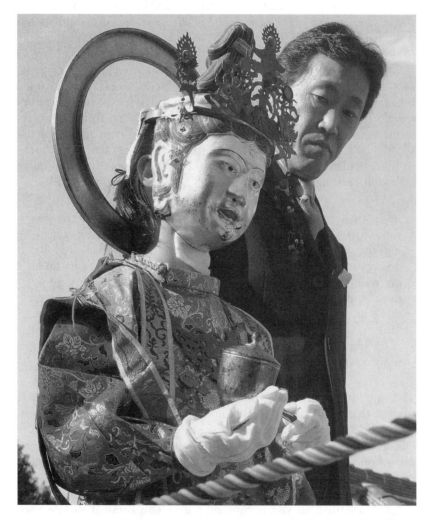

Figure 1 Bodhisattva with Ponytail, Welcoming Ceremony at Sokujōin Hall, Kyoto, Fall 2004

such as buying food and drink from small stalls. The actors, no longer bodhisattvas, were simply hot people wearing costumes.

The Glancing-Back Amida

Living in Kyoto's Zenrinji temple, also called Eikandō Hall, the approximately eighty-centimeter "Glancing-Back Amida" stands on a tall altar in the back of the main hall. Whereas most Buddhist statues face straight ahead, this Amida peers back over his left shoulder. Worshippers can walk around the altar and view the Amida from all sides, essentially circumambulating it.

This statue's birth story is less important than the legend of a significant event in his life, and the story of one of his devotees, a monk named Eikan (1033–1111).[12] When Eikan resided at what is now Zenrinji temple (hence its alternate name, Eikandō Hall), he frequently performed a demanding ascetic exercise called the "constantly walking meditation" (*jōgyō zamai*), which entailed spending the entire night circumambulating a statue of Amida enshrined in the center of a square hall while reciting professions of faith. The temple brochure states:

> In the early morning of the fifteenth day, second month of the year Eihō 2 [1082], when Eikan, as usual, was singlemindedly performing the walking *nenbutsu*, the central image, Amida Buddha, descended from the altar and assumed the role of leading Eikan in his walking devotions. Eikan was taken aback and, thinking he must be dreaming, stopped in his tracks. Amida Buddha perceived this and, looking back chastisingly over his shoulder, called out, "Eikan, you're dawdling." Eikan returned to his senses and looked at the statue, exclaiming, "May the appearance of this miracle long remain for future generations."[13]

The English version of this brochure, however, explains that "in order to share that image of Amida Buddha who encouraged him with others, Eikan had a sculptor carve a statue of Amida Buddha looking back over His shoulder."[14] Thus the non-Japanese tourist is told that the statue was carved on the basis of Eikan's vision, while the Japanese version states that the statue is one and the same as that which spoke to Eikan. The Japanese brochure allows the statue to be alive. The translator of the brochure seems to have "corrected" the text to bring it in line with Western sensibilities about statues.

The model Hana, of course, had her own interpretation of the Glancing-Back Amida: "At that moment, I came to believe what I had once heard: that a man looking back over his shoulder is sexy."[15] She also speculated about other reasons he looks back: perhaps he sees dandruff; maybe he is noticing a fly; he could be backing out of a driveway.[16] Certainly, as Hana is aware, a statue with a noticeable and unique characteristic is more likely than others to receive attention and perhaps affection, just like a quirky person.

The constantly walking meditation is still conducted at Zenrinji temple in the bitter cold of Kyoto winters. Anyone who contacts the temple in advance is allowed to participate. The scholar Tanaka Takako poignantly explains that she has always wanted to participate in this ritual, but her fears that the Buddha will not appear before her to encourage her prevent her from doing so.[17] To her, the Glancing-Back Amida is alive, and she is afraid of anything that might prove otherwise.

Textual Bases for Devotion to Amida

Devotees of Amida Buddha claim that he provides an easier way to salvation than the approaches taken by most other Buddhist schools, which demand complex rituals and ascetic exercises. Only faith is required to be saved by Amida. As explained in chapter two, all buddhas, because of their infinite store of merit, are able to create Pure Lands. Through certain practices, after death believers can be born in a Pure Land. There, sitting at the Buddha's feet and listening to his teachings, they can easily attain enlightenment.[18] The practices vary considerably, but they share an emphasis on devotion to and faith in the Buddha who created that Pure Land out of his compassion. Amida's Pure Land came to be recognized as the best of all. In part, this was due to the persuasive powers of sutras that recount Amida's story. They explain that when he was just an ordinary monk starting out on the bodhisattva path, with the help of the buddha of his day, he contemplated all existing Pure Lands and selected the best parts of each, vowing to incorporate them into the buddha land he himself would bring into existence.

The textual basis for belief in Amida Buddha's Pure Land is found primarily in the *Sutra of the Buddha of Immeasurable Light* (Sk. *Sukhāvatīvyūha sūtra*; J. *Muryōju kyō*). This was probably compiled in northwest India no later than the third century CE. It tells the story of Dharmākara (J. Hōzō Bosatsu), who later becomes Amida Buddha, vowing to become a

buddha. He plans to embark on many lifetimes of rigorous devotion and ascetic practices in order to achieve buddhahood, but he looks around him and sees that most people are incapable of such difficult actions. Out of his compassion, he resolves to create a Pure Land for all those living beings who are not capable of taking the hard route to salvation. He thereupon makes forty-eight vows outlining conditions required for his Pure Land. If these are not fulfilled, he will not accept buddhahood. At the end of the sutra, we learn that he did indeed become a buddha; therefore, everything he vowed must have come true.

Many of the vows deal with relatively inconsequential matters; for example, in Amida's Pure Land there are no animals, everyone's body is colored gold, and the trees are filled with jewels. As Amida's popularity grew, the eighteenth vow, often called the Primary Vow (*hongan*), was singled out as most important, because it dictates what is necessary for birth in Amida's Pure Land. The Chinese version states:

> May I not gain possession of perfect awakening if, once I have attained buddhahood, any among the throng of living beings in the ten regions of the universe should single-mindedly desire to be born in my land with joy, with confidence, and gladness, and if they should bring to mind this aspiration for even ten moments of thought and yet not gain birth there. This excludes only those who have committed the five heinous offenses and those who have reviled the True Dharma.[19]

Confusion over the meaning of "ten moments of thought" (J. *jūnen*) resulted in widely varying interpretations of what those who desire birth in Amida's Pure Land should do. Eventually, the *nenbutsu*, a brief declaration of faith in Amida, came to be considered the action that leads to Pure Land birth. In modern times, reciting the *nenbutsu* means repeating the phrase "Namu Amida Butsu" ("Hail to Amida Buddha").[20] In premodern times, however, performing the *nenbutsu* sometimes included reflecting on the Buddha's virtues, saying the Buddha's name, visualizing his body or Pure Land, or a combination of these and other practices.

Vow number nineteen, though not as crucial as the Primary Vow, provides the textual basis for the comforting vision of Amida and his bodhisattvas coming to greet the dying person:

> May I not gain possession of perfect awakening if, once I have attained buddhahood, any among the throng of living beings in the

ten regions of the universe resolves to seek awakening, cultivates all the virtues, and single-mindedly aspires to be reborn in my land, and if, when they approached the moment of their death I did not appear before them, surrounded by a great assembly.[21]

These two vows, numbers eighteen and nineteen, provide the basis for almost all Amida worship in Japan.

Amida in Early Medieval Japan

Interest in Amida and his Pure Land surged in early medieval Japan, largely because of the widespread conviction that the world was entering a downward spiral from which there could be no recovery. The Chinese, and later the Japanese, developed the theory that after the death of Śākyamuni, the world was passing through three consecutive, and progressively declining, time periods. No single sutra outlines the details, although many speak of a dark period when the Buddha's teachings will no longer exist. The schema, as it evolved in China, held that the first period was that of the True Dharma (J. Shōbō), which began immediately after the Buddha died. During the True Dharma, the world was just as it had been when the Buddha was alive, his teachings flourishing, and people properly practicing and achieving enlightenment. In the second period, the Counterfeit Dharma (J. Zōhō), the teachings remain, and people practice, but no one achieves enlightenment. In the last period, that of the Final Dharma (Mappō), only the teachings remain, but no one practices or reaches enlightenment.[22]

The first two periods were thought to last either five hundred or one thousand years each. Since the Chinese, like everyone else, did not know when the historical Buddha actually lived, this allowed for creative calculations. They finally settled on the year 552 CE as the initial year of the Final Dharma. As that year approached and passed, Pure Land Buddhist thought and practices spread like wildfire throughout China. Amida's teachings were regarded by some as the only means to salvation in the time of the Final Dharma, because humans were incapable of performing any good works or religious practices. Only Amida, who created his Pure Land specifically to help such people, could save them.

The Japanese performed the calculations somewhat differently, concluding that the year 1052 CE would be the beginning of the Final Dharma. This was confirmed by the upheaval Japan experienced in the eleventh and twelfth centuries. Plagues were rampant in the city of

Kyoto, and death was always present. The aristocrat Fujiwara Sanesuke, for example, noted in his diary entry for the nineteenth day of the fourth month of 1015 that "in recent days, there are a great number of dead people in the capital. They are placed at the head of roads, causing even more epidemics."[23] Numerous other problems tormented Kyoto. Almost every year, floods, earthquakes, and fires ravaged the city. Moreover, in the thirteenth and fourteenth centuries, a military elite that sought power through brute force arose, which resulted in major battles. It would have been hard for the early medieval Japanese to doubt that the Final Dharma had truly begun. As the Japanese turned their attention to Amida Buddha, his promise of *raigō*, as stipulated in the nineteenth vow of the *Sutra of the Buddha of Immeasurable Light*, provided comfort: one's dying moments would be bearable, or even pleasurable, and one's subsequent birth in the Pure Land was assured.

Essentials for Pure Land Birth

The monk Genshin's *Essentials for Pure Land Birth*, composed in 984, is often credited with popularizing Pure Land Buddhism in the late tenth century. Although its contemporary influence was more limited than is usually assumed, Genshin himself was leader of a number of religious fellowships in the Yokawa area of Mt. Hiei, most of which centered on rituals involving a statue.[24] Thus *Essentials for Pure Land Birth* provides a window on some major elements of his thought and practice.

In the introduction to this ten-chapter work, Genshin declared that his purpose in writing it was to explain the most appropriate practice that would lead to birth in the Pure Land during the Final Dharma.[25] Genshin displayed great familiarity with Buddhist texts in accomplishing this task. In fact, most of *Essentials for Pure Land Birth* consists of quotations from other texts: he referred to 160 works, quoting or paraphrasing 654 passages from sutras and commentaries, with his own comments interspersed throughout.[26]

A discussion of *raigō* occupies a significant portion of the first chapter, "Longing for the Pure Land" ("Gongū jōdo"). Genshin vividly described, with an emphasis on visual elements, the dying moments of a Pure Land devotee:

> When a person who has committed evil deeds draws near the end of his life, the elements of wind and fire depart his body first, causing his movements to become agitated, and he suffers greatly.[27] When the person who has performed good deeds draws near death,

the elements of earth and water depart his body first; his move-ments are slow and peaceful, and he does not suffer. How much more, then, will the person who has accumulated merit from the *nenbutsu*, and for many years has given his heart over to Amida's Pure Land, spontaneously be born with great joy [in the Pure Land]? Therefore, Amida Buddha, by means of his Primary Vow, with various bodhisattvas and a gathering of a hundred thousand monks, emits a great light, and appears clearly before the eyes [of the person about to die]. At that time, the compassionate Kanzeon extends his hands adorned with a hundred virtues, raising the jeweled lotus pedestal and arriving in front of the practitioner.[28] At the same time, Seishi, with a numberless multitude of holy beings, offers praise and takes [the practitioner's] hands, welcoming him. The practitioner then sees with his own eyes what is happening around him, and rejoices deeply in his heart. His heart and mind are at peace, as though he is in a state of meditation. When, in his humble hut, he closes his eyes, he [finds that he] is sitting on the lotus pedestal. He follows behind Amida Buddha, among the bodhisattvas, and in one moment he has attained birth in the Land of Supreme Bliss in the western direction. . . .

The pleasure [of living] a hundred million thousands of years in the Tōri Heaven, and the pleasure of deep meditation in the palace of the Bon Heaven, and other pleasures as well, still do not mea-sure up to this pleasure.[29] This is because [in those cases,] transmi-gration continues, and one has not escaped the suffering in the three evil paths. However, having been granted the jeweled lotus pedestal in the hands of Kannon, one forever crosses the ocean of suffering, and for the first time is born in the Pure Land. Words cannot express the joy in one's heart at this time.[30]

Chapter six, "Nenbutsu for Special Times" ("Betsuji nenbutsu"), presents concrete instructions for one's deathbed moments. Here, Genshin quoted the Chinese monk Shandao's (613–681) *Dharma Gate of the Virtues of the Ocean-Like Samādhi of the Visualization of the Attributes of Amitābha Buddha* (Ch. *Guannian Amituofo xiang hansanmei gongde famen*, usually abbreviated as *Guannian famen*):

Whether believers are ill or not, when their life is about to end, they should compose their mind and body using exclusively the *nenbutsu* meditation method described above. They should turn their countenance toward the west, concentrate their mind, and

contemplate Amida Buddha. They should coordinate mind and voice with each other, and there should be constant chanting [of the *nenbutsu*]. They should generate the thought of being born in the Pure Land without fail and of [Amida's] saintly host coming with the lotus throne on which to usher them into the Pure Land.[31]

In the same section, Genshin instructed:

When the strength of the sick is about to dissipate at last, you should say: "The Buddha has arrived along with Kannon, Seishi, and his immeasurable saintly host. They are offering you the jeweled lotus throne, and they are guiding you, the follower of the Buddha [to the Pure Land]."[32]

Genshin's emphasis on actualizing the coming of Amida and his retinue through contemplation and expectation prefigured what was to take place in the later Welcoming Ceremonies.

The Meditation Society of Twenty-Five

Welcoming Ceremonies began as a practice of the Meditation Society of Twenty-Five (Nijūgo zanmai-e), a group founded in 986 by monks devoted to Pure Land practices.[33] They met at Yokawa, the remote sector of Mt. Hiei that was also the site of Śākyamuni Fellowship activities. Genshin soon became their leader. The group's activities consisted of a monthly meeting during which members chanted the *nenbutsu* and took numerous vows, including the promise to be present at the death of any member who became fatally ill. Two extant charters outline in detail the procedure to be followed both at the monthly meetings and at the deathbed of a member.[34] A death register (*kakochō*), begun in 1013, records the date of each member's birth and death, and for some a brief biography that concentrates on the final moments.[35] These three texts provide a wealth of information about the society. Although all the members were monks, complex doctrinal themes are noticeably absent from the biographies, which focus on ritual activities, many involving images.

The first known use of the term "Welcoming Ceremony" (Mukaekō) is in one of the biographies. Of the monk Nenshō, it is said: "He [Nenshō] composed the rules for participants in the Welcoming Ceremony and drew an illustration of the coming of Amida and his retinue (*shōju raigō sō*), which he always carried with him and embraced, sometimes opening it. When he opened it, he shed tears."[36] The death

register's biography of Genshin himself also mentions the Welcoming Ceremony. According to this account, one of Genshin's disciples, Nōgu, had a dream in which he visited Genshin's room and found him about to embark on a long journey:

> Monks were lined up on the right and left sides of the road. There were four boys, very beautiful in both appearance and dress. They were divided to the right and left, lined up with the monks. All in all, it resembled the Welcoming Ceremony of Yokawa. The bishop of Yokawa instructed, "Let the little boys go first and the big boys follow [and so forth]." After arranging themselves in accordance with his order, they began marching towards the west. In this dream, Nōgu thought, "It's strange that they're walking on the ground." Immediately they gradually rose up and [began to] walk in the sky. They intoned out loud, "We have transcended the Triple Realms (sangai)." Intoning this repeatedly, they disappeared to the west . . .[37]

When Nōgu reported this dream to others, they informed him that Genshin had died that night. Nōgu's dream, then, was a vision of Genshin's actual birth in the Pure Land, which resembled a Welcoming Ceremony.

In both these accounts, the writer assumed that his reader knew what the Welcoming Ceremony of Yokawa is. The only concrete information provided is that rules were written for participants, the ceremony involved a reenactment of the arrival of Amida and his retinue, and some type of procession to the west took place down a road lined by numerous monks and four younger boys. In addition, the ceremony seems to have taken place outside, in contrast to most rituals, which were conducted within the confines of a hall and so visible to a limited number of people.

Genshin's biography in the *Miraculous Tales of the Lotus Sutra* (*Hokke genki*, mid-eleventh century) stated:

> Genshin prepared the appearance of Amida coming to greet the dying person, revealing the ceremony of welcome to the splendor of the Pure Land. Those who gathered to observe the ceremony included the young and the old, priests and laypeople, the vagrants and the ignorant. All shed tears, wished for birth in the Pure Land, kneeled and bowed their heads to the ground in worship, and planted the seeds for their future enlightenment.[38]

This account provides a crucial detail: monks were not the only ones who observed the ceremony. Even "vagrants and the ignorant" were in attendance. Although it is not clear to whom this phrase referred, we can assume that monks and nuns were not thought to belong to this category. Another important element is the description of a highly moving scene that gave rise in observers to a desire for birth in the Pure Land. Unfortunately, this passage does not state whether the Welcoming Ceremony took place at Yokawa, bringing laypeople to Mt. Hiei, or elsewhere, whether the participants wore masks, or whether a statue was involved.

The *Biography of the Monk Genshin* (*Genshin Sōzu den*), composed within about forty years of Genshin's death, offers the first detail regarding a statue:[39]

> In the fifth month of that year [1004], Genshin was appointed to the position of Gon Shōsōzu, but he retired from it the following year.[40] After that, he did nothing for that position. He secluded himself in Mt. Hiei and devoted himself to practices which would lead to birth in the Pure Land. To the southeast of Ryōgon'in Hall, he built a small hut and there enshrined a three-meter gilt image of Amida. He named the hall Kedaiin. On this land, he organized gatherings for practitioners who hoped to see Amida coming to their deathbed (*raigō gyōja no kō*). This traced the process of Amida coming to greet the dying person. Bodhisattvas and other deities walked around to the right and left, and music was played. Those who participated included monk and lay, high and lowly. They felt as though they had been born in the Pure Land.[41]

This passage provides the remarkable detail that laypeople, including the "lowly," actually came to Kedaiin Hall, located in Yokawa, for the Welcoming Ceremony. As explained in chapter two, Mt. Hiei in general, and Yokawa in particular, had been off limits to laypeople since the time of Saichō (767–822). That they were allowed to attend the Welcoming Ceremony speaks to the desire of Genshin and other members of the Meditation Society of Twenty-Five to communicate their beliefs to those beyond Mt. Hiei and provide them with comfort at their death.

The human element that I have noted in my account of modern Welcoming Ceremonies was also present in early medieval Japan. *Sand and Pebbles*, a thirteenth-century collection of legends, relates an amusing incident in which the person enacting the role of Kannon during a

Welcoming Ceremony broke wind as he approached the Hall of This Defiled World. Seishi began to giggle, and soon everyone stopped chanting the *nenbutsu* and burst into laughter.[42]

Welcoming Ceremonies, Masks, and Images of Amida

It is not known when masks began to be used in Welcoming Ceremonies. In modern times, certainly, masks create an environment that facilitates the interaction of humans with the bodhisattvas. At Kumedera temple, the aforementioned removal of the bodhisattvas' masks owing to the heat seemed to ruin, for that day, the delicate balance among deity, statue, and human being.

One of the earliest uses of masks in Welcoming Ceremonies may have been in those sponsored by the monk Eikan, famous for his association with the Glancing-Back Amida. Eikan's biography in the *Gathered Biographies of Birth* (*Shūi ōjōden*, early twelfth century) states that in 1109 he fashioned twenty bodhisattva costumes for a Welcoming Ceremony at Yoshidadera temple in Nakayama, an area of Kyoto where many Pure Land devotees resided.[43] Whether the costumes included masks, however, is unknown.

Another story that suggests the early use of masks is found in *Tales of Times Now Past* (early twelfth century).[44] Every year, on the last day of the twelfth month, a holy man who had complete faith in Amida Buddha and desired to be born in the Pure Land handed a boy a letter and instructed him to return in the evening, knock on the door, and declare, "This is a letter from Amida Buddha in Paradise." The boy always did as he was told, and the holy man, shedding tears, would open the letter, which said, "I will definitely be coming today." One year, a great admirer of this holy man was selected to succeed as governor of Tango province, where the holy man lived. The holy man requested that the new governor assist him in establishing the Welcoming Ceremony in that province. The governor agreed, sending for musicians and dancers from the capital. The holy man told the governor, "At the time of this Welcoming Ceremony, I intend to receive the welcome from the Pure Land. I want to die at that moment." The governor, however, doubted that this could actually happen.

The day arrived, the ceremony began, and the holy man lit incense and waited in the hall that had been designated as the Hall of This Defiled World. The Buddha drew near to him, followed by Kannon extending a platform of purple-gold, Seishi holding a parasol, and other bodhisattvas playing music. The holy man was deeply moved, weeping

as Kannon extended the pedestal to him, but he remained still. Onlookers thought that he was rendered immobile by intense emotion, but at that moment, the holy man ceased to breathe and died. No one noticed because the music was so loud. The Buddha, ready to begin his return journey to the Pure Land, waited for an utterance from the holy man, who neither spoke nor moved. At last everyone realized that he had actually gone to the Pure Land. The story ends with the words "Truly, he was never even a bit sick, but when he saw the Buddha, he thought, 'He has come to welcome me,' and died. The people exclaimed, 'We can have no doubt that he was born in the Pure Land.'"[45] The holy man believed not that he saw an imitation of the Pure Land but rather that it had been created before his eyes. Moreover, those surrounding him were convinced, simply because the Welcoming Ceremony had been real to him, that he had achieved Pure Land birth.

This story does not prove that masks were used, but it suggests their presence. The governor sent to the capital for musicians and dancers, who may well have brought with them their own costumes and masks. The text refers repeatedly to "the Buddha," "Kannon," and "Seishi" and describes Kannon extending the lotus pedestal. Amida in some form must have appeared. This description indicates a fairly well-developed form of the Welcoming Ceremony.

A similar version of this story is told in the thirteenth-century *Sand and Pebbles*, but at the end it states, "This is said to have been the origin of the Amida Welcome Service. Some say that it started in Ame no Hashidate, and others that it began with Priest Eshin [Genshin] spreading pieces of broken chopstick over his armrest and drawing it slowly forward, saying that it was like the Buddha's coming to welcome spirits into the Pure Land."[46]

Although no early definitive accounts of masks being used in Welcoming Ceremonies exist, many masks dating to the twelfth century and after do survive. Numerous Japanese performing traditions, including many that could be classified as belonging to the Shintō tradition, made use of masks early in Japanese history. The earliest known Japanese bodhisattva mask, inscribed with the date 1086, is held at the Honolulu Academy of Arts.[47] A set of masks that show signs of frequent use is owned by Jōdoji temple in rural Hyōgo prefecture, which also sponsored Welcoming Ceremonies in the thirteenth century.

Until recently, some masks dating from the fourteenth century, including those of Kannon and Seishi, were used in Taimadera temple's Welcoming Ceremony. Those masks were enlivened by use and

worship much longer than most. I first saw the Taimadera temple Welcoming Ceremony in 1997 and was deeply moved by the appearance of such beautiful, old masks in a public ritual. When I attended Taimadera temple's Welcoming Ceremony a second time, in 2005, I was looking forward to encountering these masks again. I was shocked when I saw Kannon and Seishi parade over the bridge in shiny new masks. It turned out that 2005 was the first year the old masks were retired and replaced by modern copies. This marks a new chapter in the lives of the fourteenth-century masks. They remain Important Cultural Properties and will no doubt be displayed in museums from time to time, as are the Jōdoji temple masks, but I am certain that I am not the only one who feels disappointed no longer to have the chance to see the old masks spring to life during the ceremony.

Statues of Amida may have appeared as part of the ceremony before masks were used. The *Biography of the Monk Genshin*, quoted above, speaks of a welcoming Amida, enshrined in a hall, that was used as part of Welcoming Ceremonies. Stories of Welcoming Ceremonies in *Tales of Times Now Past* and *Further Gathered Biographies of Pure Land Birth* (*Goshūi ōjōden*, mid-twelfth century) also suggest that Amida appeared. For example, an account in *Further Gathered Biographies* of the aristocrat Minamoto Toshifusa speaks of the Amida welcoming statue (*Amida gōshō no zō*) which was enshrined in a temple hall he built.[48] What form Amida took in those early Welcoming Ceremonies is, however, unclear.

An early statue known to have been used in Welcoming Ceremonies lives at Jōdoji temple in rural Hyōgo prefecture. In this temple's twelfth-century Welcoming Ceremony, the huge Amida, over three meters tall, was pulled around on a cart during the ritual, causing it to move as though alive. Despite its size, the statue is quite light and stands on a long pivot, which allows it to be transported with relative ease. Moreover, the top half of the statue is unclothed and may have been dressed in real clothing for the Welcoming Ceremony. Much effort was devoted to making this Amida appear to be alive.

Another type of Amida image, which perhaps more successfully gave the impression of life, was made in the thirteenth and fourteenth centuries specifically for use in Welcoming Ceremonies. The function of such statues was discovered only relatively recently. One, which stands next to the mandala in the main hall at Taimadera temple, was long thought to be a rather ordinary statue of no particular note. Researchers found, however, that it is hollow and that a person can enter and move it, peering out through its chest. It appears that someone would climb

inside the image when Welcoming Ceremonies were performed, enabling Amida to walk out of the hall to greet the returning Princess Chūjō when the retinue returned to the "Pure Land," as depicted in a 1531 illustrated history of Taimadera temple (*Taimadera engi*).[49] The statue now at the temple was probably carved in the mid-thirteenth century and may be the same image depicted in the illustrated scroll.[50] This statue experienced a considerable comedown in his later life, as the scholar who has conducted the most research on him, Seki Nobuko, sadly notes.[51] Formerly the star of the ceremony, he now remains inconspicuously in the main hall.

Connection to the Buddha with Threads

It is not permissible in most cases to touch a Buddhist statue. But since touch is known to be fundamental to human relationships, it must also be important in relationships with images. To provide a physical connection, threads were tied to the hands of images, and people grasped the other end. In the consecration ceremony of the Great Buddha of Tōdaiji temple, mentioned in chapter one, strings connected to the brush used to paint in the pupils of the eyes were employed in much the same way. *Miraculous Stories of Karmic Retribution* also relates several instances in which a petitioner ties a string to a Buddhist image, praying while holding the other end.[52] In these cases, however, the string was not necessarily attached to the image's hand, nor was the ritual associated with the deathbed.

In the eleventh century, the practice of holding threads connected to the hands of an Amida Buddha image while dying became common. This ritual is closely related to *raigō* thought. In fact, many of the paintings to which the threads were attached depicted *raigō* scenes. In other cases, the threads were connected to a statue of the Buddha, creating a three-dimensional *raigō* illustration in which the dying person was an active participant. This was a concrete means of making a physical connection with the Buddha at a crucial and potentially frightening time, when one must be able to see Amida and his retinue approaching. Japanese texts often speak of the dying person "pulling" (*hiku*) the threads, but more likely the devotees thought of themselves as *being pulled*. This constitutes a highly effective way of ensuring that Amida does not, by chance, return to the Pure Land without his devout follower.

Genshin was interested in the practice of holding such threads. In *Essentials for Pure Land Birth*, he quoted the Chinese monk Daoxuan's

(596–667) *Notes on the Four-Part Vinaya* (Ch. *Sifenlü shanfan buque xingshi chao*):

> In the northwest corner of the Jetavana retreat where the setting sun [can be seen], there is constructed the Impermanence Hall. If people are ill, they are placed within it. . . . Within that hall a standing image [of the Buddha] is installed. It is covered in gold leaf, and it is turned facing the western direction. The right hand of that image is raised, and the left hand is grasping a single, five-colored pennant, the tail of which hangs down to the ground. The sick person should be placed behind the image, holding the tail of the pennant in the left hand . . .[53]

The earliest extant account of a Japanese actually dying in this manner was recorded by the monk Yoshishige Yasutane (d. 1002), a close associate of Genshin, in his *Japanese Records of Birth in the Land of Bliss* (*Nihon ōjō gokurakuki*, 986). According to this text, the abbot of Enryakuji temple on Mt. Hiei, Enshō, died in 964 in front of images of Amida, holding threads fastened to "the Buddha's hands."[54] The term for statue was not used.

Mention of such threads does not appear again in any extant historical documents until the death register of the Meditation Society of Twenty-Five, begun in 1013, which related the following story:

> The night of his [Shōkin's] death, his disciple said that a light had appeared on a hanging mandala, and then immediately disappeared. The sick man attached a thread to the hands of the Buddha and himself grasped the other end. He then wrote a vow, faced west, and formed the concentration mudra. He died as if he were entering into meditation.[55]

Again, the narrator, who in this case was probably Genshin, did not feel the need to specify that the strings were attached to an "image" of the Buddha. For the practitioner, there was no difference between an image and the Buddha himself.

Other early descriptions of the use of such threads indicate that the practitioner held them not only on his deathbed but also in everyday life. This practice figures prominently in the membership register of the Meditation Society of Twenty-Five's narration of Genshin's death. On the ninth day of the sixth month of 1017, anticipating that he would soon die, Genshin tied a string to Amida's hands and grasped the other end

himself. After reciting passages from various sutras, he put the strings down and ate a meal. The next day he again picked up the strings and began reciting the *nenbutsu*. He then died, grasping the strings attached to the hands of the Buddha.[56] Holding the threads in everyday life provided practice for actualizing the appearance of Amida and his retinue, so that at the time of death, this could be accomplished instinctively.

Tale of Flowering Fortunes (*Eiga monogatari*), a historical novel written around 1028, provides a brief description of the statues used in a deathbed ritual.[57] In 1020, at the height of the aristocrat Fujiwara Michinaga's power, an enormous temple building called the Muryōjuin Cloister was built as part of his Hōjōji temple complex, which unfortunately does not survive. Inside stood nine three-meter Amida statues, as well as a Kannon and a Seishi image.[58] *Tale of Flowering Fortunes* tells of Michinaga occasionally holding threads tied to the buddhas:

> There were also cluster-dyed lotus fiber braids that were threaded through the hands of the nine buddhas, brought together at the central image, and thence stretched eastward to the place where Michinaga intoned his pious recitations. His Lordship could avoid remissness in the invocations by concentrating on the braids, and he probably also intended to pull them at the hour of his death in order to ensure his birth in the Pure Land. He must have had the nine images made as symbols of the nine categories of birth.[59]

According to this novel, Michinaga died in the twelfth month of 1027, grasping the threads. This probably was not the case, since Michinaga suffered a number of painful illnesses and would not have been in a condition to die in such a ritualized manner.[60] Nevertheless, the author of *Tale of Flowering Fortunes* felt it appropriate to report that Michinaga breathed his last in this auspicious fashion, demonstrating that, at least among certain circles, this was regarded as an ideal death.

Stories of people dying while holding threads connected to an image of the Buddha appear more frequently in later collections of biographies. For example, in the *Gathered Biographies of Pure Land Birth* (*Shūi ōjōden*), four people die this way; in *Later Gathered Biographies of Pure Land Birth* (*Goshūi ōjōden*), five do.[61] Medieval illustrated scrolls, such as the *Illustrated History of the Holy Man Hōnen* (*Honen Shōnin eden*), *History of the Burned-Cheek Amida* (*Hohoyake Amida engi*), and *History of Taimadera Temple* (*Taimadera engi*) often depict a character dying in this manner.

The image of threads is also found in verse. *Songs to Make the Dust Dance* contains the following song, which is borrowed from a poem by

the monk Hōen in the *New Collection of Japanese Poems, Past and Present* (*Shin kokin wakashū*, 1201):

> Hail to Amida Buddha.
> With this thread from the hands of the Buddha
> I end [this life] in peace.[62]

This made its way into a collection of songs sometimes performed by commoners, perhaps even prostitutes, suggesting that even they were familiar with this ritual.

The only extant image of any sort proven to have been used in these rituals is a painting owned by Konkaikōmyōji temple in Kyoto. A large Amida emerges from behind a mountain, in front of which stand Kannon and Seishi, Kannon extending the lotus blossom. When propped upright, the painting folds into three sections, with the two sides bent in toward the worshipper, drawing her into it. Amida's hands, forming a teaching mudra in the center of the painting, still hold the remains of the five-colored threads that a dying person would have clutched.

However, most illustrated scrolls, including those mentioned above, depict the dying person grasping threads that are attached to a statue. In some cases, the top of the person's head is directed toward the statue, so he would not be able to see it, though he would still be connected to it, touching it, as it were, through the threads. Since the attachment of threads to the hands of a statue would leave no damage, unlike in the case of a painting, most statues used in this deathbed ritual would show no trace of this part of their history.

The Glancing-Back Amida, Revisited

In modern Japan, the story of the Glancing-Back Amida centers on Eikan dawdling while performing ritual circumambulation around the image. In early medieval Japan, a more detailed story circulated about the central image of Zenrinji temple. The *History of Zenrinji Temple* (*Zenrinji engi*) explained that the statue that eventually became the temple's central image originally belonged to Tōdaiji temple, where it was kept hidden in the storehouse. Eikan, a Tōdaiji monk at the time, happened upon it and thought it should be worshipped. The emperor agreed, entrusting him with the statue.[63] Eikan carried it on his back, as though it were a baby, while returning to Kyoto. However, some monks from Tōdaiji temple wanted the image back and tried to take it from Eikan, but Amida refused to be separated from Eikan. The monks

were forced to give up and return home empty-handed.[64] The statue had a mind of its own and asserted its fidelity to Eikan.

The statue now at Zenrinji temple postdates Eikan and so cannot be the one that appears in these stories. It was probably constructed as part of a *raigō* scene. *Raigō* paintings often depict a "returning *raigō*," with Amida glancing back over his shoulder, as if to ascertain that the dying spirit is safely atop the lotus pedestal. The Glancing-Back Amida was likely born as a *raigō* figure of this type, but has subsequently spent most of his life encouraging people not to be lazy in their devotions.[65]

The Burned-Cheek Amida

A text entitled *Illustrated History of the Burned-Cheek Amida (Hohoyake Amida engi emaki*, late thirteenth century) tells the story of a living Amida statue that performs a body substitution (*migawari*) miracle.[66] Body substitution stories involving statues became common in early medieval temple histories, illustrated scrolls, and collections of tales. All manner of buddhas and bodhisattvas perform these miracles, which usually follow a formulaic pattern: a devotee of a particular image at a particular temple is in a painful or life-threatening situation. The statue then appears to rescue the devotee, who is often unsure of what has taken place until she visits the temple where the statue lives and notices the marks of pain and injury on the statue itself. This is, surely, one of the most enlivening stories that can be produced by a community of response. The buddha or bodhisattva who rescues the devotee is a specific statue, not a generalized deity.

The story of the Burned-Cheek Amida centers on a thirty-five-year-old woman who is referred to only as Lady of the Town (Machi no Tsubone).[67] In 1215, she visited the famous sculptor Unkei, begging him to carve a statue of Amida that she could worship every day. When Unkei quickly acquiesced, she sent her servants to find quality wood from Izu, an area known for its forests. She herself collected gold and silver, and delivered it all to Unkei. Moved by her devotion, Unkei purified himself daily, and in forty-eight days, as promised, completed the statue. The Lady of the Town enshrined the statue in her own home and offered it incense, flowers, and candles every morning and evening. Everyone in her household worshipped it as well.

As the years passed, however, the statue became neglected. Only one of the lowliest servants, a man named Manzai, never failed to offer his prayers to it. One day, Manzai told some female attendants of the Lady of the Town, "This life is a dream; have faith and practice the *nenbutsu*."

Manzai, believed by everyone in the household to be a liar and a thief, was disliked by all. When the Lady of the Town heard of his comment, she became furious, blaming all manner of household problems on him. She ordered that he be tied up and branded on the face with a hot iron for punishment, but she herself left the house, saying she had important business to attend to. As instructed, another servant tied Manzai up and branded his left cheek with a heated bit for a horse. Manzai cried, "How sad! How painful! Please, Buddha, help me! Hail to Amida Buddha!" The others in the household laughed at him, telling him that the Buddha was hardly likely to come to the aid of a miserable creature such as himself. The next day, however, there was no mark on Manzai's cheek. The servant who had done the branding, fearing rebuke from the Lady of the Town when she returned, once again branded Manzai's cheek.

Later that second day, the Lady of the Town returned and went straight to bed. That night, Amida appeared to her in a dream and said: "For what reason did you apply the brand?" With that, he pressed a brand to his own left cheek and shed tears. Waking up with a start, the Lady of the Town purified herself and went to see her Amida image. Just as in the dream, Amida's left cheek bore the bright red mark of a brand. In fear, she ran and checked Manzai's cheek and found no mark there. She understood that Amida, who had regularly received the faith and offerings of Manzai, had taken the place of Manzai in receiving his punishment.

Worried that if this story got out, her name would be dragged through the mud, the Lady of the Town consulted with a monk of her acquaintance. On his advice, she hired a sculptor to repair the statue's face, but no matter how often he covered the burn mark with gold leaf, it continued to be visible. The sculptor attempted to cover the mark twenty-two times, but was unsuccessful. At this point, the woman realized that to hide the mark was contrary to the will of the Buddha, so she herself told everyone about this miraculous event. Those who heard the story, male and female, rich and poor, wanted to see the image for themselves. Her house became crowded with worshippers, and realizing it was selfish to keep such a miraculous image in her own home, she found a holy site, built a hall, and enshrined the Buddha there. The temple was named Iwakuradera (also pronounced Ganzōji), but most people called it "Brand-Mark Hall" (Kaindō).

Manzai received money in reparation from the woman, built a small hut, and there devoted himself to practicing the *nenbutsu*. Upon his death, music played, purple clouds floated by, flowers fell from the sky, a beautiful fragrance filled the room, and he was born in the Pure Land.

The Lady of the Town took the tonsure and became a nun. In 1251, at the age of seventy-three, she sat grasping a five-colored thread attached to the Amida statue, recited the *nenbutsu*, and was born in the Pure Land.

The servant who had done the branding was himself a bad sort, but he realized that by reciting the *nenbutsu*, even he could be saved. Both he and his wife became monastics at Iwakuradera temple and at last were born in the Pure Land. The daughter of the Lady of the Town also became a nun, died at eighty-three, and was born in the Pure Land. The illustrated scroll closes with the statement that all these people achieved birth in the Pure Land through their close karmic connections with this Buddha.

Because the scroll has suffered extensive fire and water damage, some sections are illegible. The illustration in the best condition is that of Amida and his two attendants appearing at the Lady of the Town's bedside in her dream. Amida appears to be wiping tears from his eyes, not only suffering from the branding but also lamenting the evil deeds of the Lady of the Town. It is impossible to determine whether the illustrator intended this Amida to be the woman's own statue or a generalized Amida. Perhaps he did not attempt such a distinction.

Kōsokuji temple claims that the statue it enshrines today "is said to be" the one that appears in this story, and that Kōsokuji itself used to be Iwakuradera temple. In fact, next to nothing is known of the long-lost Iwakuradera temple, including whether it had any relation to Kōsokuji temple. The face of the Amida now at Kōsokuji shows the wear and tear of almost eight hundred years, but nothing unusual appears on the left cheek. One scholar argues that devotees should not worry about such "scientific" evidence; they should just worship the statue faithfully.[68] But part of what makes certain statues alive is the physical proof they bear of having performed a miracle.

In modern times, the Burned-Cheek Amida needs a better publicist. The temple is known for its illustrated scroll, and the statue itself is nationally recognized as an Important Cultural Property, but its rival for attention at the temple is an outdoor Jizō statue made of stone, nicknamed "Salt-Sucking Jizō" (Shioname Jizō), so called because, according to legend, it was once offered salt, which then mysteriously disappeared. That Jizō is now arguably more enlivened by its community of response than is the Amida. Once again, it is the relationship between the worshipper and a statue that is the cause of its living status.

CHAPTER FOUR

Kannon: Whatever It Takes

In the dark, candle-lit worship hall of a temple, I heard a woman tell her husband, "What a beautiful Kannon." He agreed. I looked closely at the statue. It was Amida Buddha. A wooden tablet in front of the altar bore the name in Sino-Japanese characters. But to the devout worshipper, a label makes no difference.

Such is the popularity of Kannon in Japan, and, indeed, in most of East Asia. Although orthodox Mahāyāna doctrine holds that there are numerous buddhas and bodhisattvas in all "ten directions" of the cosmos, some East Asian Buddhists assume that almost every image they see is Kannon. In our everyday experience, a similar kind of mistaken identity occurs with ordinary people who bear some resemblance to a celebrity. A tourist visiting New York City, for example, might believe that she saw a famous actor or politician on the streets, return home, and tell her friends and family about the incident. In reality, she may have spotted someone who merely looked like the celebrity in question, but as far as her own subjective experience was concerned, her sighting was real.

To his devotees, Kannon might manifest himself as Amida, another deity, or even a celebrity on the streets of New York. Kannon is known for quick-change appearances. His compassion is believed to be such that he responds to the needs of people by appearing in whatever form they require, in accordance with the demands of the situation. Because Kannon can assume any guise he chooses (and because other bodhisattvas, too, have similar abilities), orthodox iconographic systems of the sort relied on by art historians and scholars of religion may not always provide an accurate guide to the identification of a Buddhist statue in the minds of the believers who worship before it.

In Japan, deeply revered cultural heroes have sometimes been regarded as manifestations of Kannon. The seventh-century regent of Japan, Prince Shōtoku, was believed by many to have been an incarnation of Kannon. And if Prince Shōtoku was Kannon, then perhaps Kannon was Prince Shōtoku as well. This lies behind the common belief, which cannot be historically verified but dates from at least the eighth century, that an early seventh-century statue of Kannon at the Dream Hall (Yumedono) of Hōryūji temple in Nara is carved in Prince Shōtoku's likeness.[1] The faces of many other Kannon statues are also understood to be those of famous people. Hokkeji temple in Nara houses an early ninth-century Kannon image that many guidebooks claim was modeled on the historical figure Empress Kōmyō (701–760).[2] In Kyoto, a thirteenth-century Kannon at Sennyūji temple, brought to Japan by a pilgrim returning from Song China, is believed to be the likeness of the daughter of a Chinese emperor. A more contemporary example stands in the cemetery of Gyokuhōji temple in Tokyo. The face of this tall stone Kannon is that of Kitahara Yōko, a popular actress of the early 1980s who perished in the August 12, 1985, crash of a Japan Airlines jet en route from Tokyo to Osaka. Her family, parishioners of the temple, had the statue carved and erected as a memorial to her.

Kannon possesses a peculiar power to move people. Daniel Leighton, an American monk, speaks of becoming interested in Buddhism upon witnessing an elderly woman making offerings to a Kannon at the Nara temple Kōfukuji:

> As I turned away, an old woman offered incense and bowed deeply to the Kannon image. Suddenly, I felt that all the statues I had just seen were very much alive; this definitely was not just a museum. Twenty years later I was head monk at Tassajara monastery, where, for his first lecture, the head monk is supposed to relate how he personally came to practice. I said that if there was one time when I first became a Buddhist, it was when I saw that old woman sincerely bowing to that Kannon statue.[3]

For Leighton, the story does not end there. He tells how he returned to Japan twenty years later, only to find that this particular Kannon had become a secret buddha that could be viewed just one day a year. The day he visited Kōfukuji temple again was exactly that day. Leighton appears to conclude that a karmic connection with this particular Kannon facilitated his meeting it once again.[4] Such perceptions of a

personal bond with a specific statue, although expressed by an American, are typical of those found throughout Japanese history.

Kannon is now almost always understood to be female, even when the physical features of an image might suggest otherwise. A famous 1883 painting by Kanō Hōgai portrays a somewhat portly figure with a moustache, but the artist himself titled the canvas *Compassionate Mother Kannon* (*Hibo Kannon*). Kannon originated as an Indian bodhisattva whose name in Sanskrit, Avalokiteśvara, is a masculine noun that means "Lord (*Iśvara*) who looks down from on high (*avalokita*)." Having entered China in sculptures, paintings, and Mahāyāna Buddhist scriptures, his name was rendered into Chinese as Guanshiyin (Guanyin for short), which means "One who observes the cries of the world." That translation certainly captured the sense of the Sanskrit "Avalokiteśvara," which refers to an all-seeing, infinitely compassionate savior figure, but it did not carry over the gender marker of the Sanskrit, for the Chinese language has no such inflections. Perhaps because compassion was understood to be a particularly feminine attribute in China, Guanyin (whose Chinese name is pronounced Kannon in Japanese) gradually came to be regarded as a woman by his/her devotees in China. Statues of the deity with a feminine appearance began to be sculpted in the seventh century and became common by the tenth; by the sixteenth century, almost all Chinese forms of the deity were feminine in appearance. Retracing the exact process of gender transformation through textual evidence is difficult, however, precisely because Chinese nouns are not marked for gender.

Miura Jun, who frequently professes physical attraction to statues, considers images of Kannon to be female. When he visited the Kyoto temple Hōkongōin Hall, for example, he was drawn to a small statue of Kannon in a cabinet shrine (*zushi*), even though the temple's main image is a striking Amida. He declared that he could smell the pheromones of this beautiful Kannon, confessing that ever since he was young, he had been especially attracted to deities in cabinet shrines.[5] On another occasion, he compared Hokkeji temple's Kannon, distinctive for the lotus flowers that take the place of a halo, to a woman in one of Gaugin's paintings of Tahiti.[6] Precedent for Miura's statements is found in the venerable Watsuji Tetsurō's *Pilgrimage to Ancient Temples* (*Koji junrei*), first published in 1918. Of the same Kannon at Hokkeji temple, Watsuji remarked on her red lips and also on her prominent chest, exclaiming that it reminded him of a woman's breasts.[7]

Kannon is one of the few Buddhist deities to appear regularly in the West. Often referred to as the "Goddess of Mercy" in English, Kannon statues are sometimes sold in New Age catalogues. In the comparative

study of religion, she is often likened to the Virgin Mary, a parallel first drawn by Jesuit missionaries in the sixteenth century. When Christianity was persecuted in Japan in the seventeenth century, Christians driven underground learned various methods for concealing their religious faith, one of which was to construct statues of the Virgin Mary that, if they were questioned, they could claim were Kannon.

The only major deity in East Asian Mahāyāna Buddhism considered female, Kannon owes much of her tremendous popularity to her identity as a woman. In discussing Kannon in modern Japan, I use the pronoun "she," whereas for early medieval Japan, I use "he." Ultimately, assigning Kannon a gender is an arbitrary decision; like many Buddhist deities, she is understood to transcend gender.

Kannon in Modern Japan

Pilgrimages and Seal Books

The very phenomenon of pilgrimages to famous statues indicates that statues are regarded as living. Postcards and books, and now the Internet home pages of temples, often present beautiful photographs of a temple's statues, even when the image is actually a secret buddha. More often than not, a statue can be seen much more clearly in such photographs than in person. A book entitled *Secret Buddhas* lists more than one hundred secret buddhas and provides photographs, when available. Only twelve of the temples refused to allow a picture of their secret buddha to be published.[8] With such reproductions so easily available, we may infer that the pilgrim's motivation is something other than the viewing of a work of art.

In fact, pilgrims often visit a temple with a particular request in mind, aware that when asking a special favor from someone in a position of power, going in person is the most effective approach. The physical appearance of the person is irrelevant. Japanese pilgrims may even visit a temple, pray before a deity, and return home without realizing that they did not actually see the image. Moreover, the further out of their way supplicants must go, the more the person will be inclined to listen to their requests. The journey itself thus constitutes a crucial part of the pilgrimage, and accounts of pilgrimages focus not only on the experience of meeting the deity but also on the events that took place on the way there and back. In *Record of Seeing the Buddhas*, Itō and Miura record their own experience of pilgrimages, although they do not use that word. They tell of the means of transport they used to get to the temple,

the weather, the monk they spoke with, and other mundane events. Fashion model Hana does likewise, focusing in particular on cakes and sweets that she buys along the way.

A pilgrimage can consist of a journey to a single deity or trips to a series of temples, but in modern Japan, it usually entails the latter.[9] Longer pilgrimages often center on a group of associated temples that enshrine a particular deity, although some, such as the Shikoku Pilgrimage of Eighty-Eight Sites (Shikoku hachijūhachi kasho), involve temples that house different deities. Among the former, pilgrimages to temples enshrining Kannon are by far the most common.

Proof that one has indeed worshipped a particular deity is extremely important. In modern Japan, this usually takes the form of a "red seal notebook" (shuinchō), a small hardcover book with pages folded accordion-style. For 300 yen (about three dollars), a representative of the temple inscribes the temple name and other information on a page, also stamping it in red ink with several of the temple's seals.[10] In a nod to the contemporary demand for speed, sometimes a hair dryer is supplied to hasten the drying process so that the ink will not smear when the book is closed.

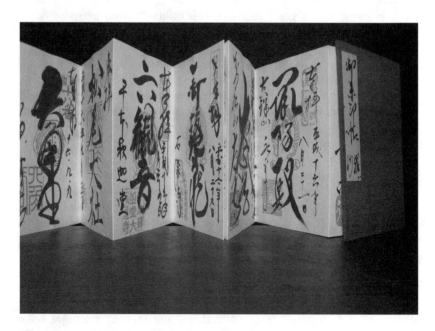

Figure 2 A Red Seal Notebook (Shuinchō)

The custom of collecting temple seals derives from the Muromachi (1392–1573) and Edo (1603–1867) periods, when travel was strictly controlled by the military government, and those who journeyed needed seals to prove they had ventured only to preapproved locations. Temples later adopted the custom as an acknowledgment that a worshipper had copied sutras and brought them as offerings to the deity. Today, no offerings other than the 300-yen charge are required, although some temples are quite concerned that visitors should have worshipped the deity before requesting the seal.

One monk in Kyoto sternly lectured me on the difference between these seals and ordinary stamps. The entries in a red seal notebook, he explained, contain the spirit of the deity. After inscribing the page, he carefully recited a brief mantra and waved his hands over the book before handing it over to me. At that point, I was ready to believe the deity's spirit occupied the entry. Although for many people in modern Japan, red seal notebooks are a type of souvenir, for others they are precious treasures. According to one scholar, such red seal notebooks are sometimes placed in the casket of the deceased as a "passport" to the Pure Land.[11] Miura Jun refers to entries in a red seal notebook as the signatures of deities, to collect as one would those of a celebrity.[12] As usual, there is more than a grain of truth in his light-hearted perspective. A celebrity's signature is proof of having met him in person; an inscription in a red seal notebook serves the same purpose for deities.

The best-known Kannon pilgrimage in Japan today is the Western Pilgrimage of Thirty-Three Sites (Saikoku sanjūsan kasho). The number thirty-three is based on chapter twenty-five of the *Lotus Sutra*, which provides canonical basis for the belief that Kannon can manifest himself in any form. The *Lotus Sutra* lists thirty-three different appearances that he might take, and for this reason the number thirty-three is often incorporated into various practices that focus on Kannon. In fact, the thirty-three forms in the *Lotus Sutra* do not play an important role in Japanese Kannon worship, and the thirty-three temples on the Western Pilgrimage route do not house representatives of each of these thirty-three manifestations. The important point, rather, is simply that Kannon can appear in any guise whatsoever.

The pilgrimage begins at a temple near the famous waterfall at Nachi in Wakayama prefecture. It then moves to the west coast of the Kii Peninsula and turns up through Nara, Kyoto, and Shiga prefectures, dips back through Osaka to Hyōgō prefecture, veers up to northern Kyoto and Shiga prefectures, crosses Lake Biwa, and ends at a temple on a mountaintop in Gifu prefecture. A pilgrim who visits all the temples in

sequence will cover almost 2,500 kilometers. In premodern times pilgrims walked or rode horses or carriages. Today, however, people usually drive from one temple to the next, or participate in organized pilgrimage bus tours. Nevertheless, many of the halls that house the Kannon image are on the top of a mountain, with no cable car or other easy means of transportation. For example, the Kannon at Daigoji temple in Kyoto, number eleven in the Western Pilgrimage, lives in a hall atop a small mountain. While climbing the mountain on a hot, sticky summer day, I was tempted to give up and try again in a cooler season, but I was humbled to see bent-over elderly women on their way down from the top. Needless to say, I persevered. Even in modern Japan, those who wish to complete the pilgrimage cannot do so without investing considerable time and energy in the project.

The founding of the Western Pilgrimage is usually attributed to the retired emperor Kazan (968–1008), who abdicated the throne and became a monk when his beloved consort died. He then made pilgrimages to famous sites such as Kumano, on the Kii peninsula. According to legend, at Kumano, an oracle from the Shintō deity Kumano Gongen informed the retired emperor that King Enma, a deity associated with hell, had taught the monk Tokudō of Hasedera temple about Kannon's thirty-three sacred sites and asked Tokudō to revive the pilgrimage. Tokudō was instructed to find a monk named Bugatsu at Ishiyamadera temple (some sources substitute a monk named Shōkū of Mt. Shosha for Bugatsu) to assist him in this venture. Thus, the founding legend of the pilgrimage incorporates two of its most important sites. The songs (*goeika*) sung by pilgrims as an offering to the specific Kannon of each temple are also attributed to the retired emperor. Today, CDs and DVDs of the songs are readily available in many Japanese bookstores.

This founding story first appears in the writings of some Muromachi-period Zen monks, but there is no evidence from the tenth century that the pilgrimage actually took place at that time, although many of the temples on the pilgrimage do date to the tenth century or shortly thereafter. The Western Pilgrimage itself became established in some form in the twelfth century but did not become popular until the late fifteenth.[13]

The temples on the pilgrimage route are numbered, but visiting them in that order is not required. The number is important to the temple itself, which will usually state at the top of its brochure that it is number such-and-such on the Western Pilgrimage. Indeed, this number is part of the inscription of each temple in the red seal notebook. Some people purchase a red seal notebook just for this pilgrimage or invest in a more expensive (and heavier) scroll on which each temple's seal is placed,

around a central painting of Kannon. Obtaining proof of one's visit to a deity in the form of a seal or talisman has been so crucial a part of the pilgrimage since at least the Edo period that each of the thirty-three temples is also called "place of the talisman" (*o-fudasho*). A relatively recent addition is the colored paper lotus petal, inscribed with a Chinese character and the temple's name, received when the book is handed back to the pilgrim. When all thirty-three are collected, the Chinese characters spell out a passage from the *Lotus Sutra*.

Today, all but five of the Kannons on the Western Pilgrimage are secret buddhas. Some of them are revealed at regular intervals, such as once a year, and most can be viewed in photographs, but four are absolute secret buddhas about which there is no information. Most pilgrims do not get to see the image at almost all of the temples they have traveled so far to worship—and most are completely unconcerned with this fact.

Let us consider four of the most popular temples on the Western Pilgrimage of Thirty-Three Sites, all located in or near the city of Kyoto. While some of the more distant temples on the pilgrimage route are today visited almost exclusively by people completing the pilgrimage, these four temples are frequently the sole object of a worshipper's journey. Even in such cases, the temple's identity as one of the sites of the Western Pilgrimage lends to its Kannon authenticity as a powerful, venerable deity. Guidebooks to temples in and around the city of Kyoto, moreover, routinely list the particular benefits that can be gained by a visit to the temple, and these are understood to be bestowed by the deity herself. Kannon, more than any other Buddhist deity in modern Japan, grants practical, worldly benefits to the worshipper, and the statues at different temples specialize in helping with different problems.

Kiyomizu Kannon

Perhaps the most-visited temple in Kyoto today, Kiyomizudera temple is perched precariously on a steep mountainside on the eastern edge of the city. Its main hall, which dates to 1633, sits on a wooden platform atop an enormous scaffolding of 139 main pillars, the longest of which (on the downhill side) are almost 27 meters tall. From the front and sides of the main hall, visitors enjoy a panoramic view of Kyoto. Having one's picture taken on the platform, with Kyoto as the backdrop, is de rigueur for the Japanese tourist. So famous is the platform that it has become part of a Japanese idiomatic expression: to do something requiring enormous courage is said to be "jumping from the platform at Kiyomizu temple"

(*Kiyomizu no butai kara tobioriru*). Acting out this proverb, however, almost certainly results in death, as has been demonstrated several times over the centuries.

The central deity at Kiyomizudera temple, an Eleven-Headed, Thousand-Armed Kannon image that is certified by the government as a National Treasure, is a secret buddha revealed only once every thirty-three years. Because her last unveiling took place in the year 2000, those of us who missed it then will have to wait some time to meet her face to face. The number thirty-three is, again, tied to the thirty-three forms in which the bodhisattva is said to appear.

Popular in Japan, the Eleven-Headed, Thousand-Armed Kannon renders in a literal form Kannon's ability to see all sufferers and help them in whatever way they need: the heads face different directions, and the hands, an eye in every palm, are ready to assist any who call for help. Most Japanese Thousand-Armed Kannons actually have forty-two arms, with each of the extra forty believed to serve twenty-five worlds, but the distinctive Kiyomizu Kannon has forty-four arms, with the extra two meeting over the top of the head to support a small statue of Amida Buddha. Each hand holds a different object, such as a wish-granting jewel, a stupa, and an arrow. For worshippers, the specific items are not important and may not be visible in any case, although to those interested in basic iconography, the two additional hands of the Kiyomizu Kannon that hold Amida over her head are well known. For most, the multitude of hands and heads simply tells them that whatever they may require, Kannon is equipped to see and do something about it.

The legendary birth story of the Kiyomizu Kannon, as related by the temple to its visitors, centers on the eighth-century monk Enchin of Nara. Instructed in a dream to find a pure fountain in the northern part of the Kizugawa river, Enchin arrived at Otowa ("Sound of a Feather") Falls, one of the main attractions of Kiyomizudera temple today. There, he built a small hut and engaged in long years of ascetic practice, invoking the power of Kannon. With a piece of sacred wood given him by a hermit, he carved a statue of Kannon and enshrined it in his hut, the predecessor of Kiyomizudera temple. Several years later, a military general, after killing a deer while hunting in the area, met Enchin, who lectured him on the sin of taking life and the compassionate power of Kannon. The general, deeply chastened, returned home and told his wife about Enchin and the power of the Kiyomizu Kannon. Together they became devotees of the image and built a proper hall in which to enshrine it.

Two elements of this story point to special qualities of the deity Kannon. First, in Japan she is frequently associated with wood, as indicated

by the sacred wood from which the Kiyomizu Kannon is said to have been carved. Wooden statues, usually of Japanese cypress (*hinoki*), are more common in Japan than in other Buddhist countries, in part because of the Japanese emphasis on wood as a holy substance. Certain types of wood in particular are termed "sacred wood" (*reiboku*), a word that appears frequently throughout Japanese history.

Modern sculptors of Buddhist images often speak of their task as revealing the buddha that already exists inside the wood, as the contemporary sculptor Matsuhisa Hōrin expressed in the following poem:

> Greeting the buddha inside the wood—
> The work of the chisel.[14]

When an image is made from a piece of wood that is sacred, it is already living, so rituals such as eye-opening ceremonies become unnecessary.

The converse of this is that if a piece of wood is not sacred, no amount of carving can make a Buddhist statue of it. A short story by the famous novelist Sōseki Natsume (1867–1916), found in the text *Ten Nights of Dreams* (*Yume jūya*), presents this theme. In "The Sixth Night," one of the chapters in this work, the unnamed protagonist dreams that he has been transported to the thirteenth century. He joins a crowd of people, who are all, like him, from modern times, watching the great sculptor Unkei (d. 1223), a historical figure, carve the face of a statue of a Buddhist guardian deity. The protagonist remarks aloud on the sculptor's great skill, but a bystander informs him, "What he's really doing is excavating with the help of the mallet and chisel those nose and eyebrow shapes that lie buried in the wood. He can't go wrong. It's just like digging stones up from the soil."[15] The protagonist decides that if that is the case, then he himself can carve a statue. He returns home and tries to uncover the statue in a piece of wood, but there is none to be found. He concludes that the wood of the present does not contain deities. While obviously an expression of Sōseki's disappointment with modern times, the story also indicates his conviction that a Buddhist image is something to be uncovered rather than created.

The second characteristic of Kannon revealed in the legendary tale of the origin of Kiyomizudera temple is her connection to water. The name of the temple itself, Kiyomizu, means "Pure (or Clear) Water." To this day, ascetics occasionally stand under the ice-cold water tumbling from Otowa Falls, on stones placed for this purpose. In an English guide to temples in Kyoto, Gouverneur Mosher told of witnessing this event one spring evening, while standing on the

enormous platform in front of the main hall:

> A sound attracted my gaze to the sacred waterfall below, and I
> looked down through the cool evening air. There was a man stand-
> ing in the waterfall. The water fell on the back of his neck. He
> wore, for all I could see, a shapeless white garment which could
> have been the cotton kimono of a pilgrim or even underwear. The
> cold water poured steadily on the back of his neck, and with head
> bowed he danced under it—not moving away, just slowly dancing
> where he stood, right in the center of the fall.[16]

Most visitors, however, drink the water, extending a metal cup with a
long handle under one of the three streams into which the falls has been
divided. This practice is so popular that in heavy tourist seasons, a long
line forms and people may wait up to an hour for their turn. By drink-
ing the water, they are told, they partake of the benefits bestowed by the
Kiyomizu Kannon. The abbot of Kiyomizudera temple emphasized, in
a 2005 speech, that the temple's Kannon is particularly effective at pro-
ducing miracles relating to issues of health and prosperity. He also stated
that the water tumbling from Otowa Falls is itself a transformed body
(*keshin*) of the Kiyomizu Kannon. The belief that the temple's Kannon
can grant the devotee the blessings of good health is attested to in the
many guidebooks to Kyoto temples that repeat this claim.[17]

Like the connection to wood, Kannon's association with water has a
long historical basis that originated in China. Even today, many hot
springs resorts in Japan enshrine a Kannon on the premises, explaining
that she is the guardian deity of the property and that it is she who is
responsible for the healing powers of the water.[18]

The Kannons of Hasedera and Ishiyamadera Temples

Hasedera and Ishiyamadera temples, both featured in the founding leg-
end of the Western Pilgrimage, are numbers eight and thirteen on the
pilgrimage route. Although somewhat removed from the center of
Kyoto, both receive numerous pilgrims. Located about seventy-three
kilometers from Kyoto in rural Nara prefecture, Hasedera temple is
known for its Eleven-Headed Kannon, which is almost eight meters tall.
Unusual among statues on the Western Pilgrimage, the Hasedera
Kannon is not a secret buddha, although only the top half is visible to
worshippers. This distinctive statue holds a vase with a lotus in one hand
and a walking staff in the other, the significance of which, the temple

explains, is that it combines the best attributes of Kannon and Jizō. To the worshipper, however, the most striking feature of this Kannon is simply its size. The temple claims that it is the largest wooden statue in Japan.[19]

As in the case of the Kiyomizudera temple statue, the wood from which the image is carved is believed to be holy. The brochure distributed to visitors, although it admits that the current central image dates back only to the sixteenth century, emphasizes that it was carved from the same huge sacred block of wood as the original eighth-century statue.[20] This cannot be verified, but most worshippers at the temple require no proof. The birth story of the original image, as related in modern guidebooks, tells of an enormous tree trunk, washed up in a flood, that was carved into a statue by the holy man Dōtoku in 727 at the request of the emperor.

Tales of the miracles performed by the Hasedera Kannon have been passed down to the present. One of the most popular, that of the Straw Rich Man (Warashibe chōja), is featured in a cartoon book for children about Kannon, one of a series entitled *Educational Cartoons* (*Kyōiku manga*). The protagonist, a boy with neither family nor money, was honest and hardworking, but nothing he did ever came out right. One day, he decided to visit the Hasedera Kannon, known as the Kannon of Good Fortune. An illustration in the cartoon book shows the boy gazing from afar at the temple's famous nineteen-meter-long covered walkway leading up to the main hall.[21]

The boy visited the temple twenty-one days in a row, praying for happiness. On the morning of the twenty-first day, Kannon told him, "You, boy! I will grant your wish. Listen closely to what I tell you. The first thing you pick up after you leave the temple, you must treat as a treasure." In the cartoon, these words are written in a bubble emerging from the mouth of the image, leaving no doubt that the statue is speaking.[22]

The stunned boy thanked her profusely and went on his way, wondering what he would pick up, imagining something spectacular, such as money or a sword. Upon leaving the temple, he stumbled, knocking his head against the ground. When he stood up, his head spinning, he noticed that he was holding a piece of rice straw. Remembering what Kannon had told him, he determined to treasure the straw, though he could not believe that it was what she had meant him to pick up.

He grabbed a fly that was buzzing in his face, and just for fun, he tied it to the end of the straw, which then span around in an amusing manner. A child stuck his head out of a passing carriage and cried, "Daddy! I want that!" The father asked for the straw/fly contraption, but the boy

replied that Kannon had told him to treasure it, and he could not part with it so easily. Finally, they agreed to an exchange: the straw and fly for three sweet oranges.

As the boy walked away with the oranges, he marveled at Kannon's power. Then he saw a beautiful woman ahead on the road fall to her knees, begging for water. Her servant asked the boy whether there was any water in the area, to which he replied that there was not, but that he had three sweet oranges he could give the woman. After eating the oranges, the beautiful woman quickly recovered, thanking the boy for saving her life. In gratitude, she gave him three bundles of silk.

In this way, a straw became three sweet oranges, which became three bundles of silk, all thanks to Kannon, he mused. Just then he saw a man ride by on a gorgeous horse and thought to himself, "I want that horse." At that very moment, the horse fell to the ground. His rider was in tears, lamenting that this, the best horse in all of Japan, was now dead. The boy, noting that it had died at the moment he had the thought of wanting it, wondered whether the horse could become his. He offered the man a bundle of silk for the horse. The man, amazed that someone would want a dead horse, agreed.

After the man departed with the silk, the boy recited Kannon's name, asking her to bring the horse back to life. Sure enough, it opened its eyes, and the boy rejoiced. He stopped by a shop to purchase a golden saddle and a red bit, which he paid for with two bundles of silk. Near Kyoto, the boy on his resplendent horse spied a bustling mansion. A servant who came out to greet him told him that the master of the household was looking for just such a fine horse as this, and invited him in. Indeed, the master asked whether he could have the horse in exchange for the mansion and its rice fields, explaining that he was off to fight in a war and had no need of anything else.

First a straw, then sweet oranges, then silk, then a horse, and now a mansion, all due to Kannon, the boy marveled. After that, everything went well, no matter what he did. The rice was plentiful, and the store-houses filled to bursting. He married a beautiful woman, and together they went to offer thanks to the Hasedera Kannon, the Kannon of Good Fortune.[23]

One of the first appearances of this legend is in the thirteenth-century *Tales of Times Now Past*. The story has changed little over the centuries, although in *Tales of Times Now Past*, the Kannon itself did not speak. Rather, a monk appeared, in a dream, from behind a curtain setting off the inner altar, and told the boy that although he had sinned greatly in a past life, in this life Kannon would bestow upon him good fortune if he

picked up the first thing he saw.[24] The enduring appeal of the story is the assurance it provides that the Hasedera Kannon can help even the most hopeless.[25]

Ishiyamadera temple, located on the banks of Lake Biwa in present-day Ōtsu City in Shiga prefecture, houses a Wish-Granting Jewel Kannon (Nyoirin Kannon) dating to 1096. The birth story of the statue as related by the temple and guidebooks today centers around an eighth-century monk named Rōben, who was delegated to find gold with which to gild the Great Buddha at Nara's Tōdaiji temple. In order to do this, he borrowed a statue of a Wish-Granting Jewel Kannon from the emperor, enshrined it on a cliff near Lake Biwa, and worshipped it. Gold was almost immediately discovered.

This Kannon, a secret buddha that, like the Kiyomizu Kannon, is usually revealed only once every thirty-three years, was last seen in 2002, timed to coincide with an exhibit at the Nara National Museum of the temple's treasures. The next regularly scheduled display of the icon will take place in 2024.

The Kannon at Ishiyamadera is believed to be especially helpful in answering prayers for safe childbirth, marriage, and good fortune. She is also known for inspiring struggling authors. Ishiyamadera temple is famous as the site at which Lady Murasaki is supposed to have composed much of the *Tale of Genji*. According to legend, the emperor's chief consort commanded Lady Murasaki to compose a novel to entertain her. Lady Murasaki made a pilgrimage to Ishiyamadera temple, staying for seven days, requesting Kannon's assistance. Inspired by the view of the shimmering moon over Lake Biwa and aided by the Ishiyamadera Kannon, she was able to write a story that is now regarded as one of the greatest novels in the world.

Rokuharamitsuji Kannon

Rokuharamitsuji, number seventeen on the Western Pilgrimage, is a small temple located on a narrow road near the center of Kyoto. It houses a two-and-a-half-meter-tall Kannon, a secret buddha revealed only once every twelve years. Kūya (903–972), an itinerant monk beloved for spreading Pure Land practices throughout Japan and performing good works such as building hospitals and digging wells, is said to have carved this statue himself in 951, at the request of the emperor, on the occasion of a devastating epidemic in Kyoto. Kūya is believed to have placed the Kannon on a cart and pulled it around Kyoto, effectively causing the statue to walk through the plague-ridden city. After offering

tea made of bamboo, seaweed (*konbu*), and a pickled plum (*umeboshi*) to the image, he then distributed it to the ill, who were cured. Unlike many other statues on the Western Pilgrimage route, the Kannon at Rokuharamitsuji temple dates to the time that the founding story claims and is thought by scholars to be associated with Kūya, if not actually to have been carved by him. This is a matter of interest only to scholars, however; to the average worshipper, the birth stories of all the images are true.

In celebration of Kūya's success in healing those suffering from the plague, the temple now serves Emperor-Healing Tea (Ōfukucha) to visitors for the first three days of the New Year. Said to be the same tea Kūya used to heal the sick, it derives its name from the legend that the emperor was one of the people healed by drinking the tea that Kūya offered. Ōfukucha, written with different Chinese characters, can also mean "Tea of Great Luck." It is, in any case, an auspicious drink.

The most famous statue at Rokuharamitsuji temple today is of the monk Kūya himself. Although small, it is lifelike, showing veins bulging under his flesh. He is carved in the garb of the itinerant monk, with rough sandals on his feet and a drum hanging from his neck. Six small buddhas, one for each of the Chinese characters in the *nenbutsu*, Na-mu A-mi-da Butsu, stand on a metal strip emerging from his mouth. But although this statue is more famous than the main image of the temple, appearing in most Japanese history textbooks, he does not overshadow the Kannon, at least in the eyes of the devout. Because he is enshrined in the Treasure Hall of the temple, along with several other notable sculptures, rather than the main hall, all rituals taking place in the main hall are in offering to Kannon, not Kūya.

In December, for example, temple monks perform the dancing *nenbutsu* (*yuyaku nenbutsu*) in the sunken altar area in front of the closed shrine housing Kannon. The dance is said to be the same as that performed by Kūya when he pulled the Kannon around the city of Kyoto. After the dance, worshippers are allowed, one by one, to enter the inner altar area and kneel in prayer in front of the closed shrine. Each is then given a small paper talisman, on the outside of which is printed "Kanzeon" and "Removing All Ills." The talisman is not meant to be opened, but if one should do so, one would find a spell (Sk. *dhāraṇī*) in praise of Kannon, in the form of a red stamp of Sanskrit characters arranged in a circle.

Although its Kannon is a secret buddha, Rokuharamitsuji temple also boasts a relatively recent, life-sized reproduction of the statue, carved in stone, in front of the main hall. A guidebook to the benefits bestowed

by the various deities at Kyoto temples states that because this stone statue takes the exact form of the secret buddha, and because its construction was financed by believers, it is especially efficacious at smoothing relationships among people, in particular between men and women. She can help the devotee meet the love of her life (*en musubi*), for example, or she can strengthen the relationship between spouses. Many people, the guidebook continues, have their fortune told at the temple, and then rub the piece of paper on which the fortune is recorded on the clothes or the hands of the stone statue and return home with it.[26]

Textual Bases for Devotion to Kannon

Sutras

The precise origin of the deity now identified as Kannon (Sk. Avalokiteśvara; Ch. Guanyin) is unknown. The *Lotus Sutra* refers to him as Kanzeon ("One who observes the cries of the world"); the *Heart Sutra*, as Kanjizai ("Lord who sees"). Sutras translated into Chinese around the third century sometimes call him Kōzeon ("Illuminating the cries of the world"). Such names may once have referred to different deities, but they are all now understood to be the same bodhisattva.

The twenty-fifth chapter of the *Lotus Sutra*, "Universal Gateway [to Salvation] of the Bodhisattva, Observer of the Cries of the World" (J. "Kanzeon bosatsu fumonbon"), provides the most important textual basis for Kannon belief. So popular is this text that it is often treated as an independent sutra, called the *Kannon Sutra*.[27] Various chapters of the *Lotus Sutra* focus on different deities, but Kannon is the one who can do the most for the largest number of people.

Śākyamuni Buddha, who preaches this sutra, explains:

Suppose there are immeasurable hundreds, thousands, ten thousands, millions of beings who are undergoing various trials and suffering. If they hear of this bodhisattva Perceiver of the World's Sounds and single-mindedly call his name, then at once he will perceive the sound of their voices and they will all gain deliverance from their trials. . . . If someone, holding fast to the name of Bodhisattva Perceiver of the World's Sounds, should enter a great fire, the fire could not burn him. This would come about because of this bodhisattva's authority and supernatural power. If one were washed away by a great flood and called upon his name, one would immediately find himself in a shallow place . . .[28]

Other things from which Kannon can rescue the believer include imprisonment, lust, ignorance, and stupidity.

Kannon's other outstanding feature, according to the "Universal Gateway" chapter, is that he can manifest himself in whatever form a living being needs:

> The Buddha said to Bodhisattva Inexhaustable Intent:
> "Good Man, if there are living beings in the land who need someone in the body of a Buddha in order to be saved, Bodhisattva Perceiver of the World's Sounds immediately manifests himself in a Buddha body and preaches the Dharma for them. . . . If they need a rich man to be saved, immediately he becomes a rich man and preaches the Dharma for them. . . this Bodhisattva Perceiver of the World's Sounds has succeeded in acquiring benefits such as these and, taking on a variety of different forms, goes about among the lands saving living beings. For this reason you and the others should single-mindedly offer alms to the Bodhisattva Perceiver of the World's Sounds.[29]

As mentioned, the number of forms listed here in which Kannon can manifest himself is thirty-three.

The *Flower Garland Sutra* (Sk. *Avataṃsaka sūtra*) provides the other major textual basis for Kannon devotion. The chapter "Entering the Dharma World" explains that Kannon lives on Mt. Fudaraku (Sk. Potalaka, "Mountain of Bright Light"), an island in the ocean.[30] The young boy Zenzai Dōji (Sk. Sudāna), on a journey in search of the true Buddhist teaching, meets Kannon there and hears him preach the truth. Kannon is credited in this text, too, with amazing efficacy in saving people from all kinds of ills.

In the late sixth century, Buddhist sutras expounding the miraculous powers of various transformed appearances of Kannon found their way to China and then to Japan. Esoteric Buddhism, a form of Mahāyāna influenced by Hindu Tantra that emphasizes complex secret teachings, was in large part responsible for these iconographic developments. In both Hinduism and esoteric Buddhism, deities frequently sport multiple arms, legs, and heads. Examples of esoteric forms of Kannon, in addition to the Eleven-Headed and Thousand-Armed Kannons, include the Wish-Granting Jewel Kannon (J. Nyoirin Kannon), which usually has six arms, and the angry Horse-Headed Kannon (J. Battō Kannon). Among the influential esoteric texts centering on Kannon that found their way to Japan was the *Eleven-Headed Dharani Sutra*, which

lists ten benefits and four karmic rewards granted by this form of Kannon. The benefits include plentiful money and clothes, escape from fire and flood, being met by various buddhas on one's deathbed, and avoiding rebirth in hell.[31]

Miracle Tales

Collections of Buddhist miracle tales began to appear in China in the late fourth century and had become common by the eighth. Indigenous Chinese tales that predated the entry of Buddhism into China exerted considerable influence on these Buddhist stories, usually compiled by laypeople, in which complex doctrine was not a concern. Most do not survive as separate texts but rather are included in encyclopedic collections such as the seventh-century *Grove of Pearls from the Garden of the Dharma* (Ch. *Fayuan zhulin*).[32] The stories sometimes mention images of the Buddha, although not nearly as frequently as their later Japanese counterparts. For example, a Chinese collection of miracle stories dating to 501 includes the story of a man who had leprosy and prayed to a statue of Kannon. The image rubbed his sores, and he was healed, but its hand remained extended, never to return to its original position.[33]

The earliest extant complete Chinese Buddhist miracle tale collection, the late fourth-century *Records of Miracles concerning Guanshiyin* (Ch. *Guanshiyin yingyan ji*), relates only stories of Kannon, attesting to his popularity. This work contains seven stories of supplicants rescued from disaster by calling out Kannon's name, one of which refers to the "Universal Gateway" chapter of the *Lotus Sutra*, but statues do not figure prominently in the narratives.[34]

A statue does take center stage in a famous story found in a fifth-century collection of tales not limited to Kannon. A gilt statue was unearthed in the garden of a cruel king, who ordered it to be installed in the privy to hold a "toilet scraper." Not long after, the king developed a painfully swollen scrotum and became seriously ill. He then instructed that the statue be enshrined properly and made offerings and apologies to it, whereupon he was cured.[35]

A body-substitution story found in numerous Chinese collections of miracle tales tells of the conscript Sun Jingde, who from 535 to 537 guarded the northern border of China and daily worshipped a golden image of Kannon that he had made. Wrongly sentenced to death for a crime he did not commit, he survived numerous attempts at execution, with the knife that was to behead him breaking each time. When Sun closely examined the statue of Kannon, he saw cuts on its neck.[36] Stories

such as this clearly served as models for later Japanese tales of body-substitution miracles.

Records of Supernatural Retributions (Ch. *Mingbao ji*), a mid-seventh-century collection of miracle tales, directly influenced Japanese works such as *Miraculous Tales of Karmic Retribution* and *Tales of Times Now Past*, both of which quote it heavily, although they do not usually acknowledge this source.[37] Kyōkai, author of *Miraculous Tales of Karmic Retribution*, does refer specifically to the *Mingbao ji* in his introduction, and eight of the stories he includes come more or less directly from that text.[38]

Kannon in Early Medieval Japan

In the tenth century, aristocrats, their wives, and their children began to make frequent pilgrimages to temples in the Kyoto region that enshrined Kannon images believed to be miraculous. To encourage this, temples prepared histories, to be preached by monks of the temple, expounding the miracle stories of their central image. The miracles that made these temples famous were not limited to those mentioned in the *Lotus Sutra*; they were, rather, specific to the Kannon of a particular temple.

The Evidence of Diaries, Novels, and Tales

The diaries of top-level male aristocrats, most belonging to the indomitable Fujiwara family, speak frequently of Buddhist images, rituals, and temples. Fujiwara Sanesuke (957–1046), in particular, often mentioned pilgrimages in his diary, especially ones to Kiyomizudera, Hasedera, and Ishiyamadera temples.[39] The most powerful of all aristocrats, Fujiwara Michinaga (966–1027), also visited these three temples.[40] The eleventh-century historical novel *Tale of Flowering Fortunes* briefly described one of his journeys to Hasedera temple:

> It was during that period that Michinaga journeyed to Hasedera temple for a seven-day retreat. Not wishing to burden the provincial governor, he took with him whatever he needed from the capital, even down to the oil and wicks for a myriad-lights service to be held during his stay. He had a complete supply of Buddhist paraphernalia—curtains to hang before the buddhas, and all kinds of other things.[41]

In fact, however, the records that survive of aristocrats' consorts and daughters going to temples are more detailed than those of the aristocratic men themselves. Aristocratic women in the eleventh and twelfth centuries rarely traveled. Pilgrimages to temples provided one of the few legitimate chances for escape from the confines of their homes, and they seem to have taken full advantage of this opportunity. Usually accompanied by attendants, they traveled by carriage or, very occasionally, on foot.[42] Rather than journeying to a number of temples, they almost always visited only one temple on a single outing. The temples to which they made pilgrimages usually were associated more than other temples with miracles of the resident Kannon.[43] The sectarian affiliation of a temple did not matter.

The diaries of these aristocratic women, which differ greatly from the terse, factual journals of the top-level aristocratic men, provide valuable information regarding such journeys. Most were written by women of the second-tier aristocracy, usually the daughters of provincial governors who served as ladies-in-waiting to female royalty, and they reveal the complex emotions and divided loyalties of their authors. In the following pages I focus on three such diaries: *Gossamer Diary* (*Kagerō nikki*, 954–974), *Pillow Book* (*Makura no sōshi*, completed around 1001), and *Sarashina Diary* (*Sarashina nikki*, 1009–1059). The early tenth-century *Tale of Genji*, by the woman we now know as Lady Murasaki, who belonged to this class of second-tier aristocrats, also speaks frequently of temple visits.

From these diaries and the *Tale of Genji* emerge details of what took place in early medieval Japan during an aristocratic visit to a temple. The entire procedure differed greatly from that of today. Before even embarking on a journey, pilgrims were required to undergo a period of purification that included fasting. In the *Tale of Genji*, when the character Ukifune decided to embark on a pilgrimage to Ishiyamadera, her attendants were required to undergo purification rituals.[44] Lady Sarashina also stated that when a monk was sent by her mother in proxy to Hasedera temple, to pray for a divination of her future, she was forced by her mother to "observe strict rules of abstinence."[45]

The pilgrims spent at least one night at the temple, usually in the main hall, in front of the image. For the upper-class pilgrim, a small enclosure was prepared, consisting of mats on which to rest and folding screens to mark off individual space and shield the visitor from prying eyes. Sei Shōnagon described some monks erecting this type of small room at Hasedera temple:

> One day at sunset a large party came to the temple, evidently intending to stay for a retreat. The acolytes bustled about efficiently,

installing tall screens (which looked so heavy that I should not have thought they could possibly carry them) and flopping straw mats noisily on the floor. The visitors were taken directly to their quarters, and soon I heard a loud rustling sound as a blind was hung over the lattice-barrier to separate rooms from the sanctuary. All the arrangements were carried out in a most effortless fashion: the acolytes were used to their job.[46]

Spending the night at the temple did not, however, mean engaging in a usual night's sleep. Part of what the pilgrim hoped to gain from the visit to the deity was a vision of the future or directions for her life, expected to take the shape of a dream. The women unfailingly reported in their diaries the dreams they had while on retreat at temples, clearly regarding them as messages from "the buddha," the term they used to refer to almost all Buddhist deities, including Kannon.

Sleep appears to have been difficult in any case, as evidenced by several diaries that speak of constant noise, which included other pilgrims chattering and praying aloud, and monks offering official petitions to the deity. The author of *Gossamer Diary* related that in retreat at Hasedera temple, "I could not sleep, and with little else to occupy my mind, I found myself fascinated, even moved to tears, at the prayer of a blind man, not very well dressed, who was pouring forth his petition in a loud voice without a thought that someone might be listening. Though I really should have liked to stay longer, we started out with much of a stir the following morning."[47] If the women wanted to sleep, they went to other buildings on the temple grounds that were available to members of the upper classes. Some texts indicate that female pilgrims may have retired to a monk's quarters to rest after a night in the main hall.[48]

The degree to which the women were able to see the statue is unclear; it probably varied from one situation to the next and would have depended to some extent on the location in the hall of the pilgrim's enclosure. The *Tale of Genji*, for example, tells how the character Ukon invited some acquaintances and their attendants over to be with her, right in front of the Buddha at Hasedera temple.[49] Sei Shōnagon spoke in her *Pillow Book* of a pilgrimage, also to Hasedera temple, explaining:

On the way to our rooms we had to pass in front of rows of strangers. I found this very unpleasant; but, when I reached the chapel and got a view past the latticed screen and right up into the sanctuary, I was overcome with awe and wondered how I could

have stayed away for so many months. My old feelings were aroused and they overwhelmed all else. The lamps that lit the sacred image in the sanctuary were not permanent ones, but had been brought by pilgrims as offerings. They burnt with terrifying brightness, and in their light the Buddha glittered brilliantly.[50]

The latticed barrier to which she referred usually stood between the pilgrims and the image, obscuring the worshippers' view. Sometimes a curtain seems to have been lowered in the same area. In any case, the women almost never provided a physical description of the statue itself. Sei Shōnagon's statement that the buddha "glittered brilliantly" in the lamp light supplies the most detail of any diary.

Although pilgrimages appear to have been made by commoners also, these are less well documented. Female aristocrats sometimes mentioned the presence of the masses, usually with distaste. Sei Shōnagon, not known for kindness or tact, related:

It is very annoying, when one has visited Hasedera temple and has retired into one's enclosure, to be disturbed by a herd of common people who come and sit outside in a row, crowded so close together that the tails of their robes fall over each other in utter disarray. . . . Having made my way up the long steps, deafened by the fearful roar of the river, I hurried into my enclosure, longing to gaze upon the sacred countenance of the Buddha. To my dismay I found that a throng of commoners had settled themselves directly in front of me, where they were incessantly standing up, prostrating themselves, and squatting down again. They looked like so many basket-worms as they crowded together in their hideous clothes, leaving hardly an inch of space between themselves and me. I really felt like pushing them all over sideways. Important visitors always have attendants to clear such pests from their enclosures; but it is not so easy for ordinary people like me . . .[51]

The author of *Gossamer Diary* also mentioned the commoners at Hasedera temple, lamenting, "The beggars at the temple, each with his earthen bowl, were most distressing. I recoiled involuntarily at being so near the defiling masses."[52]

Tales of Times Now Past relates many stories of the pilgrimages of commoners and is the most valuable source of information on this matter. Chapter sixteen alone contains thirty-nine miraculous tales of Kannon, most of which concern a specific statue at a specific temple. Ishiyamadera

temple, Kiyomizudera temple, and Hasedera temple are among those named. These temples also frequently appear in the twelfth-century *Songs to Make the Dust Dance*, a collection thought to have been sung by commoners. One such poem simply provides a list of temples housing miracle-producing Kannons:

> Temples to witness the miracles of Kannon:
> Kiyomizu, Ishiyama, the mountain of Hase,
> Kokawa, Hitone mountain in Ōmi,
> And closer to home, Rokkakudō.[53]

The Kannon of Kiyomizudera Temple, Revisited: Bestower of Wealth

With its convenient location close to the center of Kyoto, Kiyomizudera temple in the early medieval period was, as it is today, the most frequently visited home of a miraculous Kannon image. Sei Shōnagon spoke of going on retreat there on the eighteenth of the month, Kannon's holy day, and finding it crowded with pilgrims from distant locations.[54] In the *Tale of Genji*, when the hero Hikaru Genji was parted from one of his many lovers, he was stricken with grief and unable to move. His companion, at wit's end, "turned and made supplication to the Kannon of Kiyomizu. Genji somehow pulled himself together. Silently invoking the holy name, he was seen back to Nijō."[55] It was not simply a visit to the temple that was important; rather, it was prayers to the Kannon of that temple that brought results.

Chapter sixteen of *Tales of Times Now Past* contains six stories extolling the virtues of the Kiyomizu Kannon, a greater number of stories than is devoted to any other single deity at a particular temple. Several of these tales focus on the Kiyomizu Kannon's ability to help the poverty-stricken achieve wealth. For example, one describes an impoverished Kyoto woman who regularly visited Kiyomizudera temple but appeared to receive no miraculous benefits. Although she had no husband, she became pregnant and, as she had no home, worried about where she could give birth. She prayed and wept on her visits to Kiyomizudera temple, having no alternative but to tell her troubles to Kannon.

One day, another woman visited the temple with her, and both fell asleep in front of the Kannon. In a dream, a monk appeared to the pregnant woman and told her not to worry and that her troubles would be taken care of. The two women visited the temple again the following

day, this time sitting in front of the guardian deity of the temple. An object wrapped in paper appeared before the other woman, but because it was dark outside, she did not try to open it. That night, the two women again fell asleep in the main hall of the temple, and this time the monk appeared in the other woman's dream, telling her to give the object to the pregnant woman. In the morning, when she unwrapped the paper, she found three pieces of gold but decided not to hand them over to the pregnant woman, reasoning that she herself had worshipped the Kiyomizu Kannon as well, and if Kannon wanted the pregnant woman to have money, she could give some more directly. That night, however, as she slept in her own home, the monk appeared again in a dream, angrily asking why she had kept the money. Upon awakening, she gave the money to the pregnant woman, who went on to buy a house, safely give birth, and become wealthy. The story concludes by assuring us that all this happened very recently.[56]

Another story in *Tales of Times Now Past* tells of a low-level samurai who visited Kiyomizudera two thousand times, either because he had nothing better to do or because he saw other people visit one thousand times and wanted to double their feat. Later, he lost a game to another lowly samurai and was supposed to give him something valuable as a forfeit; as he had no possessions, he offered the other samurai his two-thousand pilgrimages to Kiyomizudera temple. Bystanders who over-heard the conversation thought this was a ridiculous way to get out of paying a debt, but the samurai who won agreed to accept the completed pilgrimages as payment. Shortly after, the winner married well and became the retainer of a wealthy master. The fortune of the loser, mean-while, continued to get worse, and those who heard of the story praised the winner and had sympathy for the loser.[57] Although the fate of the samurai who handed over the pilgrimages may seem unduly harsh, what we are meant to understand from this story is that the people who ini-tially laughed at the idea of two thousand pilgrimages to the Kiyomizu Kannon being something of great value were proven wrong.

The Kannon of Hasedera Temple, Revisited: Affairs of the Heart

Although Hasedera temple proudly tells of the sacred wood from which its Kannon was carved, it neglects to tell the whole story. According to the tenth-century *Three Jewels*, a great flood occurred in 601, washing up a huge tree. Because the tree was not treated properly, the local villagers suffered. Finally, someone heard of the tree and vowed to have it carved

into an Eleven-Headed Kannon, but he died without accomplishing this. The tree remained untouched for eighty years, causing a plague in the village. When the tree was revealed to be the source of the misfortune, the villagers threw it into the Hasegawa river. Finally, the young monk Tokudō learned of the tree, was impressed by its power, and decided to make it into an Eleven-Headed Kannon, moving it in 720 to what is now Hasedera temple. Unable to have the image carved, however, "He grieved and lamented for seven or eight years, constantly seating himself before the tree and chanting: 'May my worship of your wondrous power enable the image of the Buddha to be formed!'"[58] At last, the empress supported the project, and the image was completed in 727.[59]

Variants of this story are found in numerous later works, including *Tales of Times Now Past*.[60] To the modern visitor, this tale would no doubt be frightening and unappealing. But the early medieval devotee would have regarded it as proof of the power of the Hasedera Kannon, inherent in the wood itself. The story also would have served as a warning about the dangers of neglecting an image.

A journey to Hasedera temple (often called Hatsusedera temple in early medieval texts), about seventy-three kilometers from Kyoto, was challenging and difficult; nevertheless, the temple appears frequently in diaries and in the *Tale of Genji*. In most cases, the trip was made to bring changes in the romantic status of the devotee. To be single after a certain age was in part the result of a woman having not yet been accepted into the more exclusive circles of society and therefore not being regarded as desirable. A trip to Hasedera temple or Ishiyamadera temple, then, would be made to place before Kannon a request for a more favorable position in society as well as a suitable marriage.

The authors of *Sarashina Diary* and *Gossamer Diary* told of journeys to Hasedera temple that took two nights and three days each way. The overprotective mother of the author of *Sarashina Diary* refused to allow her daughter to visit Hasedera temple, and Ishiyamadera temple as well, because of the danger involved in the trip. Lady Sarashina was allowed to visit only Kiyomizudera temple, which is in the city of Kyoto itself. However, because the daughter was getting older and was still unmarried, her mother requested that a certain monk go to Hasedera temple and receive a divination from Kannon regarding her daughter's future:

> As I was whiling away the time in gloomy musings, it occurred to me that I might go on some pilgrimages. "How terrifying!" said Mother, who was a very old-fashioned woman. "If we go to Hase, we may be attacked by brigands on Nara Slope and what will

become of us then? Ishiyama is also very dangerous because one has to pass the barrier mountain . . ." She obviously regarded me as a great nuisance and unfit for normal society; the most she would allow was a retreat to Kiyomizu . . .

Mother ordered a one-foot mirror to be made for Hase Temple. Since she was unable to take it there herself, she decided to send a priest in her place and gave him the following instructions, "You are to stay in retreat for three days and you must pray for a dream about my daughter's future." While the priest was away, Mother made me observe strict rules of abstinence.[61]

When the priest returned, he informed the mother and daughter that he had dreamed of a graceful woman holding up a mirror that showed sorrowful people reflected on one side, and beautiful garments, flowers, and birds on the other. No one knew what to make of this dream, and Lady Sarashina herself was uninterested.[62] Later, after marrying and having a child, she did manage to visit Hasedera temple, as well as other temples removed from the capital, several times:

Now that I was able to do exactly as I wished, I went on one distant pilgrimage after another. Some were delightful, some difficult, but I found great solace in them all, being confident that they would bring me future benefit. No longer having any sorrows of my own, I concentrated on providing the best possible upbringing for my children and waited impatiently for them to grow up. I also prayed for my husband's future, and I was confident that my prayers would be answered.[63]

When her husband died, ending an apparently happy union, Lady Sarashina remembered the mirror the priest had dreamed about and realized that the sorrowful figures reflected on one side had prefigured her future unhappiness upon her husband's death.[64]

The author of *Gossamer Diary* was in more dire straits, and her pilgrimages show greater urgency. She was perpetually suffering from unrequited love—at least it appeared that way to her. The second wife of the prominent aristocrat Fujiwara Kaneie (929–990), she had achieved a life of luxury that most women with her background as a second-tier aristocrat would have envied. Even though she was apparently an extremely beautiful woman, the author of *Gossamer Diary* agonized over her husband's other wives and numerous affairs, alternately becoming furious with him and desiring him all the more. Of a

rainy visit to Hasedera temple, she stated:

> I was in acute discomfort as we climbed to the main hall. There
> were many things I ought to be thinking about, but I was much too
> depressed to collect them into anything coherent. The dawn came
> without my having made any of my supplications to the Buddha.
> And still the rain went on.[65]

In the *Tale of Genji*, Lady Tamakazura also visited Hasedera temple to
find a husband, a difficult task because she had just returned from the
provinces and lacked connections in the capital. She was sent by
concerned people to various temples but to no avail:

> "And then," said the vice-governor, "there is Hatsuse. It is known
> even in China as the Japanese temple among them all that gets
> things done. It can't help doing something for a poor lady back
> after all those years so far away." And this time he sent her to
> Hatsuse.
> The pilgrimage was to be on foot. Though not used to walking,
> the girl did as she was told. What sort of crimes had she been guilty
> of, she was asking, that she would be subjected to such trials? . . . Late
> on the morning of the fourth day, barely alive, they arrived at
> Tsubaichi, just below Hatsuse.[66]

At Hasedera temple, she met her mother's former servant, who brought
her into the Genji household, thus establishing her position in society.

The *Records of Miracles of the Hasedera Kannon* (*Hasedera Kannon genki*),
a text containing fifty-two stories about the power of the Hasedera
Kannon, comprises various sections from different periods. Scholars
have dated portions of it to anywhere from the late twelfth century to
the fifteenth.[67] Two of the stories echo the *Tale of Genji* in stating that
the Hasedera Kannon was known even in China for its miracles. The
first concerns a man who became devoutly religious and prayed to the
Hasedera Kannon for guidance in leading his wife to the truth as well.
He disappeared for some time to engage in ascetic practices, and his
wife, not knowing where he had gone, went on a seven-day retreat to
Hasedera temple. In a dream, she discovered the location of her husband
and thought, "The Hasedera Kannon excels especially in granting favors.
I have heard that even a Chinese empress, ignoring the Buddhas and
gods of her own country, asked a favor from this Hasedera Kannon in
another country, and she prayed for help to overcome some problems

that could not be solved by human means. Perhaps now I too may be blessed with another favor."[68] After she found her husband, they agreed that both would embark on lives of devotion to Kannon.

The second legend in which the statue's popularity in China is mentioned centers on three unmarried sisters. The daughters began to make monthly pilgrimages to Hasedera temple after their parents died. The two younger girls were spotted at the temple by an aristocratic woman, who took them to be her ladies-in-waiting, thus increasing their chances of a good match. The oldest sister, however, remained at home and was told by those around her that she should stop visiting Hasedera temple, since this was not producing results, and that she should worship local gods and buddhas instead. She replied: "I have heard that the Kannon will extend mercy even to unrelated people. The Great Holy One of this temple is said to grant, even to people from places as distant as China, what other gods and Buddhas will not supply."[69]

She then went on a hundred-day pilgrimage to Hasedera temple, venting her frustration to Kannon. On the ninety-ninth day, her deceased mother appeared in a dream and told her not to be angry with the Kannon, because her ill fortune was due to her own karma from evil deeds in a past life. She actually had been destined to be born in hell, the mother explained, but Kannon's compassion had enabled her to escape that fate. The mother continued:

"Your merit and pious devotion in reciting Kannon's name will release you from your karma of descending into hell and will allow your soul to attend to me eternally. If you actually have an opportunity to see the living Kannon, your grave sins will be reduced and instantly change into blessings. Now I will reveal my true appearance to you. Worship me joyfully."

On saying this, the dim figure was about to enter the main hall, and the surprised eldest sister looked at the priest's place in front of the altar. Behold! The faint figure of her deceased mother, dressed in a thin robe, glided from the eastern doorway to the main altar. Her back, seen through the sheer garment which faintly reflected the candlelight of the altar, appeared exactly like that of the Eleven-Faced Kannon.[70]

The eldest daughter subsequently was welcomed into the same household in which her sisters worked, and her life improved greatly. Four other people who had witnessed the appearance of Kannon received

numerous positive benefits. In this story, the Kannon of Hasedera actually assumed the appearance of the mother to best convey her message to the oldest daughter.

Tales of Times Now Past even includes a story about a Korean empress who had heard of the Hasedera Kannon. She had an affair, and when her husband, the emperor, found out, he ordered her to be suspended by her hair about thirty centimeters off the ground. The agony was more than she could bear, but there was no one to help her. Suddenly, she remembered that she had once heard about a country to the east, called Japan, where a miraculous Kannon lived at a place called Hase. Contemplating the compassion of bodhisattvas, larger than the entire world, the empress prayed with all her heart, begging the Hasedera Kannon to rescue her from the torture. She briefly closed her eyes, and when she reopened them, she suddenly saw a golden stool below her on which she could stand. As soon as she did, she felt no pain whatsoever. But because no one else could see the stool, she was safe from further punishment. The empress knew that this was all because of the Hasedera Kannon's great mercy. After a few days, the empress was forgiven by her husband and allowed to return to her normal life. In gratitude, she sent gold, money, and other desirable items in offering to the Hasedera Kannon.[71] Through stories like this, the Hasedera Kannon developed a reputation as an international celebrity.

The Kannon of Ishiyamadera Temple, Revisited: More Affairs of the Heart

The Ishiyamadera Kannon was known for many of the same types of miracles for which the Hasedera Kannon was renowned. In fact, identical miracle stories are sometimes ascribed to the two Kannons, with one temple name simply substituted for the other. Ishiyamadera temple, while not in the city of Kyoto proper, was much closer than Hasedera temple. It also was situated next to Lake Biwa, Japan's largest lake, and was famous as a site for moon viewing. The moon, especially as reflected in water, has long been associated with Kannon. A common Chinese depiction of Kannon features her sitting by a lake, gazing at the reflection of the moon. Early medieval diaries do not speak directly of such paintings, but when describing pilgrimages to Ishiyamadera temple they invariably remark on the moon.

The distraught author of *Gossamer Diary* visited Ishiyamadera temple to pray for her husband's undivided attention, encouraged to go by her

attendants, with whom she was ruminating about who the current object of his affections might be:

> "Well, he is after someone, we can be fairly sure of that," they concluded. "But in any case you will not accomplish much sitting here moping, as cheerful as the last light of day. Why don't you make a pilgrimage somewhere?"
>
> Indeed I had nothing to do but sit and brood. Yet it was so extremely hot—but then, as they said, there was nothing to be gained by staying on here. So, in the middle of the Seventh Month, I decided without consulting anyone to go to Ishiyama. I started out quietly before daybreak, not even telling my sister. Somehow they heard about it back at the house, and at the river I was over-taken by a few attendants. The sky was bright with the late moon, the way was quiet, and we met no one. There was a dead body lying in the river bottom as we passed, but I was quite beyond being frightened by that sort of thing. . . . Late in the afternoon we reached the temple. I washed myself in the purification hall, but I could only toss and weep. I washed myself once more and went up to the main hall. I could not control my sobs long enough to tell my story to the Buddha, however, and, choked with tears, I looked out into the night. The hall was built high over a heavily wooded valley, and the moon, just past full, here and there leaked through the trees, lighting the river down which we had come. The spring at the foot of the hill shone like a mirror.[72]

She spent the night in the main hall, crying and begging the Buddha to help her. After a while she fell asleep and dreamed that a monk poured water on her right knee. The dream awakened her, and not surprisingly she concluded, "It must have been a sign from the Buddha, an unhappy one, no doubt."[73]

Lady Sarashina made numerous pilgrimages to Ishiyamadera temple, and also received an ambiguous message from the Buddha in a dream, hearing a voice tell her that valuable incense had been given to her.[74] She, too, commented on the moon and water, explaining, "It seemed to be raining heavily all night long. What a nuisance rain is for trav-ellers, I thought as I opened the lattice and looked out. By the light of the pale moon I could see all the way to the bottom of the valley. Then I realized that what had sounded like rain was water flowing at the base of the trees."[75]

Tales of Times Now Past relates several stories of commoners who found domestic bliss through the power of the Kannon of Ishiyama temple. In one, the parents of an unnamed beauty in Kyoto who had been born mute, worried that the muteness was a curse from the gods, prayed to both the gods and the buddhas and requested a venerable monk to conduct prayers on their behalf, but to no avail. The girl grew older but still could not speak. The parents at last gave up on her, leaving only her childhood nursemaid to care about her. Soon after, both parents died.

Lamenting the girl's fate, the nursemaid decided to find a man who could marry her and have a child with her. She arranged for a handsome suitor to marry the girl by hiding from him the fact that she was mute. The new husband frequently visited her, as it was not customary at the time for a husband and wife to live together. He always found it hard to take leave of such an appealing woman and would continue speaking to her at length, thinking that it was out of shyness that his wife never replied. On one occasion, he saw tears well up in her eyes and realized that she wanted to speak but could not. After that, he visited less frequently, and the girl, pained by the situation, left the house. When he came to see her and found her missing, the husband realized his deep love for her and started out in search of her.

The girl had fled to Ishiyamadera temple, where a relative of her nursemaid was a monk. She was considering becoming a nun. Remembering that Kannon was the buddha who answered impossible prayers, she begged for a cure for her muteness, and prayed that if her condition was the result of bad karma from a past life, and thus could not be cured, she be allowed to die soon, so Kannon could help her in her next life.

A monk from Mt. Hiei who was renowned for his successful prayers visited Ishiyamadera temple, saw the girl, and wondered why she had ensconced herself in such a secluded place. When she wrote down her problem and showed it to him, the monk told her he would pray for her recovery. He performed rituals in front of Kannon continuously for three days and nights; still the girl showed no change. When the distraught monk continued the rituals, the girl opened her mouth, vomited for two hours, and then began to talk nonstop. After that, she was able to speak normally. In thanks, she presented the monk with some crystal prayer beads she had treasured her whole life, which he then took back to Mt. Hiei. Meanwhile, her husband, unable to find her, had been on a retreat to Mt. Hiei and saw the monk, who coincidentally was a friend of his. Startled to see the familiar prayer beads, he asked the monk how

he had come by them. When he heard about the mute girl whose voice was restored, he went to Ishiyamadera temple and was happily reunited with his wife. Both were certain that this miracle had occurred thanks to the Ishiyamadera Kannon, whom they continued to worship the rest of their lives.[76]

Another story in *Tales of Times Now Past* of marital harmony restored tells of a man whose wife was so beautiful that all the local governors, one after another, wanted her for their own. She refused to have anything to do with them, declaring her exclusive interest in her husband, but one of the governors would not give up. He convinced the husband to agree to a deal: the two of them would have a contest, and whoever won got to have the beautiful woman for a wife. The governor then wrote a verse on paper, slipped the paper in an envelope, pressed his seal on the envelope, and placed it in a box. He gave the box to the husband and informed him of the rules of the contest: he could not open the box or read what the governor had written, which was the first line of a poem. The man had seven days to come up with the second line of the poem, which had to fit with the first perfectly.

When he informed his wife of the situation, she told him that Kannon loves everyone as a parent loves a child, and he must ask the Ishiyamadera Kannon for help. He made a pilgrimage to the temple, but by the third day, he still had not gained any insight into his problem. Leaving the temple, he was walking in the street, wailing, when an extremely cultured young woman asked him what was wrong. At first he demurred, but she pressed, and he, thinking that perhaps she was a manifestation of Kannon, told her that he had prayed three days and nights to the Ishiyamadera Kannon about a certain problem, but it appeared that Kannon was not going to help him.

The woman recited what appeared to be the second line of a poem. The man rejoiced and asked her where she was from, but she refused to reply and simply walked away in the direction of the temple. The man went with his wife to the district office, where they presented the line to the governor. He opened the box and removed the first line of the poem from the envelope. The line the man received from the anonymous woman fit with it perfectly, and the governor was forced to admit defeat.[77]

As in the case of Hasedera temple, there are numerous texts whose sole purpose is to recount the miracles associated with the Ishiyamadera Kannon. An illustrated scroll in thirty-three sections, *History of Ishiyamadera Temple* (*Ishiyamadera engi*), most of which dates to the fourteenth century, depicts several stories from *Gossamer Diary* and

Sarashina Diary. The scroll, however, put a more positive spin on the visit of the author of *Gossamer Diary* to Ishiyamadera temple. In her diary, she recounted a dream, mentioned above, of a monk pouring water on her knee, and glumly concluded that this must be an ill omen. The scroll depicts this scene, but frames it as a positive sign, after which she is united with her repentant husband.[78] The portion drawn from *Sarashina Diary* shows Lady Sarashina visiting the temple in the eleventh month, when the hills are covered with snow. After she arrives, a monk appears in a dream and offers her incense. This scene is taken from the diary without adaptation.

The Kannon of Rokuharamitsuji Temple, Revisited: Missing in Action?

In contrast to Kiyomizudera, Hasedera, and Ishiyamadera temples, Rokuharamitsuji temple, originally called Saikōji temple, does not appear in most early medieval diaries and novels. This is in part because the area in which the temple is located was an enormous charnel field, where bodies of the indigent were simply abandoned to decay. To the south, in what is now the area of Ima Kumanodera temple, was the graveyard for aristocrats and royalty. For Kūya, this was an ideal site for spreading Pure Land teachings, but for the aristocratic pilgrim, it would have been a place of impurity.

In the twelfth century, leaders of the Taira clan built their mansions in the area around Rokuharamitsuji temple. When they lost the Genpei Wars (1180–1183) to the Minamoto clan, they burned their own homes to the ground, and most of the temple complex was destroyed as well, although the main hall survived. The temple is thus associated with many stories concerning the Taira family, but Kannon does not usually play a role in these narratives. Rokuharamitsuji temple does appear regularly in *Tales of Times Now Past* as a site popular with commoners, but in that text it is famous for its Jizō statues, discussed in the following chapter, rather than its Kannon.

The Miraculous Kannon of Kokawadera Temple

Located in Wakayama prefecture on the Kii peninsula, hundreds of kilometers from Kyoto, Kokawadera temple is no longer a major pilgrimage site, except for those determined to visit all thirty-three sites of the Western Pilgrimage, on which it is number three. But it was famous in

early medieval Japan, although its distance meant the aristocratic women of Kyoto did not visit it. Sei Shōnagon mentioned Kokawadera temple in a list of prominent temples.[79] The retired emperor Kazan (r. 984–986) is thought to have made pilgrimages to this temple, and several twelfth-century aristocrats belonging to the Fujiwara family did as well.[80] The temple name also appears in a verse contained in *Songs to Make the Dust Dance*.[81]

Today, Kokawadera temple is best known for its twelfth-century illustrated narrative scroll (*Kokawadera engi*) that relates the birth story of its central image.[82] A hunter named Kujiko saw in the mountains a mysterious light and built a small worship hall there, in the belief that it must be a sacred site. He had no Buddhist statue to enshrine, however. One day a young boy appeared, requesting lodging, in return for which he promised to carve a statue for the worship hall, stipulating that Kujiko should not look inside for seven days. Kujiko agreed, and the boy secluded himself in the hall for seven days. On the seventh day, Kujiko opened the door, only to discover that the boy was gone, and a bright gilt statue of the Thousand-Armed Kannon stood in the center of the room. Realizing that the boy had been a transformed manifestation of Kannon, Kujiko vowed never to take a life again. This is a body-substitution story of a complex nature. In many such stories, as discussed in the previous chapter, a statue takes the place of someone who is suffering, and the marks of the affliction appear on the image. In this case, however, the statue takes the form of a young boy and essentially carves itself.

The illustrated scroll also relates what happened next. When the daughter of a wealthy man became deathly ill, the same young boy appeared and, by reading sutras at her sickbed, healed her. In appreciation, she presented him with a small sword and a red scarf. Later, she visited the small worship hall, hoping to thank the boy again. There she discovered the Kannon image holding the sword and the scarf and realized that the boy was a manifestation of this Kannon image. The daughter became a nun and devoted her life to worship of Kannon.

This same statue, an absolute secret buddha that is never displayed, is said to live in the main hall at Kokawadera temple, and it is the object of devotion for the pilgrims who visit the temple. An auxiliary hall dedicated to the young boy enshrines a statue of him. Nowadays, every year on December 18, the last of Kannon's holy days in the year, a ceremony is held in which the statue of the boy is revealed, the only time it can be seen. This presents some logical problems. The Kannon in the main hall is the boy, as indicated by the statue's birth story. Why, then, would a

separate statue of the boy be worshipped independently? The devotee, once again, does not worry about such issues. The boy who was Kannon carved a statue of Kannon, and he is that very statue, but he also is a separate statue. This convoluted body-substitution story is a perfect illustration of the ways in which Kannon can take any form.

CHAPTER FIVE

Jizō to the Rescue

Jizō is everywhere in Japan: the edge of town, the street corner, the playground, next to the rice field. He is the most commonly depicted deity, his images outnumbering even those of Kannon. The observant visitor to modern Japan will immediately notice the abundance of small stone images at roadsides. At first, however, he might not realize these are statues of a deity. Sometimes wrapped in a bib, or topped with a cap, the rock might be ornamented with a simply drawn face or be only vaguely human in shape, with no face at all. These small statues are almost always of Jizō Bodhisattva.[1]

In addition to the many Jizōs that stand directly on the ground, about five thousand Jizōs in roadside shrines live within the city limits of Kyoto.[2] These shrines consist of a box, usually wooden, anywhere from ten centimeters to one meter cubed that is elevated from the ground on a platform, often concrete, about one meter high, at what would be eye level for a child. In Japanese, such small shrines are called *hokora* and can be found throughout the country but are most common in Kyoto. A guide to "mysterious places" in Kyoto provides an explanation for the power of these simple images: "Although many do not even have eyes, nose, or a mouth, all that is necessary is the [sincere] heart of the person offering the prayers."[3] A very basic introduction to Buddhist statues that is sold at hundred-yen shops—the Japanese equivalent of dollar stores—declares that Jizō is a "very busy bodhisattva."[4] Another book for the general reader states that "no other Buddha is so close to the people, having fun with them, sharing their sorrows."[5] The birth stories of these Jizōs are unknown. These are not celebrity images, commanding attention. They reside quietly by the roadside, making sure that all is well.

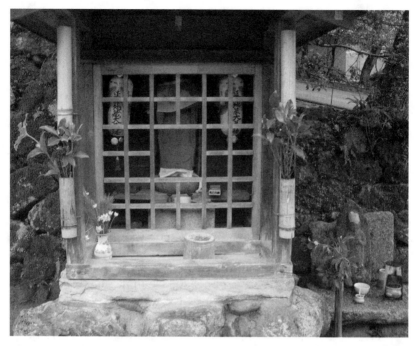

Figure 3 A Roadside Jizō in a Small Shrine (*Hokora*)

Most Japanese temples also enshrine Jizō, often as an auxiliary deity somewhere on the temple grounds. Temples that enshrine him as the central image usually are not major tourist sites, unlike many of those that house major Kannon statues. Jizō temples are often crowded, but with worshippers from the neighborhood rather than tourists. The strength of belief in and practices surrounding Jizō appears puzzling at first. Whereas Kannon, as an important figure in the *Lotus Sutra*, was central to the Tendai school of Buddhism, belief in Jizō was not fundamentally connected to any particular Buddhist school. But Jizō has undeniable appeal. Perhaps more than any other deity, he is treated as living, although many statues of him take only a vaguely human form. He is also one of the Buddhist deities least likely to become a secret buddha.[6]

Even when carved with full iconographic features, Jizō in Japan does not resemble any other buddha or bodhisattva. As noted in chapter one, most bodhisattvas wear elaborate clothing, crowns, and jewelry, and most buddhas are garbed in simple robes, sit in meditation, and display

the most obvious of a buddha's marks: an *uṣṇīṣa*, or large bump on the top of the head, which is said to be filled with wisdom. Jizō, on the other hand, looks like a simple, shaven-headed monk, occasionally making it impossible to determine whether a particular statue is actually of a monk or of Jizō.[7] That he appears as a human rather than a deity facilitates identification with him; he is a friend that a believer could spend time with. Since the eleventh century, he has usually been depicted in a standing posture, with the staff (*shakujō*) of a wandering monk in his right hand, indicating that he is ready to go wherever he is needed. It is also commonly said that he thrusts the tip of the staff into the depths of hell for sinners to grab and be pulled to safety. His left hand usually holds a wish-granting jewel.

Jizō in Modern Japan

Closely associated with both life and death, Jizō is thought to be the deity willing to endure the pains of hell to help those suffering there. He is also said to assist living beings who have fallen into one of the other unfavorable rebirths and to be the special guardian of deceased children. To appreciate the context of religious belief and practice in which Jizō operates, some detailed background information is necessary.

Jizō and the Afterlife

According to the orthodox Buddhist cosmology that found its way into Japan from India via China and Korea, the deceased go to one of six possible realms of rebirth, usually termed "paths." The six paths (*rokudō*) or states of existence are: (1) human beings (*ningen*); (2) gods (*ten*; Sk. *deva*, a cognate of the English "deity"); (3) demigods (*ashura*); (4) animals (*chikushō*); (5) hungry ghosts (*gaki*); and (6) hell (*jigoku*). All of these paths are part of the cycle of birth and death (*shōji* or *rinne*; Sk. *saṃsāra*), which is regulated by the principle of "deeds" (*gō*) or "causality" (*innen*), better known in English by the Sanskrit word karma. The basic idea is that good deeds will result in a good birth in one's next life or lives; bad deeds, in unpleasant or painful rebirths. It is important to note that in traditional Buddhist cosmology, birth in a heaven is not the equivalent of salvation; heaven is desirable, and those reborn there are gods, but eventually, as a result of past karma, even the gods will be reborn again elsewhere. The same is true of hell: no matter how evil the deeds that lead one to hell, the sinner will eventually burn off that bad karma and

achieve a better rebirth. In the traditional Buddhist scheme, rebirth as a human, preferably a man, is the most desirable path, because humans suffer just enough to inspire a desire for nirvana, escape from the round of rebirth altogether. The three lower paths—hell, hungry ghosts, and animals—are referred to as the three evil paths (*san akudō*), because the suffering they entail is acute.

The six paths were a recurring theme in medieval Japanese literature and remain more or less familiar to people today, although other concepts of the afterlife are equally or more compelling. The Pure Land, for example, does not figure in the traditional Buddhist cosmology of six paths. Nor does the generic East Asian (originally Chinese) understanding of ancestral spirits sit very well with orthodox Buddhist cosmology as it was formulated in India. The ancestral spirits, as most Japanese today conceive of them, retain basically the same identities as when they were alive. As spirits, they can come and go, but they are often understood to occupy the mortuary tablets (*ihai*) enshrined in a family's household buddha altar (*butsudan*). Ancestral spirits need to be nourished with regular offerings of food and drink, and they need to be remembered, consulted, and obeyed. Neglected spirits and those with no living descendants to care for them can become angry and vengeful and can cause various calamities.

Most Buddhist rites for the dead in Japan involve producing merit (*kudoku*), a kind of good karma in cash form, by having monks chant sutras and *dhāraṇīs*; the merit is then dedicated (*ekō*) to the deceased. According to orthodox Buddhist doctrine, this is supposed to help the newly deceased attain a better rebirth than their own karma might otherwise dictate. Few if any Japanese today, however, think of their deceased parents or grandparents as being reborn with the body of an animal, god, or human being in some other, unrelated family. They conceive of the offering of merit, rather, as a kind of spiritual "nourishment" (*kuyō*) that augments the offerings of food and drink. Their loved ones remain who they always were—father, mother, and so on—albeit in a more or less eternal realm of ancestral spirits.

There is, nevertheless, a kind of abstract belief in the round of rebirth or six paths, where one's ancestors, their individual identities intact, may either thrive or suffer. In particular, the generic East Asian idea of disconnected, suffering spirits who have no living descendants to care for them became associated, in Japan as well as China and Korea, with the Buddhist realms of hell and hungry ghosts. Of the two, hell is naturally worse, and it is there that the bodhisattva Jizō is believed to do some of his best work.

In East Asia, a figure called King Enma (J. Enma Ō; Ch. Yanmo Wang), a name with which most Japanese are familiar, is believed to be the judge of the afterlife. He examines the deeds (karma) of the deceased and decides what their reward or punishment should be, just like an imperially appointed magistrate in a medieval Chinese court. King Enma is a modified form of the Indian deity Yama, but the element of bureaucratic judgment he introduces into the theoretically impersonal workings of the law of karma may be seen as a peculiarly Chinese interpretation of the Indian Buddhist tradition, revealing a heavy Daoist influence. Enma also belongs to a panel of judges known as the ten kings of hell. Each of these kings presides over his own court, through which the newly deceased must pass, receiving judgment from each in turn.

King Enma, judge of the fifth court, is singled out in Japan for special attention and is closely associated with Jizō. King Enma never assigns a punishment worse than the sinner deserves, but sometimes this fearsome deity can be lenient when encouraged by Jizō. A hundred-yen shop guide to Buddhist statues states that after a person dies, Jizō will serve as a lawyer and negotiate with King Enma.[8] There is also a less prevalent concept that King Enma and Jizō are actually one and the same, which is found in several sutras and sometimes appears in modern guidebooks.[9]

When Japanese people think about what happens after death—a realm of the imagination that is dominated by a complex and not necessarily logical or consistent set of beliefs in karmic retribution and rebirth, ancestral spirits, and a hellish bureaucracy—they know that Jizō is the deity who will look after those who have died. Jizō is often juxtaposed with Amida, the buddha who brings the devotee to the Pure Land. Jizō rescues believers from unfavorable rebirths, especially those of hell and the realm of hungry ghosts.

Jizō and Deceased Children

Jizō, as noted above, is also closely associated with children, although this connection does not appear to have been made in India, China, or early Japan. Many of the statues of Jizō that dot the roadsides of Japan resemble a young child, and the fact that a monk with a shaven head is somewhat similar in appearance to an infant would not have been lost on the devotee. As Jizō's connection to children grew stronger, a sad legend, still known by the Japanese today, developed concerning the fate of stillborn fetuses and deceased infants. They are believed to go to a place called the Sai riverbank (Sai no kawara), a state of limbo. The river itself separates "this world" (*kono yo*) from "that world" (*ano yo*). On this

rocky riverbank, deceased children gather stones and pile them into small stupas, but demons from hell constantly appear and knock the stupas down with their spiked iron bars. This story is found in the *Jizō Song (Jizō wasan)*,[10] of unknown origin but probably dating in its earliest forms to the medieval period, which begins as follows:

> This is a tale that is not of this world,
> but of the Sai riverbank
> at the foot of the mountain on the road beyond death.
> Just to hear it is to be moved to pity.
>
> Two, three, four, five—
> no, more than ten infants
> gather at the Sai riverbank.
> "I miss father, I miss mother . . ."
>
> Those crying voices, "I miss, I miss,"
> are unlike any voices heard in this world:
> their sadness pierces to the bone.
> What are the infants doing?
>
> Gathering stones from the river
> and piling up a merit-dedication stupa.
> "The first layer piled is for our fathers,
> the second layer piled is for our mothers,
>
> The third layer piled is for hometown siblings
> and for ourselves—to these we dedicate this merit."
> Even if at noon one infant is able to relax,
> about the time when the sun is setting,
>
> A devil from hell appears.
> "Hey, you all, what are you doing?
> Your parents who remain in the world
> do nothing to send you benefits or make merit.
>
> All they do is grieve from morning to night,
> which is cruel, sad, and useless.
> Your parents' grieving is the cause
> of your agony piling up all the more."[11]

No matter how much the children try to accumulate merit by piling up stones, a devil appears and smashes down the laboriously piled stones. Thus, the pile of stones never amounts to an offering stupa, and the

children are helpless to save themselves by their own good deeds. Finally, in the very place where this vain activity is repeated, the bodhisattva Jizō appears, chases off the devil, and saves the children.

The Jizō volume of the *Educational Cartoons* series tells many stories of Jizō, accompanied by often horrific illustrations of people undergoing various tortures in hell. In one section, the cartoon book features a monk telling the story of the Sai riverbank to children gathered around him, most of whom appear fascinated and delighted with the scary story. His story is then illustrated with small naked children on a riverbank piling up stones and praying to the stupas they have made. These children sing the *Jizō Song*, translated above, which was known to almost all Japanese about fifty years ago. Modern children usually know only the lines the children utter as they pile the rocks: "The first layer piled is for our fathers, the second layer piled is for our mothers . . ."

When night falls, the cartoon story within a story continues, the children begin fruitlessly searching for their parents. A fierce red-horned demon appears, growling, "What are you doing here? Just because you're small doesn't mean you will be forgiven." He tells them that they have been unfilial in dying before their parents and says, "This is what I do to those who aren't filial!" Taking his spiked iron bar, he knocks down their stupas. The demon adds that to make matters worse, their parents do not believe in the Buddha and do not make offerings. They just feel sorry for themselves and their dead children. "This is what your parents get in return for their mourning," he cries, and chases the children with the iron bar.

The scene in the comic book briefly shifts back to the monk telling the story, who remarks, "I guess you know by now the place I'm talking about. It's the Sai riverbank."

Back at the riverbank, the children run from the demon but have nowhere to hide. Then, suddenly, in the distant sky appears a light, from which Jizō emerges, telling the children to come to him and think of him as their father and mother. The exhausted children can no longer walk and are forced to crawl over the rocks, but finally they reach Jizō and pull themselves up by his staff. The angry demon commands Jizō to stop causing trouble and hand over the children, arguing that it is his job to punish unfilial children, and that anyway, he is stronger than Jizō. The demon and Jizō have a standoff, the demon insisting that Jizō give him the children, Jizō refusing to do so. The smiling children peer out from behind the safety of Jizō's robes, and all is well.[12]

This is the legend of the Sai riverbank as it is most commonly known today. The legend seems to have taken shape in Japan around the

fifteenth century. The idea that children who die have behaved in an unfilial manner toward their parents is not common in modern Japan, but it does sometimes appear in contemporary renderings of the story such as this one.

The origin and meaning of the word Sai are unknown. Some scholars speculate that it derives from West Hall riverbank (Saiin no kawara), an area outside Kyoto where in the medieval era the bodies of the indigent were abandoned. To this day, several places in Japan are named Sai riverbank, the most famous of which is in Hakone, near Tokyo. Such locations do indeed usually feature a rocky riverbank. Perhaps the most prominent theory, however, is that originally Sai was Sae, another name for native guardian deities of the land that were known as Dōsojin. Statues of Dōsojin, usually carved very simply into stone, were erected both as road markers and as protectors of the traveler. When passing by, people would place a stone in front of the statue as an offering. Jizō may have become the Buddhist form of this native deity, and the rock offerings may have contributed to the development of the Sai riverbank legend.[13] The following verse from the *Lotus Sutra*, which speaks of children building stupas of sand, may have also influenced the story:

> . . . even if little boys at play
> should collect sand to make a stupa,
> then persons such as these
> have all attained the Buddha way.[14]

In modern Japan it is not uncommon to see in rocky portions of the grounds of a temple seemingly random piles of stones. Worshippers pile these stones with the understanding that they are assisting the spirits of the deceased, especially children.

The story of the Sai riverbank became part of several beloved folk songs. Today, there are numerous extant versions of the *Jizō Song*, some quite short and others lengthy. Scholars believe the shorter versions took shape earlier, with details being added over time. Most versions are attributed, probably inaccurately, to the monk Kūya, discussed in the previous chapter.

But Jizō is not associated exclusively with dead children; he is also the guardian of living ones. A cheerful children's song speaks of

> The Jizō at the village edge
> Always smiling, always watching.[15]

Here, it is clear that the roadside statue itself is alive, benevolently watching over the daily activities of the children. He does not suddenly appear when needed; rather, he is always present. Thus, children do not necessarily associate Jizō with frightening stories of death. He is simply a familiar face there to make sure they are safe.

A modern-day phenomenon that has captured the attention of Western scholars is the *mizuko* Jizō, a statue that resides at a temple and receives prayers from parents, usually mothers, for miscarried or aborted fetuses, both of which are referred to as *mizuko* (literally "water child"). Stillborn children and deceased infants are also included in this category. In many cases, the parent of a *mizuko* purchases a small statue of Jizō and leaves it at the temple, returning regularly to make offerings to it of items that a child might enjoy, such as toys and candy. When I first visited Japan years ago, unaware of this custom, I was amused by the sight of a small, cute stone statue surrounded by stuffed animals. My Japanese friends, however, remained serious, and gave only the vaguest of answers when I asked about the purpose of these images. Later I learned the significance of the statues and understood their reticence to discuss them.

The prayers to the image are of an unusual sort. The parent prays to this Jizō to take care of the child. At the same time, the parent speaks to the image and treats it as though it were the child itself. The Jizō statue is a stand-in for the miscarried or aborted fetus or the deceased infant. An offering to the statue is an offering to this child. Jizō as a stand-in for a deceased child is a relatively recent phenomenon, and the modern-day *mizuko* Jizō practice in which a small statue is left at the temple dates back only to the 1970s, but the concept of Jizō as a stand-in for a suffering person has a long history.[16]

That Jizō is often perceived to be a child is obvious to anyone who frequents the souvenir shops of temples. These shops almost always sell an assortment of small Jizō statues to decorate the home, attach with a strap to a cell phone, or hang from a purse. Such figures also can often be found at stores unaffiliated with a temple. These Jizōs are, almost without exception, unbearably cute, resembling nothing more than a small child or infant. Though the figures are not considered to be living themselves, they are treated as good luck charms, bestowed as an assurance of Jizō's protection.

Jizō and the Bon Festival

In August, many Japanese city dwellers return to their ancestral home-towns, if relatives still reside there, to visit the family graves and welcome

the spirits of deceased ancestors during the Bon Festival (*O-bon*). Some areas of Japan celebrate the Bon Festival on July 15 (by the Western, i.e. Gregorian, calendar, which is now standard in Japan), for the traditional date of the festival under the old lunar calendar was the fifteenth day of the seventh month. For agricultural communities attuned to the seasons, however, that places the Bon Festival considerably earlier in the summer than it used to be, so many have picked the middle of August as a closer approximation of the original date.

The Bon Festival finds some scriptural justification in the *Ullambana sūtra* (Ch. *Yulanpen jing*; J. *Urabon kyō*), a short Buddhist sutra that, in the view of modern scholars, is probably an apocryphal work that originated in sixth-century China. Scholars debate the meaning of the Sanskrit word *Ullambana*, and its etymology remains obscure. One theory is that it means "hanging upside down," a reference to the pitiful state of spirits who are "left hanging" when they have no living descendants to make the usual offerings of food and drink to them. Another theory is that *Ullambana* refers to "bowls" (Ch. *pen*; J. *bon*) that are used in making offerings to spirits, but that may be just a folk etymology: the Chinese character *pen* was probably used simply for its sound value in transliterating the fourth syllable of the Sanskrit *Ullambana*.

In any case, the protagonist of the *Ullambana sūtra* is a monk named Mokuren (Sk. Maudgalyāyana; Ch. Mulien), one of the Buddha Śākyamuni's ten great disciples who was known for his magical power. Being a filial son, he made the usual ancestral offerings of food to his deceased parents and assumed that all was well with them. One day, however, he decided to use his magical powers to check up on them in the afterlife. Mokuren saw that his father had achieved a favorable rebirth as a brahmin but was shocked and distressed to discover that his mother had become an emaciated hungry ghost. She could not eat the ancestral offerings that he gave to her because her bad karma made the food burst into flames every time she brought it to her mouth. In despair, Mokuren asked Śākyamuni for help but was told that his mother had accumulated so much bad karma that she could not be saved by the actions of just one person. Śākyamuni recommended that on the fifteenth day of the seventh month, when the three-month-long monastic retreat is over and the monks are replete with good karma, Mokuren should make offerings of food to the monks. The merit from that good deed, which in fact tapped into the vast merit created by the Buddhist sangha (monastic order) itself, could then successfully be dedicated to his mother. The spiritual power of the sangha, in short, could ensure that the traditional offerings of nourishment got through without bursting

into flames. Moreover, the sutra argues, offerings to the sangha at the end of the summer retreat is the best way to save one's parents and ancestors for seven generations from the three worst rebirths. After Mokuren followed these instructions, his mother was reborn out of the path of hungry ghosts.

Mokuren expressed the desire to share this with future disciples of the Buddha, to which Śākyamuni declared:

> on the fifteenth day of the seventh month, the day on which Buddhas rejoice, the day on which monks release themselves, they must all place food and drink of one of the hundred flavors inside the *yü-lan* bowl and donate it to monks of the ten directions who are releasing themselves. When the prayers are finished, one's present parents will attain long life, passing one hundred years without sickness and without any of the torments of suffering, while seven generations of ancestors will leave the sufferings of hungry ghosthood, attaining rebirth among gods and humans and blessings without limit.[17]

This basic story of Mokuren was further elaborated upon in folklore and drama in China, where it informed the Festival for Feeding Hungry Ghosts (Ch. Shiegui hui; J. Segaki-e), also known as "saving the burning mouths." The Buddhist order thus inserted itself into traditional Chinese ancestor worship. It also became a kind of public charity that promised to care for and placate disconnected, potentially dangerous spirits who had no other family.

The Mokuren story, ghost-feeding rituals, and associated beliefs and practices all found their way to Japan by the eighth century. Today, the Bon Festival is popularly known as O-bon ("o-" is an honorific prefix that the Japanese attach to many nouns). During the festival, offerings of food are made to "all the spirits of the triple world" (*sangai banrei*) at Buddhist temples, but most of the lay participants understand this as a way of caring for the spirits of their own ancestors. Few comprehend the spiritual dynamics, but what happens is that the merit produced by feeding hungry ghosts and making offerings to the Buddhist order is dedicated by the officiating monks to the ancestors of the lay sponsors.

Observance of the Bon Festival in Japan can be traced to early medieval times. It is mentioned, for example, in the tenth-century *Gossamer Diary* (*Kagerō nikki*).[18] However, at that time the festival was not associated with Jizō. In Japan today, Jizō is intimately connected with the Bon Festival. The festival used to occupy the better part of a

month but now takes place over about a week in mid-July or mid-August. The Japanese understanding is that at this time, the spirits of the ancestors come down from the mountains to spend a few days with their descendants. People clean the graves of family members and make offerings of fruit, fresh flowers, and incense. Because the spirits need guidance through the dark, lanterns or candles are often lit on the graves. The eastern sector of Kyoto, where graveyards were traditionally located and still are found today, is especially busy during the Bon Festival.

Much activity centers on Rokudō Chinnōji temple (sometimes also called Rokudō Chinkōji temple; hereafter referred to as Chinnōji temple), an otherwise very quiet, small temple where "this world" meets "that world." In other words, this is the site where the world of the living comes in contact with the world of the dead. A stone marker in front of the temple, and another around the corner, identify this as the "crossroads of the six paths of rebirth" (*rokudō no tsuji*). A visit to Chinnōji temple on August 7–9 is referred to as the Six Paths Pilgrimage (Rokudō mairi). At this time, the narrow streets around the temple become crowded with vendors selling all manner of objects for the home Buddhist altar, including candles, incense, bells, and ceramics to contain offerings. Because new utensils for the altar have traditionally been bought each year to welcome the ancestors home, a huge outdoor ceramics fair is now held along Kyoto's Fifth Avenue to coincide with the Six Paths Pilgrimage.

Before entering Chinnōji temple, pilgrims purchase a branch of *kōyamaki*, a type of pine. With this in hand, they proceed through the temple gates to a table lined with busy monks. For a fee of three hundred yen (about three dollars), the monks write the Buddhist name (*kaimyō, hōmyō*) of the deceased on a thin piece of wood called a "water stupa" (*mizu toba*), shaped like the altar tablets (*ihai*) found in temples and on home altars. If worshippers need to pray for the spirits of several deceased family members, they buy one water stupa for each.

Worshippers then walk several meters across the temple grounds to the famous Welcoming Bell (Mukaegane). Completely enclosed in a shed, this bell cannot be seen by worshippers; it is rung by pulling on a rope emerging from a hole in the wall. Most Japanese temple bells are rung by pulling a rope to move a hanging beam away from the bell and then back toward it. How the Chinnōji temple bell works is not clear, for the mechanism is not visible, but the fact that it is rung with a unidirectional pulling motion has led to the notion that by ringing it, the worshipper is "pulling" the ancestors home. In addition, the bell is thought to be audible in all the other paths of rebirth. Indeed, the sound

of the Chinnōji temple bell in the streets of eastern Kyoto in August immediately brings to mind those who have died. During these three usually unbearably hot August days, the line to ring the bell snakes through the temple grounds, but no one skips this essential act.

Next, worshippers proceed to the large incense burner in front of the main hall. There, they gather the thick incense smoke in their open palms and fan it onto their heads, and perhaps onto body parts that are ailing. They then cense the water stupas in the smoke. Finally, they move to a large group of about two hundred stone Jizō statues gathered around one large Jizō. The small statues have been collected over the years from the area and probably marked the graves of the unknown deceased. These Jizōs are far more the object of common worship than the main image of the temple, a Yakushi Buddha. Pilgrims place the water stupas in a trough of water in front of the Jizōs, dip their branches of pine in it, and brush the water over the entire piece of wood. This practice is called Water Merit-Transfer (Mizu ekō); after it is over, the spirit of the ancestor clings to the pine, which the pilgrim takes home. The water stupa remains in the trough, to be burned in a ritual fire at the end of the festival. On the night of August 16, many worshippers place the pine and other offerings that stood on their home altar during the Bon Festival in the Kamogawa river or Horikawa river. In this way, the people of Kyoto summon the spirits of the ancestors with water, in the Water Merit-Transfer ritual, and send them away in water, through a river.

The central Jizō at Chinnōji temple, of relatively recent origin, is carved with a mask on his face. I have been unable to determine the significance of the mask, and when I asked visitors to the temple about it, they all stated that they had never noticed it. Nevertheless, the mask is clearly present, especially when the statue is viewed from the side. But, as I have established, those offering prayers to an image are rarely concerned with details of its physical appearance. In any case, the mask adds both a literal and figurative layer to the role of the Jizō images at this temple. The worshipper in this case does not single out any of the stone statues for attention, except perhaps for the central one, but as a gathering of the guardians of the spirits of countless deceased, they are certain to care for the loved one of the pilgrim as well.

Though not officially a part of the Six Paths Pilgrimage, a small hall at Chinnōji temple houses statues of King Enma and a historical figure named Ono no Takamura side by side. Ono no Takamura, a leading member of the literati and poet who lived in the ninth century, somehow became entangled in later legends involving Jizō, King Enma, and

hell, although no documents of his time suggest why this is so. The story told to modern Japanese worshippers has Ono no Takamura, holding a branch of pine, making nightly journeys to hell through a well on the grounds of Chinnōji temple. During the day, he was an important personage in the imperial court; hence no one suspected his close association with King Enma and hell. This is the extent of Chinnōji temple's Ono no Takamura legend, but, as I explain below, he appears in numerous stories, often as a friend of Jizō. Chinnōji temple still boasts a well that it claims is the exact one used by Ono no Takamura to enter the underworld. The ancestors are thought by some to return through this well, whereas others say they appear from a hole underneath the Welcoming Bell.

People in Kyoto, whether or not they make the Six Paths Pilgrimage, engage in a range of Bon Festival rituals, many of which involve calling the spirits home and escorting them back to the mountains with fire. A special altar, or "shelf," may be erected for the occasion and placed outside the house, under the eaves. On the altar, memorial tablets are placed, surrounded by offerings of seasonal vegetables and fruit, candles, flowers, and incense. On the first day of the Bon Festival, family members light small piles of flax stalks or other twigs in front of the altar on the street to welcome the ancestors to this world. On the last day of the festival, they do it once again, this time to light the way for the ancestors to return to the other world.

Even for those who do not engage in such rites at their own homes, the culmination of the Bon Festival in Kyoto takes place on August 16, when bonfires are lit on five of the surrounding mountains, once again to help the ancestors find their way back. The ritual is called Five Mountains Sending-Off Fires (Gozan okuribi). The fires are burnt in the shape of Chinese characters and other designs, the most popular one forming the character for "large" (J. *dai*). This festival is so close to the hearts of the citizens of Kyoto that supposedly in 1944, during World War II, when any light at night was dangerous, schoolboys dressed in white and stood on the mountains in the shape of the characters during the daytime.[19]

After the Bon festivities, so-called Jizō Bon Festivals are held for children. Though Jizō Bon is most common in Kyoto and the surrounding areas of western Japan, villages in other parts of Japan have adopted the practice as well. The festival is usually set for August 23 and 24, as Jizō's holy day is August 24, but in modern Japan the festival is sometimes held on the nearest weekend. The city of Nara adheres to the lunar calendar, celebrating both the Bon and Jizō Bon festivals in July.

The Jizō Bon Festival centers on the Jizō statues in neighborhood shrines, or *hokora*. During most of the year, the Jizō, often nothing more than a stone with a red bib tied around it, sits quietly in the small shrine, receiving offerings of fruit, flowers, and water, sometimes daily, from elderly women in the neighborhood. These women understand the Jizō to be a kind of guardian deity who will take care of the residents, especially children. It would not be effective to pray to the Jizō in the next neighborhood over: the Jizō who lives in one's own neighborhood is the one to go to for protection. (As an aside, I have noticed that although incidents of petty crime, including vandalism, are rising in Kyoto, these small shrines are almost never touched, even when they are located in an area packed with drinking establishments.)

During the Jizō Bon Festival, neighborhood children gather in a tent erected before the shrine, or the Jizō is taken out and moved for the day to the tent, where he is cleaned and repainted if necessary. The atmosphere is that of a party. Children eat candy and other treats and enjoy summer games such as catching goldfish in a basin using only a small scoop made of thin paper (*kingyo sukui*). In the evening, paper lanterns painted with the two Chinese characters for "Jizō" are suspended from ropes strung around the tent. Sometimes a local monk stops by to give a short sermon and chant sutras. Another common activity is the circulation of one large string of prayer beads (*juzu kuri*, or *juzu mawashi*), grasped by children seated in a circle. This is similar to the practice mentioned in chapter three, only on a much smaller scale. As the children pass the beads around, a monk or one of the parents recites a sutra. Although this practice stems from the Pure Land school of Buddhism, the Japanese have come to believe that the beads themselves possess power to protect people. Several years ago there was a "boom" (*būmu*) in Japan in which people wore small strings of prayer beads around their wrists for this reason. Some athletes, especially baseball players, still do. For the children and their families, the circulation of the prayer beads bestows protection.

The Jizō Bon Festival is not associated with any particular school of Buddhism; neighborhood families may be parishioners of any temple. In modern times the festival has become less common, but it is still often held in Kyoto neighborhoods and has made something of a comeback in recent years. Scholars believe that the festival took shape in its current form during the early Edo period, when Jizō's association with children grew particularly strong.

The Jizō volume of the *Educational Cartoons* series explains the Jizō Bon Festival to the reader, speaking of the "honorable Jizōs in the

neighborhood" (*machi no naka no Jizōsama*), reassuring the children that "Jizō is always with us," that "he takes on our suffering for us," and suggesting, "Let's thank him for taking care of us and our families."[20] True to form, however, the cartoon also relates a scary story concerning the origin of the Jizō Bon Festival. When a monk named Jōshō of the temple Miidera died at the age of thirty, he found himself in hell and was horrified by the suffering he witnessed. As a demon held him up in front of the mirror that would reflect all the evil actions of his life, Jizō stepped in and said, "That's Jōshō! When you were twenty, you made a statue of a monk and called it 'Jizō.' I am that Jizō. From that time, both day and night, I have always protected you and never left you, but you ended up here anyway. That is because you always thought you were in the right, spoke ill of others, and failed to forgive them. Now I will bargain with King Enma over your fate."

Suddenly, Jōshō awoke in his sick bed to find himself surrounded by his fellow monks, and he informed them that Jizō had helped him come back to life. An older monk exclaimed, "You must have done something good when you were young. This is the twenty-fourth of the eighth month. We will make this Jizō's holy day." Kneeling in front of a candle-lit altar, the older monk said, "Thank you, Jizō." The final page of the story declares that this is believed to be the origin of the Jizō Bon Festival and depicts a large statue of Jizō outside, surrounded by candles and happy devotees.[21] This same story, related in cartoon form to children today, is found in the twelfth-century *Tales of Times Now Past*.[22] The message it transmits to all who have heard it throughout the centuries is that if they develop a karmic relationship with a particular statue of Jizō, that is the Jizō who will assist them should they ever be in desperate straits. The statue need not be big, famous, or beautiful. One can even make it on one's own. But one must then worship that particular statue to receive the benefits it can bestow.

A festival for adults that coincides with the children's Jizō Bon Festival and is in some ways an adult version of it is the Six Jizōs Pilgrimage (Roku Jizō mairi) that takes place on August 22 and 23. The concept of Six Jizōs, one for each of the six paths of rebirth, may have begun among early eleventh-century aristocrats, alongside the already prevalent idea of Six Kannons. Unlike the Six Kannons, however, which are described in a single text, the Six Jizōs idea was formed by combining concepts from a number of sutras and stories.[23] A Japanese apocryphal sutra, for example, explains that Jizō will manifest himself in six different ways to save sentient beings.[24] Participants in the Six Jizōs Pilgrimage journey to six temples on the outskirts of Kyoto that enshrine Jizō as their central

image. Unlike the humble Jizōs housed in roadside shrines, these have birth stories and have assumed the role of minor celebrities. The six temples are located at what were formerly the entrances to the city of Kyoto. The first temple on the pilgrimage, Daizenji, is near a train station named Six Jizōs in southern Kyoto.[25]

A leaflet published by the Six Jizōs Association (Roku Jizō Kai) summarizes the *History of the Six Jizōs* (*Roku Jizō engi*), a document dating to 1665 that survives only in the archives of Daizenji temple. No typeset version of this text exists. The story centers, once again, on Ono no Takamura, who this time is more closely connected to Jizō. The *History of the Six Jizōs* states that in 849, at the age of forty-eight, Takamura became deathly ill, dreamed he was in hell, and saw a monk extending his hand to people in agony in the flames. The monk told Takamura that he came to hell every day to help those suffering in this degenerate time when Śākyamuni is no longer in the world. He intended to save everyone with his miraculous power, the monk continued, but it was hard to rescue those with whom he had no karmic connection. Therefore, he instructed Takamura to return to the world to warn people that their evil deeds might land them in hell unless they took refuge in Jizō. Takamura, deeply moved, did as he was told and carved six Jizōs from a single large cherry tree, enshrining them in 852 in the area where Daizenji temple now stands. In the early twelfth century, Emperor Go Shirakawa became a devotee of these images, and he prayed to them for wealth, escape from illness, the safety of his country, the safety of travelers to Kyoto, and the happiness of all ordinary people in this life and the life hereafter. In 1157, he ordered that the statues be placed at the six entrances to the city and that temples be constructed to enshrine them. According to this history, then, the six statues are like siblings, each with the same parents and a similar birth story.[26]

The leaflet on the Six Jizōs Pilgrimage also lists the ten benefits received by devotees who complete the pilgrimage, citing the apocryphal Japanese *Longevity Jizō Sutra* (*Enmei Jizō kyō*). The benefits include safe childbirth for women, avoidance of illness, long life, wisdom, wealth, and the love of others, topped off by great awakening.[27] The pilgrimage can also be performed, the leaflet adds, to acquire merit for transfer to those who died in the past year. If the pilgrimage is completed in three successive years the loved one will escape rebirth in the six paths and attain awakening.[28]

At each temple, in addition to stamps in their red seal notebooks or on special scrolls, the pilgrims receive "banners" (*o-hata*) of six colors. These small strips of cloth, each bearing the name of one of the temples, are to

be placed outside the doors of the pilgrims' homes, for protection. Like most talismans in Japan, they are considered effective for only one year, after which they must be returned to a temple. I happened to visit Jōzenji, one of the temples on the Six Jizōs Pilgrimage, on a fall day about two months after the pilgrimage. I found that although all the temple buildings were closed, and I could see Ono no Takamura's Jizō statue only through a small opening in the door of the main hall, a long five-colored rope tied to the statue's hand was threaded through a hole above the main hall door and out into the courtyard of the temple, where it was fastened to a pole. By touching this rope or the pole, the visitor could form a karmic connection to the Jizō even without being able to see him clearly. Tied to the rope were banners, more than a year old, brought back to the temple by pilgrims. They had been returned to Jizō himself.

Other Facets of Jizō

Because Jizō stands at street corners observing all the goings-on, it is only natural that he should take an interest in everything he sees. People make supplications to Jizō regarding all sorts of concerns, large and small. Some Jizōs become known as specialists in dealing with particular problems, thus acquiring appropriate nicknames. This occurs with beloved statues of many deities, but none so frequently as those of Jizō. In Kyoto alone one can find a People-Eating Jizō, Tooth-Shaped Jizō, Pain-Receiving Jizō, Nail-Removing Jizō, Wig-Holding Jizō, Ailing-Eye Jizō, and Happiness Jizō. In various other parts of Japan, one encounters a Bound Jizō (tied up in ropes), Thorn-Removing Jizō, Sweating Jizō, Buckwheat Noodle–Eating Jizō, Bed-Wetters' Jizō, Child-Granting Jizō, and more. Despite the disturbing names of some of these Jizōs, all are fondly worshipped, usually by local residents rather than tourists, in hopes of benefits. In the following pages I summarize worship of the Pain-Receiving Jizō, Nail-Removing Jizō, Wig-Holding Jizō, Ailing-Eye Jizō, and Happiness Jizō, all of whom live in Kyoto.

The Pain-Receiving Jizō (Daijuku Jizō) lives in a small temple on Teramachi Avenue, a long, busy Kyoto shopping street that is covered by an awning and restricted to pedestrians. Although his temple is modest, his reputation is big, and he also goes by a number of other epithets: the Hell Jizō (Jigoku Jizō), the Living-Body Jizō (Ikimi Jizō), and the Yatadera Temple Jizō (Yatadera Jizō). Visible from the street through the open front gate of the main temple building, he is an angry-looking 158-centimeter-tall wooden Jizō. In front of him, rather than behind,

stands a halo of fire, giving the impression that he is in hell, wading through the flames. This underscores a unique characteristic of Jizō: Kannon may have eleven heads, one thousand hands, and thirty-three different forms, but she does not usually hang out in hell. Jizō does.

The birth story of the Pain-Receiving Jizō, as told in modern guide-books, centers on Ono no Takamura. At the request of King Enma, Takamura brought his friend, the monk Manbei, abbot of Yatadera temple, to administer some ethical vows called the bodhisattva precepts to him. While in hell, Takamura saw Jizō walking among the flames. Deeply moved, when he returned to life, he carved a replica of the Jizō he had seen.[29] This Jizō, enshrined in Yatadera temple, then became famous for taking the place of suffering beings, especially those in hell. In some ways, this story parallels that of the Seiryōji temple Śākyamuni, which was said to have been carved as an exact likeness of the Buddha and then to have begun acting on its own volition.

A scene from a famous miracle story involving the Pain-Receiving Jizō is depicted on votive tablets sold by Yatadera temple. According to this narrative, a man named Yasunari unintentionally killed his mother and in repentance visited the Yatadera Jizō every month. Upon his death, Yasunari fell into hell, but the Yatadera Jizō, remembering Yasunari's devotion, waded through the flames to save him. The scene on the votive tablet, taken from one of the most famous sections of a thirteenth-century illustrated history of Yatadera temple, shows Jizō pulling Yasunari out of a boiling cauldron full of sinners, as demons impale others and throw them into the pot.

Manbei is a historical figure who lived in the ninth century, but both the iconography of the statue and the wood from which it is carved suggest that it dates to the twelfth century.[30] Moreover, the Yatadera temple in Kyoto is not really the temple to which the story refers, although most visitors are unaware of that fact. That honor goes to Yata Kongōzenji temple in rural Nara prefecture. Kyoto's Yatadera is a branch temple of the Yata Kongōzenji temple, and its statue was a relatively recent gift from the head temple.

Multiple images of a specific temple's deity can pose a conceptual problem if we think of them as living. The existence of numerous Jizōs is easy to understand, but the existence of two Yatadera Jizōs is puzzling. I have posited earlier that a kind of transmigration occurs from one image to its replacement. If there is more than one replacement, then the deity must have been reborn as multiple deities. In many Buddhist circles, it is indeed considered possible for one person to be reincarnated as two or more people in his or her next life. To the devout worshipper,

certainly, both the Yatadera Jizō in Kyoto and that in Nara can be the very same Jizō, in physical form, although neither is the original statue.[31] In fact, the felicitous location of Kyoto's Yatadera temple on a busy downtown shopping street has made it much more visited than the out-of-the-way head temple in the countryside. For its part, the Yata Kongōzenji temple in Nara does not usually advertise its Jizō image as its main attraction, ceding that claim to its Kyoto counterpart. Among the biggest draws of the Nara temple are the beautiful hydrangeas that bloom there in the spring.

Yatadera temple also sells a small stuffed Jizō made of gray felt, with magic marker eyes. As with the regular votive tablets, worshippers record their prayers on the small dolls. Although some of the supplications on the votive tablets and the dolls resemble those at other temples, such as requests to find an appropriate marriage partner or gain admission to a top university, the majority deal with serious illnesses. Many people visit the temple specifically to pray for themselves or a family member with a

Figure 4 Votive Tablet and Doll from Yatadera Temple, Kyoto

grave disease. Yatadera temple also features the Sending-Back Bell (Okurigane), the counterpart to Chinnōji temple's Welcoming Bell, which is rung by visitors at the end of the *O-bon* season to guide dead ancestors back to the other world.

In an area of Kyoto known for traditional occupations such as weaving, where tourists do not often venture, stands a temple housing the Nail-Removing Jizō (Kuginuki Jizō). Although the temple is properly named Shakuzōji, it is usually called the Nail-Removing Jizō, in honor of its central image. According to the temple brochure, the statue was carved in the ninth century by the monk Kūkai, renowned founder of the Shingon school of Buddhism.[32] The monks Kūkai, Gyōgi, and Genshin alone are attributed with carving perhaps as many as a fourth of the statues in the city of Kyoto.

A body-substitution miracle by the central image is connected with the temple's nickname. According to legend, in the sixteenth century a prominent merchant suddenly experienced intense pain in both hands, and no treatment proved effective. When he heard of the miraculous powers of this Jizō, he visited the temple and prayed to him. That night, the businessman had a dream in which Jizō told him that in a past life, he had wished ill of someone, made a doll of that person, and stuck nails in its hands. Because of the bad karma produced by that deed, he was now suffering pain in his own hands. However, the story continued, by his divine power, Jizō had removed those nails. The next day, the merchant went to the temple and saw that the floor in front of the statue was stained a bright red. Then he saw two blood-covered nails.[33]

This legend notwithstanding, modern scholars believe that the Nail-Removing Jizō was originally a Pain (*ku*)-Removing (*nuki*) Jizō whose name was mispronounced and transformed into Nail (*kugi*)-Removing (*nuki*) by the inadvertent addition of the one syllable "*gi*" to the initial syllable "*ku*." There are Pain-Removing Jizōs elsewhere in Japan, but with a slip of the tongue, one of them took on a new specialization as a nail remover.

In any case, the legend has given rise to some unusual imagery. For example, the votive tablets sold by the temple feature a small pair of pliers and two nails glued to the wood. Hundreds of these, bearing the names of devotees, cover the walls of the main hall. In addition, the first thing one encounters upon entering the temple grounds is a large metal object wrapped in cloth. This turns out to be a pair of pliers that vaguely resembles the outline of Jizō and is wrapped in bibs, as a Jizō statue would be. The pair of pliers is, in a sense, a body substitute for Jizō, just as he is a body substitute for so many others.

Worshippers make a small circumambulation outside the main hall, pouring water over small stone statues of Jizō and other deities, and bow in worship in front of a large image of Kannon. Many make this circuit several times. Although the Nail-Removing Jizō cannot be seen, it is understood that he is inside the main hall, which cannot be entered. I asked one of the temple monks whether the Jizō could ever be viewed. He informed me that the deity in the main hall was actually Kannon, and that the Jizō had been moved to the back of another building. If I called ahead and made special arrangements, I could perhaps view the Jizō on another occasion. He told me that none of the worshippers ever questions whether Jizō is in the main hall, and the temple does not publicly advertise that he is not. In any case, the devotees have no doubt whatsoever that the Jizō hears their prayers, regardless of whether they can see him.

The Wig-Holding Jizō (Katsurakake Jizō) lives in the Treasure Hall of Rokuharamitsuji temple in Kyoto. Jizō has always been closely associated with Rokuharamitsuji temple. As mentioned in chapter four, the temple stands in an area that was, from at least the eleventh century, a large charnel field where the bodies of the indigent were frequently abandoned. Rokuharamitsuji temple lies just around the corner from Chinnōji temple and is also flooded with worshippers during the Bon Festival. Since Jizō was associated with death, his residence at this temple was appropriate. The Wig-Holding Jizō, about 160 centimeters tall, clutches a wig of real hair in his left hand, his gentle gaze apparently focused on the bundles of black hair, wrapped in white paper, stacked in front of him. Numerous stories about this Jizō's powers circulate. One version holds that he can prevent husbands from straying, if the wife secretly clips a bit of her husband's hair, mixes it with some of her own, and offers it to the statue.[34] A scholarly text more prudently asserts that people are offering the hair of the deceased to Jizō.[35] Another explanation states simply that women cut their hair and offer it to the Jizō when they make a request of him.[36] Yet another explains that anyone, not just women, can offer hair and be assured answers to their prayers.[37] Whatever the request, the worshipper must visit the Jizō in person.

The Eye-Healing Jizō (Meyami Jizō) is a popular body-substitution Jizō in downtown Kyoto. The devotee can worship the large central image of the temple, over four meters tall, without even entering a building. Down a small sidewalk that branches off from the busy Fourth Avenue is a small wooden building with a glass facade. Jizō's inlaid crystal eyes glow with a tinge of red around the pupils, demonstrating that he has taken on the eye ailments of his worshippers. Hence he is

especially popular with many of the elderly, who flock to the temple daily for a quick visit.

The temple tells how this statue, according to legend, was responsible for stopping heavy rain that was causing the Kamogawa river, which runs through the center of Kyoto, to flood. Its original name was Rain-Stopping Jizō (Ameyami Jizō), which sounds much like Meyami Jizō. The name thus shifted though mispronunciation, as may have been the case with the Nail-Removing Jizō. This temple freely publicizes the story of the mispronunciation, even printing it on a plaque in front of the statue. Worshippers are not bothered that the image once had expertise in something else. He simply underwent a change mid-career.

The Happiness Jizō has an excellent publicist. "This is the number one most popular temple in Kyoto! Our Happiness Jizō (Kōfuku Jizō) has the reputation of granting any wish!" announces Suzumushidera temple in big, bold characters on the front of its brochure. On the fall day I visited the temple, the line of people waiting to enter snaked down the long stone staircase leading to the main hall, all the way out into the street. Unlike at most temples, the worshippers at Suzumushidera temple include many in their teens and twenties. There are several reasons for their enthusiasm. Before viewing the temple garden, visitors file into a large room where they are served a cup of tea and a special sweet. In glass cages on the sides of the room live bell crickets (*suzumushi*) that produce rasping sounds considered by the Japanese to be relaxing and poetic. Legend has it that the crickets used to sound year-round at this temple. This effect is now produced artificially with the help of cages and heat lamps. While eating sweets, drinking tea, and listening to crickets, visitors listen to a sermon given by a charismatic monk, who is rewarded with enthusiastic laughter for all of his jokes.

But no one who visits the temple fails to present her petition to the large stone Happiness Jizō that stands in front of the main gate. The difference between this Jizō and most others is that his feet are visible, and he is wearing straw sandals (also carved in stone). Generally, a deity's feet are covered by long, flowing robes. The sandals on the Happiness Jizō indicate that he is willing to travel. Therefore, the temple says, the worshipper must be sure to include her name and address with her prayer, so that this Jizō can walk to her home and grant her wish. The abbot admonishes that if a devotee should forget to do this or should change homes without informing the Jizō, he may be unable to answer her prayer.

This is obviously a highly successful money-making technique for the temple. Other temples have attempted similar tactics, but without the

Figure 5 Offering Prayers to the Happiness Jizō, Suzumushidera Temple, Kyoto, Fall 2004

dramatic results of Suzumushidera temple. Throngs of people do indeed bow in front of this Jizō, clasping their hands in prayer, muttering their address. If asked, most of these worshippers would probably state, with some embarrassment, that they do not really believe this Jizō will visit them and that they are just doing the ritual for fun, but their bowed heads and serious expressions when offering prayers give quite a different impression.

Naked Jizōs

Statues are usually carved wearing a robe, but naked statues are carved with various markers such as a lotus denoting genitalia. They are then dressed in real fabric clothing. Such statues are not common in Japan, but many do exist, most dating to the early medieval period. Two notable examples that still receive worship in a temple setting are of Jizō.

The first, affectionately known as the Naked Jizō (Hadaka Jizō), lives at Denkōji temple in the city of Nara. On July 23, as part of larger Jizō

Bon Festival celebrations, the clothing of this thirteenth-century Jizō is changed in a highly ritualized ceremony. Denkōji, today a small temple that is usually closed to the public, enshrines as its central image a seated Śākyamuni, and for most of the year its famous Jizō lives in a separate building, always kept tightly shut, to the left of the main hall. For the Clothes-Changing Ceremony (Kigaeshiki), however, this small, 97-centimeter Jizō is bestowed a place of honor in front of the main image. A festive atmosphere permeates the temple grounds, with children who attend the temple's nursery school singing, dancing, and playing games as part of their Jizō Bon Festival. Neighborhood residents, mostly elderly women, gather to enjoy the children and to see Jizō. Lanterns with the words "Hadaka Jizō" (Naked Jizō) hang in front of the main hall. The statue wears fairly typical monk's robes made by female parishioners, but the color varies from year to year. After the old robes have been removed from the statue, they are cut into pieces and put into small brocade bags as talismans to be distributed to those who attend the ceremony the following year.

Before the clothing is changed, a long ritual is held in the small, usually stiflingly hot hall. Several monks chant sutras, and the abbot burns incense. Finally, the heart of the ritual begins. The clothes are removed by monks who wear masks of white paper over their mouths, giving the impression of surgeons performing an operation before an audience of worshippers. When I witnessed this ritual, as layers were removed and Jizō's legs appeared, the throng of worshippers exclaimed over how "cute" his legs were, and how they looked like those of a child. The most delicate part of the Clothes-Changing Ceremony, replacing his last item of clothing, a loincloth, was handled with extreme care. The two monks changing the clothes arranged it so that one held the new loincloth in front of the statue while the old one was removed. This prompted a wave of laughter among the worshippers, who said, "They did it so we couldn't see! Ah, that makes sense," in recognition of the uncomfortably voyeuristic aspect of the ritual. But although worshippers did not see the statue entirely unclothed, photographs that reveal a small spiral marking the genitalia are published widely in books on Buddhist statues.[38]

When the Clothes-Changing Ceremony was over, the statue's red robes had been replaced by purple ones; worshippers gasped and exclaimed that he looked happy and refreshed after his change of clothing. Indeed, he looked far more refreshed than any of us who had been sitting in the heat, which had reached 95° Fahrenheit. After the ceremony at Denkōji temple was finished, worshippers proceeded to Fukuchiin

Hall, which houses a large seated Jizō. They also walked to Jūrin'in Hall, where an unusual stone triad—Jizō in the center, flanked by Śākyamuni on his left and Maitreya on his right—resides in a cave. The triad probably dates from the early thirteenth century and clearly shows that Jizō was regarded as the deity who would save living beings after Śākyamuni's death and before Maitreya's descent, a point that was driven home numerous times by monks at each of the temples.

Shin Yakushiji temple's naked Jizō is now called, by the temple itself, Testicle Jizō (Otama Jizō), owing to the presence of somewhat realistic genitalia. The main hall of Shin Yakushiji enshrines a beautiful statue of Yakushi Buddha, surrounded by the twelve generals with whom he is associated. All of these images are National Treasures, and they are what most worshippers and tourists come to see. But if the knowledgeable visitor makes a special request, she may be escorted to a small building off to the side that houses the Testicle Jizō. Taped to the outside windows of this building are newspaper and magazine articles, most dating back to the 1980s, announcing the discovery of the unusual nature of this statue.

The statue used to have the more distinguished nickname of Kagekiyo Jizō, on the basis of a legend connecting it with the twelfth-century warrior Taira no Kagekiyo (d. 1196), who appears in the thirteenth-century *Tale of Heike* and in many later Noh and kabuki dramas. Several versions of the legend circulated, but the most popular told how Kagekiyo planned to attack the famous Minamoto Yoritomo (1147–1199), a prominent member of the ultimately victorious family, to avenge his own clan. Kagekiyo intended to kill Yoritomo on the day of the eye-opening ceremony for the restored Great Buddha at Nara's Tōdaiji temple, which had been burned in its hall during the war between the two clans. The assassination attempt, however, was unsuccessful, and when Kagekiyo later visited his mother who lived nearby to say goodbye, he left his own bow clutched in the hand of her Jizō statue. The trademark of the Kagekiyo Jizō, therefore, was the bow in its right hand, instead of the walking staff carried by most Jizōs.

Until 1984, the Testicle Jizō was residing at Shin Yakushiji temple as a "guest buddha" (*kyakubutsu*) from the nearby temple Shōgan'in Hall, but in that year, monks at Shin Yakushiji temple sent the statue to Tokyo University of Fine Arts (Tōkyō Gakugei Daigaku) for repairs. At that time, the monks thought it was a rather ordinary, though old, image, but X-rays revealed that it was constructed of an outer layer of wooden clothing and an inner statue that was entirely naked. Inside the hollow statue itself, researchers found an original, smaller head. At some

point, perhaps about thirty years after the statue's completion, a decision was made to cover it in wooden clothes rather than clothe it in real garments, like the Denkōji image.[39] This entailed carving a larger head to match the now larger statue in his wooden clothes.

According to a leaflet distributed by the temple to those who request to see the statue, a document discovered inside the statue reveals that the monk Sonben commissioned the statue around 1238, praying thereby to escape the suffering of birth and death, to attain enlightenment, and to end life without pain. The statue was also a memorial to his master Jisson, who had recently died. Some scholars believe the statue was made in the image of Jisson, which may account for its somewhat unusual, ponderous facial features. It appears that Sonben dressed it in his master's real clothing, waiting on the statue morning and night.[40]

The leaflet ends by admonishing the visitor to view the image "in a proper state of mind."[41] For the understated Japanese, this is a direct request not to laugh at the odd statue. Indeed, it is enshrined in a most unusual manner. Visitors who enter the small room that houses the Jizō see two statues. Leaning on the left wall is the statue in its clothed form, which the visitor now knows is hollow inside. It is treated as an interesting piece of history but not as a living statue. The Testicle Jizō, however, stands completely naked in a lighted alcove to the right. This is the statue that the temple regards as the one to be worshipped. It is the statue that is alive. He is offered incense, and candles are lit before him. For a small fee, the visitor can then purchase a paper amulet bearing the words "Testicle Jizō," which is said to provide protection from all manner of ills.

Thus, this statue has undergone some major identity shifts. It came into being as a replacement for the living presence of Sonben's master Jisson, and Sonben treated it as he would have his master. After it was permanently covered in wooden clothing, it became associated with the warrior Taira no Kagekiyo. And now it may have reason to rue its fate, standing as it does permanently unclothed in an alcove in the back hall of a famous temple.

Textual Bases for Devotion to Jizō

Jizō has humble beginnings suitable to a deity often found by the roadside. Most scholars believe that, like other buddhas and bodhisattvas, his origins are in India, although he did not become a popular Buddhist deity there. They assign Kṣitigarbha as his Sanskrit name. Kṣitigarbha,

meaning "earth womb," may predate Buddhism, they speculate.[42] Only one of the major sutras to focus on Jizō is thought by scholars to be authentic, having originated in India. This is the *Mahāyāna Ten Wheels of Jizō Sutra* (J. *Daijō daijitsu Jizō jūrin kyō*; hereafter referred to as the *Ten Wheels Sutra*), which appeared, at the earliest, in the fourth century. The theme of this sutra is Jizō's necessity in a world where Śākyamuni no longer dwells and his successor, Maitreya, has yet to appear. The text explains that Jizō assists living beings in this buddha-less time of the five evils and five defilements.[43] The sutra also lists the ten benefits that Jizō will bring to those who worship him, which are, for the most part, practical and this-worldly, such as sufficient food, clothing, and medicine.[44]

But the most important reason to worship Jizō, according to the *Ten Wheels Sutra*, is that he will take care of believers after death. Rebirth in any of the six paths is undesirable, but this sutra emphasizes that Jizō specializes in saving sentient beings from hell, the worst rebirth of all.[45] Moreover, Jizō's appearance in the *Ten Wheels Sutra* is that of a monk.[46] From this time onward, almost all texts described Jizō as looking like a monk rather than an ordinary bodhisattva.

Although Jizō was not important in India, he became so popular in China after his introduction in the late fourth century that new sutras praising him were composed. The most influential was the *Sutra of the Past Vows of Jizō Bodhisattva* (Ch. *Dizang pusa penyuan jing*; J. *Jizō bosatsu hongan gyō*), said to have been translated into Chinese in the seventh century but probably composed in China in the tenth. This text served to legitimize Jizō's power in the eyes of the populace. Although obscure to most Westerners interested in Buddhism, the *Sutra of the Past Vows* was among the first translation projects undertaken by the Buddhist Text Translation Society; it was completed in 1982. The then-chairman of the society, the abbot of a Chinese monastery, explained that he was giving it priority because of its highly practical nature.[47] For East Asian Buddhists, Jizō, more than all other Buddhist deities, is a practical savior. He takes care of the bottom line: how does one avoid rebirth in hell?

The most important element in the *Sutra of the Past Vows* is Jizō's vow, reminiscent of the vow by Amida, not to become a buddha until all the hells are empty. Referred to repeatedly in Chinese and Japanese collections of Jizō legends, this vow appears in the sutra in several different forms. How can one be assured of salvation? In contrast to the *Ten Wheels Sutra*, the *Sutra of the Past Vows* states that if the devotee causes an image of Jizō to be made and performs offerings to it, the devotee will,

in addition to having a safe home, long life, and this-worldly benefits, be assured of salvation by Jizō from the three worst rebirths:

> . . . the awesome spirit and vows of this Bodhisattva are beyond thought. If good men or women in the future hear this Bodhisattva's name, praise him, regard and worship him, make offerings to him, or if they draw, carve, cast, sculpt, or lacquer his image, they will be born among the Heaven of the Thirty-Three one hundred times, and will never again fall into the Evil Paths.[48]

Another immensely appealing aspect of the *Sutra of the Past Vows* is its description of Jizō's past lives. In Buddhism, a deity's earlier lives are just as important as the present one, and an entire genre of Indian Buddhist scripture centers on the Buddha Śākyamuni's previous lives. If one believes in transmigration, then the actions of a person in a past life are reliable indicators of what that person will do in his present life, just as a person's earlier actions in this life suggest future behavior.

Two of Jizō's four previous lives, as described in the *Sutra of the Past Vows*, were as a woman, which is extremely unusual for a prominent deity. In one life, Jizō was the devout daughter of a faithless brahmin woman. The mother died and fell into the worst hell of all, the Uninterrupted Hell (Muken jigoku). Distraught, the daughter made offerings to a buddha image and prayed to have the details of her mother's rebirth revealed to her. While gazing at the image, she heard a voice identifying itself as the statue inform her that she would soon see her mother.

The daughter then fell into hell herself, where she was told that because of her meritorious actions, her mother had already been reborn in one of the heavens. Everyone else in hell was also saved. Rejoicing, the daughter vowed before the buddha to save any living beings who were suffering in hell because of their past evil deeds.[49]

The second past life story in which Jizō was a woman is similar. In this narrative, he was a girl named Bright Eyes (J. Kōmoku). When Bright Eyes asked a monk where her deceased mother had been reborn, he entered a meditative state in which he was able to see that the mother was in hell. The monk advised Bright Eyes to commission a statue and paintings of a buddha and to worship them. She did so, whereupon she dreamed the buddha told her that her mother would soon be born into her house. Shortly thereafter, one of her servants gave birth to a boy. Three days later the infant told her that he was her mother, but that he would soon die again and undergo terrible suffering. This, he said, was

the result of the karma reaped from killing and slandering. He also told Bright Eyes about the horrors of hell. She took a vow "in front of the buddha" that if her mother could forever escape the three worst rebirths, she would rescue everyone in hell and the two other worst paths. She would not accept enlightenment until this was done. The buddha accepted her vow and said that her mother would indeed attain better rebirths and then become a buddha.[50] The daughter, many lives later, became Jizō. In both cases, worship of a statue was the primary cause of salvation for the sufferers in hell.

The first sutra to associate Jizō with the ten kings of hell and name all of the kings was the *Sutra on the Ten Kings* (Ch. *Yuxiu shiwang shengqi jing*), probably composed in ninth-century China.[51] The text displays a complex mingling of native Confucian and Daoist thought with Buddhism, the religion imported from India. The idea of ten kings who judge the dead actually predates the entry of Buddhism to China. King Enma, like the other kings, is depicted in illustrations accompanying this text dressed in the clothes of a Chinese Daoist official, wearing a large hat, grasping in his right hand a thin wooden plank on which he records information about the deceased. Although the *Sutra on the Ten Kings* mentions Jizō's name only once in passing, accompanying tenth-century illustrated scrolls of the ten kings and hell frequently feature his image pleading with the kings on behalf of the newly deceased soul in hell.[52] These kings also appear in Japanese Buddhist texts, but the most important for Japan was the king of the fifth court of hell, King Enma.

In addition to these and other sutras, collections of Jizō miracle tales appeared as his popularity grew. In 989, Chang Jinji compiled the *Record of Miracles of the Jizō Bodhisattva* (Ch. *Dizang pusa lingyanji*; J. *Jizō bosatsu reigenki*), which related thirty-two stories of Jizō helping people escape from hell, sometimes by actually taking the place of the sufferer. The miracles were almost always the result of merit gained through the construction of Jizō images.[53]

Jizō in Early Medieval Japan

Although Jizō appears everywhere in modern Japan, this was not always the case. The other ubiquitous bodhisattva, Kannon, became popular soon after the official introduction of Buddhism to Japan in the sixth century, but Jizō did not make significant appearances as an independent deity, worshipped apart from a group, until the eleventh century. When

he did, however, he acquired unique characteristics not found in other countries. Initially, commoners displayed more interest in Jizō than did the elites. Testimony to intense belief in Kannon, as outlined in the previous chapter, is found in eleventh-century texts such as *Tale of Genji* and *Pillow Book*, but these works almost never mentioned Jizō. Aristocrats frequently referred to pilgrimages to famous Kannon images, but not to those of Jizō. An exception is the eleventh-century aristocrat Minamoto no Tsuneyori, who mentioned in a 1019 entry in his diary that he attended meetings of a Jizō Fellowship in the mornings and evenings.[54] Commoners were ardent devotees of Jizō from as early as the eleventh century. Unable to perform significant meritorious deeds, they were often forced to engage in the killing of animals and other activities that contemporary Buddhist doctrine held would prevent them from entering the Pure Land. With neither the means nor the time to engage in acts to produce good karma, they tended simply to pray to Jizō in hopes of avoiding the pains of hell. They were directed to do so by monks from the Yokawa area of Mt. Hiei, who organized meetings at which they prayed to an image of Jizō. In the following pages I discuss those fellowships, summarize two Jizō sutras that were composed in Japan and two collections of miracle tales that focus on Jizō, and describe some specific Jizōs that were popular in the early medieval period.

Jizō Fellowships

A group of Tendai monks from the Yokawa area of Mt. Hiei were instrumental in introducing Jizō to the populace through Jizō Fellowships (Jizōkō, Jizō-e). Many of those monks also participated in the Śākyamuni Fellowship and the Meditation Society of Twenty-Five. The monk Genshin is said to have founded Jizō Fellowships, although this cannot be proven. The assertion is based in part on a passage in the thirteenth-century *Important Records of Mt. Hiei* (*Eigaku yōki*), which states that Genshin carved an image of Jizō at Yokawa, placing inside it thirty-five different objects.[55] A text entitled *Procedures for the Jizō Fellowship* (*Jizōkō shiki*), attributed to Genshin, contains prayers requesting escape from the pains of hell through the protection of Jizō and birth in Amida's Pure Land. To this end, the document calls for a monthly meeting of the Jizō Fellowship.[56] Both Genshin's *Essentials for Pure Land Birth* (*Ōjōyōshū*) and the texts for the Meditation Society of Twenty-Five demonstrate his interest in various bodhisattvas and in the six paths of rebirth. Genshin's devotion to Jizō, widely regarded as the bodhisattva

who helped those who found themselves in an undesirable rebirth, probably developed from this concern. In fact, all the fellowships led by Genshin focused, in one way or another, on escape from the six paths. Attention to Jizō, widely regarded as the bodhisattva who helped those in an undesirable rebirth, was a natural result.

Tales of Times Now Past attributes the founding of Jizō Fellowships to the monk Ninkō, who was a fellow disciple of Genshin's master Ryōgen:

In a time now past, there was in Kyoto a temple called Gidarinji, where a monk named Ninkō lived. He was a disciple of Bishop Jie of Yokawa.[57] He believed in the principle of cause and effect, reverenced the three treasures, maintained the precepts in all his bodily actions, and had sympathy for all living beings. He was like a buddha.

But once, in the fourth month of the third year of the Jian era [1023], an epidemic broke out in Kyoto and spread to all of Japan. Great numbers of people died of this illness. The streets were crammed with the bodies of the deceased. People, high, middle, and low, constantly faced the skies and cried out. At that time, a small monk appeared in Ninkō's dream. He appeared very tidy. He entered the room and asked Ninkō, "Do you think the things of this world are impermanent, or not?" Ninkō replied, "The people I saw yesterday I will not see today, and the people I see in the morning are gone by evening. This [I realized] only recently."

The small monk smiled and said, "You should not be lamenting, [even for] this first time, the impermanence of the world. If things happen to you and you feel afraid, quickly make an image of Jizō Bodhisattva, and in front of the statue, sing his merits. If you do this, you will quickly save those companions who are lost in the five pollutions, and in the long run you will offer worship on behalf of those who are suffering in the three worst rebirths (*sanzu*)." At this, Ninkō awoke.

After that, Ninkō gave rise to aspiration for the Way, and immediately went to the house of the great Buddhist sculptor Kōjō and consulted with him. Within the day, Kōjō had carved a statue gilt with fifty-percent gold, and performed an eye-opening ceremony. After that, he [Ninkō] began holding Jizō Fellowship meetings. Monk and lay, male and female, bowed their heads, pressed their palms together, and with great hopes, established karmic connections with the Jizō. And in that temple, and in the hall where Ninkō lived, no one became ill.

Hearing about this dream, those who knew Ninkō and various people from Yokawa became members of the fellowship, and none of them encountered any ills. "This is a miracle!" they said, and the Jizō Fellowship flourished more and more. In this way, Ninkō lived to eighty. When he died, he was calm, faced the west, sat back properly on his heels, recited the names of Amida Buddha and Jizō Bodhisattva, and died as if he were going to sleep. Then all the people knew that there was none greater than Jizō Bodhisattva at bestowing benefits of the two worlds [i.e., benefits in this life and the next]. Everyone believed, and reverently spoke of what had happened to others.[58]

A death that resembled sleep served as miraculous proof to the early medieval Japanese that the deceased had indeed been born in the Pure Land of Amida.

The Japanese Tendai school of Buddhism, to which Genshin, Ninkō, and other monks connected to Jizō Fellowships belonged, was founded on the teachings of the *Lotus Sutra* but came to include other types of unrelated Buddhist practice and belief, including Jizō devotion and Pure Land faith. In this way, Jizō became associated with Amida and his Pure Land. In China, devotion to Jizō was often directed toward the goal of rebirth in one of the heavens, but not in the Pure Land of Amida. In Japan, faith in Jizō, as evident in the above tale, was frequently the cause for Pure Land birth.

A story about specific benefits reaped by attending Jizō Fellowship meetings appears in *Tales of Times Now Past*. The setting is Mt. Tateyama (sometimes pronounced Tachiyama), which lies in the middle of the mountain range in central Japan that is now referred to as the Japan Alps. Long known as the site under which hell lies, Mt. Tateyama has hot springs bubbling up from the desolate landscape.

The legend states that late one night, when the devout ascetic monk Enkō was staying at Mt. Tateyama, a shadowy figure appeared to him. Enkō trembled with fright and turned to leave, but the shadow, a girl, cried and begged him to listen. She explained that she had lived near Seventh Avenue in Kyoto, where her parents and siblings still resided, but her karma had dictated that she die young, and she had fallen into the hell below Mt. Tateyama. She had once or twice attended the Jizō Fellowship at Gidarinji temple in Kyoto, although she had never performed any other meritorious deed. Even so, she continued, Jizō Bodhisattva visited hell three times in the afternoon and three times in the evening to undergo her punishment in her stead.

The scene of her punishments is vividly illustrated in a thirteenth-century scroll that follows the Japanese tradition of depicting several different events, involving the same people, in a single illustration. In this rendition, Jizō substitutes for her in two of three specific punishments she has been assigned, which are: being consumed by fire, climbing a mountain of swords, and being beaten by demons. At the upper right of the picture, the girl is speaking to Enkō at Mt. Tateyama. To the left, the girl kneels, her hands folded in prayer, in front of Jizō, who though engulfed in flames wears a peaceful expression. To the far left, Jizō is depicted climbing a tree of swords, with the girl gazing up at him in wonderment. In both these scenes, Jizō appears to be looking directly at her. The last scene, below that of Jizō in flames, graphically depicts an angry red demon beating the naked girl, hung by her ankles, with his spiked iron bar. Blood runs down her back.[59]

In the legend as related in *Tales of Times Now Past*, the girl asked Enkō to inform her parents and siblings of her predicament and to request that they make offerings to Jizō. Then she disappeared. Although still frightened, the monk felt pity for her and did as she asked. Her family cried and thanked him repeatedly, and immediately they copied the *Lotus Sutra* and requested that a sculptor carve a statue of Jizō. They held services in a hall, with the monk Jōgen officiating. Everyone was deeply moved by his sermon. The tale ends by encouraging devotion to Jizō, exclaiming that if he could help a woman who had merely attended one or two meetings of the Jizō Fellowship, how much more would his regular devotees be assured of aid should they find themselves in similar circumstances.[60]

Demonstrating the fluidity and overlap of the roles of particular deities, the mid-eleventh-century *Miraculous Tales of the Lotus Sutra* (J. *Hokke genki*) relates a similar story, but here the deity who takes the girl's place in hell is Kannon:

> While still alive, I thought of devoting myself to Kannon and wished to recite the sutras of Kannon. Yet I died before fulfilling my wish. However, just once, I observed the precept on the eighteenth of a certain month [Kannon's holy day]. Although my observation of the precept was not done correctly as described in the Law, I reflected and wanted to serve Kannon. On account of this good seed of mine, on the eighteenth of every month, Kannon has been appearing for a day and a night to undergo my sufferings in my place. During that time, I can leave hell and have relief.[61]

As Jizō's popularity grew, he began to take over many of the duties Kannon had previously been responsible for.

According to *Tales of Times Now Past*, Rokuharamitsuji was one of the temples that sponsored Jizō Fellowship meetings. One story tells of a devout Kyoto woman who attended the Jizō Fellowship gatherings every month on the twenty-fourth, Jizō's holy day. Deeply moved by Jizō's vow to save all who suffer, she decided to commission a small statue of him and gave her clothes to the sculptor as payment. Before the eye-opening ceremony could be held, however, she fell ill and died within a few days. Her children sat weeping next to her body, but six hours later, she returned to life with a strange story to tell.

She had found herself lost in a large field when suddenly a man wearing a crown appeared and told her to follow him. Then a small monk came to her and proclaimed that she, the Kyoto woman, was his own mother and that she would immediately be returned to life. The man with the crown, on hearing this, referred to the scroll he held. He told her she must repent of two sins. First, she had had a relationship with a man. To make amends, she should build a pagoda of mud and make offerings to it. Second, when she had attended meetings of the Jizō Fellowship, she had left before the sermon was finished. She must repent of these two wrongs, the man with the crown told her. Then he let her go and disappeared. The young monk asked whether she knew who he was, to which she replied that she did not. "I am the Jizō Bodhisattva that you made," he said. "You made an image of me. Because of that, I came here to help you. Now go back to the land of the living." With that, he showed her the way back and departed.[62] The man with the crown, the reader is to understand, was King Enma.

The Sutra on Jizō and the Ten Kings
and the Longevity Jizō Sutra

With the advent of aristocratic interest in Jizō in the late twelfth century, he became highly regarded for his ability not only to rescue people from undesirable rebirths but also to bestow this-worldly benefits. Particularly prominent among those was recovery from illness, mentioned in both the *Ten Wheels Sutra* and the *Sutra of the Past Vows*. Those benefits were expanded upon in several later apocryphal sutras produced in Japan. The two most important were the *Longevity Jizō Sutra* (J. *Enmei Jizō kyō*), probably produced in the twelfth century, and the *Sutra on the Bodhisattva Jizō's Aspiration for Enlightenment and the Ten Kings* (J. *Jizō bosatsu hosshin in'en jūō kyō*; hereafter referred to as the *Jizō and Ten*

Kings Sutra), compiled between 1000 and 1300, when belief in Jizō became prominent in Japan.[63]

Although the medieval Japanese were fond of both texts and believed them to be genuine, modern scholars have deduced through the language used and the topics mentioned that both were produced in Japan. This academic knowledge, however, has not prevented even the highly educated from revering the sutras. For example, the late Itō Kokan, president of Hanazono University in Kyoto, affiliated with the Rinzai Zen school of Buddhism, said of the *Longevity Jizō Sutra:*

> This sutra is said to have been translated by the Tang dynasty monk Fukū Sanzō, but this we cannot believe.[64] It is not recorded in any of the Chinese catalogues of sutras, and there is no person said to have brought the sutra to Japan. But its contents are magnificent, and many commentaries have been written on it. Because it explains that the person who believes in Jizō will have a long life and escape disasters, the masses of ordinary commoners rejoiced and read this sutra . . .[65]

The *Longevity Jizō Sutra* is also quite short, which no doubt contributed to its popularity.

At the start of the sutra, the narrator, Śākyamuni, outlines the benefits that can be expected by the devotee of Jizō. Then Jizō himself bursts forth from the ground and repeats all that Śākyamuni has said. Of particular importance to the Japanese have been the ten types of good fortune described by the sutra; the leaflet I received regarding the Six Jizōs Pilgrimage listed all ten and cited the *Longevity Jizō Sutra* as its source.[66] The first in the list and the most prominent, a good fortune that may both reflect and have been instrumental in creating Jizō's associations with children, is safe childbirth. In many ways this simple sutra had greater influence on the development of Japanese Jizō worship than did any other work.[67]

The second text, the *Jizō and Ten Kings Sutra,* is clearly modeled on its Chinese counterpart, the *Ten Kings Sutra,* but it makes up for what would have been, in the eyes of the Japanese, the main flaw of the Chinese version: that it mentions Jizō only once.[68] The Japanese sutra focuses on Jizō, and to that end dwells particularly on the fifth court of hell, in which King Enma resides.[69] The sutra matches each of the kings of hell with a buddha or bodhisattva, indicating that the kings are but manifestations of Buddhist deities. In this paradigm, Jizō is the true form of King Enma. This concept no doubt stems from the

contemporary Japanese process of pairing native Japanese deities with Buddhist deities, the rationale being that the Buddhist figures were the original form of the manifested Japanese gods (*honji suijaku*). The ten Buddhist deities whom this sutra lists as the original form of the ten kings later became the crux of the funereal belief in the thirteen buddhas (*jūsan butsu*) who care for the deceased and form the basis of most rituals held to mark regular intervals in the years following a person's death.

The *Jizō and Ten Kings Sutra* also describes hell in great detail, explains that Jizō will manifest himself in six different ways to save sentient beings, and lists the six forms of Jizō that appear in each of the paths of rebirth.[70] Most important, this sutra declares that Jizō will serve as a body-substitute for those undergoing torture in hell.[71]

Accounts of the Miracles of Jizō Bodhisattva *and* Tales of Times Now Past

Japan's first known collection of Jizō tales is *Accounts of the Miracles of Jizō Bodhisattva* (*Jizō bosatsu reigenki*). This text was compiled from earlier documents in the mid-eleventh century by the monk Jitsuei of Miidera temple; only fragments of later copies survive. Those copies contain many serious discrepancies that call their reliability into question. Because *Accounts of the Miracles of Jizō Bodhisattva* is so problematic, most scholars focus on *Tales of Times Now Past*, which takes numerous stories directly from the former work. Of the thirty Jizō tales in the seventeenth chapter of *Tales of Times Now Past*, seventeen are probably derived from *Accounts of the Miracles of Jizō Bodhisattva*.

Some later versions of *Accounts of the Miracles of Jizō Bodhisattva* are illustrated, which is not the case for *Tales of Times Now Past*. The best preserved illustrated scroll of *Accounts of the Miracles of Jizō Bodhisattva* dates to the mid-thirteenth century and is owned by the Freer Gallery in Washington, DC. Although much of it is missing or damaged, the remaining illustrations are engaging and informative. In fact, the story related above about Jizō substituting for two of the three punishments of a girl in hell is thought to have originated in *Accounts of the Miracles of Jizō Bodhisattva* and then found its way to *Tales of Times Now Past*. The illustration described above is found in the Freer Gallery scroll.

Most of the Jizō stories in *Tales of Times Now Past* that are based on *Accounts of the Miracles of Jizō Bodhisattva* describe him as a young monk, no doubt contributing to the modern conception of Jizō as a baby or child. The stories also make constant reference to Jizō's vow, which was

understood as a pledge to save all his devotees from hell, although very rarely is a specific sutra mentioned. Another story believed to have been taken from *Accounts of the Miracles of Jizō Bodhisattva* contains the first extant reference to Six Jizōs in Japan. The legend features the priest of a shrine dedicated to a Japanese native deity (*kami*). Named Koretaka, the priest had, from childhood, deep faith in the three treasures of the Buddha, his teachings, and the monastic order; and in Jizō.

In 998, Koretaka fell ill and died after six or seven days. Finding himself lost in a large field, he began to weep. Suddenly, six young monks appeared. One held an incense burner, one had his hands folded in prayer, one grasped a wish-granting jewel, one held a staff, one bore a flower basket, and one carried prayer beads. The monk with the incense burner introduced himself and the others as the Six Jizōs and explained that they appeared in six forms to help sufferers in the six paths of rebirth. He further stated that although Koretaka was a Shintō priest, they were sending him back to the world of the living, because they knew he had great faith in Jizō. Once he returned to life, they added, he should build and worship images of the Six Jizōs.

Three days and nights had passed when Koretaka returned to life. He told everyone about these events, and his listeners were deeply moved. Erecting a grass hut named the Six Jizōs Hall, he enshrined there life-size brightly colored images of the Six Jizōs. After conducting an eye-opening ceremony, he began to worship them. Many devotees came from near and far to form karmic connections with the Jizōs. Finally, when Koretaka was more than seventy years old, he shaved his head and became a monk, praying for birth in Amida's Pure Land. On his deathbed, he recited Amida's name, concentrated on Jizō's great vow, faced west, and died. At that time, a monk named Jakushō dreamed that Koretaka had been born in the Pure Land. He told everyone of his dream, and it was taken as proof that Koretaka had indeed been born in the Pure Land.[72] Koretaka was able to do this, even as the priest of a shrine housing a *kami*, because he had been a devotee of Jizō and had faith in his vow.

Yatadera Temple Jizō, Revisited

Several works, including hanging scrolls and illustrated picture scrolls, relate the Yatadera Jizō's biography, which proved to the devotee that Jizō did indeed inhabit Yatadera temple. Most of his biographies, the earliest extant version of which dates to 1202, describe one or both of two major events in the life of the Yatadera Jizō. I related both briefly

above as they are told to visitors to the temple in modern Japan. The full story, however, is more complex.

In its extended form, found in thirteenth-century documents, the legend tells of the monk Manbei, who lived at Yatadera temple from 796 for more than twenty years, and conducted rites of confession to Jizō. Ono no Takamura was a devout follower of this monk. As related in so many other stories, during the day Takamura served at the imperial palace, and at night he visited the chambers of King Enma. On one occasion, when King Enma requested that Takamura bring to hell a virtuous person from whom he could receive the bodhisattva precepts and thus stop a fire that was burning his castle, Takamura returned with Manbei. After Enma took the precepts, the fire was extinguished. King Enma was so grateful that he wanted to repay Manbei. Manbei requested a tour of hell. There, he witnessed Jizō Bodhisattva amid all the flames and suffering. Jizō told Manbei that he had received instructions from Śākyamuni Buddha himself to save those suffering in hell, and requested that Manbei return to the world of the living and encourage people to form karmic connections with him. Manbei did so, asking a sculptor to carve a life-size statue of the Jizō he had seen. The first attempt resulted in a statue that differed from the figure Manbei had seen in hell. The image was remade and enshrined in Yatadera temple.[73] As an additional expression of gratitude, King Enma sent Manbei back to the land of the living with a box of rice. No matter how much rice Manbei ate, the box always remained full. This is the origin of Manbei's name, which means "Full of Rice."

Part of the appeal of the Yatadera temple story, and one of the reasons it was copied and spread so widely, is that the main character, Manbei, was led on a tour of hell and saw things that ordinary people could never witness. Though Buddhists are frightened of hell, they have a natural curiosity about what takes place there. Through the Yatadera legend, they were able to hear, from the lips of one who had been there, what it was like.

Yatadera's Jizō, who would go to hell himself to save the suffering, became increasingly popular. The thirteenth-century *Sand and Pebbles* tells the following story:

> In Nara lived an aristocratic nun who for many years placed her trust in the Jizō of Yatadera temple, tending and venerating it with undivided attention. Whenever she invoked the name of the Buddha, her opening statement was: "I do not rely on the Fukuchiin Jizō, the Jūrin'in Jizō, the Chizokuin Jizō, and certainly

not the Jizōs which stand on the city streets. Praise be to my Bodhisattva Jizō of Yatadera temple!"[74]

The Wig-Holding Jizō, Revisited

As mentioned, several texts tell of Jizō Fellowship meetings, sometimes headed by monks from the Yokawa area of Mt. Hiei, that were held at Rokuharamitsuji temple. This temple served as the gathering place of Jizōs of all sorts, although only two Jizō images reside there now. One of these is the Wig-Holding Jizō. The image's living status can be traced to the early medieval period, when two major legends, each with several variants, developed.

The oldest known version of the first legend, found in the late twelfth-century *Collection of Treasures* (*Hōbutsushū*), tells of a woman who lived in eastern Kyoto and frequently visited the nearby Rokuharamitsuji Jizō. When her mother died, the daughter sat crying, having no means of disposing of the body. At dusk, a monk appeared and, learning of her situation, carried the mother's body away on his back. The next day, the daughter went to Rokuharamitsuji temple to thank Jizō, to whose power she attributed this event. There Jizō stood, his feet covered in dirt, revealing that the statue himself had walked to her home to help her.[75] No wig appears in this story, but a much later text, dating to 1702, explains that the wig the image holds in his right hand is that of the deceased mother.[76]

The second story, found in the slightly later *Tales of Times Now Past*, provides more detail. A man named Kunitaka died and fell into hell. There he saw, among all the sinners, a small, solemn monk bustling about, holding a scroll in one hand. Told that this monk was Jizō Bodhisattva, Kunitaka tearfully pleaded to be saved, arguing that since he had been a virtuous man he did not belong there. Alas, Jizō informed Kunitaka that he had been reborn in hell for the sins he committed with women. To make matters worse, he added, Kunitaka had never worshipped him. "I don't know you," Jizō stated flatly, and turned away.

The desperate Kunitaka promised Jizō that if he were returned to life, he would use all his money to worship the three jewels of Buddhism and be his devotee. Jizō decided to have compassion on him, returning him to life after only half a day in hell. Remaining silent about his experiences, Kunitaka simply shaved his head and became a monk, requesting that the great sculptor Jōchō carve a life-size gilt image of Jizō. Then he copied one section of the *Lotus Sutra* on multicolored paper and held

services at Rokuharamitsuji temple. The lecturer at these services was the Yokawa monk Jōgen. Men and women, monk and lay, attended, and "all believed in the miracles of Jizō." This Jizō is present at Rokuharamitsuji temple even today, says *Tales of Times Now Past.*[77] Today, devotees believe that the standing Jizō with a wig in his right hand in Rokuharamitsuji temple's Treasure Hall is that which appears in this legend.

The Rice-Planting Jizō (Taue Jizō)

The *Collection of Treasures*, which related the tale of the woman who could not care for the body of her deceased mother, tells another story of a Jizō image coming to life. An elderly devout woman made frequent offerings to the Jizō on her household altar. She hired someone to plant her rice fields, but the lazy man accomplished nothing. The woman complained to her Jizō image, telling him that if he were human, she would ask him to plant the rice. Later, in a dream, she saw a young monk who told her that he would plant her rice himself. Upon awakening, she discovered that all the fields had been planted overnight. Noticing small footprints in the mud, she returned home, visited her Jizō image, and saw that his feet were covered in mud.[78] In this story, the woman revealed her understanding that the statue was just a statue, a piece of wood that could not help her. But the statue proved her wrong, showing her and all who heard her story that an image can truly be living.

In contrast to the Jizōs at Rokuharamitsuji temple, who could actually be visited by people who heard these stories, the Rice-Planting Jizō lived in a nameless woman's home shrine. Therefore, although the stories about the Rokuharamitsuji Jizō may have served in part to bring more worshippers, and thus more funds, to the temple, the rice-planting story would not have accomplished any particular monetary goal. The listener might, however, have believed that a Jizō image would perform similar miracles for her.

Numerous versions of the Rice-Planting Jizō story circulate to this day, and many farming communities claim to enshrine a Rice-Planting Jizō at a local temple. Modern versions of the legend always mention the footprints left by Jizō. The historical Buddha Śākyamuni's footprints are worshipped in most Buddhist countries, including those he never visited. Footprints provide a vital form of proof of a person's presence at a particular site, as the criminal justice system well knows. The footprints

of Jizō in these stories prove that he truly comes to the aid of his devotees.[79]

The Jizō Who Needed His Eyes Opened

The *Collected Tales of Uji* (*Uji shūi monogatari*), thought to have been compiled in the early thirteenth century, tells a story of a Jizō who displays his living status in a most unusual manner:

> Long ago there was a spot on the dry beach of the river at Shinomiya, on the route to Yamashina, which was known as Sodekurabe and was a meeting place for merchants. Now, a certain poor man in the neighborhood had had a statue of Jizō made, but he had not had the eyes put in to complete it, and had shut it away in a chest which he had stored in a back room. He was so busy with his everyday affairs that after a while he forgot all about the statue, and it remained stored away for three or four years.
>
> One night in a dream he heard some passer-by in the street calling out in a loud voice. "What do you want?" he shouted. "Hey, Jizō, Jizō!" shouted the voice in front of the house, and from the back room came an answering call of "What do you want?" "Aren't you coming to Indra's Jizō service tomorrow?" "I'd like to," said the voice from the back of the little house, "but I can't because my eyes are not open yet." "You must manage to come somehow." "How can I, when I can't see?" The man woke with a start and pondered the meaning of what he had dreamed. Next morning he made a careful search through the back of the house, and then he remembered the Jizō he had stored away, and brought it out. "It must have been this Jizō in my dream," he said to himself in amazement, and they say he had the eyes put in as soon as possible.[80]

This story contains two surprising elements. First, the statue was clearly alive before its eyes were opened: failure to conduct the proper ceremony simply affected its ability to function. Second, the statue appears to have been intended, perhaps not by the sculptor but by the statue himself, to be the central image of a Jizō meeting, perhaps a Jizō Fellowship. To this day, some people believe that the Jizō in this story lives on at Tokurin'an temple near Shinomiya. This image, affectionately called the Yamashina Jizō after the area of Kyoto in which the temple is situated, is one of the Jizōs on the modern-day Six Jizōs Pilgrimage.[81]

Naked Jizōs, Revisited

The Jizō at Denkōji temple is the oldest known naked statue in Japan, although a number of such statues were produced in the thirteenth and fourteenth centuries.[82] There is some evidence that the naked statue phenomenon occurred in Song-dynasty (960–1278) China, which may well have influenced Kamakura-period (1185–1333) Japan.[83] Naked statues never became common, but they still have much to tell us about the communities that enlivened them.

An inscription on the Denkōji Jizō dates it to 1228, and several items discovered inside the statue itself tell of its birth. The most important of these is a dedicatory text by the eighty-three-year-old nun Myōhō, which records a prayer that the merit gained through the construction of the statue be transferred to her deceased parents. Particularly concerned with the fate of her mother, Myōhō referred to the story of Bright Eyes from the *Sutra of the Past Vows*, telling how the daughter in that case was able to save her mother from being reborn in the three worst paths by constructing a statue. She herself therefore wished to dedicate the merit accrued through sponsoring construction of the statue to her deceased mother. Myōhō also requested the assistance of the four Kasuga Shrine deities in her quest to save her mother. A dedicatory text by another nun was also found inside the statue. This nun, named Yuishin, prayed for rebirth as a man. A third text offered prayers similar to those of Myōhō.[84]

Both the Kasuga Shrine and Kōfukuji temple were at that time affiliated with the powerful Fujiwara family. Myōhō appears to have been a member of this prominent clan and thus would have felt particularly close to the deities at its shrine and temple. As was common in Japan at that time, the Shintō deities at Kasuga Shrine were each identified with a specific buddha or bodhisattva, who were believed to be the original form of the deity.[85] Jizō was the "original buddha" of the deity of the third of the four Kasuga shrines, Ameyonokane. Thus the Denkōji Jizō began its life as a prayer to Jizō himself, one of the tutelary deities of the Fujiwara family, for the salvation of Myōhō's mother. The details of his life after that are unclear, but many scholars speculate that he was a private buddha (*nenji butsu*) for Myōhō and those around her and that he was carefully dressed according to season.[86]

The birth of the Testicle Jizō at Shin Yakushiji temple is also connected to the Fujiwara family, because it originally lived at Shōgan'in Hall, a subtemple of Nara's Kōfukuji temple. A 1238 dedicatory text by the Kōfukuji monk Sonben that was found inside the statue contains

prayers for the salvation of his master Jisson (1180–1236) and for a peaceful death when his own time came. As stated above, Sonben probably dressed the statue in Jisson's own clothing and regarded him as the continued living presence of his master.[87] Sonben almost certainly was aware of the Denkōji image, which had been made only ten years earlier. This Jizō statue, like so many before and after, was essentially a body substitute.

Secret Buddhas, the Veiled Presence

Varieties of Secret Buddhas

It would be impossible to count all the secret buddhas in Japan, but more than fifty of them have been designated Important Cultural Properties (*Jūyō bunkazai*) or National Treasures (Kokuhō) by the national Ministry of Culture (Bunkachō).[1] Because the statues must undergo an inspection by art historians who are government officials, no absolute secret buddhas have received this designation, although some that are revealed very infrequently have. For example, the Kannon at Rokuharamitsuji temple in Kyoto is a National Treasure that can be viewed only once every twelve years, and the Kannon at Kiyomizudera temple, also a National Treasure, only once every thirty-three years. The temples that house these statues receive government funding, which ultimately comes from taxpayers. Many of the temples that receive regular visitors, such as those on the Western Pilgrimage, house a secret buddha that is a National Treasure or Important Cultural Property, and several of the images discussed in previous chapters are secret buddhas. That the Japanese do not make a fuss about their tax money being used for the upkeep of a large number of images they can rarely view speaks to the importance these living images hold in their lives.

Secret buddhas fall into several different categories. They may be shown once or twice a month, twice a year, once a year, every seven years, every thirty-three years, every sixty years, once in the lifetime of an abbot, or never. Some are also revealed on the occasion of significant events, such as the enthronement of a new emperor. In recent years, the term "secret buddha" has come to be used quite loosely, with some temples advertising "secret buddhas" that are just exhibits in a temple

museum that is open only twice a year. Moreover, some secret buddhas can be viewed if the visitor calls ahead to make arrangements, and others are regularly seen by monks but not laypeople.

At one temple I visited on the outskirts of Kyoto, I was told that I could not see a beautiful twelfth-century Kannon who lived there because she was a secret buddha, and I accepted that. But after learning that I am a scholar of Japanese Buddhism, some of the monks decided to show me the image after all. They took me to a small hall whose doors were protected by several layers of locks. Finally they opened the door, and there she was. Because the monks had not expected to show her, the lotus flower that she usually held was on the floor beside her, which must have been part of a storage procedure. They made sure to fold their hands in prayer before her, asking that I do likewise, and they lit some candles and incense but conducted no elaborate rituals. I am certain that no spirit-removing ceremony was conducted before I saw her.

A guidebook to temples throughout Japan contains an index listing all the secret buddhas for which it could obtain information, and the times when the images are revealed.[2] For the serious Buddhist statue "junkie," as another book calls people who are determined to visit as many statues as possible, this is essential information.[3] At the end of the list, the guidebook includes ten pages of statues that either are never revealed or are housed in temples that choose not to release any information about scheduled curtain openings. The secret buddha system is by no means logical or organized, and all attempts to represent it as such are inevitably flawed. Moreover, the term is never used to refer to the many statues whose faces are obscured by curtains hanging in front of them.

The term "secret buddha" (*hibutsu*) itself has no direct counterpart in other Buddhist countries, nor did it appear in Japan until at least the thirteenth century. It entered everyday use only in the Edo period. The practice of obscuring a statue from the eyes of worshippers, however, is found much earlier. A late ninth-century record of the belongings of Hōryūji temple, for example, tells of a wooden image of Yakushi Buddha that stood in a locked hall.[4] *Tales of Times Now Past* states, at the conclusion of a story about Nara's Yakushiji temple, "Even monks could not enter the hall. Only the servant boys, who are lay, could enter, making offerings to the buddha and lighting lamps."[5] Another tale regarding Yakushiji temple from the same work once again discusses this statue:

> From long ago, no one has been allowed to enter the inner altar of the Golden Hall (Kondō) of this temple. Only three lay persons who are administrators of the hall, having purified themselves, each may

enter for ten days, after which the next person takes over. Other than that, even monks who have maintained the precepts their entire lives have not entered the hall. In the past, there was a monk whose actions were entirely pure. He thought, "I have never committed a transgression with any of the three categories of actions. Why cannot I enter?"[6] Upon this, he attempted to enter the hall, but suddenly the doors blew shut, and he was not able to go in. Finally, he departed. This tells us that truly, the Yakushi statue is known in the world as a buddha who produces miracles, for which we are grateful.[7]

The Case of the Savior Kannon of Hōryūji

A secret buddha with a dramatic and well-known biography lives today, as it has for centuries, in the Dream Hall (Yumedono) of Hōryūji temple in Nara. This seventh-century Kannon, over two meters tall and enshrined in the Dream Hall in 739, was originally called the Dream Hall Kannon but later acquired the nickname Savior Kannon (Guze Kannon). Eighth-century sources explain that the statue was carved in the likeness of Prince Shōtoku (574–622), a deeply revered regent of Japan, during his own lifetime. At some point in the succeeding centuries, the Kannon became an absolute secret buddha, but when and why this happened is a matter of some debate.

The low-level aristocrat Ōe no Chikamichi, who lived in the city of Kyoto, described the pilgrimages he made to Nara temples in the 1106 *Journal of the Seven Great Temples* (*Shichidaiji nikki*) and the follow-up *Journal of Pilgrimage to the Seven Great Temples* (*Shichidaiji junrei shiki*) in 1140. In *Journal of the Seven Great Temples*, Chikamichi stated that he was unable to see the statue because a jeweled curtain hung in front of it. He identified the image as a Savior Kannon.[8] The *Journal of Pilgrimage to the Seven Great Temples*, however, reveals that it was on display when he visited the temple a second time, 34 years later. Here he noted that although the statue resembled Kannon, it was not a Buddhist image at all, but rather one of Prince Shōtoku. He stated that the statue's hands held a wish-granting jewel, but added that it was still difficult to see.[9]

About a hundred years later, such confusion over the identity and appearance of the statue was complete, and the image was no longer displayed. In a 1238 text, the Hōryūji temple monk Kenshin stated:

Installed in the Dream Hall is a gilded image of Guze Kannon, the same size as Prince Shōtoku. Its appearance is unknown now nor

was it known in earlier times. Some say it is Prince Shōtoku as a layman carrying an imperial sword; others say it is a two-armed Nyoirin Kannon.[10]

Although the image was housed in this monk's own temple, he was unsure of its identity and appearance. It must, therefore, have already been a secret buddha for some time. Other documents from the following centuries did not describe the statue, except to state that it stood behind a brocade curtain or, in the Edo period, that it was a secret buddha.

In 1884, a new chapter began in the biography of the Savior Kannon, and indeed in those of all secret buddhas. The incident that marked this new beginning was instigated by the American Ernest Fenollosa (1853–1908). The time was Japan's Meiji period (1868–1912), which commenced when the Americans, led by Commodore Perry, forced Japan's doors open to foreign contact. It was a time of enormous upheaval, when Japan was devoted to learning from Europe and the United States all that it had missed out on during the previous three hundred years of isolation. At the same time, a strong sense of nationalism prevailed. During this period, Fenollosa, a graduate of Harvard University, was living in Japan. At the young age of twenty-five, he had been made the founding chair of philosophy at the prestigious University of Tokyo, where he remained from 1878 to 1886. During that time, he amassed a considerable collection of Japanese works of art, many of them Buddhist in nature. He was able to do so with relatively little money, since economic conditions under the new government forced many temples and previously wealthy families to sell their statues and paintings at a price well beneath their value. Numerous other Westerners also collected Japanese pieces, and much of the Japanese art found in museums in the West today was acquired at that time. Fenollosa was then appointed an Imperial Commissioner of Fine Arts in Japan, a post he occupied from 1886 to 1890. In 1889, he began working at the newly opened Tokyo Fine Arts Academy.

Upon returning to the United States in 1890, Fenollosa became curator of the Department of Japanese Art at the Museum of Fine Arts in Boston. At this point, he had become convinced that Japanese art was on a par with that of the West and was determined to introduce prominent examples of it. In 1896, he once again traveled to Japan with this goal in mind. Accompanying him was Okakura Tenshin (1862–1913; also called Okakura Kakuzō), known today primarily as the author of the *Book of Tea*. Fenollosa petitioned the Japanese government, which expressed interest in displaying Japanese cultural treasures overseas, to

examine a number of important images, concentrating particularly on Buddhist statues in the city of Nara. His attention was caught by a statue that no one had seen for hundreds of years: the Savior Kannon at Hōryūji temple. But when he and Okakura visited and asked to be shown the image, the resident monks refused, explaining that if they complied they would suffer punishment from the buddhas.

Fenollosa then sought and received permission from the government in Tokyo to view the statue. He and Okakura returned to Hōryūji temple, where the monks, under enormous pressure, finally agreed to open the doors of the hall. They themselves, however, would not go inside. After Fenollosa and Okakura entered the hall, which Okakura later said smelled of mold, they unwound the layers of white silk that had been wrapped around the statue. For the first time in hundreds of years, human eyes saw the image. Although it had been carved more than 1200 years earlier, in the first half of the seventh century, it remained in almost perfect condition. Fenollosa told of this event in a somewhat abbreviated fashion:

> This most beautiful statue, a little larger than life, was discovered by me and a colleague in the summer of 1884. I had credentials from the central government which enabled me to requisition the opening of godowns and shrines. The central space of the octagonal Yumedono was occupied by a great closed shrine, which ascended like a pillar towards the apex. The priests of Horiuji confessed that tradition ascribed the contents of the shrine to Corean work of the days of Suiko, but that it had not been opened for more than two hundred years. On fire with the prospect of such a unique treasure, we urged the priests to open it with every argument at our command. They resisted long, alleging that in punishment for the sacrilege an earthquake might well destroy the temple. Finally we prevailed, and I shall never forget our feelings as the long disused key rattled in the rusty lock. Within the shrine appeared a tall mass closely wrapped about in swathing bands of cotton cloth, upon which the dust of ages had gathered. It was no light task to unwrap the contents, some 500 yards of cloth having been used, and our eyes and nostrils were in danger of being choked with the pungent dust. But at last the final folds of the covering fell away, and this marvelous statue, unique in the world, came forth to human sight for the first time in centuries.[11]

In fact, the statue had remained unseen not for two hundred years, but for almost eight hundred.

Fenollosa is often criticized by the Japanese for turning buddhas into art rather than objects of devotion.[12] Nevertheless, after his death in 1908, his ashes, temporarily interred in a cemetery in London, were transferred to the grounds of Miidera temple, outside of Kyoto. Fenollosa had once lived and studied Buddhism there and had requested that this temple be the site of his grave. The interring of his ashes at Miidera was marked by a large ceremony. The sizable grave is maintained with great care and is visited by many to this day.

The Savior Kannon, which had not been viewed for hundreds of years, suddenly became accessible to the public. It can now be seen twice a year, for about three weeks in the fall and again in the spring. When I made the journey, I was surprised to find that it is kept in a large cabinet shrine in the middle of the darkened Dream Hall, which cannot be entered. Worshippers must simply peer in through the slatted windows. I could barely make out the golden outlines of this famous Kannon. Perhaps the concern that Fenollosa had turned religion into art is unfounded. Today, the statue stands literally in the shadows of the great hall in which it lives.

Attitudes toward Secret Buddhas

The Hōryūji temple monks who feared revealing the statue displayed an attitude toward secret buddhas that is still prevalent today. Many people in modern Japan would probably argue that they do not believe that a statue possesses a spirit or that it will seek revenge if treated improperly, but the behavior of those who have contact with statues often tells a different story. For example, representatives of the government who conduct inspections of statues to determine whether they should be designated National Treasures or Important Cultural Properties have been known to show deep concern about details such as wearing a paper mask to avoid exhaling directly on the statue and going through personal purification rituals before touching the image. One unidentified government representative stated:

> It is said that secret buddhas that have long been shielded from the human gaze may seek vengeance (*tatari*) when the doors [of the cabinet shrine] are opened, or that the buddha's punishment will be sent down, and so on. Hearing such things is unpleasant. The monks at temples truly believe it, and they can give examples. When I hear this, I am all the more disturbed, because what I do is just a job, and in order to repair a statue, [the shrine] absolutely

must be opened. I thought of all that as mere superstition, but later I heard that someone involved had died.[13]

It is also said that if the secret Kannon image at Kanshinji temple is revealed without good reason, the abbot will become ill.[14] The images are feared precisely because they are miraculous. If they have the power to work miracles, they also have the power to become extremely angry.

Does anyone sneak in and look at the statues at times other than official curtain openings? Government representatives who inspect the statues actually recommend that monks check the image at least once a year to make sure that it has not been stolen, gnawed on by mice, or suffered any of the other misfortunes that may befall a statue, especially a wooden one, that is left unseen.[15] However, in many cases, it is clear that absolutely no one sees the statue outside the regularly scheduled times, owing largely to the fear of retribution from an angry deity.

The existence, popularity, and fear of secret buddhas in Japan provide proof that the power of statues does not depend on appearance. In the case of some absolute secret buddhas, such as the famous Zenkōji temple image, the iconography is well known. With others, the appearance may be noted only by scholars. And in several cases, nobody knows what the statue looks like.

Zushi: Home of the Deity

Buddhist statues in Japan often reside in wooden cabinets called *zushi*. The typical *zushi* is taller than it is wide. It has a pair of solid doors in front, hinged at both sides of the cabinet, which may be opened wide to give an unobstructed view of the interior, or closed (meeting in the middle, in the manner of French doors), completely obscuring the interior from view. In Japanese, this style of door is known as "Kannon-opening" (*Kannon biraki*), a term used today even in non-Buddhist settings. The phrase was coined because, for reasons discussed below, Kannon is more frequently enshrined in a *zushi* than any other deity. Some *zushi* are large and resemble a temple building itself, whereas others are small and portable. Most *zushi* enshrine statues, but they may also contain painted images, relics, and scriptures.

Although similar enclosures that mark off some kind of sacred space can be found in every culture, *zushi* are a characteristic feature of the religious landscape in Japan. Most Buddhist temples have a number of them on the premises, enshrining a variety of deities; the vast majority of

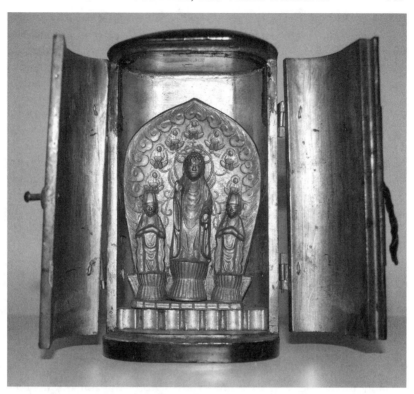

Figure 6 A Miniature *Zushi* Enshrining a Replica of the Central Image at Zenkōji Temple

these are not secret buddhas, and so the *zushi* in which these figures dwell generally stand with the doors open.

When a secret buddha is displayed, the doors of its *zushi* are opened, but the statue is almost never removed. The *zushi* is not only the buddha's home; it is his environment. Frequently, paintings of bodhisattvas, famous figures, landscapes, or Pure Lands adorn the inside of the doors and the walls of a *zushi*, and flying deities are sometimes hung from the roof, as befits a buddha's dwelling place. The paintings on the inside of the back wall of *zushi* are almost impossible to see, because the image stands or sits directly in front of them. The purpose of the paintings is to create a three-dimensional Buddha Land.[16] Even, or especially, when the doors of a *zushi* are closed, the buddha is properly located.

The origin of the word *zushi* is unknown. There is no clear Sanskrit precedent.[17] The first character was used in a different two-character

compound in China and Japan to refer to a cupboard that stores food (J. *chūbō*), and that character can still be seen today on the signs of some Chinese restaurants in Japan. On this basis, many scholars assert that the word *zushi* originally referred to cabinets for storing food in kitchens; it then came to designate a boxlike storage unit for writing utensils and scrolls; and finally it was applied to cabinets used to hold religious objects such as sutras, ritual implements, and statues. A more convincing argument involves an alternative Chinese character for the syllable "*zu*." This character can also be pronounced "*hitsu*," and it is used in the common Japanese word for "coffin" (*hitsugi*). The latter "*zu*" character was not often used in Buddhist contexts in China, but it did appear on occasion. For example, a seventh-century Chinese text speaks of some Buddhist deities that were enshrined in a "*chu*" (pronounced "*zu*" in Japanese), and others that were enshrined in a "*gui*" (pronounced "*hitsugi*" in Japanese).[18]

In Japanese Buddhist terminology, a deceased person is commonly called a buddha (*hotoke*), and such human buddhas are generally placed in coffins before their cremation (which is the norm in contemporary Japanese funerals). Buddhas that are statues are also placed in "coffins" of a sort, and this association does not rest entirely on the contested etymology of the word *zushi*. The formal word for the coffin (*gan*) used in a Buddhist funeral is the same word that is used to designate a "niche" or "altar" in which the statue of a buddha or other deity is enshrined in a Buddhist temple, and the same word denotes the innermost "reliquary" in a Buddhist stupa, or the stupa itself. Not only linguistically, but architecturally as well, there is a close relationship in East Asian Buddhism, especially Japanese Buddhism, between *zushi* and reliquaries, altars, and coffins, for all of these containers often take shapes that derive from or allude to the Buddhist stupa, which is a mortuary mound or tower, as it evolved in South, Central, and East Asia. In Japan, moreover, all of them enshrine buddhas, in one sense or another, which may or may not be visible to the eye. As Robert Sharf argues with reference to relics, the visible appearance of a buddha so enshrined may not matter very much: "While the stupa or icon may possess considerable aesthetic appeal, the allure of a relic lies elsewhere."[19] Although a secret buddha could certainly qualify as an icon, there is much similarity between secret buddhas and relics.

The many niches carved into Indian cave temples may have influenced the development of *zushi*, but they served a fundamentally different purpose. Made of stone, the niches had no doors and thus no convenient means of concealing the images they enshrined.[20] Another

possible predecessor to the Japanese *zushi* is a type of portable folding altar in which two outer sections fold over an inner core. Such altars meant that important buddhas could be safely transported, so they were always close at hand. The premise, however, was that when not en route, the altar would always be unfolded.[21] In contrast, the Japanese *zushi* that enshrine secret buddhas are not usually intended to be portable; rather, they were created with the assumption that an image would frequently need to be concealed. Many *zushi* are far too large ever to be moved. Moreover, a few *zushi*, such as one at Tōdaiji temple's Second-Month Hall (Nigatsudō), have no doors at all. The entire purpose is concealment of the statue.

The term *zushi* does not appear in early Japanese documents. Several eighth-century texts refer to what appear to have been *zushi* but call them buddha platforms (*butsudai*), buddha halls (*butsuden*), and palaces (*kūden* or *gūden*).[22] Hōryūji temple in Nara houses two of Japan's oldest *zushi*, both probably dating to the seventh century: the Jewel-Beetle Zushi (Tamamushi zushi) and the Lady Tachibana Zushi (Tachibana fujin zushi).[23] Their designation as *zushi*, however, did not take place until several hundred years after their construction. The Jewel-Beetle Zushi, in particular, resembles the main hall of a temple in miniature. About 226 centimeters high when standing on its pedestal, the *zushi* features, on its outer walls and the walls of its stand, colorful depictions, done in iridescent beetle wings, of the past lives of Śākyamuni. The back of the *zushi* bears an illustration of him preaching the *Lotus Sutra* on Vulture Peak. The Lady Tachibana Zushi is supposed to have housed the personal tutelary deity of an aristocratic woman, although there is no substantial evidence to support this assertion. The *zushi* now has doors, but scholars believe that originally the roof was supported by pillars and the shrine open on all sides. In this case, then, the purpose would not have been concealment. Moreover, both these *zushi* seem to have been for personal use in the owner's home, and therefore are not indicative of what took place at temples.[24]

Zushi came to be commonly used to enshrine statues during the thirteenth century, and the term itself appears frequently from that time onward. Before this, many concealed statues were not necessarily inside a *zushi* but rather had a curtain draped in front of them. Today, many statues live in *zushi* that date to the Kamakura period. In numerous cases, the statue is older than the *zushi* in which it resides, suggesting that the statue was not initially made to be concealed.

The late sculptor Nishimura Kōchō (1915–2004) speculated on whether the sculptors of most secret buddhas carved them with that

purpose in mind. He had assumed that they did not and that the images later became secret buddhas as a result of circumstances such as those discussed above or concerns about theft. However, he had an odd experience when he was commissioned to carve a statue to be the central image of a small hall at Mt. Hiei. He was informed from the start that it was intended to be a secret buddha, and he had been considering what type of doors would be appropriate for the *zushi*. When the statue was almost completed, he stepped back from it one or two meters to get a better look. Suddenly, he felt that he could not see the statue anymore. He moved closer, and once again it came into view, but when he tried walking back again, he could not see it. Nishimura explained: "In front of my own eyes, the door I had planned for the secret buddha appeared, and it shut."[25]

The traditional Buddhist altars (*butsudan*) that many lay households maintain are sometimes referred to as *zushi* and are obviously closely related. Like *zushi*, they are boxlike structures with two doors opening in the front. A layperson's guide to Buddhist rituals states, "We call the small hall where the Buddha resides a '*zushi*,' but it is best, is it not, to call the household *zushi* that enshrines the Buddhist statue and the ancestral tablets a Buddhist altar (*butsudan*)?"[26] *Talking about Home Buddhist Altars* (*Butsudan no hanashi*), one of a series of introductory guides to Buddhism sold at hundred-yen shops, explains that the altar is like the home of a buddha and of the ancestors. It acknowledges the indebtedness of the tradition to Chinese Daoist and Confucian precedents, especially regarding memorial tablets, but declares that the "box" altar is found only in Japan.[27]

Why Secret Buddhas?

Most Japanese, even those who often visit temples, never wonder about secret buddhas. They are simply a part of the Japanese world. Even Miura Jun, coauthor of *Record of Seeing the Buddhas*, declared when he was unable to view the Śākyamuni statue at Seiryōji temple in Kyoto, "Buddhist statues aren't something we can just see any time, you know."[28] In the past twenty years, however, a few scholarly books and articles have been published on the topic. The primary reason they offer for the phenomenon of secret buddhas is that something that is normally kept from view becomes more holy; therefore, on the few occasions it can be viewed, the object is all the more highly esteemed.[29]

This argument is not without merit, but it is also true that many unseen things are simply forgotten. Moreover, numerous secret buddhas

are absolute: they can never be viewed, so there is never an occasion when their power is manifest in this manner. And most worshippers will never see the statues that are revealed once a year or once every several years. Consider the case of the Western Pilgrimage. Almost all the Kannons on that route are secret buddhas, so those who complete the pilgrimage will not have seen most of the statues.

Scholars suggest a number of factors that may have contributed to the strength of the secret buddha tradition in Japan. Whereas some argue that one or the other of these is solely responsible, it seems likely that they all worked together to form the practice of enshrining images as secret buddhas. The most prominent influences adduced are esoteric Buddhism, Shintō, practical considerations, and general cultural sensibilities. All are discussed below.

The Influence of Esoteric Buddhism

Since esoteric, or Tantric, Buddhism emphasizes secret teachings and rituals, secret images are naturally integral to its practice.[30] At least two esoteric Buddhist sutras, both of which may have originated in China and were known in Japan by the late eighth century, direct that certain images should be concealed. The *Sutra on the Kokūzō Ritual of Finding, Hearing, and Maintaining the Dharma* (Ch. *Xukongzang jiuwenchi fajing*; J. *Kokūzō gumonji hōkyō*) states that a statue of Kokūzō, a bodhisattva who is the main icon in the text, should be placed in a pure hall and wrapped in a clean cloth.[31] The other sutra, the *Sutra on the Dhāraṇī of Jundai* (Ch. *Zhunti tuoluoni jing*; J. *Jundai darani kyō*), also explains that the icon, in this case an esoteric form of Kannon called Jundai or Juntei, should be enshrined in a pure room. Moreover, the rites must be performed in secret, and at all other times the image must be covered with a cloth.[32] Although both sutras speak of covering the statue with a cloth, neither mentions a boxlike *zushi*.

That esoteric Buddhism strongly influenced the practice of enshrining secret buddhas is also indicated by the facts that Kannon images are the most common secret buddhas and that among these images, esoteric forms such as the Eleven-Headed Kannon are most numerous.[33] Eleven-Headed Kannon images have historically been used by esoteric Buddhists in Japan to achieve this-worldly benefits rather than the goal of "attaining buddhahood in this very body" (*sokushin jōbutsu*) that many scholars associate with esoteric Buddhism. It is the deities associated with practical rewards who have tended to become secret buddhas, rather than others, such as Dainichi Buddha, who is used in more orthodox doctrinal contexts.[34]

Another factor in the designation of esoteric deities as secret buddhas is the worry that some fearsome looking statues might be misunderstood by people who are unfamiliar with esoteric doctrine and practice, and thus do more harm than good. For example, many esoteric Buddhist deities have frightening, angry facial expressions; some also feature bright red skin, multiple eyes, protruding teeth, and weapons. Those deities are understood by the initiated as protectors who scare away all that would hinder their progress to awakening and who are useful in obtaining practical, this-worldly benefits. But to the outsider, an angry buddha may indeed be difficult to comprehend.

Misunderstandings might also arise regarding esoteric deities of a sexual nature, or what one Japanese scholar termed "adult Buddhist statues."[35] Although these are much less common in Japan than in Tibet, a deity called Kangiten, also known as Seiten, is enshrined in many Japanese temples and probably became popular in Japanese monastic circles from the twelfth through the fourteenth centuries.[36] The statue often consists of a pair of deities, sometimes in sexual embrace. Thought to be derived from the Indian god Ganesha, the deities usually sport elephant heads. The legend behind the Japanese form of the deity centers on a minister of the imperial court in ancient India who began an illicit relationship with the emperor's wife. When the emperor became aware of his wife's deception, he soaked the meat of an elephant in wine and tricked the minister into drinking the wine by informing him that it was medicinal. Elephants are sacred in India, and eating the meat of one has traditionally been viewed as being fatal.

When the emperor's wife learned what had come to pass, she told the minister, "You ate elephant meat, and you will surely die before the night is past. Go to the mountain, soak your body in oil, and eat radishes." But the minister was overcome by anger toward the king who had tried to kill him and transformed into a deity able to lay curses on people. He then proceeded to make the emperor's life miserable. The emperor's wife, realizing she must do something to stop him, visited the deity. He rejoiced when he saw her, but she informed him that she had come for the sake of all living beings to ask him to stop causing harm. At that moment, he repented of his evil ways and embraced her in gratitude. This is the moment that is supposedly depicted in the statues. But the story, although it is set in India, does not appear in any Indian texts.[37]

The statue's elephantine appearance may sound comical, but the deity is greatly feared by those in Japan who are familiar with it. Few people are aware of its existence, because it is almost always a secret buddha, but those who know of Kangiten are usually afraid of images of him, believing

that if the proper rituals are not conducted before the statue every day, it will become angry and cause all manner of difficulties. In highly secret ceremonies, monks pour oil over the images, which are usually made of metal. Special rice cakes, radishes, and sake are also offered to the deity. The same tremendous power that is so greatly feared can also be manipulated to serve the best interests of the supplicant if he knows the proper ritual procedures. Kangiten is believed to be especially efficacious in granting this-worldly wishes such as harmonious conjugal relations and successful business dealings.

Esoteric Buddhism was undoubtedly a strong factor in the formation of the secret buddha tradition in Japan. However, there are numerous instances of Amida and other decidedly non-esoteric deities being treated as secret buddhas. For example, Nishi Honganji temple in Kyoto houses an image of the monk Shinran (1173–1262) that is rarely revealed to the public. Esoteric Buddhism cannot be the only contributing factor to the popularity of secret buddhas in Japan.

The Influence of Shintō

Some scholars argue that the practice of hiding certain Buddhist statues from human gaze developed as a result of Shintō influence. They point out that Shintō deities (*kami*) are usually not represented in the form of statues, and that even when they are, the statues are rarely revealed.[38] Moreover, Shintō shrines, in contrast to Buddhist temples, tend to segregate the deities they enshrine from the worshippers who come to appeal to them. Visitors to shrines stand in front of an offering hall, and the main building housing the deity is located behind the hall and cannot be entered by anyone except priests of the shrine. The *kami* are virtually all invisible and isolated behind a multilayered array of architectural and ritual barriers.

As has been frequently noted in recent years, however, Buddhism and Shintō in Japan are inextricably intertwined. Most scholars believe that the idea of representing *kami* in the form of statues occurred under Buddhist influence in the first place. It is a mistake to assume that what is now called Shintō, the modern meaning of which is a product of the nationalist polemics of the Meiji period, ever existed as an original, indigenous Japanese "religion" prior to, or apart from, the influence of Buddhism. Before the official introduction of Buddhism from Korea in the sixth century, Japan had no written language. Its earliest histories, the 712 *Record of Ancient Matters* (*Kojiki*) and the 720 *Chronicles of Japan* (*Nihon shoki*), were written in various hybrid forms of Chinese. Those

two texts are the oldest extant written sources providing information on "Shintō," a Chinese word that only later came to be understood as the name of Japan's ostensibly native, non-Buddhist religion. A case can be made that indigenous forms of *kami* worship influenced the development of secret buddhas in Japan, but it is also true that Buddhist concepts of deity had an effect on the enshrinement and worship of *kami* in the medieval period. Many Shintō shrines (*jinja*) were clearly influenced by continental (that is, Chinese Buddhist) modes of architecture, and even today the formal costume of Shintō priests resembles nothing so much as the dress of Tang Chinese courtiers.

Practical Concerns

Several concerns of a decidedly secular nature may influence the designation of images as secret buddhas. Two major motivations are the use of secret buddhas as fundraising devices and attempts to hide the degraded conditions of statues from the public. Any temple can attract attention and increased donations by making an image a secret buddha. As one scholar explains,

> In many ways the most effective fund-raising technique available to a Buddhist temple is careful control of access to its most important icon. If people can see and worship the icon at any time they wish, the spiritual resonance of that activity would be devalued. Consequently, most of the important icons in Japan, except those of extremely large scale, are kept in closed shrines, behind curtains.[39]

This cannot, however, explain the phenomenon entirely. For example, when a major hall at Mt. Kōya burned to the ground in 1930, the central image of Yakushi Buddha, which was an absolute secret Buddha, was burned with it. It is thought that the image was a magnificent piece of sculpture that dated to the ninth century, but no one will ever know for sure.[40] If the temple authorities had simply wanted to use the image to raise money, presumably they would have displayed it occasionally, or at least revealed details of its physical appearance to worshippers.

Another practical concern is that if a statue has not aged well, or perhaps was not carved in a pleasing fashion in the first place, worshippers might be disappointed or even upset if they actually saw it. This is not merely a recent concern. The thirteenth-century *Sand and Pebbles* explains that "[o]ne can either venerate an old statue just as it is; or, if it becomes unsightly, the regulations provide that it may be hidden behind

a curtain. Just as a homely woman may appear fascinating when she is concealed and cannot be seen, so also may an old image attract the faith of believers."[41] Sometimes the government approaches a temple, asking for permission to inspect a secret buddha for possible inclusion as a National Treasure or Important Cultural Property. At other times, the abbot of a particular temple will ask government representatives to visit, explaining that if the temple's secret buddha could receive either of those designations, he would be willing to reveal it at certain regular intervals. On one such occasion, when the government official opened the shrine he saw only a blackened mass of wood. Not knowing what to do, he told the monk, "This is truly a revered buddha. Wouldn't it be better to keep it as a secret buddha, as it has been until now?" And with that, he closed the doors to the cabinet shrine.[42] In such cases, it is the worship of the image by its devotees that keeps it alive, even though it is in very bad physical condition.

Concealment in Japanese Culture

Secrecy and concealment undeniably play an important role in Japanese religion and culture. The novelist Tanizaki Jun'ichirō (1886–1965) argues in his long essay *In Praise of Shadows* that most positive aspects of Japanese culture are derived from its emphasis on darkness and concealment:

If the roof of a Japanese house is a parasol, the roof of a Western house is no more than a cap, with as small a visor as possible so as to allow the sunlight to penetrate directly beneath the eaves. There are no doubt all sorts of reasons—climate, building materials—for the deep Japanese eaves. The fact that we did not use glass, concrete, and bricks, for instance, made a low roof necessary to keep off the driving wind and rain. A light room would no doubt have been more convenient for us, too, than a dark room. The quality that we call beauty, however, must always grow from the realities of life, and our ancestors, forced to live in dark rooms, presently came to discover beauty in shadow, ultimately to guide shadows towards beauty's ends.

And so it has come to be that the beauty of a Japanese room depends on a variation of shadows, heavy shadows against light shadows—it has nothing else. Westerners are amazed at the simplicity of Japanese rooms, perceiving them bereft of ornament. Their reaction is understandable, but it betrays a failure to comprehend the mystery of shadows.[43]

Tanizaki relies heavily on outdated stereotypes, and his arguments must be used with caution. Nevertheless, Japanese history does demonstrate a certain appreciation for subtleties in its visual culture. His description of the importance of shadows calls to mind the experience of peering at a Buddhist statue in a Japanese temple that, if visible at all, stands in the back of a dimly lit *zushi*.

Another example of the significance attached to concealment, even in modern Japan, are the paper talismans (J. *o-fuda*) sold at temples that feature a sketch of the central image. The drawing is often covered by an additional piece of opaque white paper, making it almost impossible to see anything but the vaguest outline of the image. I was warned, moreover, not to remove or even to peek under the top layer of paper. When I asked why, a friend told me that she did not know, but that it would certainly be bad luck if I did so. Fear regarding these talismans is similar to that of secret buddhas, which may become angry and cause bad luck if seen in an inappropriate context.

A Doctrinal Explanation

The late Buddhist sculptor Nishimura Kōchō proffered a doctrinal explanation of secret buddhas, suggesting that they are even more important than images that can be seen and likening the relationship between a secret buddha and the *zushi* to that between a person's illusions (*bonnō*) and her buddha nature (*busshō*). Just as a *zushi* obscures a secret buddha, he explained, so people's illusions obscure their true buddha nature. Therefore, opening the doors of the *zushi* is akin to seeing one's own buddha nature.[44] He also compared worshippers speculating on the appearance of a secret buddha to a mother wondering what her unborn child will look like. In these examples, Nishimura consciously drew a parallel between the Mahāyāna doctrine of buddha-nature, which holds that everyone carries within them the seeds of awakening, and the statue in the *zushi*.[45] The problem with these analogies, however, is that they do not take into account the fact that many people never see the doors of the cabinet shrine opened and that in the case of absolute secret buddhas the doors are never opened at all. It is highly unlikely that secret buddhas came into existence through such closely reasoned doctrinal arguments.

Many of the aforementioned factors have no doubt contributed, at least in part, to the secret buddha phenomenon. But what scholars usually neglect to mention is that it all makes sense on a certain instinctive level. If the statue is living, and the *zushi* is its home, then of course

access is regulated. No one really wants her home open all the time, with complete strangers visiting whenever they feel like it.

Curtain Openings and Stand-Ins

The term for the display of a secret buddha is "curtain opening" (*kaichō*). This is true even when there is no curtain and it is only the doors of the *zushi* that are opened. Often, however, even if the image lives in a *zushi*, a long, beautiful brocade curtain is hung directly in front of the statue, inside the doors. Then, when the moment of revelation arrives, the curtain is slowly rolled upward. This is usually done with great ceremony, in front of gathered worshippers. When the statue appears, a perceptible wave of emotion runs through the crowd, which often emits a collective gasp at the first glimpse of the statue. Some worshippers cry.[46] The entire situation calls to mind fans waiting breathlessly for the first glimpse of a beloved celebrity, which is tightly controlled by the celebrity's handlers.

One scholar, a representative of the Ministry of Culture, tells of her unforgettable first curtain opening. The temple in question, named Kiyomizudera temple (there are several Kiyomizudera temples in Japan, most of them unrelated), is number twenty-five on the Western Pilgrimage and is located on top of a mountain in a large mountain range in the Setsu area of Japan. Formerly a huge temple complex covered the entire mountain with 360 halls, but the buildings and most of the buddhas they enshrined were destroyed in a Taishō-era (1912–1926) fire. The central image of Kannon, however, was carried away from the temple to safety. It is now a secret buddha, and monks at the temple say that it is so powerful that when they pass the road in front of the hall where it resides, they bow their heads in prayer and then run to the other side of the street, fearing the consequences should they accidentally offend the deity.[47]

When the official of the Ministry of Culture arrived at the temple and asked to see the statue, the temple monks replied that since they had also been planning to have a look, they would conduct a curtain opening:

At last it was time for the curtain opening, but first, the abbot recited living-essence-removing sutras, to extract the spirit of the buddha. We sat, listening intently. At last the sutras were finished, and the abbot slowly opened the doors of the cabinet shine. Our eyes were glued to what was behind the opening doors. What kind of figure would the buddha statue we were about to lay eyes on

take? When was it made? Maybe it would be very old. What kind of feelings did this secret buddha elicit in worshippers who visited the temple? We had thoughts such as these. At the moment when the door was opened, our thoughts melted together. I was joyous that I had this moment in time when my thoughts were one with those of all the people who had been connected to this buddha statue, from the time of its construction, that I was about to see.[48]

This concludes her account of the event. In a telling move, she does not actually describe the statue she saw when the doors of the cabinet shrine were opened. For this scholar, the most memorable part of the experience was the moment when the doors opened and her expectancy united her with worshippers throughout the ages.

There are differences of opinion regarding whether the spirit of a statue is removed, as discussed in chapter one, at the time of a curtain opening. In the case just cited, the ritual was conducted. Other scholars also state that this must take place, but the abbot of a temple just outside the city of Kyoto informed me that the spirit is not removed for curtain openings, because the whole point is for humans to have contact with the living image. The monk also explained that it is because the spirit has not been removed when the statue is cleaned that those conducting a Body-Cleaning Ceremony (Minugui shiki) must wear a mask, so that their breath will not come into direct contact with the image. The spirit is removed only for repairs, this monk concluded, or when cleaning a large statue that requires it to be stepped on. As with so many of these matters, when and why spirit-removing ceremonies are conducted probably varies considerably from one temple to the next.

The term "curtain opening" refers not only to the moment when a statue is exposed but also to the time it remains open for viewing. That may be for only a day or for as long as several months. If the temple is famous, it may advertise the curtain opening through newspapers, magazines, and posters in trains and subways, and worshippers may travel long distances just to see the image. Even in the age of the Internet, when a click of the mouse will frequently lead to a photograph of the desired image, many people still are satisfied only by visiting the statue in person.

In the spring of 2005, I went to see a famous ninth-century Kannon statue at Kanshinji temple in rural Osaka prefecture during its two-day curtain opening. I was aware that this famous statue could be viewed only on the seventeenth and eighteenth of March each year, and I had considered making the journey, but when the first day arrived, I decided

I was too busy to go. In the early afternoon of the eighteenth, however, I had the nagging realization that if I did not make the journey then perhaps I would never see the statue, and I especially wanted to witness what I had heard described as the lifelike glow of the statue's wood that caused it to resemble human skin.

I ran to the subway station, traveled on various trains for a couple hours, and arrived at Kanshinji temple a little before 4:30 p.m. The people staffing the entrance told me that it was too late: the temple was closed for the day, and the statue was hidden for another year. When I rather shamelessly presented my plea that I might never have another chance to see the statue, they finally told me that if I ran, I might be able to get to the hall before the doors were shut. Dripping with sweat, I entered the main hall. There was the statue, still in her *zushi*, but with the doors open. And for all the world, I felt that she had been there waiting for me and that her skin did indeed appear to glow. The hype around the curtain opening and the effort the visitor makes to attend it clearly contribute greatly to the ongoing relationship between the statue and its community. The taxi driver who took me back from the temple to the rural train station informed me that the previous day he had driven a businessman who had come all the way from Tokyo on a workday, just to see this Kannon.

Curtain openings are of two basic types: the residential curtain opening (*igaichō*) and the traveling curtain opening (*degaichō*). In the former, the statue remains in the temple where it lives, and the worshipper journeys there to visit it. The latter involves taking the statue to various parts of the country so that those in distant locations have an opportunity to form a karmic connection with the deity and, not incidentally, to make a financial contribution. The tradition of holding curtain openings is as old as secret buddhas themselves, but the early ones were almost exclusively residential. In the Edo period, however, traveling curtain openings became popular as fundraising techniques for cash-strapped temples. When traveling curtain openings took place in Tokyo, the most common destination, they were usually held at the temple Ekōin, meaning "Spreading Merit Hall," which was located in the center of the entertainment district.[49] The Seiryōji Śākyamuni statue was one of many to participate in these traveling curtain openings.

Absolute secret buddhas may also have curtain openings, both residential and traveling, but in those situations it is the secret buddha's stand-in, or *maedachi*, that is actually displayed. The term *maedachi* literally means "standing in front," and that is exactly what most stand-in statues do: placed before a closed *zushi*, they serve as a body substitute

for the main image. They are usually said to be iconographically identical to the main image, but that is not always the case. Although many of the less well-known absolute secret buddhas have no stand-in, most of the famous ones do, including those at Sensōji temple in Tokyo and at Zenkōji temple in Nagano City, which are discussed below. At both temples, the stand-in itself also became a secret buddha, adding multiple layers to the phenomenon. The stand-in at Sensōji temple is revealed once a year, while that at Zenkōji temple can be viewed only once every seven years.

A Modern-Day Curtain-Opening Celebration

William Bodiford describes a ceremony at a rural Zen temple named Jingūji involving a Kannon image that is revealed for thirty-three days only once every thirty-three years, most recently in 1993.[50] Jingūji temple is unusual in that because it has no lay parishioners (*danka*), it is unable to support itself through fees for funerals, the upkeep of graves, and memorial services, which are the main sources of income for most Buddhist temples in Japan. The monks hold jobs outside the temple to support themselves, and the temple survives through donations from the parishioners of other Buddhist temples in the area. It is unusual for parishioners of one temple to make substantial monetary gifts to another, but Bodiford explains that in this case it occurs because everyone in the community feels an obligation to the local temple and its Kannon. The Eleven-Headed, Thousand-Armed Kannon enshrined at Jingūji was supposedly carved by the storied monk Gyōgi (668–749), but in reality it probably dates from the twelfth century, something the temple brochures do not mention. The image was an absolute secret buddha from the time of its repair in 1370 to 1681, when the doors to the cabinet shrine are said to have suddenly opened of their own accord, an indication from the deity that she no longer wanted to remain secret. That was the year of its first curtain opening.[51]

The abbot of Jingūji temple stated that very few people would have noticed, at least initially, if the curtain opening had not actually taken place.[52] But when its approach was announced, the preparations were prodigious: numerous committees were formed, souvenirs were sold, and businesses were solicited for donations. The temple sent letters requesting money to local households, emphasizing the image's venerable history and the ways in which she had performed miracles and protected the town over the centuries.[53] Unlike many other curtain openings, especially those at major temples in Kyoto and Nara, that at

Jingūji temple in 1993 was completely local, with no advertisements in newspapers or on posters in trains. Because this Kannon is the protector of a very specific village, the temple had no interest in drawing tourists from a broader area.[54]

The moment when the Kannon was revealed was played to great effect by the monks of the temple. Bodiford recounts the drama in all its glory:

> When it became time to open the cabinet doors, the voices of the chanting priests became lower and lower, and they began rhythmically twirling small *vajra* bells, producing a sound effect just like a circus drumroll. Then the lights went out. Everyone in the audience strained their necks to see what might happen next. Under the cover of darkness the head priest ascended the altar, opened the Kannon cabinet, and tied the ends of a multicolored rope to the Kannon's hands. (The rope stretched across the Kannon Hall to the bell that hung at its entryway, and from there to a commemorative pillar, or *tōba*, that had been consecrated to signal the start of the thirty-three-day *kaichō*.) When the lights were switched back on, the electricity seemed to run through the audience. This ritual, like the consecrations, concluded as the villagers (many with tears in their eyes) lined up to offer their individual sticks of incense and to bow their heads in prayer.[55]

After this, the monks and important guests attended a banquet, while most of the other worshippers sat on the floor of the main hall in front of the now-open *zushi* and ate box lunches they had prepared. Next, a variety of entertainments took place in front of the statue, including a comedy show, a musical performance, and a magic show, most of which were not overtly religious. But, as Bodiford explains,

> Throughout the entire evening's performances the Kannon image gazed down from its open cabinet on the actors and audience. The spiritual joy evoked by the revealed image merged with the magic of the drama, illusions, and songs to provide an obvious emotional uplift to the entire crowd. When asked whether the Kannon or the entertainers provided the main attraction of the evening, most villagers refused to make any distinction.[56]

The event was basically a party for the village, with Kannon as the guest of honor. At the previous curtain opening in 1960, when most villagers did not have a television, one was placed before the image, and people

came to watch it every day.[57] Such performances inside the hall itself seem to have been the rule at curtain openings since the medieval period.[58] A curtain opening has often been the occasion for a good time to be had by all, including the statue.

Three Absolute Secret Buddhas

The most dramatic type of secret buddha is the absolute secret buddha (*zettai hibutsu*). These have been seen by nobody for several generations, a fact that calls into question the notion that making images into secret buddhas is largely financially motivated or that it is intended to increase the holiness of the image when it is revealed. Absolute secret buddhas, which began to appear in the Kamakura period, are less common than ordinary secret buddhas, but they are by no means unusual.[59]

The Kannon of Sensōji Temple

Sensōji, one of the oldest temples in Tokyo, is known for the enormous red lantern hanging from its Thunder Gate (Kaminari mon), which appears on the cover of many a guidebook. After passing through that gate, visitors proceed down a long path lined on both sides by small, lively shops selling souvenirs of all kinds. At the end of the path stands the main hall.

The central image of Sensōji temple is Kannon, but she is an absolute secret buddha. The temple's brochure, under the heading "Kanzeon Bodhisattva, the Central Image," states:

> Kannon, among all the buddhas, is the one whose compassion is deepest. She sees people's pain and removes it, hears people's pleas and responds to their desires. She grants pleasures. In particular, the benefits bestowed and miracles wrought by the Kannon who is the central image of Sensōji temple are unrivaled, both today and in the past. During the almost fourteen hundred years from her appearance to the present, she has saved and protected countless human beings.[60]

Nowhere in this section of the brochure is it mentioned that the statue cannot be viewed, but that is not because the temple intentionally misrepresents itself; other sections of the brochure do relate the history of the statue and explain that it is an absolute secret buddha. For those

concerned with the benefits to be gained by praying to the Sensōji Kannon, however, her appearance is irrelevant.

The legendary history of the temple, as related by the brochure, emphasizes the statue's miraculous birth story:

> In the early morning of the eighteenth day of the third month of 638, two brothers were fishing in what is now the Sumida river. Unexpectedly, they saw a Buddhist statue. They showed it to the local mayor, who recognized it as Kannon, took great faith in her and took the opportunity to become a monk, making his own home into a temple, where he enshrined the Kannon statue and worshipped it for the rest of his life.
>
> Later, in 645, the holy man Shōkai visited the temple, built a special hall for Kannon, and, as instructed in a dream, made the image a secret buddha. . . . In the early Heian period, the great master Jikaku revived this temple, and copying the central image he made a stand-in . . .[61]

The brochure also states that the central image enshrined today is the very one found in the Sumida river by the fishermen. The English version of the brochure, however, neglects to mention that the statue cannot be viewed and omits the portion of the legend that tells of the statue becoming a secret buddha.[62]

The first temple history, which dates from 1398, grants even greater agency to the statue than do most modern versions of the legend. In this rendition, when the brothers pulled in their nets, they saw a small gold statue rather than fish. Knowing nothing of Buddhism or Kannon, they threw the image back into the water and moved to another part of the river. Once again, they caught the statue in their net.[63] Realizing that the statue had no intention of leaving, they built a small hall in which to enshrine it and noticed that when they worshipped it, their fishing expeditions were particularly successful. The local governor recognized the statue as Kannon Bodhisattva and became a devotee of the image, erecting a beautiful temple in which to enshrine it. In 645, the holy man Shōkai, who was traveling around Japan, rebuilt the temple, and in a dream the Kannon told him that it wished to become a secret buddha. Thus the Kannon of Sensōji temple became a secret buddha at its own request. In fact, this temple has burned down numerous times over the centuries, so the original image cannot have survived. But, as is the case with images such as the Hasedera Kannon and the Yatadera Jizō, this is unimportant to the devotee.

The stand-in for the Sensōji Kannon, said to have been carved by the famous monk Ennin (794–864), has also become a secret Buddha. The stand-in and the main image reside in the same *zushi*, called a "palace" (*gūden*) by the temple, which is four-and-a-half meters wide, six meters tall, and has two separate "rooms," much like a house. When a curtain opening occurs for the stand-in, the front portion of the zushi is opened, while the back part, which houses the main image, remains forever closed. The stand-in is revealed every year on December 13, and for a longer period once every thirty-three years. Although the main image is said to be barely over five centimeters tall, the large *zushi* no doubt causes worshippers to imagine that the statue fills it. As the sculptor Nishimura remarked, when people see a large *zushi*, they picture a deity of the same size. Nishimura noted that this was true of himself as well, even when he was the one who had carved the statue and was fully aware of its actual size.[64]

The importance of the Sensōji Kannon is such that the temple itself is often called, by synecdoche, Asakusa Kannon (the same two Chinese characters may be read either as "Asakusa" or "Sensō"). The temple holds services of worship for the central image every morning at 6:00 in the summer and at 6:30 in the winter, with additional services at 10 a.m. and 2 p.m. Paper talismans with drawings of the image and metal talismans with a relief of the statue are sold to worshippers. It probably does not occur to the majority of devotees that they are taking home a depiction of a deity they did not actually see. This is a Kannon who is daily enlivened by the community of believers. As an article in a popular magazine for lay Buddhists succinctly put it, "Even though we cannot see it, its power to protect Tokyo is without limit."[65]

Zenkōji Temple: The Amida Triad

Perhaps the most famous absolute secret buddha in all of Japan is that at Nagano City's Zenkōji temple, featured in Western television coverage of the 1998 Winter Olympics. No living person has ever seen the Amida triad that is the temple's central image. The stand-in, which dates to 1195, is also a secret buddha, revealed in a curtain opening only once every seven years. Both statues are regarded as miraculous and powerful. A book written by temple representatives begins with the words "The central image of Zenkōji temple is a living buddha that has the warmth of human skin, speaks to people, and emits the light of wisdom from between his eyebrows."[66]

The legendary birth story of the statue took shape over the centuries and is found primarily in various redactions of the *History of Zenkōji Temple (Zenkōji engi)*, which often take the form of illustrated scrolls.[67] Those texts and drawings tell how the statue originated with a miserly old rich man in ancient India named Gakkai, who in his dotage had a daughter he greatly loved. When an epidemic spread through the country and his daughter became deathly ill, he consulted with every doctor he could find, but none could cure her. Finally he asked Śākyamuni, whom he had previously ignored, for help. Śākyamuni told him to believe in Amida Buddha and his Pure Land. When the miser chanted "Namu Amida Butsu" ten times, Amida Buddha and his two attendants, Kannon Bodhisattva and Seishi Bodhisattva, appeared from the west. Engulfed by the light emitted by Amida, the girl was immediately cured, and the plague that had beset the land vanished.

Out of gratitude, the miser decided to construct statues of the three deities who had appeared. He placed a gold nugget in a pot, and Amida and Śākyamuni radiated light upon it. Out came an Amida triad that looked exactly the same as Amida and his attendants. The rich man built a large temple just for the statues and worshipped them constantly. After the triad had saved everyone in India, it flew to Korea and proceeded to save people there. The emperor of Korea at that time was said to be an incarnation of the rich man Gakkai. Nine generations later, the emperor declared that the image told him it had completed its job of saving the people of Korea and wished to go to Japan. The statue then floated to Japan by sea.

The emperor of Japan gave the image to the Soga clan, which supported the adoption of Buddhism, in opposition to the Mononobe clan, which insisted that worship of foreign deities would anger the native gods. Sure enough, shortly after the Sogas began worshipping the statue, an epidemic spread throughout Japan. The Mononobe clan burned down the Soga family temple and threw the image into a nearby canal.

At this point, a worker in Shinano province named Honda Yoshimitsu, who was yet another incarnation of the miser Gakkai, came to the capital to serve the emperor. As the man proceeded down the canal on his way back to Shinano, the image jumped out of the water of its own accord and landed on his shoulder, expressing its desire to go with him. By day, he carried it on his back; by night, it carried him. When they reached Shinano, he built a little shrine next to his house and worshipped the image there. Every night, however, the statue returned from the shrine to his house. After a while, people began to call his

house Yoshimitsudera temple. ("Zenkōji" is an alternative pronunciation for the characters that read "Yoshimitsudera.") When Yoshimitsu's oldest son, Yoshisuke, died, his grieving parents asked Amida to petition King Enma to allow their son to escape from hell. Their prayers were answered; Yoshisuke returned to life.

Portions of this legend are vividly illustrated in a cartoon book published by the temple. In one dramatic drawing, the statue lies invisible under water, and the bubble in which its words are enclosed comes out of the canal. The statue says, "I came to Japan to save those people who are suffering. I have been waiting in this canal a long time for you to come." Yoshimutsu fishes the statue out of the water and exclaims, "Oh! This is definitely a statue of Amida." He kneels before the image, which then informs him, "You are a person with a deep karmic connection to me. Take me back with you to Shinano."[68]

One of the most striking parts of this legend is the conflation of the Zenkōji temple image with the first Buddhist statue in Japan, sent from the king of the Korean kingdom of Paekche in the year 538, as related in the 720 *Chronicles of Japan* (*Nihon shoki*). That identification appears to have been made relatively early in the statue's long history. For example, the early thirteenth-century *Tale of Heike* (*Heike monogatari*) relates:

> Around that time, word spread that Zenkōji temple had been destroyed by fire. As regards that temple's Buddha: there was a certain Amitābha triad sixteen inches tall, the most precious set of images in the entire world, which the Buddha, the holy Maudgalyānana, and the Elder Somachatta had had made long ago, using Jambudvīpa river-gold obtained from the Nāga Palace, in accordance with a suggestion put forward by Somachatta when the Five Dread Evils were claiming innumerable lives in the central Indian land of Śrāvastī. The Amitābha statue stayed in India for more than five hundred years after the Buddha's death; then it moved to Paekche as a natural consequence of the eastward diffusion of the dharma; and then, a thousand years later—during the reigns of King Sóngmyŏng in Paekche and Emperor Kinmei in Japan—it came from that country to our land, where it remained on the seacoast at Naniwa in Settsu. Because it diffused a golden radiance, the era was named Golden Light (Konkō).
>
> Early in the Third Month in the third year of Konkō, a resident of Shinano Province, Ōmi no Honda Yoshimitsu, went to the capital, saw the image, and forthwith prevailed on it to go home with him. By day, he carried it on his back; by night, it carried him; and

when he reached Shinano he enshrined it at a place in Minochi District. In all the more than five hundred and eighty years since, there had never been a fire there.[69]

Although the image is an absolute secret buddha, its iconography is well known because, like the Seiryōji temple Śākyamuni, the Zenkōji Amida inspired numerous replicas that still live in various temples throughout Japan, many of which are thought to have been produced before it became a secret buddha. Probably constructed of gilt bronze, the central image displays an unusual iconography not generally seen in Japan. Many scholars believe it to have been imported from Korea at some point in the late sixth or early seventh century.[70] Others, however, argue that it was constructed around the eighth century in Japan. In any case, it is unlikely that it dates as far back as the mid-sixth century as in the legend. Nevertheless, a guidebook written by the temple states unequivocally that this is the oldest statue in Japan.[71] Since no one can view the image, this assertion cannot be disproved.

The first replica of the Zenkōji Amida is said to have been made in the Kamakura period by Jōson, a devout monk who had learned all the sutras by heart when still a boy. One night, he dreamed that a monk appeared to him and said, "I am a messenger of the Zenkōji Buddha. Go to Zenkōji temple immediately." Jōson did so, and spent three months ensconced in the temple, reading sutras every day. On the night of the fifteenth day of the tenth month, the three layers of doors protecting the statue suddenly opened of their own accord, and the central image appeared in a flood of bright light, proclaiming, "I want to help all the living beings in Japan. Hasten to raise funds from all the people, and construct images in my exact likeness." Jōson made a sketch of the statue and then constructed a triad of Amida, Kannon, and Seishi that was exactly the same as the one he had seen. That statue, just like the original, healed people and caused the blind to see; when disaster struck, it even perspired.[72]

The most important copy, of course, is the stand-in for the Zenkōji main image, which was made in the Kamakura period and is said to be a manifestation (*keshin*) of the main image.[73] Traveling curtain openings for this stand-in began to be held regularly in the Edo period, the first in 1692. They were such a success that the mother of the military ruler (*shōgun*) requested that the image be brought to her own home.[74] For residential curtain openings, worshippers often traveled long distances and would spend the night in Zenkōji temple in front of the stand-in itself, a custom that continued through the Edo period. At a curtain

opening in 1847, when the hall was filled with worshippers spending the night in front of the stand-in, an enormous earthquake struck a little after 11 p.m., violently shaking the hall.[75]

In modern Japan, there is a rumor that the *zushi* said to hold the central image is actually empty. The temple's guidebook, of course, refutes that contention, pointing out that once a year, on December 28, five monks clean the *zushi* and practice carrying it, a procedure they would have to conduct in case of fire. These monks report that the *zushi* is so heavy they can barely lift it. Surely, they say, the *zushi* itself could not account for all that weight. There must be a metal statue inside.[76]

The *zushi* in which the central image lives sits at the back of the temple's main hall, toward the left, the west side, which is the location of the Pure Land. The altar on which it stands is called the Lapis Lazuli Altar (Ruridan); in front of it hangs a brocade curtain depicting a phoenix and a dragon. Visitors to the temple cannot, however, see the *zushi*. Most temples have an outer worship area (*gejin*) and an inner worship area (*naijin*), with the inner area accessible only to monks. Zenkōji temple has an inner inner worship area (*nai naijin*), physically removing the worshipper even further from the image. Nevertheless, every morning and evening a monk makes offerings in front of the *zushi* and cleans the area around it.

Worshippers get the opportunity to connect physically with the image during the curtain opening of its stand-in, once every seven years. The stand-in, contrary to what the term *maedachi* would suggest, actually lives in a separate building at all times other than the curtain opening. I was told by a guide at the Zenkōji Information Center that only two people have keys to that building: one a monk of the Tendai school and the other a monk of the Jōdo school. Although the temple itself is not affiliated with any particular school of Buddhism, monks representing those two schools are in charge of guarding the stand-in. The day before the curtain opening, the image is transported with great ceremony in a palanquin to the main hall. A similar ritual takes place when it is brought back to "rest" until the next time it is displayed.[77]

During the curtain opening, the stand-in, in its *zushi*, stands directly in front of the *zushi* that houses the main image. Worshippers are allowed to see it during the fifty days of the curtain opening, but they cannot, of course, touch it. Nevertheless, they can have physical contact with the stand-in through the Pillar of Merit Transfer (Ekō bashira), a huge pole erected in front of the main hall that weighs about three tons and is ten meters tall and forty-five centimeters wide on each side.[78] One end of an extremely long cord is attached to the right hand of the stand-in, and the other to the pillar. By touching the huge pillar, worshippers are

able to form a direct, physical karmic connection with the Zenkōji Amida. In 1992, almost four million people visited the temple during the curtain opening, which lasted from April 4 to May 26.[79] They stood in line for long periods to see the stand-in and crowded around the Pillar of Merit Transfer for the chance to make that physical connection.

The unveiling of the pillar itself constitutes a major ceremony. When the cloth veiling it is removed, a gasp emerges from the crowd. The pillar is sometimes referred to as a stupa, further illustrating its association with the living body of a buddha. In fact, the curtain opening at this temple is also referred to as the "transfer of merit" (goekō).[80] The practice of erecting a pillar, with a cord running from the pillar to the deity, is not uncommon during modern curtain openings. I also saw this done with an Amida statue at Shinnyodō Hall in Kyoto.

Even if the worshipper cannot visit during the time of a curtain opening, the temple offers numerous ways to form karmic connections with its central image. The most popular is the Platform Pilgrimage (Kaidan meguri), in which the devotee descends a narrow staircase into a pitch-dark tunnel under the inner inner altar. She then walks slowly down the tunnel, using only her hands for guidance, searching for a heavy iron "key" on the wall. This key, which has the shape of a latch, is said to be the key to the Pure Land; the worshipper who, upon finding it, pulls it up and down, is assured of birth in the Pure Land. I can attest to the fact that it is entirely possible to go through the tunnel without finding the key. When I reached the end of the tunnel, I had to backtrack, thereby running into many people, who luckily could not see that I was a bumbling foreigner.

The temple states that this key is located directly under the secret buddha. What does it mean to form a connection with the Buddha of limitless light by fumbling around in the dark? Among the many explanations, the most common holds that entering the pitch-black tunnel is akin to experiencing death, and emerging from it, after encountering Amida Buddha, is a restoration to life, just as took place with Yoshisuke. One elderly woman said that when she was in the dark tunnel, her son who had been killed during the war appeared, took her hand, and guided her through to the end.[81]

The Two Kannons of Tōdaiji Temple's
Second-Month Hall (Nigatsudō)

The Nara temple Tōdaiji, on the circuit of most tourists making the rounds of temples in Kyoto and Nara, is famous for housing the

enormous Great Buddha in its main hall. But many of its other buildings are also home to statues, including the Second-Month Hall (Nigatsudō), which enshrines two absolute secret buddhas: the Large Kannon (Ōgannon) and the Small Kannon (Kogannon). Second-Month Hall generally goes unnoticed; laypeople are rarely allowed to enter, and women are forbidden from ever going in. But on March 1–14, an extended ritual called the Water-Gathering (Omizutori) attracts hordes of tourists and worshippers.[82]

Second-Month Hall stands on a steep hill, and the most spectacular part of the proceedings for the casual observer takes place on March 12, 13, and 14, when enormous torches made of pine branches are carried along the front veranda of the hall, several meters above the crowd. Because this is performed after sunset, visitors cannot see the monks who are carrying the torches. Great balls of fire appear to dance their way down the corridor, sometimes dangling over the edge of the veranda and the crowd below. Onlookers attempt to catch the falling sparks, a dangerous pursuit that sometimes results in burns. Catching one and keeping the ashes is considered good luck, so much so that at the end of the ceremony people scour the ground to find leftover ashes. This fire ritual and its accompanying excitement may be the only thing that many people associate with the Water-Gathering ritual. It is so popular that every year, the television news programs in western Japan show footage of the balls of fire hovering above the crowd. The term "Water Gathering" came to replace the ceremony's proper title, Second-Month Practices (Shuni-e), because deep in the night of March 12, water is gathered from a well at the base of the hill on which the hall stands, offered to the Kannons, and then distributed to those present.

In fact, the entire purpose of all the ceremonies associated with the Water-Gathering ritual, including the torch carrying and the water gathering, is worship of the two central deities of the hall, the Large Kannon and the Small Kannon. This ritual is said to have been conducted every year, without interruption, since it was begun in 752.[83] The legendary origin of the hall, as related in the *History of the Second-Month Hall* (*Nigatsudō engi*), centers on the monk Jitsuchū (b. 726), a disciple of Tōdaiji temple's founder, who discovered an Eleven-Headed Kannon, a "living" statue, floating in the ocean and built the Second-Month Hall specifically to enshrine it. This Kannon is believed to be the Small Kannon now enshrined at Second-Month Hall. There, in the second month of the year, Jitsuchū held an Eleven-Headed Kannon rite of repentance in front of the statue. This is said to have taken place in 752, the same year that Tōdaiji temple's Great Buddha was consecrated.

In eighth-century Japan, monks conducted a number of different repentance rites, each of which focused on a particular deity. The time of these rites depended on the deity in question. The twelfth month, for example, was for rites of confession to Yakushi Buddha, while repentance rituals in the first month centered on a female deity called Kisshōten. Repentance rites in the second month were to the Eleven-Headed Kannon. A special building, called Repentance Hall (Kekadō), was often constructed for these ceremonies.[84]

The Water-Gathering ritual involves repentance before the Large and Small Kannons. In a Buddhist context, repentance rites do not usually entail individual confessions of wrongdoing, as is often the case in Western religions. Rather, participants engage in a number of demanding ascetic rituals that have the overall goal of purification of body and mind.[85] During the two-week Water-Gathering ceremony, all of the religious activities in which the monks engage fall under the general rubric of repentance rites. The most dramatic of the ascetic exercises, at least from the point of view of the visitor who cannot enter the Second-Month Hall, is that in which the monks repeatedly throw their bodies on the hard wooden floor (*gotai tōchi*). Those standing at the bottom of the hill under the hall listen in awe to the sound of the weight of human bodies slamming into the floor. When not performing one of the six daily rituals in the unheated Second-Month Hall, the monks are housed in a nearby hall where they eat only one meal each day and are not allowed contact with outside monks.

In the medieval period, this ceremony was performed in a similar manner. In his *Journal of Pilgrimage to the Seven Great Temples*, composed in 1140, Ōe no Chikamichi briefly described what he termed "the ceremony of the Second-Month Hall," explaining that fifteen or sixteen monks were sequestered in Second-Month Hall for twenty-seven days, beginning on the first day of the second month. Inside the hall, they engaged in demanding ascetic exercises and recited statements of devotion to Kannon Bodhisattva. On the night of the fourteenth day, they performed a *taimatsu*, or igniting of branches of wood. He added that the ritual had always been performed every year, without fail.[86]

Chikamichi also mentioned a statue that is thought to correspond to the Small Kannon, stating that on the first day of the ritual, a "small *zushi*" was removed from the Second-Month Hall's treasure house and lifted to a platform in the main hall in front of the central image. Inside this *zushi*, he continued, there was said to be a statue of the Eleven-Headed Kannon.[87] Today, both statues live in the same hall, but at Chikamichi's time, the Large Kannon was the central image, and the

Small Kannon merely visited during the ritual as a "guest buddha" (*kyakubutsu*).

It is not known when these two statues became absolute secret buddhas, but before the thirteenth century, several texts, including iconographic manuals, described them, indicating that at that time they could still be viewed. The *Notes of Kakuzen* (*Kakuzen shō*), for example, provided sketches of the heads of both images.[88]

The fourteenth-century *Interpretive Text of the Genkō Era* (*Genkō shakusho*) related a story that is thought to pertain to the current Small Kannon. It told of Jitsuchū visiting one of the Buddhist heavens, Tuṣita (J. Tosotsu), and witnessing a ritual in honor of Kannon. He wished to practice the same ritual in this world, but he did not have the statue he needed to do so. Finally, after much prayer, he saw an image of Eleven-Headed Kannon appearing from the direction of Fudaraku, Kannon's Pure Land, across the waters of the Naniwa Canal. It was of gilt bronze, about twenty-one centimeters tall, and seemed to have the warmth of human skin.[89]

A fourteenth-century illustration of the *Mandala of the Second-Month Hall* (*Nigatsudō mandara*) depicted the outside of the Second-Month Hall from above, with an Eleven-Headed Kannon seeming to descend on a cloud over the roof. The iconography of the Kannon in this picture, however, does not match that mentioned in the earlier iconographic manuals, suggesting that by this time, both Kannons had become secret buddhas.[90]

The Large Kannon is thought to be a life-size statue of gilt bronze dating to the early eighth century. An illustration of this statue's head appeared in the *Notes of Kakuzen*. Moreover, portions of its halo are now in the possession of the Nara National Museum. When the Second-Month Hall burned in the year 1667, the Small Kannon escaped injury, but the Large Kannon suffered serious damage. The halo for the head broke into twenty pieces and that for the body into sixty-seven.[91]

Today, both statues are regarded as the central image of Second-Month Hall. The Large Kannon sits in a *zushi* on a platform in the center of the inner hall. The Small Kannon's *zushi* is usually placed in front of that of the Large Kannon, suggesting that the Small Kannon is a stand-in for the Large Kannon, but the Small Kannon is actually thought to be the older of the two. Moreover, in the temple fires of 1180 and 1667, the Small Kannon was the first to be rescued, further indicating that this image was the central one.[92] The small Kannon resides in a doorless *zushi* that looks like a palanquin, and it is said that there are several further layers of *zushi* inside the outer one.

The ceremony is divided into two periods of seven days. The Large Kannon is the focus of the first seven days, while the Small Kannon is the focus of the second period. Although the Small Kannon is usually enshrined in a *zushi* in front of the large one, for the first seven days of the Water-Gathering ritual, its *zushi* is placed behind that of the Large Kannon. At sunset on the seventh day, the *zushi* of the Small Kannon is moved briefly into a nearby small hall and then, in the middle of the night, is transferred to the front of the *zushi* of the Large Kannon. In a sense, then, the Water-Gathering rite is made up of two smaller rituals, each centered on a different Kannon image.

The eleven monks who participate in this ritual are chosen by the temple several months in advance, and their names are announced December 16. To be chosen is an honor, but as befits participants in a rite of repentance, they must undergo strict supervision and difficult austerities from the moment their names are announced. They must live separately from all the monks who will not be part of the ritual, and they are absolutely forbidden to go near Second-Month Hall. In late February, they move to a temporary residence near Second-Month Hall, and the ceremony begins on March 1.[93]

During the fourteen days of the Water-Gathering, these select monks engage in ascetic practices day and night. According to an eighty-year-old monk who has participated in the ritual numerous times over the past forty years, the monks taking part in the ritual do not consider the images to be two separate Kannons; they are both simply the Kannon of the Second-Month Hall.[94] Moreover, the elderly monk explained that although other people may think of this Kannon as deeply compassionate and gentle, for the monks engaged in the rituals of the Water-Gathering ceremony, she is a very stern deity indeed. For example, even though the monks are undergoing difficult ascetic exercises, they are not allowed to drink any water after noon. Although it would be fairly easy for them to drink water without being caught, they fear Kannon so much that they dare not break the rules, and feel that she is always watching them, even more so because they cannot see her.[95]

Conclusion

In this book, I have established that in Japan the physical appearance of a statue is often inconsequential to those who worship it. To the devotee, the statue's identity is that of an individual with a history, personality,

and certain propensities. There are times when we judge other people solely by their appearances, but such judgments are shallow, and in many cases we form our expectations of others without knowing anything at all about their physical characteristics. By the same token, the interactions that people have with statues in Japan are often based on factors beyond those visible to the eye.

Why, then, has it generally been accepted by scholars that the significance of a Buddhist statue lies in its appearance: the mudra its hands form, the expression on its face, the drape of its clothing, and similar issues? Perhaps this is because Western art historians were the first to take Japanese Buddhist statues as a serious object of academic study. They naturally wished to know the identities of the figures represented, for it was by names such as Shaka, Kannon, and Jizō that the objects could be categorized and explained. They were further concerned with issues such as the time period when an image was made, the sculptor and his style, and the all-important question (for museums and collectors) of its authenticity. Icononography, the materials used and matters of artistic style could all provide valuable clues as to an image's provenance.

The field of Buddhist Studies at large has traditionally been concerned with philological examinations of so-called orthodox texts, and with questions regarding their philosophical contents. It has only been within the past decade or two that scholars in the field of Buddhist Studies have turned their attention more toward material culture. With that development, their research interests began to intersect with those of Asian art historians, at least in the sense that both were now looking at images. Many scholars of Buddhism began to focus on the ritual function of images and portraits, and on the contents of the inscriptions that they sometimes bore.[96] However, there is still a tendency for such studies to focus somewhat on a statue's appearance, as if that were necessarily connected with its "meaning" in a ritual or devotional context. Scholars have also concentrated on statues in monastic settings, perhaps because that topic can still be approached through examination of orthodox "religious" texts, albeit those dealing with ritual.

In Japan, a country where most statues in temples cannot be clearly seen, if indeed they are visible at all, the significance of Buddhist images must lie not only in their appearance but also in their history as "individuals." I do not deny that, in many cases, the appearance of a statue is extremely important. In discussing the naked Jizō statues, for example, I have assumed that much of their significance revolved around the fact that they are sometimes unclothed. Even in these cases,

however, I speak of the statues in question in the same manner that I would speak of a person. If a person were to appear naked in a public setting, that would almost certainly be the most interesting thing about him at that moment. In general, however, I present few details about an image's physical appearance, concentrating for the most part on other aspects of its identity.

My findings in this book can help us better understand Japanese Buddhism, but they also have implications for the study of religion in general. Most studies of images and their function in Christianity, for example, also focus almost exclusively on their physical appearance, positing those as the locus of meaning and power. In Japan, the importance of statues as individuals with whom both monastics and the laity maintain ongoing relationships continues to the present day. Although many Japanese claim not to be religious, Buddhist statues of every shape and size, including those that cannot be viewed, are enlivened on a daily basis by the community of worshippers. This will continue to be the case as the biographies of existing statues expand and new images are born. The landscape of Japanese religious practice is indeed changing in the modern period, and books and videos such as Miura Jun and Itō Seikō's *Record of Seeing the Buddhas* series may serve as the contemporary equivalents of early medieval collections of legends such as *Tales of Times Now Past*. Moreover, most major temples now have Internet home pages that relate miraculous stories associated with their central images, and fans of particular types of Buddhist statues meet on the World Wide Web to share their enthusiasm. But far from replacing visits and devotion to Buddhist statues, this has led to increased interest in images as individuals rather than merely objects of art and has further enlivened the countless Buddhist statues that find their home in Japan.

One final example may serve to illustrate the relationship many Japanese still have today with Buddhist statues. In the spring of 2005, I took a tour, led by a monk, of the Zaōdō Hall of Kinpusenji temple in rural Nara prefecture. As he showed us a large statue of the deity Zaō Gongen, he explained that the statue had just returned after having been a "guest buddha" (*kyakubutsu*) at several museums. Upon its homecoming to Zaōdō Hall, the monk continued, the other deities in the hall welcomed him with great, crashing thunder and lightening. One of the local women in the group muttered, as if to herself, "But of course." To this woman, it did not matter when the statue was made, how its iconography could be interpreted, or what type of monastic ritual it may have starred in. To her, it was a local deity who lived in that temple and

was welcomed home by his friends after an absence. Such is the life of a Buddhist statue in Japan. It is my hope that future studies of Buddhist images in Japan will focus more broadly on such issues of identity, rather than narrowly concentrating on the physical appearance of statues and paintings.

NOTES

One Introduction: Living Buddhist Statues

1. Donald Lopez, "Introduction: Buddhism," in *Religions of Asia in Practice*, ed. Donald S. Lopez, Jr. (Princeton: Princeton University Press, 2002), 169.

2. The Sino-Japanese character *butsu* in such a case can refer to either a sculpted or a painted image. Sometimes it can be discerned as one or the other from context; sometimes this remains unclear.

3. Richard Davis, *Lives of Indian Images* (Princeton: Princeton University Press, 1997), 8–9.

4. Ibid., 11.

5. The following discussion is based on Nishimura Kōchō, *Butsuzō wa kataru* (Tokyo: Shinchōsha, 1990), 156–159.

6. Today, this image resides in Tōji temple's museum, which is open for a limited period every year in fall and spring.

7. Nishimura, *Butsuzō wa kataru*, 159.

8. James H. Foard, "The Tale of the Burned-Cheek Amida and the Motif of Body Substitution," *The Japan Foundation Newsletter* 26 (Nov. 1998): 8.

9. For an outline of the major issues surrounding religious images and their relationships to humans, see David Freedberg, *The Power of Images: Studies in the History and Theory of Response* (Chicago: University of Chicago Press, 1989). An intriguing analysis of one aspect of this relationship, what it might mean to "see" the Buddha in an Indian Buddhist context, is presented in Malcolm David Eckel, *To See the Buddha: A Philosopher's Quest for the Meaning of Emptiness* (Princeton: Princeton University Press, 1992).

10. D.T. Suzuki, *An Introduction to Zen Buddhism* (1934; rpt., New York: Grove Press, 1964), 39.

11. Carlyle Adler, "Dazzled by Demons," *Time Asia* 164, no. 24 (Dec. 13, 2004): 54.

12. T 51: 880b4–9. Translation from Samuel Beal, trans., *Si-yu-ki: Buddhist Records of the Western World* (1884; rpt., New York: Paragon Book Reprint Corp., 1968), 1: 103.

13. For Xuanzang's account, see T 51: 898a6–16, and the English translation in Beal, 1: 235–236. For Faxian's narrative, see *Gaoseng Faxian zhuan* in T 51: 860b18–23 and the English translation in James Legge, trans., *A Record of Buddhistic Kingdoms: Being an Account by the Chinese Monk Fa-Hien of His Travels in India and Ceylon (A.D. 399–414) in Search of the Buddhist Books of Discipline* (1886; rpt., New York: Dover, 1965), 56–57. For a discussion of the historical accuracy of Xuanzang's account and of his interest in miraculous images, see Robert L. Brown, "Expected Miracles: The Unsurprisingly Miraculous Nature of Buddhist Images and Relics," in *Images, Miracles, and Authority in Asian Religious Traditions*, ed. Richard Davis (Boulder: Westview Press, 1998), 24–27.

14. *The Long Search: Footprints of the Buddha* (New York: Time Life Video, 1977).

15. Richard Gombrich, "The Consecration of a Buddhist Image," *The Journal of Asian Studies* 26, no. 1 (Nov. 1966): 24–25. For detailed descriptions of eye-opening ceremonies in Thailand, also a Theravāda country, see Donald Swearer, *Becoming the Buddha: The Ritual of Image Consecration in Thailand* (Princeton: Princeton University Press, 2004).

16. Davis, *Lives of Indian Images*, 13. For an in-depth discussion of the agency for the miracles performed by Buddhist images, see Robert L. Brown, "The Miraculous Buddha Image: Portrait, God, or Object?" in *Images, Miracles, and Authority in Asian Religious Traditions*, ed. Richard Davis (Boulder: Westview Press, 1998), 37–54.

17. Deitrich Seckel, *Buddhist Art of East Asia*, trans. Ulrich Mammitzsch (Bellingham, WA: Western Washington University, 1989), 189. The original work in German was first published in 1957.

18. Ibid., 194.

19. Robert H. Sharf, "Prolegomenon to the Study of Japanese Buddhist Icons," in *Living Images: Japanese Buddhist Icons in Context*, ed. Robert Sharf and Elizabeth Horton Sharf (Stanford: Stanford University Press, 2001), 18.

20. The probable reason this statue became associated with mothers is that it contains, in its hollow wooden body, a smaller Yakushi statue. Thus, like a mother, it carries a living being inside its "womb." This detail, however, is unknown to most of the statue's devotees.

21. See, for example, T. Griffith Foulk, "Religious Functions of Buddhist Art in China," in *Cultural Intersections in Later Chinese Buddhism*, ed. Marsha Weidner (Honolulu: University of Hawaii Press, 2001), 13.

22. In Japan, a ritual called *misogi*, which involves blessing the wood just before carving begins, rivals the eye-opening ceremony in importance, at least among monastics. It is not well known, however, among laypeople, and has not been widely studied by scholars.

23. The following discussion is based on Nishimura, *Butsuzō wa kataru*, 94–97.

24. This gesture is the same as that of the Christians, although the two are not related in origin.

25. Nishimura, *Butsuzō wa kataru*, 94–96.

26. Freedberg, *Power of Images*, 96.

27. The Japanese term *butsuzō*, or buddha image, is often used informally to refer to a statue of any deity, whether it belongs to the Buddhist or the Shintō pantheon. This is more reasonable than it may at first sound, because in some cases, the deity may have developed through influence from both traditions, and may not easily be classified as belonging exclusively to either.

28. Watsuji Tetsurō, *Koji junrei* (1918; rpt. Tokyo: Iwanami Shoten, 1979).

29. Itō Seikō and Miura Jun, *Kenbutsuki* (Tokyo: Kadokawa Shoten, 1993). The term "seeing the buddhas" (*kenbutsu*; Ch. *xianfo*) occurs frequently in classical Chinese Buddhist texts. It is, however, unlikely that Itō and Miura were aware of that fact, and even more improbable that their readers know this. For them, the word functions as a clever pun.

30. *Otera ni ikō!* ed. Kojima Dokkaan and Mikami Ken'ichi (Tokyo: Fusōsha, 2004), 8.

31. Hana, *Chiisai butsuzō, ōkii butsuzō* (Tokyo: Tōkyō Shoseki, 2003), 30.

32. Ibid., 60.

33. SNKBT 30: 81. For an English translation, see Kyoko Motomochi Nakamura, trans., *Miraculous Stories from the Japanese Buddhist Tradition: The Nihon Ryōiki of the Monk Kyōkai* (Cambridge, MA: Harvard University Press, 1973), 178.

34. Nishimura Kōchō, *Butsuzō no koe* (Tokyo: Shinchōsha, 1995), 160.

35. See Royall Tyler, *Japanese Tales* (New York: Pantheon Books, 1987), xix, for a discussion of the development of tale literature.

36. James Foard, "Ippen Shōnin and Popular Buddhism in Kamakura Japan" (Ph.D. diss., Stanford University, 1977), 51.

37. SNKBT 42: 5. Translation from D.E. Mills, trans., *A Collection of Tales from Uji: A Study and Translation of Uji Shūi Monogatari* (Cambridge: Cambridge University Press, 1970), 83.

38. SNKBT 30: 4. For an English translation, see Nakamura, *Miraculous Stories from the Japanese Buddhist Tradition*, 101.

39. Nakamura, 35.
40. Foard, "Ippen Shōnin and Popular Buddhism in Kamakura Japan," 40.
41. The system itself derives from early orthodox scripture such as the *Mahāvairocana sūtra*, which discusses each category in roughly the order we find them now, although it does not explicitly state that they are a system (Mimi Hall Yiengpruksawan, "Buddha's Bodies and the Iconographical Turn in Buddhism," in *Buddhist Spirituality: Later China, Korea, Japan, and the Modern World*, ed. Takeuchi Yoshinori [New York: Crossroad Publishing Company, A Herder & Herder Book, 1999], 407).
42. The exact dates of Śākyamuni Buddha are a matter of much dispute. Traditionally, he is thought to have died between 486 and 477 BCE, but the Theravāda tradition assigns a date about one hundred years earlier, while some in Japan argue for a date about one hundred years later.
43. Yiengpruksawan, "Buddha's Bodies," 410.

Two Śākyamuni: Still Alive in This World

1. Traditionally, the date for this rite was the eighth day of the fourth month according to the lunar calendar; it has been celebrated in April since the adoption of the Western (Gregorian) calendar in the Meiji period.
2. Note that monasteries are different from ordinary temples. The Zen school in Japan, for example, has about 21,000 temples all over the country, but only 60 monasteries. The priests of ordinary temples are focused on serving the needs of lay parishioners, mainly by performing funerals and memorial services. Monasteries, on the other hand, are training grounds for those who will become temple priests, and thus are the site of the most involved daily ritual activity. The Flower Festival celebrations attended by most laypeople occur at ordinary temples, not monasteries.
3. Sōtōshū Shūmuchō Kyōkabu, ed., *Shōwa shūtei, Sōtōshū gyōji kihan* (Tokyo: Sōtōshū Shūmuchō, 1988), 131. Translated by T. Griffith Foulk, *Standard Observances of the Sōtō Zen School* (Forthcoming). I am grateful to Professor Foulk for providing his translation.
4. Ibid. Tathāgata is an honorary epithet for the Buddha, literally meaning "thus-come one."
5. Ibid., 133.
6. *Gasshō* refers to the joining of the two palms in prayer, which is also a gesture of respect.
7. The Sumeru altar is the central platform of a Buddhist altar upon which the main image is placed. In Buddhist cosmology, Mt. Sumeru is the large mountain in the center of the universe.
8. Sōtōshū Shūmuchō Kyōkabu, ed., *Shōwa shūtei, Sōtōshū gyōji kihan*, 115.
9. A dramatic photo of the contents of the statue at the moment the cavity was uncovered may be found in George Henderson and Leon Hurvitz, "The Buddha of Seiryoji: New Finds and New Theory," *Artibus Asiae* 19, no. 1 (1956): 9.
10. Shimizu Mazumi, *Butsuzō to hito no rekishi hakken: taimu kapuseru ga hikarete* (Tokyo: Ribun Shuppan, 2000), 85–86.
11. Bijutsushi Gakkai, ed., *Besson Kyōto butsuzō zusetsu* (Kyoto: Usui Shobō, 1943), 40–44.
12. In Buddhist cosmology, several levels of heavens exist above the earthly dwelling-place of humans. While these heavens are a more comfortable abode than is this world, they still are part of the cycle of rebirth and suffering. The Buddha's mother is said to have died shortly after giving birth to him and was reborn in the second of the heavens, the Heaven of Thirty-Three (Sk. Tranyastriṃśas). Since she missed the opportunity to hear her son preach, he is said to have ascended to this heaven for several weeks to preach to her.
13. T 51: 860b18–23. Translation from James Legge, trans., *A Record of Buddhistic Kingdoms: Being an Account by the Chinese Monk Fa-Hien of His Travels in India and Ceylon (A.D. 399–414) in Search of the Buddhist Books of Discipline* (1886; rpt., New York: Dover, 1965), 56–57, slightly

modified. The Buddha attained nirvana with remainder when he reached enlightenment at the age of thirty-five under the bodhi tree. ("Remainder" refers to his physical body, the remainder of past karma, which will be present until his death.) Upon dying, the Buddha enters nirvana without remainder (*parinirvāṇa*).

14. T 51: 898a12–14. Translation from Samuel Beal, trans., *Si-yu-ki: Buddhist Records of the Western World* (1884; rpt., New York: Paragon Book Reprint Corp., 1968), 1: 235–236, slightly modified.
15. For an exhaustive overview of legends regarding the Udāyana statue, see Martha L. Carter, *The Mystery of the Udayana Buddha* (Napoli: Istituto Universitario Orientale, 1990).
16. SNKBT 40: 11–14.
17. Seiryōji, "Saga Shakadō, Godaisan, Seiryōji" [brochure, n.d.].
18. SNKBT 40: 12.
19. SNKBT 40: 4.
20. Much of the scroll is reproduced in *Shaka shinkō to Seiryōji: tokubetsu tenrankai*, ed. Kyōto Kokuritsu Hakubutsukan (Kyoto: Kyōto Kokuritsu Hakubutsukan, 1982), 68–75. The entire scroll can be seen in *Shaji engi e*, ed. Nara Kokuritsu Hakubutsukan (Tokyo: Kadokawa Shoten, 1974), 274–308.
21. See *Shaka shinkō to Seiryōji*, 75.
22. Ibid., 72.
23. Seiryōji, "O-Minuguishiki yurai" [brochure, n.d.].
24. Itō Seikō and Miura Jun, *Kenbutsuki* (Tokyo: Kadokawa Shoten, 1993), 255.
25. The name of the tune that Miura has the Seiryōji Śākyamuni singing is "Rokuharamita Blues" (257). *Haramita* is the Japanese transliteration of the Sanskrit *pāramitā*; *roku* means six. The six *pāramitā*s are stages through which a bodhisattva must progress on the way to enlightenment, according to orthodox Buddhist doctrine.
26. Hana, *Chiisai butsuzō, ōkii butsuzō* (Tokyo: Tōkyō Shoseki, 2003), 59–60.
27. T 9: 43c6–13. Translation from Burton Watson, trans., *The Lotus Sutra* (New York: Columbia University Press, 1993), 231, slightly modified.
28. T 14: 538c4–539a5. An English translation may be found in Burton Watson, trans., *The Vimalakirti Sutra* (New York: Columbia University Press, 1997), 29–31.
29. SNKBT 25: 244. Numinous Mountain is one of the Japanese terms for Vulture Peak.
30. SNKBT 56: 57–58.
31. SNKBT 30: 49–50. Translation from Kyoko Motomochi Nakamura, trans., *Miraculous Stories from the Japanese Buddhist Tradition: The Nihon Ryōiki of the Monk Kyōkai* (Cambridge, MA: Harvard University Press, 1973), 148.
32. SNKBT 30: 105. Translation from Nakamura, *Miraculous Stories from the Japanese Buddhist Tradition*, 199, slightly modified.
33. SNKBT 30: 105–106. Translation from Nakamura, *Miraculous Stories from the Japanese Buddhist Tradition*, 199.
34. SNKBT 31: 181. Translation from Edward Kamens, trans., *The Three Jewels: A Study and Translation of Minamoto Tamenori's Sanbōe* (Ann Arbor: Center for Japanese Studies, University of Michigan, 1988), 307, slightly modified.
35. This will is found in *Important Records of Tōdaiji Temple* (*Tōdaiji yōroku*), ZZGR 11: 69.
36. Moritaka Matsumoto, "The Iconography of Shaka's Sermon on Vulture Peak and Its Art Historical Meaning," *Artibus Asiae* 53, nos. 3–4 (1993): 369.
37. DNKK, *Shōyūki* 5: 30 (Kannin 2/1018.5.11).
38. DNKK, *Chūyūki* 4: 71 (Jōtoku 2/1089.10.12).
39. DNBZ 120: 7. Translation from Matsumoto, "The Iconography of Shaka's Sermon on Vulture Peak," 370, modified. Statues of Yakushi Buddha in Japan are often accompanied by twelve guardian "generals."
40. DNBZ 120: 16.

41. Ryōzen'in literally translates as Numinous Peak Hall. Another common term for Vulture Peak in Japan was Ryōjusen, which literally translates as Numinous Eagle Peak. Enryakuji temple has three main sectors: the East Pagoda (Tōtō), West Pagoda (Saitō), and Yokawa. Yokawa is the most remote, but in the early medieval period it was the center of activity for a number of religious fellowships that were to profoundly influence the evolution of Japanese Buddhism.

42. GR 14: 516–517.

43. Nakano Satoshi, "Reigen butsu toshite no Daianji Shaka nyorai zō," *Nihon no geijutsu* 249 (Mar. 2000): 93.

44. Kawasaki Yasuyuki, *Genshin*, Nihon no meicho 4 (Tokyo: Chūō Kōronsha, 1972), 391–402, gives an annotated version of this list, providing brief information for those names that are identifiable.

45. ZGR 8.3: 476.

46. *Mainichi sahō, Heian ibun*, 13 vols., ed. Kodaigaku Kyōkai and Kodaigaku Kenkyūjo (Tokyo: Kadokawa Shoten, 1994), 11: 267.

47. The *Hōshakkyō* (Sk. *Mahāratnakūṭa sūtra*) is a compendium of forty-nine separate sutras.

48. This translation is based on the text found in *Dai Nihon shiryō*, 320 vols., ed. Tōkyō Daigaku Shiryō Hensanjo (Tokyo: Tōkyō Daigaku Shuppankai, 1922–present), vol. 2, no. 5: 906–908.

49. ESZ 5: 665.

50. His other major legacy was the newest imprint of the Chinese version of the Buddhist canon (Tripiṭaka) that he brought to Japan, which he had been given by the Song ruler, and which became the template for many future generations of canon transcription in Japan.

51. Henderson and Hurvitz, "The Buddha of Seiryoji," 48.

52. Translation from Henderson and Hurvitz, "The Buddha of Seiryoji," 48–49, slightly modified. In the Henderson and Hurvitz translation, the blood appears on the head, but later scholars have determined that the character used refers to the image's back.

53. Ibid., 48.

54. This translation is from Henderson and Hurvitz, "The Buddha of Seiryoji," 46–47, slightly modified. A translation of the complete document may be found in Henderson and Hurvitz, 45–47, and a photograph of this document may be found on p. 26. Dharma refers, in this case, to the teachings of the Buddha. Maitreya is the Buddha of the future, who will descend from Tuṣita heaven, where he currently resides, when Śākyamuni's teachings have completely disappeared. Jambudvīpa refers to the world in which humans live. In the tenth and eleventh centuries, it was not uncommon to hope for rebirth in Tuṣita heaven, so that one could again be born in this world when he descended. This would enable the devotee to sit at the Buddha's feet and hear his teachings directly from his mouth.

55. Kyōto Kokuritsu Hakubutsukan, ed., *Shaka shinkō to Seiryōji*, 33. Henderson and Hurvitz state that the handprints were in their own blood (25), but this has turned out not to be the case.

56. This is believed to be the oldest surviving example of *hiragana* syllabary in Japan. A photograph of this item may be found in *Shaka shinkō to Seiryōji*, 92.

57. Translation from Henderson and Hurvitz, "The Buddha of Seiryoji," 53, slightly modified.

58. DNKK, *Shōyūki* 1: 119 (Eien 1/987.2.11).

59. SNKBT 40: 11.

60. Donald McCallum, "The Replication of Miraculous Icons: The Zenkoji Amida and the Seiryoji Shaka," in *Images, Miracles, and Authority in Asian Religious Traditions*, ed. Richard Davis (Boulder: Westview Press, 1998), 214–215.

61. For a detailed discussion of the replication of statues, including this one, see McCallum, "The Replication of Miraculous Icons," 207–226.

62. NKBT 85: 281–282.

63. Yamanaka Yutaka, *Heian jidai no nenjū gyōji*, Hanawa sensho 75 (Tokyo: Hanawa Shobō, 1972), 191.

64. Kamens, *The Three Jewels*, 313, note 2.

65. The Five Pollutions (J. *gojoku*) are negative conditions present in the world today. They are war, pestilence, and disaster; the flourishing of heresies; the presence of strong passions; the physically and mentally weak state of humankind; and the short lifespan of humans.

66. Gyōki (668–749), also pronounced Gyōgi, was a Japanese monk deeply revered for his efforts to promote societal well-being, including the building of bridges and hospitals. Even today, he is often referred to as a *bosatsu* (bodhisattva), an honorific sometimes applied to highly esteemed monks.

67. SNKBT 31: 184–185. Translation from Kamens, *The Three Jewels*, 312.

68. See *Diary of the Muryōjuin Regent (Midō kanpakuki)*, DNKK 3: 153 (Kannin 2/1018.4.78); and *Genji monogatari*, SNKBT 21: 186. Translation from Edward G. Seidensticker, trans., *The Tale of Genji* (New York: Alfred A. Knopf, 1978), 529.

Three Connected to Amida Buddha

1. Not all temples use the term "Welcoming Ceremony" (*Mukaekō*); many call the ritual Parade Offering (*Neri kuyō*).

2. I use the term "born" rather than "reborn," because in Buddhist thought rebirth implies a continuation of existence in the cycle of samsara; one is still trapped in inescapable suffering. Birth in Amida's Pure Land removes one from samsara, into a realm free of suffering, from which nirvana is easily attainable. In later Japanese thought, birth in Amida's Pure Land becomes equivalent to nirvana. The Pure Land of Amida is in "the west," outside the world of samsara. Thus the western direction becomes important in Pure Land art.

3. In terms of institutional presence, the Zen schools in Japan have about 21,000 temples while the Pure Land schools have about 30,000. All Buddhist temples are places where lay parishioners have funerals and memorial services for deceased ancestors performed. Far more parishioners associated with temples belonging to the Pure Land and True Pure Land schools of Buddhism know something about the teachings of their schools than do parishioners associated with Zen temples.

4. According to the doctrine of Shinran's (1173–1262) True Pure Land school (Jōdo Shinshū), one should not think about the welcoming scene, but rather concentrate on gratitude toward Amida during everyday life. On a popular level, however, people value the welcoming scene and the comfort it offers.

5. Seki Nobuko, " 'Mukaekō Amidazō' kō I: Taimadera no raigōe to Kōbōji no mukaekō Amidazō," *Bukkyō geijutsu* 221 (July 1995): 104.

6. Taimadera temple still enshrines what is popularly believed to be this very illustration of the Pure Land. Designated a National Treasure, this enormous mandala is woven, rather than painted. Its condition is so fragile that it is almost never displayed. For an English account of this legend, see Hank Glassman, " 'Show Me the Place Where My Mother Is!' Chūjōhime, Preaching, and Relics in Late Medieval and Early Modern Japan," in *Approaching the Land of Bliss: Religious Praxis in the Cult of Amitābha*, ed. Richard K. Payne and Kenneth K. Tanaka (Honolulu: Kuroda Institute, University of Hawaii Press, 2004), 139–168.

7. Sagazaki Shirō, "Shōjū raigō no hi: nijūgo bosatsu nerikuyō," in *Jōdo e no akogare*, Taiyō hotoke no bi to kokoro shiriizu 2, Taiyō shiriizu 34, ed. Satō Shinji (Tokyo: Heibonsha, 1983), 121.

8. Ibid.

9. Hana, *Chiisai butsuzō, ōkii butsuzō* (Tokyo: Tōkyō Shoseki, 2003), 81.

10. The five colors are red, blue, black, white, and yellow. These are believed to be the main colors with which the Pure Land is bedecked.

11. Sokujōin, "Gokuraku jōdo, Kyōto no kosatsu, Sokujōin" [brochure, n.d.].

12. His name is more properly pronounced Yōkan, but since most Japanese now refer to him as Eikan, I will follow that usage in this book.

13. Zenrinji, "Zenrinji, Eikandō" [brochure, n.d.]. This story is based on the 1542 *Zenrinji History* (*Zenrinji engi*).
14. Zenrinji, "Zenrin-ji and Its History" [brochure, n.d.].
15. Hana, *Chiisai butsuzō*, 45–46.
16. Ibid., 46.
17. Tanaka Takako, *Butsuzō ga kataru shirarezaru dorama* (Tokyo: Kōdansha, 2000), 200.
18. In Shinran's True Pure Land school, birth in the Pure Land is the equivalent of enlightenment.
19. T 12: 268a26–28. Translation from Luis Gomez, trans., *The Land of Bliss, the Paradise of the Buddha of Measureless Light: Sanskrit and Chinese Versions of the Sukhāvatīvyūha Sutras* (Honolulu and Kyoto: University of Hawaii Press and Honganji Shinshū Ōtani-ha, 1996), 168, slightly modified.
20. In Shinran's school of True Pure Land Buddhism, even utterance of the *nenbutsu* is unnecessary, because so corrupt is the world that there is nothing a person can do to save himself but be receptive to Amida's gift of salvation.
21. T 12: 268a29–268b2. Translation from Gomez, *The Land of Bliss, the Paradise of the Buddha of Measureless Light*, 168, slightly modified.
22. For an excellent discussion of the concept of the Final Dharma and all that it entailed, see Jacqueline Stone, "Seeking Enlightenment in the Last Age: Mappō Thought in Kamakura Buddhism, Part I" *Eastern Buddhist*, n.s. 18, no. 1 (1985).
23. DNKK, *Shōyūki* 4: 10 (Chōwa 4/1015.4.19).
24. For a detailed discussion of this topic, see Sarah Horton, "The Influence of the *Ōjōyōshū* in Late Tenth- and Early Eleventh-Century Japan," *Japanese Journal of Religious Studies* 31, no. 1 (2004): 29–54.
25. NST 6: 324.
26. Hanayama Shinshō, trans., *Ōjōyōshū* (Tokyo: Tokkan Shoten, 1972), 5.
27. In Chinese thought, the body is made up of four elements: wind, fire, earth, and water. Wind and fire are thought to cause activity and agitation; this is why the person for whom those depart first suffers.
28. Kanzeon is another name for Kannon.
29. In Buddhist cosmology, the Tōri Heaven and the Bon Heaven are both located in this world system. Therefore, as Genshin noted, rebirth in either of them does not constitute an escape from the cycle of birth and death.
30. The translation of this portion of the *Essentials for Pure Land Birth* is based on the text and notes in NST 6: 53–54, 336.
31. NST 6: 376. Translation from James Dobbins, trans., "Genshin's Deathbed Nembutsu Ritual," in *Religions of Japan in Practice*, ed. George J. Tanabe, Jr. (Princeton: Princeton University Press, 1999), 169. The original passage in the *Guannian famen* may be found in T 47: 24b21–24c28.
32. NST 6: 378; translation from Dobbins, "Genshin's Deathbed Nembutsu Ritual," 174.
33. For a detailed discussion of the Meditation Society of Twenty-Five, see Robert F. Rhodes, "Seeking the Pure Land in Heian Japan: The Practices of the Monks of the Nijūgo Zanmai-e," *Eastern Buddhist*, n.s. 33, no. 1 (2001): 56–79; and Sarah Horton, "The Role of Genshin and Religious Associations in the Mid-Heian Spread of Pure Land Buddhism" (Ph.D. diss., Yale University, 2001), 91–149. Meditation Society of Twenty-Five (Nijūgo zanmai-e), the name of the group, is puzzling. The term twenty-five meditations (*nijūgo zanmai*), found in the *Mahāparinirvāṇa sūtra*, refers to a group of meditations (*samādhi*s), performed by bodhisattvas, that put an end to rebirth in the twenty-five existences (*nijūgo u*; T 12: 448b11–12, 448c1–2). These twenty-five existences correspond to the twenty-five abodes of sentient beings in standard Buddhist cosmology. There is no evidence, however, that this meditation was performed by members of the fellowship or that they were even interested in it. The name may have been chosen simply because the number twenty-five matched the number of founding members or to convey the intention of members to lead sentient beings stuck in the cycle of rebirth to the Pure Land.

34. An English translation of these charters may be found in Richard Bowring, trans., "Preparing for the Pure Land in Late Tenth-Century Japan," *Japanese Journal of Religious Studies* 25 (Fall 1998): 221–257. Typeset editions of the Nijūgo zanmaie documents, including those in the *Taishō shinshū daizōkyō* and *Eshin Sōzu zenshū*, are extremely problematic. The titles of the texts are frequently wrong, and mistaken characters are not uncommon. A thorough discussion of these problems as well as both a photographic and typeset rendering of the original founding documents are found in Koyama Masazumi, "Tōdaiji Chūshōin shozō 'Yokawa Shuryōgon'in nijūgo zanmai Eshin Yasutane rinjū gyōgi' no sai kentō," *Bukkyōgaku kenkyū* 53 (Feb. 1997): 56–95. For this chapter, I have relied on the texts that are reproduced in this article while consulting Bowring's translation.

35. The most accurate typeset edition of this death register, which I will rely on in this chapter, is "Ryōgon'in Nijūgo zanmai kesshū kakochō," in Hirabayashi Moritoku, *Shoryōbu kiyō* 37 (1985): 41–52. For an excellent English overview of this text, see Rhodes, "Seeking the Pure Land in Heian Japan," 56–79.

36. "Ryōgon'in Nijūgo zanmai kesshū kakochō," *Shoryōbu kiyō*, 46.

37. Ibid., 50. Translation from Robert F. Rhodes, trans., "Pure Land Practitioner or Lotus Devotee? On the Earliest Biographies of Genshin," *Japanese Religions* 21, no. 1 (1995): 64.

38. NST 7: 549. Translation from Dykstra, *Miraculous Tales of the Lotus Sūtra*, 106, modified.

39. The full title of this work is *Enryakuji Shuryōgon'in Genshin Sōzu den*. It is the first full-length separate biography of Genshin.

40. Gon Shōsōzu was a relatively prestigious monastic rank.

41. ESZ 5: 665.

42. NKBT 85: 268.

43. NST 7: 381.

44. This story is found in SNKBT 35: 410–412.

45. This story is developed in further detail in later texts such as the *Continued Tales of Pure Land Birth in This Country* (*Zoku honchō ōjōden*), and *Sand and Pebbles* (*Shasekishū*, 1283). An English translation of the version in *Sand and Pebbles* may be found in Morrell, *Sand and Pebbles*, 253–254.

46. NKBT 85: 426. Translation from Morrell, *Sand and Pebbles*, 254, slightly modified. Ame no Hashidate, now a major tourist site, is on the coast of the Japan Sea.

47. Seki Nobuko, " 'Mukaekō Amidazō' kō IV: Mukaekō Amidazō zōritsu no haikei to jōdokyō geijutsu ni ataeta eikyō,"*Bukkyō geijutsu* 228 (Sept. 1996): 82–83.

48. NST 7: 655.

49. Seki Nobuko, "'Mukaekō Amidazō' kō I: Taimadera no raigōe to Kōbōji no mukaekō Amidazō," *Bukkyō geijutsu* 221 (Jul. 1995): 107.

50. Seki Nobuko, "'Mukaekō Amidazō' kō II: Taimadera no mukaekō Amidazō," *Bukkyō geijutsu* 223 (Dec. 1995): 92.

51. Ibid., 94.

52. See, for example, NKBT 30: 94, 133. For an English translation, see Kyoko Motomochi Nakamura, trans., *Miraculous Stories from the Japanese Buddhist Tradition: The Nihon Ryōiki of the Monk Kyōkai* (Cambridge, MA: Harvard University Press, 1973), 189, 226.

53. NST 6: 206. Translation from Dobbins, "Genshin's Deathbed Nembutsu Ritual," 168. The original passage in *Notes on the Four-Part Vinaya* may be found in T 40: 144a.

54. NST 7: 506.

55. "Ryōgon'in Nijūgo zanmai kesshū kakochō," in Hirabayashi, *Shoryōbu kiyō*, 48.

56. Ibid., 50.

57. The exact date of composition of the *Tale of Flowering Fortunes* is unknown. Most scholars today accept that the first thirty chapters achieved their present form not long after 1028, the last date they mention, and the following ones were probably written somewhat later by a different author. 1028 is only eleven years after Genshin's death. For a detailed discussion of the authorship and date of the *Tale of Flowering Fortunes*, see William H. McCullough and Helen Craig

McCullough, trans., *A Tale of Flowering Fortunes: Annals of Japanese Aristocratic Life in the Heian Period*, 2 vols. (Stanford: Stanford University Press, 1980), 1: 38. *Tale of Flowering Fortunes* sometimes refers to and frequently borrows from *Essentials for Pure Land Birth*. It is, however, unique in this respect. No other contemporaneous work shows much evidence of the *Essentials for Pure Land Birth*'s influence. This suggests that the unknown author of the *Tale of Flowering Fortunes* simply had, for some reason, a copy of the *Essentials for Pure Land Birth* close by.

58. Sets of nine Amida images, each for one of the nine levels of birth in the Pure Land, were common in early medieval Japan. The only surviving ones, however, live at Jōruriji temple in rural Kyoto prefecture.

59. NKBT 76: 87. Translation from McCullough and McCullough, *Tale of Flowering Fortunes*, 2: 569, slightly modified.

60. See Mimi Hall Yiengpruksawan, "The Eyes of Michinaga in the Light of Pure Land Buddhism," in *The Presence of Light: Divine Radiance and Religious Experience*, ed. Matthew T. Epstein (Chicago: University of Chicago Press, 2004), 248–249, for a discussion of Michinaga's illnesses and death.

61. NST 7: 402, note.

62. *Ryōjin hishō*, SNKBT 56: 493; *Shin kokin wakashū*, SNKBT 11: 561.

63. Referred to in Tanaka Takako, 196.

64. Ibid., 197.

65. Itō Shirō, *Heian jidai chōkokushi no kenkyū* (Nagoya: Nagoya Daigaku Shuppankai, 2001), 245–246.

66. A slightly earlier version of this story, without illustrations, appeared in *Sand and Pebbles*, and may be found in NKBT 85: 94–96. For an English translation, see Morrell, *Sand and Pebbles*, 105–106.

67. This narrative is taken from the *Hohoyake Amida engi emaki* as printed in *Naomoto moshibumi ekotoba, Nōe Hōshi ekotoba, Inabadō engi, Hohoyake Amida engi, Fudō riyaku engi, Konda sōbyō engi*, Shinshū Nihon emaki zenshū 30, ed. Takasaki Fujihiko and Minamoto Toyomune (Tokyo: Kadokawa Shoten, 1980).

68. Iwabashi Haruki, "Migawari Amida Butsu: Hohoyake Amida engi," in *Jōdo e no akogare*, Taiyō hotoke no bi to kokoro shiriizu 2, Taiyō shiriizu 34, ed. Satō Shinji (Tokyo: Heibonsha, 1983), 134.

Four Kannon: Whatever It Takes

1. See, for example, Nishimura Kōchō, *Yoku wakaru butsuzō no mikata: Yamatoji no hotoketachi* (Tokyo: Shōgakkan, 1999), 14.

2. Ibid., 95.

3. Taigen Daniel Leighton, *Bodhisattva Archetypes: Classic Buddhist Guides to Awakening and Their Modern Expression* (New York: Penguin Arcana, 1998), 190.

4. Ibid., 191.

5. Itō Seikō and Miura Jun, *Kenbutsuki 2: butsuyū hen* (Tokyo: Kadokawa Shoten, 1995), 75.

6. Itō Seikō and Miura Jun, *Kenbutsuki: oya kōkō hen* (Tokyo: Kadokawa Shoten, 2002), 131.

7. Watsuji Tetsurō, *Koji junrei* (1918; rpt., Tokyo: Iwanami Shoten, 1979), 114.

8. *Hibutsu*, ed. Mainichi Shinbunsha (Tokyo: Mainichi Shinbunsha, 1991), 194–202.

9. There is no single Japanese word that is equivalent to the English term "pilgrimage." Possibilities include the terms *junrei*, *mairi*, and *henro*.

10. This is done at many Shintō shrines as well.

11. Ian Reader, *Making Pilgrimages: Meaning and Practice in Shikoku* (Honolulu: University of Hawaii Press, 2005), 23.

12. Itō and Miura, *Kenbutsuki 2*, frontispiece.

13. Hayami Tasuku, *Bosatsu: Bukkyōgaku nyūmon*, Tōkyō bijutsu sensho 30 (Tokyo: Tōkyō Bijutsu, 1982), 39–40.

14. Matsuhisa Hōrin, *Butsuzō o horu: aru Kyōbusshi no kaisō* (Tokyo: Shin Jinbutsu Ōraisha, 1975), 14.

15. This story is found in *Gendai bungaku taikei* 13 (Tokyo: Chikuma Shobō, 1964), 446–447. An English translation is provided in Akito Itō and Graeme Wilson, trans., *Ten Nights of Dreams; Hearing Things; The Heredity of Taste* (Boston: Tuttle Publishing, 1974), 47–48.

16. Gouverneur Mosher, *Kyoto: A Contemplative Guide* (Rutland, Vermont: Charles E. Tuttle Company, 1964), 201–202.

17. See, for example, *Goriyaku Book in Kyōto*, ed. Tankōsha Henshūkyoku (Kyoto: Tankōsha, 1990), 66–67.

18. See "Kannonsama ga onsen ni," Takahashi Yoshikazu, *Kannonsama*, Kyōiku manga (Tokyo: Daidōsha, n.d.), 40–43.

19. Hasedera, "Hasedera" [brochure, n.d.].

20. Ibid.

21. Takahashi, *Kannonsama*, 11.

22. Ibid., 12.

23. The entire story as related here is found in Takahashi, *Kannonsama*, 10–19.

24. SNKBT 35: 542–547.

25. In a few cases, the Kannon in the story is identified as that at a temple other than Hasedera. From this we can surmise that the Kannon of a temple is able to do whatever the devotee believes her to be capable of. An English translation of the version of the story in *Tales of Times Now Past* can be found in Helen Craig McCullough, ed. *Classical Japanese Prose: An Anthology* (Stanford: Stanford University Press, 1990), 272–276; of the version in the early twelfth-century *Miraculous Tales of the Hasedera Kannon* (*Hasedera Kannon genki*), in Yoshiko K. Dykstra, "Miraculous Tales of the Hasedera Kannon," in *Religions of Japan in Practice*, ed. George J. Tanabe, Jr. (Princeton: Princeton University Press, 1999), 122; and of the version in *Casual Digressions* (*Zōtanshū*), a 1305 work by Mujū Ichien, also author of *Sand and Pebbles*, in Robert Morrell, trans., *Sand and Pebbles: The Tales of Mujū Ichien, a Voice for Pluralism in Kamakura Buddhism* (Albany: State University of New York Press, 1988), 276–277.

26. *Goriyaku Book in Kyōto*, 14–15.

27. This chapter of the *Lotus Sutra* may originally have been a separate text; it has long circulated both in and independent of the *Lotus Sutra*.

28. T 9: 56c6–11. Translation from Burton Watson, trans., *The Lotus Sutra* (New York: Columbia University Press, 1993), 299.

29. T 9: 57a22–57b21. Translation from Watson, *The Lotus Sutra*, 301–302.

30. Note that Potalaka is the name of the Dalai Lama's palace in Lhasa, Tibet. This is no coincidence, since the Dalai Lama is considered by Tibetans to be an incarnation of Kannon.

31. Hayami Tasuku, *Kannon, Jizō, Fudō*, Kōdansha Gendai Shinsho 1326 (Tokyo: Kōdansha, 1996), 48. A discussion in English of some of the foundational sutras for belief in the Eleven-Headed Kannon may be found in Samuel C. Morse, "The Buddhist Transformation of Japan in the Ninth Century: The Case of Eleven-Headed Kannon," in *Heian Japan: Centers and Peripheries*, ed. Mikael Adolphson, Edward Kamens, and Stacie Matsumoto (Honolulu: University of Hawaii Press, 2007), 158–160.

32. Robert Ford Campany, "The Earliest Tales of the Bodhisattva Guanshiyin," in *Religions of China in Practice*, ed. Donald S. Lopez, Jr. (Princeton, NJ: Princeton University Press), 85. *Fayuan zhulin* is found in T 53.

33. This story is found in Makita Tairyō, *Kanzeon ōkenki no kenkyū: rikuchō koitsu* (Kyoto: Heirakuji Shoten, 1970), 57. Campany, 93, provides an English translation.

34. This collection is found in Makita, 13–18. The text is discussed, and portions are translated, in Donald E. Gjertson, *Miraculous Retribution: A Study and Translation of T'ang Lin's Ming-pao chi* (Berkeley: Centers for South and Southeast Asia Studies, University of California at Berkeley, 1989), 16–19.

35. T 52: 5410a21–5410b5. An English translation of the story is provided by Gjertson, *Miraculous Retribution*, 20–21.

36. The oldest extant version of this tale is found in *Continued Biographies of Eminent Monks* (Ch. *Xu gaoseng zhuan*), T 50: 692c23–693a. An English translation of the story is provided by Chün-fang Yü, trans., in *Kuan-yin: The Chinese Transformation of Avalokitesvara* (New York: Columbia University Press, 2001), 115–116.

37. See Gjertson, *Miraculous Retribution*, 1.

38. Kyoko Motomochi Nakamura, trans., *Stories from the Japanese Buddhist Tradition: The Nihon ryōiki of the Monk Kyōkai* (Cambridge, MA: Harvard University Press, 1973), 38. See SNKBT 30: 4 and Nakamura, 101 for Kyōkai's reference to the *Mingbao ji*.

39. See DNKK, *Shōyūki* 1: 116 (Eien 1/987.1.23), 1: 119 (Eien 1/987.2.11), 1: 120 (Eien 1/987.2.17), 1: 124 (Eien 1/987.3.18).

40. See DNKK, *Midō kanpakuki* 1: 26 (Chōhō 1/999.7.27), 1: 27 (Chōhō 1/999.8.3), 1: 163 (Kankō 2/1005.10.25), 2: 143 (Chōwa 1/1012.3.14).

41. NKBT 76: 126. Translation from William H. McCullough and Helen Craig McCullough, trans., *A Tale of Flowering Fortunes: Annals of Japanese Aristocratic Life in the Heian Period*, 2 vols. (Stanford: Stanford University Press, 1980), 2: 643.

42. Barbara Ambros, "Liminal Journeys: Pilgrimages of Noblewomen in Mid-Heian Japan," *Japanese Journal of Religious Studies* 24, nos. 3–4 (1997): 311.

43. Ibid., 303–304.

44. SNKBT 23: 207. English translation in Edward Seidensticker, trans., *Tale of Genji* (New York: Alfred A. Knopf, 1978), 982.

45. SNKBT 24: 403. Translation from Ivan Morris, trans., *As I Crossed a Bridge of Dreams: Recollections of a Woman in Eleventh-Century Japan* (New York: Harper and Row Publishers, 1971), 76–78.

46. SNKBT 25: 158. Translation from Ivan Morris, trans., *The Pillow Book of Sei Shōnagon* (Harmondsworth, UK: Penguin Books, 1967), 141. Note that while the original text as reproduced in SNKBT names Kiyomizudera, not Hasedera, as the temple where this occurred, an earlier portion of the same passage mentions a long, roofed bridge, suggesting that Sei Shōnagon was actually speaking of Hasedera (SNKBT 25: 154–155, note 17). This is no doubt the reason Morris chose to use "Hasedera" in his translation.

47. SNKBT 24: 89. Translation from Edward Seidensticker, trans., *The Gossamer Years: The Diary of a Noblewoman of Heian Japan* (Boston: Charles E. Tuttle Publishing Company, 1964), 67.

48. Ambros, "Liminal Journeys," 321.

49. SNKBT 20: 349–50.

50. SNKBT 25: 155–156. Translation adapted from Morris, *The Pillow Book*, 140.

51. SNKBT 25: 345–346. Translation from Morris, *The Pillow Book*, 254–255, slightly modified.

52. SNKBT 24: 91. Translation from Seidensticker, *The Gossamer Years*, 67.

53. SNKBT 56: 89.

54. SNKBT 25: 273.

55. SNKBT 19: 135. Translation from Seidensticker, *Tale of Genji*, 77, slightly modified. Note that Seidensticker chose the words "made supplication to Kiyomizu," although most versions of the Japanese say "made supplication to the Kannon of Kiyomizu."

56. SNKBT 35: 552–554.

57. Ibid., 565–566.

58. SNKBT 31: 189–191. Translation from Edward Kamens, trans., *The Three Jewels* (Ann Arbor: Center for Japanese Studies, University of Michigan, 1988), 321.

59. Ibid., 320–321.

60. See SNKBT 35: 81–83.

61. SNKBT 24: 402–403. Translation from Morris, *As I Crossed a Bridge of Dreams*, 76–78.

62. SNKBT 24: 403–404. Translation from Morris, *As I Crossed a Bridge of Dreams*, 80.

63. SNKBT 24: 424. Translation from Morris, *As I Crossed a Bridge of Dreams*, 112.

64. SNKBT 24: 430. Translation from Morris, *As I Crossed a Bridge of Dreams*, 119.
65. SNKBT 24: 163. Translation from Seidensticker, *The Gossamer Years*, 116.
66. SNKBT 20: 344–345. Translation from Seidensticker, *Tale of Genji*, 394–395.
67. See Yoshiko K. Dykstra, "Tales of the Compassionate Kannon: The *Hasedera Kannon Genki*," *Monumenta Nipponica* 31, no. 2 (Summer 1976): 121. The *Hasedera Kannon genki* is highly problematic, with several redactions, portions of which date to significantly different times. One of these may be found in ZGR 27: 2, 179–275.
68. ZGR 27: 2, 242–244. Translation from Dykstra, "Tales of the Compassionate Kannon," 128.
69. ZGR 27: 2, 243. Translation from Dykstra, "Tales of the Compassionate Kannon," 135.
70. ZGR 27: 2, 267. Translation from Dykstra, "Tales of the Compassionate Kannon," 136.
71. SNKBT 35: 520–521.
72. SNKBT 24: 120–122. Translation from Seidensticker, *The Gossamer Years*, 88–89.
73. SNKBT 24: 123–124. Translation from Seidensticker, *The Gossamer Years*, 90.
74. SNKBT 24: 418–419.
75. SNKBT 24: 423. Translation from Morris, *As I Crossed a Bridge of Dreams*, 109.
76. SNKBT 35: 531–534.
77. SNKBT 35: 515–519. The same story is sometimes told with the Hasedera Kannon rather than the Ishiyamadera Kannon as the star. See Dykstra, "Tales of the Compassionate Kannon," 120.
78. This scene from the scroll is reproduced in Seidensticker, *The Gossamer Years*, Plate 7.
79. SNKBT 25: 244.
80. Hayami, *Kannon shinkō*, 238.
81. SNKBT 56: 57.
82. For scenes from the scroll and a summary of the story, see Shigemura Yasushi, *Shigisan engi to Kokawadera engi*, Nihon no bijutsu 2, no. 298 (Tokyo: Shibundō, 1991), 46–57.

Five Jizō to the Rescue

1. Occasionally the simple statue is officially a different deity, such as Dainichi Buddha, but most Japanese regard all such images as Jizō.
2. *Gekkan Kyōto* 625, no. 8 (August 2003): 10.
3. *Kyōto no makai o yuku: etoki annai*, ed. Kasha and Kikuchi Masaharu (Tokyo: Shōgakkan, 1999), 104.
4. *Butsuzō monoshiri kojiten*, Butsugu: sono 15, ed. Gendai Bukkyō Kenkyūkai (Hiroshima: Daisō Sangyō, 2004), 70.
5. Mochizuku Shinjō, Sawa Ryūken, and Umehara Takeshi, *Butsuzō: kokoro to katachi* (Tokyo: Nihon Hōsō Shuppan Kyōkai, 1965), 193.
6. Ibid., 209.
7. For example, an image now at Hōrūyji temple that some scholars argue may be the oldest statue of Jizō in Japan might actually be of a native *kami* or a monk (*Jōdo no kanata e*, Ningen no bijutsu 5, ed. Yamaori Tetsuo [Tokyo: Gakushū Kenkyūsha, 2004], 58).
8. *Butsuzō monoshiri kojiten*, 71.
9. See, for example, *Kyōto no makai e yuku*, 104.
10. The full title is *Japanese Hymn in Praise of the Life-Prolonging Jizō of the Sai Riverbank (Sai no kawara Enmei Jizō wasan)*.
11. Translation by T. Griffith Foulk. An exhaustive collection of different versions of the song may be found in Manabe Kōsai, *Jizō bosatsu no kenkyū* (Kyoto: Sanmitsudō Shoten, 1969), 171–250.
12. *O-Jizōsama*, Kyōiku manga (Tokyo: Daidōsha, n.d.), 4–15.
13. Hayami Tasuku, *Kannon, Jizō, Fudō* (Tokyo: Kōdansha, 1996), 176–177.
14. T 9: 8c24–25. Translation from Burton Watson, trans., *The Lotus Sutra* (New York: Columbia University Press, 1993), 39, slightly modified.
15. Hayami Tasuku, *Jizō shinkō* (Tokyo: Hanawa Shinsho, 1975), 1.

16. Helen Hardacre, *Marketing the Menacing Fetus in Japan* (Berkeley: University of California Press, 1997), 29.
17. T 16: 779b12–15. Translation from Stephen F. Teiser, trans., *The Ghost Festival in Medieval Japan* (Princeton: Princeton University Press, 1988), 53.
18. SNKBT 24: 119. For an English translation, see Edward Seidensticker, trans., *The Gossamer Years: The Diary of a Noblewoman of Heian Japan* (Boston: Charles E. Tuttle Publishing Company, 1964), 87.
19. Yamaguchi Tsutomu, "Daimonji," in *Bukkyō gyōji sansaku*, ed. Nakamura Hajime (Tokyo: Tōkyō Shoseki, 1991), 210.
20. *O-Jizōsama*, Kyōiku manga (Tōkyō: Daidōsha, n.d.), 27.
21. Ibid., 28–32.
22. See SNKBT 36: 33–35.
23. Hayami, *Jizō shinkō*, 70. Six Kannon are mentioned in the Chinese monk Zhiyi's (538–597) *Mohe zhiguan*.
24. Ibid., 66.
25. The other temples are Jōzenji, Jizōji, Genkōji, Jōzenji, and Tokurinji.
26. "Kyōto no Roku Jizō meguri" (Kyōto: Roku Jizō Kai, 1995) [brochure].
27. Ibid.
28. Ibid.
29. See, for example, *Kyōto no makai o yuku*, 38–39.
30. *Yatadera no butsuzō: tokubetsu chinretsu*, ed. Nara Kokuritsu Hakubutsukan and Bukkyō Bijutsu Kyōkai (Nara: Bukkyō Bijutsu Kyōkai, 2001), 7.
31. This is similar to the situation with the Hasedera Kannon discussed in chapter four.
32. Shakuzōji, "Kuginuki Jizō engi" [brochure, n.d.].
33. Ibid.
34. Umehara Takeshi, *Kyōto hakken 1: chirei chinkon* (Tokyo: Shinchōsha, 1997), 297–298.
35. *Rokuharamitsuji no kenkyū*, ed. Gangōji Bukkyō Minzoku Shiryō Kenkyūkai (Nara: Gangōji Bukkyō Minzoku Shiryō Kenkyūkai, 1975), 31–32.
36. Mochizuki Shinjō, *Jizō bosatsu—sono minamoto to shinkō o saguru* (Tokyo: Gakushōsha, 1989), 228.
37. Mochizuku Shinjō et al., *Butsuzō: kokoro to katachi*, 205.
38. Such a photograph may be found in Nishimura Kōchō, *Yoku wakaru butsuzō no mikata: Yamatoji no hotoketachi* (Tokyo: Shōgakkan, 1999), 60.
39. Shimizu Mazumi, *Butsuzō to hito no rekishi hakken: taimu kapuseru ga hikarete* (Tokyo: Ribun Shuppan, 2000), 178.
40. Ibid., 180.
41. Shin Yakushiji, "Otama Jizō engi" [brochure, n.d.].
42. However, one scholar posits that Jizō may a Chinese invention, arguing that all extant Chinese texts focusing on Jizō predate those found in Central Asia and India (Zhiru Ng, "The Formation and Development of the Dizang Cult in Medieval China" [Ph.D. diss., University of Arizona, 2000], 25–32).
43. T 13: 721c17. The five evils (*gogyaku*) are killing one's father, killing one's mother, killing an *arhat*, injuring the body of the Buddha, and causing a schism in the Buddhist order. The five defilements (*gojoku*) describe conditions of the world that prove it is degenerate. They are war, natural disasters, pestilence; the flourishing of heresies; the existence of overwhelming passions; mental and physical weakness; and a short lifespan.
44. T 13: 746c23–27.
45. The third chapter of this sutra deals almost exclusively with Jizō's ability to save living beings from even the Uninterrupted Hell (J. Muken Jigoku), the worst hell of all (T 13: 725–739).
46. T 13: 722b4–5.
47. *Sūtra of the Past Vows of Earth-Store Bodhisattva: The Collected Lectures of the Tripitaka Master Hsüan Hua*, trans., Heng Ching (New York: Buddhist Text Translation Society and the Institute for Advanced Studies of World Religions, 1974), 10.

48. T 13: 778b3–7. English translation from *Sūtra of the Past Vows*, 72.

49. T 13: 778b21–779a28. For an English translation of this passage, see *Sūtra of the Past Vows*, 76–89.

50. T 13: 780c18–781b1. For an English translation, see *Sūtra of the Past Vows*, 124–127.

51. For an English translation of this sutra, see Stephen F. Teiser, trans., *The Scripture on the Ten Kings and the Making of Purgatory in Medieval Chinese Buddhism* (Honolulu: Kuroda Institute, University of Hawaii Press, 1994), 197–219.

52. Teiser, *The Scripture on the Ten Kings*, 6.

53. Yoshiko Kurata Dykstra, "Jizō, the Most Merciful: Tales from the *Jizō Bosatsu Reigenki*," *Monumenta Nipponica* 33, no. 2 (Summer 1978): 181.

54. ZST 6: 80a (Kannin 3/1019.10.14).

55. GR 15: 572.

56. ESZ 5: 586.

57. This is an alternate name for Ryōgen.

58. SNKBT 36: 19–21.

59. For a reproduction of this scene, see *Sannō reigenki, Jizō bosatsu reigenki, Zoku Nihon no emaki* 23 (Tokyo: Chūō Kōronsha, 1992), 44–45.

60. SNKBT 36: 49–51.

61. NST 7: 210. Translation from Dykstra, *Miraculous Tales of the Lotus Sutra*, 140.

62. SNKBT 36: 51–52.

63. Teiser, *The Scripture on the Ten Kings*, 58. For a lengthy discussion, see Manabe, *Jizō bosatsu no kenkyū*, 119–124.

64. Fukū Sanzō is the Japanese name for Amoghavajra (705–774), a north Indian monk who came to China in 720 and became a great translator.

65. Itō Kokan, *O-Jizōsama* (Tokyo: Shunjūsha, 1972), 154.

66. "Miyako no roku Jizō meguri" (Kyoto: Roku Jizō Kai, 1995) [brochure]. The list may be found in KYIK 49: 295.

67. Itō Kokan, 122.

68. For a lengthy discussion of the *Jizō and Ten Kings Sutra*, see Manabe, *Jizō bosatsu no kenkyū*, 124–131.

69. King Enma's court is discussed in KYIK 49: 303–309.

70. Teiser, *The Scripture on the Ten Kings*, 58–59.

71. Itō Kokan, 162.

72. SNKBT 36: 41–43. Dykstra translates a similar story from one of the manuscripts of *Accounts of the Miracles of Jizō Bodhisattva* ("Jizō, the Most Merciful," 196–197).

73. *Yatadera no butsuzō*, 7.

74. NKBT 85: 314. Translation from Robert Morrell, trans., *Sand and Pebbles: The Tales of Mujū Ichien, a Voice for Pluralism in Kamakura Buddhism* (Albany: State University of New York Press, 1988), 210, slightly modified. These temples all still exist today and all are famous for their Jizōs.

75. SNKBT 40: 180.

76. Referred to in Tanaka Takako, *Butsuzō ga kataru shirarezaru dorama* (Tokyo: Kōdansha, 2000), 96.

77. SNKBT 36: 37–38.

78. SNKBT 40: 169.

79. Ibid.

80. SNKBT 42: 131–132. Translation from D.E. Mills, trans., *A Collection of Tales from Uji: A Study and Translation of Uji Shūi Monogatari* (Cambridge: Cambridge University Press, 1970), 236–237.

81. SNKBT 42: 131, note 20.

82. Matsushima Takeshi, *Jizō bosatsu*, Nihon no bijutsu 239 (Tokyo: Shibundō, 1986), 63.

83. Mochizuki Shinjō, *Jizō bosatsu: sono minamoto to shinkō o saguru* (Tokyo: Gakushōsha, 1989), 261.

84. Hank Glassman, "The Nude Jizō at Denkōji: Notes on Women's Salvation in Kamakura Buddhism," in *Engendering Faith: Women and Buddhism in Premodern Japan*, ed. Barbara Ruch (Ann Arbor: Center for Japanese Studies, University of Michigan, 2002), 388.

85. Ibid., 390.
86. Ibid.
87. Shimizu, *Butsuzō to hito no rekishi hakken*, 180.

Six Secret Buddhas, the Veiled Presence

1. Yoritomi Motohiro, "Hibutsu no sekai," in *Hibutsu*, ed. Mainichi Shinbunsha (Tokyo: Mainichi Shinbunsha, 1991), 105.
2. *Zenkoku jisha butsuzō gaido*, ed. Tanaka Yukiyoshi (Tokyo: Bijutsu Shuppansha, 2001), 419–429.
3. *Otera ni ikō!* ed. Kojima Dokkaan and Mikami Ken'ichi (Tokyo: Fusōsha, 2004), 43.
4. Mentioned in Fujisawa Takako, "'Hibutsu' tanjō no haikei o saguru," in *Hibutsu*, ed. Mainichi Shinbunsha (Tokyo: Mainichi Shinbunsha, 1991), 169.
5. SNKBT 35: 60. Usually such boys lived nearby, cleaning the hall and offering flowers and incense.
6. In Buddhist thought, activities can be committed through mental, verbal, or physical means.
7. SNKBT 35: 135.
8. DNBZ 120: 8b.
9. DNBZ 120: 41b
10. *Shōtoku taishi den shiki*, DNBZ 112: 58a, b. Translation from Lucie Weinstein, trans., "The Yumedono Kannon: Problems in Seventh-Century Sculpture," *Archives of Asian Art* 42 (1989): 29. Nyoirin Kannon is a category of Kannon images that usually holds a wish-granting jewel (*nyoi*) and a wheel (*rin*).
11. Ernest F. Fenollosa, *Epochs of Chinese and Japanese Art 1* (1913; rpt., New York: Dover Publications, 1963), 50.
12. See, for example, Itō Yumiko, "Hibutsu nyūmon: shinkō to tomo ni ikiru hibutsu," in *Hibutsu*, ed. Mainichi Shinbunsha (Tokyo: Mainichi Shinbunsha, 1991), 51; and *Otera ni ikō!* 18.
13. Quoted in Itō Yumiko, "Hibutsu nyūmon," 54–55.
14. *Niiro Chūnosuke gojūkaiki kinen: butsuzō shūri gojūnen* (Kyoto: Benridō, 2004), 77.
15. Itō Yumiko, "Hibutsu nyūmon," 57.
16. This is similar to the aristocrats and monks in early medieval Japan who created Śākyamuni's Pure Land on a larger scale.
17. Yoritomi, "Hibutsu no sekai," 94.
18. Sekine Shun'ichi, *Butsu, bosatsu to dōnai no shōgon*, Nihon no bijutsu 10, no. 281 (Tokyo: Shibundō, 1989), 52.
19. Robert Sharf, "On the Allure of Buddhist Relics," in *Embodying the Dharma: Buddhist Relic Veneration in Asia*, ed. David Germano and Kevin Trainor (Albany: State University of New York Press, 2004), 169.
20. Yoritomi, "Hibutsu no sekai," 94.
21. Ibid., 96.
22. Sekine, *Butsu, bosatsu to dōnai no shōgon*, 52.
23. The "jewel beetle," or *tamamushi*, has iridescent wings, which were used to decorate the Jewel-Beetle Zushi.
24. Ogawa Kōzō, "Hibutsu no nazo," in *Nyoirin Kannon: Ōsaka Kanshinji*, ed. Ogawa Kōzō (Tokyo: Mainichi Shinbunsha, 2001), 63.
25. Nishimura Kōchō, *Butsuzō no koe* (Tokyo: Shinchōsha, 1995), 260–261.
26. Fujii Masao, *Butsuji no kiso chishiki* (1985; rev. ed. Tokyo: Kōdansha, 2001), 65.
27. *Butsudan no hanashi*, Butsugu sono 7, ed. Gendai Bukkyō Kenkyūkai (Hiroshima: Daisō Sangyō, 2004), 5.
28. Itō Seikō and Miura Jun, *Kenbutsuki* (Tokyo: Kadokawa Shoten, 1993), 256.

29. See, for example, Shiraki Toshiyuki, "Hibutsu o tazuneru," *Daihōrin* 1 (2003): 120.

30. For a detailed outline of some esoteric Buddhist practices and their relationship to secret buddhas, see Fabio Rambelli, "Secret Buddhas: The Limits of Buddhist Representation," *Monumenta Nipponica* 57 (Autumn 2002): 271–307.

31. This passage may be found in T20: 602a.

32. This passage may be found in T20: 184c–185a.

33. Fujisawa Takako, "Hibutsu to wa nanika?" in *Nihon no hibutsu*, ed. Korona Bukkusu (Tokyo: Heibonsha, 2002), 114.

34. Yoritomi, "Hibutsu no sekai," 105–106.

35. Ibid., 102.

36. Tanaka Takako, *Butsuzō ga kataru shirarezaru dorama* (Tokyo: Kōdansha, 2000), 76.

37. Ibid., 78–80.

38. See, for example, Ogawa, *Nyoirin Kannon*, 65.

39. Donald McCallum, *Zenkoji and Its Icon: A Study in Medieval Japanese Religious Art* (Princeton: Princeton University Press, 1994), 169.

40. Yoritomi, "Hibutsu no sekai," 104.

41. NST 85: 107. Translation from Robert Morrell, trans., *Sand and Pebbles: The Tales of Mujū Ichien, a Voice for Pluralism in Kamakura Buddhism* (Albany: State University of New York Press, 1988), 112.

42. Quoted in Itō Yumiko, "Hibutsu nyūmon," 56.

43. Tanizaki, *In Praise of Shadows* (New Haven, CT: Leete's Island Books, 1977), 18.

44. Nishimura, *Butsuzō no koe*, 256–257.

45. Ibid., 259–260.

46. For scenes of the curtain openings of some major secret buddhas, including the Rokuharamitsuji temple Kannon and the Seiryōji temple Śākyamuni, see the DVD *Hibutsu kaichō: tokubetsu haikan no koji, meisatsu o yuku* (Tokyo: Shinforesuto, 2002). NHK video.

47. Fujiwasa, "'Hibutsu' tanjō no haikei o saguru," 154.

48. Ibid., 154–155.

49. P.F. Kornicki, "Public Display and Changing Values: Early Meiji Exhibitions and Their Precursors," *Monumenta Nipponica* 49, no. 2 (Summer 1994): 175.

50. William M. Bodiford, "Sōtō Zen in a Japanese Town: Field Notes on a Once-Every-Thirty-Three-Years Kannon Festival," *Japanese Journal of Religious Studies* 21, no. 1 (1994): 3–36.

51. Ibid., 7–9.

52. Ibid., 14. The name Jingūji literally means "shrine-temple," a title usually given to temples found on the grounds of a Shintō shrine. This temple, however, was never associated with a particular shrine and seems to have been regarded as the home of the Buddhist deity of which all local kami were manifestations (Bodiford, "Sōtō Zen in a Japanese Town," 3–4).

53. Ibid., 17–18.

54. Ibid., 22.

55. Ibid., 25.

56. Ibid., 26.

57. Ibid., 26–27.

58. Fujisawa, "'Hibutsu' tanjō no haikei o saguru," 185.

59. Fujisawa, "Hibutsu wa naze umareta no ka," 56.

60. Sensōji, "Asuka Kannon Sensōji" [brochure, n.d.].

61. Ibid.

62. Sensōji, "Asuka Kannon: The Sensōji Temple, Tokyo, Japan" [brochure, n.d.].

63. Amino Yūshun, *Sensōjishi danshō* (Tokyo: Konryūzan Sensōji, 1962), 42–43.

64. Nishimura, *Butsuzō no koe*, 258.

65. Shiraki, "Hibutsu o tazuneru," 121.

66. *Yoku wakaru Zenkōji mairi*, ed. Zenkōji Jimukyoku (Tokyo: Chikuma Shūhansha, 2000), 18.

67. The story related here is based on that found in *Shaji engi e*, ed. Nara Kokuritsu Hakubutsukan (Tokyo: Kadokawa Shoten, 1974), 48–51; and *Yoku wakaru Zenkōji mairi*, 22–26.

68. *Zenkōjisan* (Nagano City: Zenkōji Honbō Daikanjin Kyōkabu, 1995), 30.

69. SNKBT 44: 122–123. Translation from Helen Craig McCullough, trans., *The Tale of Heike* (Stanford: Stanford University Press, 1988), 88.

70. Donald F. McCallum, *Zenkōji and Its Icon: A Study in Medieval Japanese Religious Art* (Princeton: Princeton University Press, 1994), 11.

71. *Yoku wakaru Zenkōji mairi 2: Gokaichō*, ed. Zenkōji Jimukyoku (Tokyo: Chikuma Shūhansha, 2002), 16.

72. Kondō Takuji, "Gohonzon to enishi o musubu 'zen no tsuna,'" in *Hibutsu*, ed. Mainichi Shinbunsha (Tokyo: Mainichi Shinbunsha, 1991), 124.

73. *Yoku wakaru Zenkōji mairi*, 79.

74. Kondō, "Gohonzon to enishi o musubu 'zen no tsuna,'" 127.

75. *Yoku wakaru Zenkōji mairi 2: Gokaichō*, 20–22.

76. Ibid., 34. The weight of the *zushi* is also mentioned in Kondō, "Gohonzon to enishi o musubu 'zen no tsuna,'" 126.

77. *Yoku wakaru Zenkōji mairi 2: Gokaichō*, 102.

78. Ibid., 70.

79. Kondō, "Gohonzon to enishi o musubu 'zen no tsuna,'" 128.

80. *Yoku wakaru Zenkōji mairi 2: Gokaichō*, 19.

81. Ibid., 86.

82. The reason that rituals are held in the third month in Second-Month Hall is that the temple follows the lunar calendar in this regard, which places the second month in what is now March.

83. Kawamura Tomoyuki, "Tōdaiji Nigatsudō no hibutsu jūichimen Kannon," in *Hibutsu*, ed. Mainichi Shinbunsha (Tokyo: Mainichi Shinbunsha, 1991), 137.

84. Nishiyama Atsushi, "Tōdaiji Nigatsudō to Omizutori," in *Tōdaiji Nigatsudō to Omizutori*, ed. Nara Kokuritsu Hakubutsukan (Nara: Bukkyō Bijutsu Kyōkai, 1999), 4.

85. For a discussion of early Japanese repentance rites centering on the Eleven-Headed Kannon, see Samuel C. Morse, "The Buddhist Transformation of Japan in the Ninth Century: The Case of Eleven-Headed Kannon," in *Heian Japan: Centers and Peripheries*, ed. Mikael Adolphson, Edward Kamens, and Stacie Matsumoto (Honolulu: University of Hawaii Press, 2007), 161–163.

86. DNBZ 120: 11a.

87. Ibid.

88. T, Zuzōbu 4: *Kakuzen shō*, fascicle 44.

89. DNBZ 62: 112c.

90. Atsushi, 11.

91. Ibid.

92. Ibid., 8.

93. Ibid.

94. Hashimoto Shōjun, "Chōrō kikigaki 2," *Tōdaiji omizutori: Ichigatsu Shuni-e no kiroku to kenkyū*, ed. Ōga Tetsuo (Tokyo: Shōgakkan, 1985), 223.

95. Ibid.

96. See, for example, T. Griffith Foulk and Robert H. Sharf, "On the Ritual Use of Ch'an Portraiture in Medieval China," *Cahiers d'Extrême-Asie* (Bilingual Journal of the Ecole Française d'Extrême-Orient) 7 (1993–1994): 149–219. Republished in Bernard Faure, ed. *Chan Buddhism in Ritual Context* (London and New York: Routledge Curzon, 2003), 74–150.

GLOSSARY

Glossary of Chinese and Japanese Characters

Asakusa Kannon 浅草観音
Bon 盆
bonnō 煩悩
busshō 仏性
butsudan 仏壇
butsudo 仏土
chūbō 厨房
Chūjō Hime 中将姫
Daijuku Jizō 代受苦地蔵
degaichō 出開帳
Denkōji 伝香寺
Dōsojin 道祖神
edo 穢土
Eikandō 永観堂
ekō 回向
Ekō bashira 回向柱
emaki 絵巻
engi 縁起
Enma Ō 閻魔王
Enmei Jizō kyō 延命地蔵経
en musubi 縁結び
ennichi 縁日
gan 龕
gasshō 合掌
gejin 外陣
gō 業
Gozan okuribi 五山送火

Hadaka Jizō 裸地蔵
hakken shiki 發遣式
Hana matsuri 花祭り
Hasedera 長谷寺
Hibo Kannon 悲母観音
hibutsu 秘仏
hitsugi 棺
Hohoyake Amida 頬焼け阿弥陀
hokora 祠
honji suijaku 本地垂迹
honzon 本尊
igaichō 居開帳
ihai 位牌
ikimi 生身
innen 因縁
Ishiyamadera 石山寺
jakumetsu 寂滅
Jizō Bon 地蔵盆
jōdo 浄土
jōgyō zanmai 常行三昧
jūnen 十念
juzu kuri 数珠繰り
juzu mawashi 数珠廻し
Kagekiyo Jizō 景清地蔵
kaichō 開帳
Kaidan meguri 戒壇巡り
kaigen shiki 開眼式
Kanbutsu-e 灌仏会
Kangiten 歓喜天
Kannon 観音
Kannon biraki 観音開き
Katsurakake Jizō 鬘かけ地蔵
Kekadō 悔過堂
Kenbutsuki 見仏記
Kigaeshiki 着替式
Kiyomizudera 清水寺
Koji junrei 古寺巡礼
kōyamaki 高野槙
kūden 宮殿
kudoku 功徳
Kuginuki Jizō 釘抜き地蔵

kuyō 供養
kyakubutsu 客仏
Manbei 満米
Mappō 末法
migawari 身代わり
Minugui shiki 身拭い式
mizu toba 水塔婆
mizuko kuyō 水子供養
Mukaegane 迎鐘
Mukaekō 迎講
myō-ō 明王
naijin 内陣
nenji butsu 念持仏
Neri kuyō 練り供養
Nihon ōjō gokurakuki 日本往生極楽記
Nijūgo zanmai-e 二十五三昧会
Nyoirin Kannon 如意輪観音
o-fudasho お札所
Ōfukucha 皇復茶, 大福茶
o-hata お旗
Ono no Takamura 小野篁
reiboku 霊木
Rokudō Chinnōji 六道珍皇寺
rokudō no tsuji 六道の辻
Rokuharamitsuji 六波羅蜜寺
Ruridan 瑠璃壇
Ryōjin hishō 梁塵秘抄
Ryōjusen 霊鷲山
Ryōzen 霊山
Saikoku 西国
san akudō 三悪道
sangai banrei 三界万霊
sangoku denrai Shaka 三国伝来釈迦
sanzu 三途
Segaki-e 施餓鬼会
Seiryōji 清涼寺
Seiten 聖天
Sensōji 浅草寺
setsuwashū 説話集
Shabadō 娑婆堂
Shakadō 釈迦堂

shakujō 錫杖
Shin Yakushiji 新薬師寺
Shōbō 正法
shōji 生死
shōjin 生身
shōju raigō 聖衆来迎
shuinchō 朱印帳
Shūi ōjōden 拾遺往生伝
Shuni-e 修二会
taimatsu 松明
Taue Jizō 田植え地蔵
Urabon kyō 盂蘭盆経
Yatadera 矢田寺
Yokawa 横川
yuyaku nenbutsu 踊躍念仏
Zenrinji 禅林寺
Zōhō 像法
zushi 厨子

BIBLIOGRAPHY

Sources in English

Adler, Carlyle. "Dazzled by Demons." *Time Asia* 164, no. 24 (Dec. 13, 2004): 54.

Ambros, Barbara. "Liminal Journeys: Pilgrimages of Noblewomen in Mid-Heian Japan." *Japanese Journal of Religious Studies* 24, nos. 3–4 (1997): 301–345.

Beal, Samuel, trans. *Si-yu-ki: Buddhist Records of the Western World*. 1884. Rpt., New York: Paragon Book Reprint Corp., 1968.

Bodiford, William M. "Sōtō Zen in a Japanese Town: Field Notes on a Once-Every-Thirty-Three-Years Kannon Festival." *Japanese Journal of Religious Studies* 21, no. 1 (1994): 3–36.

Bogel, Cynthea J. "Canonizing Kannon: The Ninth-Century Esoteric Buddhist Altar at Kanshinji." *Art Bulletin* 84, no. 1 (Mar. 2002): 30–64.

Bowring, Richard. "Preparing for the Pure Land in Late Tenth-Century Japan." *Japanese Journal of Religious Studies* 25 (Fall 1998): 221–257.

Brown, Robert L. "Expected Miracles: The Unsurprisingly Miraculous Nature of Buddhist Images and Relics." In *Images, Miracles, and Authority in Asian Religious Traditions*, ed. Richard Davis, 23–35. Boulder: Westview Press, 1998.

———. "The Miraculous Buddha Image: Portrait, God, or Object?" In *Images, Miracles, and Authority in Asian Religious Traditions*, ed. Richard Davis, 37–45. Boulder: Westview Press, 1998.

Campany, Robert Ford. "The Earliest Tales of the Bodhisattva Guanshiyin." In *Religions of China in Practice*, ed. Donald S. Lopez, Jr., 82–96. Princeton: Princeton University Press, 1996.

Carter, Martha L. *The Mystery of the Udayana Buddha*. Napoli: Istituto Universitario Orientale, 1990.

Davis, Richard. *Lives of Indian Images*. Princeton: Princeton University Press, 1997.

Dobbins, James. "Genshin's Deathbed Nembutsu Ritual." In *Religions of Japan in Practice*, ed. George J. Tanabe, Jr., 166–175. Princeton: Princeton University Press, 1999.

Dykstra, Yoshiko. "Jizō, the Most Merciful: Tales from the *Jizō Bosatsu Reigenki*." *Monumenta Nipponica* 33, no. 2 (Summer 1978): 179–200.

———. "Miraculous Tales of the Hasedera Kannon." In *Religions of Japan in Practice*, ed. George J. Tanabe, Jr., 117–123. Princeton: Princeton University Press, 1999.

———. *Miraculous Tales of the Lotus Sutra from Ancient Japan: The Dainihonkoku Hokekyokenki of Priest Chingen*. Hirakata City, Osaka: Intercultural Research Institute, Kansai University of Foreign Studies, 1983.

———. "Tales of the Compassionate Kannon: The *Hasedera Kannon Genki*." *Monumenta Nipponica* 31, no. 2 (Summer 1976): 113–143.

Eckel, Malcolm David. *To See the Buddha: A Philosopher's Quest for the Meaning of Emptiness.* Princeton: Princeton University Press, 1992.

Foard, James. "The Boundaries of Compassion: Buddhism and National Tradition in Japanese Pilgrimage." *Journal of Asian Studies* 41, no. 2 (Feb. 1982): 231–251.

———. "Ippen Shōnin and Popular Buddhism in Kamakura Japan." Ph.D. diss., Stanford University, 1977.

———. "The Tale of the Burned-Cheek Amida and the Motif of Body Substitution." *The Japan Foundation Newsletter* 26 (Nov. 1998): 6–8.

Foulk, T. Griffith. "Religious Functions of Buddhist Art in China." In *Cultural Intersections in Later Chinese Buddhism*, ed. Marsha Weidner, 13–29. Honolulu: University of Hawaii Press, 2001.

———, trans. *Standard Observances of the Sōtō Zen School*, forthcoming. *Shōwa shūtei, Sōtōshū gyōji kihan*, ed. Sōtōshū Shūmuchō Kyōkabu. Tokyo: Sōtōshū Shūmuchō, 1988.

Foulk, T. Griffith and Robert H. Sharf. "On the Ritual Use of Ch'an Portraiture in Medieval China." In *Cahiers d'Extrême–Asie* (Bilingual Journal of the Ecole Française d'Extrême–Orient) 7 (1993–1994): 149–219. Republished in Bernard Faure, ed. *Chan Buddhism in Ritual Context*. London and New York: Routledge Curzon, 2003, 74–150.

Fowler, Sherry. "Hibutsu: Secret Buddhist Images of Japan." *Journal of Asian Culture* 15 (1991–1992): 138–159.

Freedberg, David. *The Power of Images: Studies in the History and Theory of Response.* Chicago: University of Chicago Press, 1989.

Germano, David and Kevin Trainor, ed. *Embodying the Dharma: Buddhist Relic Veneration in Asia.* Albany: State University of New York Press, 2004.

Gjertson, Donald E. *Miraculous Retribution: A Study and Translation of T'ang Lin's Ming-pao chi.* Berkeley: Centers for South and Southeast Asia Studies, University of California at Berkeley, 1989.

Glassman, Hank. "The Nude Jizō at Denkōji: Notes on Women's Salvation in Kamakura Buddhism." In *Engendering Faith: Women and Buddhism in Premodern Japan*, ed. Barbara Ruch, 383–413. Ann Arbor: Center for Japanese Studies, University of Michigan, 2002.

———. "'Show Me the Place Where My Mother Is!' Chūjōhime, Preaching, and Relics in Late Medieval and Early Modern Japan." In *Approaching the Land of Bliss: Religious Praxis in the Cult of Amitābha*, ed. Richard K. Payne and Kenneth K. Tanaka, 139–168. Honolulu: Kuroda Institute, University of Hawaii Press, 2004.

Gombrich, Richard. "The Consecration of a Buddhist Image." *The Journal of Asian Studies* 26, no. 1 (Nov. 1966): 23–36.

Gomez, Luis, trans. *The Land of Bliss, the Paradise of the Buddha of Measureless Light: Sanskrit and Chinese Versions of the Sukhāvatīvyūha Sutras.* Honolulu and Kyoto: University of Hawaii Press and Honganji Shinshū Ōtani-ha, 1996.

Grapard, Allan G. *The Protocol of the Gods: A Study of the Kasuga Cult in Japanese History.* Berkeley: University of California Press, 1992.

Hardacre, Helen. *Marketing the Menacing Fetus in Japan.* Berkeley: University of California Press, 1997.

Henderson, Gregory and Leon Hurvitz. "The Buddha of Seiryoji: New Finds and New Theory." *Artibus Asiae* 19, no. 1 (1956): 5–55.

Horton, Sarah. "The Influence of the *Ōjōyōshū* in Late Tenth- and Early Eleventh-Century Japan." *Japanese Journal of Religious Studies* 31, no. 1 (2004): 29–54.

———. "The Role of Genshin and Religious Associations in the Mid-Heian Spread of Pure Land Buddhism." Ph.D. diss., Yale University, 2001.

Images, Miracles, and Authority in Asian Religious Traditions. Ed. Richard Davis. Boulder: Westview Press, 1998.

216		*Bibliography*

Itō, Akito and Graeme Wilson, trans. *Ten Nights of Dreams; Hearing Things; The Heredity of Taste.* Boston: Tuttle Publishing, 1974.

Kamens, Edward, trans. *The Three Jewels: A Study and Translation of Minamoto Tamenori's Sanbōe.* Ann Arbor: Center for Japanese Studies, University of Michigan, 1988.

Kim, Yung-Hee. *Songs to Make the Dust Dance: The Ryōjin hishō of Twelfth-Century Japan.* Berkeley: University of California Press, 1994.

Kornicki, P.F. "Public Display and Changing Values: Early Meiji Exhibitions and Their Precursors." *Monumenta Nipponica* 49, no. 2 (Summer 1994): 167–196.

LeFleur, William R. *Liquid Life: Abortion and Buddhism in Japan.* Princeton: Princeton University Press, 1992.

Legge, James, trans. *A Record of Buddhistic Kingdoms: Being an Account by the Chinese Monk Fa-Hien of His Travels in India and Ceylon (A.D. 399–414) in Search of the Buddhist Books of Discipline.* 1886. Rpt., New York: Dover, 1965.

Leighton, Daniel Taigen. *Bodhisattva Archetypes: Classic Buddhist Guides to Awakening and Their Modern Expression.* New York: Penguin Arcana, 1998.

Living Images: Japanese Buddhist Icons in Context. Ed. Robert Sharf and Elizabeth Horton Sharf. Stanford: Stanford University Press, 2001.

The Long Search: Footprints of the Buddha. New York: Time Life Video, 1977.

Lopez, Donald. "Introduction: Buddhism." In *Religions of Asia in Practice*, ed. Donald S. Lopez, Jr., 165–196. Princeton: Princeton University Press, 2002.

Matsumoto, Moritaka. "The Iconography of Shaka's Sermon on Vulture Peak and Its Art Historical Meaning." *Artibus Asiae* 53, nos. 3–4 (1993): 358–411.

McCallum, Donald. "The Replication of Miraculous Icons: The Zenkoji Amida and the Seiryoji Shaka." In *Images, Miracles, and Authority in Asian Religious Traditions*, ed. Richard Davis, 207–226. Boulder: Westview Press, 1998.

———. *Zenkōji and Its Icon: A Study in Medieval Japanese Religious Art.* Princeton: Princeton University Press, 1994.

McCullough, Helen Craig, ed. *Classical Japanese Prose: An Anthology.* Stanford: Stanford University Press, 1990.

———, trans. *The Tale of Heike.* Stanford: Stanford University Press, 1988.

McCullough, William H. and Helen Craig McCullough, trans. *A Tale of Flowering Fortunes: Annals of Japanese Aristocratic Life in the Heian Period*, 2 vols. Stanford: Stanford University Press, 1980.

Mills, D.E., trans. *A Collection of Tales from Uji: A Study and Translation of Uji Shūi Monogatari.* Cambridge: Cambridge University Press, 1970.

Morgan, David. *Visual Piety: A History and Theory of Popular Religious Images.* Berkeley: University of California Press, 1998.

Morrell, Robert, trans. *Sand and Pebbles: The Tales of Mujū Ichien, a Voice for Pluralism in Kamakura Buddhism.* Albany: State University of New York Press, 1988.

Morris, Ivan, trans. *As I Crossed a Bridge of Dreams: Recollections of a Woman in Eleventh-Century Japan.* New York: Harper and Row Publishers, 1971.

———, trans. *The Pillow Book of Sei Shōnagon.* Harmondsworth, England: Penguin Books, 1967.

Morse, Samuel C. "The Buddhist Transformation of Japan in the Ninth Century: The Case of the Eleven-Headed Kannon." In *Heian Japan: Centers and Peripheries*, ed. Mikael Adolphson, Edward Kamens, and Stacie Matsumoto, 153–176. Honolulu: University of Hawaii Press, 2007.

Mosher, Gouverneur. *Kyoto: A Contemplative Guide.* Rutland, Vermont: Charles E. Tuttle Company, 1964.

Nakamura, Kyoko Motomochi, trans. *Miraculous Stories from the Japanese Buddhist Tradition: The Nihon Ryōiki of the Monk Kyōkai.* Cambridge, MA: Harvard University Press, 1973.

Ng, Zhiru. "The Formation and Development of the Dizang Cult on Medieval China." Ph.D. diss., University of Arizona, 2000.

Rambelli, Fabio. "Secret Buddhas: The Limits of Buddhist Representation." *Monumenta Nipponica* 57 (Autumn 2002): 271–307.

Reader, Ian. *Making Pilgrimages: Meaning and Practice in Shikoku*. Honolulu: University of Hawaii Press, 2005.

Reader, Ian and George F. Tanabe, Jr. *Practically Religious: Worldly Benefits and the Common Religion of Japan*. Honolulu: University of Hawaii Press, 1998.

Rhodes, Robert F. "Pure Land Practitioner or Lotus Devotee? On the Earliest Biographies of Genshin." *Japanese Religions* 21, no. 1 (1995): 28–69.

———. "Seeking the Pure Land in Heian Japan: The Practices of the Monks of the Nijūgo Zanmai-e." *Eastern Buddhist*, n.s., 33, no. 1 (2001): 56–79.

Ruch, Barbara, ed. *Engendering Faith: Women and Buddhism in Premodern Japan*. Ann Arbor: Center for Japanese Studies, University of Michigan, 2002.

Schopen, Gregory. *Bones, Stones, and Buddhist Monks: Collected Papers on the Archaeology, Epigraphy, and Texts of Monastic Buddhism in India*. Honolulu: University of Hawaii, 1997.

Seckel, Deitrich. *Buddhist Art of East Asia*. Ulrich Mammitzsch, trans. 1957; English edition, Bellingham, Washington: Western Washington University, 1989.

Seidensticker, Edward, trans. *The Gossamer Years: The Diary of a Noblewoman of Heian Japan*. Boston: Charles E. Tuttle Publishing Company, 1964.

———, trans. *The Tale of Genji*. New York: Alfred A. Knopf, 1978.

Sensōji. "Asuka Kannon: The Sensoji Temple, Tokyo, Japan." [Brochure, n.d.].

Sharf, Robert. "On the Allure of Buddhist Relics." In *Embodying the Dharma: Buddhist Relic Veneration in Asia*, ed. David Germano and Kevin Trainor, 163–191. Albany: State University of New York Press, 2004.

———. "Prolegomenon to the Study of Japanese Buddhist Icons." In *Living Images: Japanese Buddhist Icons in Context*, ed. Robert Sharf and Elizabeth Horton Sharf, 1–18. Stanford: Stanford University Press, 2001.

Stone, Jacqueline. "By the Power of One's Last Nenbutsu: Deathbed Practices in Early Medieval Japan." In *Approaching the Land of Bliss: Religious Praxis in the Cult of Amitābha*, ed. Richard K. Payne and Kenneth K. Tanaka, 77–119. Honolulu: Kuroda Institute, University of Hawaii Press, 2004.

———. "Seeking Enlightenment in the Last Age: Mappō Thought in Kamakura Buddhism, Part I." *Eastern Buddhist*, n.s., 18, no. 1 (1985): 28–56.

Sūtra of the Past Vows of the Earth-Store Bodhisattva: The Collected Lectures of Tripiṭaka Master Hsüan Hua. Heng Ching, trans. New York: Buddhist Text Translation Society and the Institute for Advances Studies of World Religions, 1974.

Suzuki, D.T. *An Introduction to Zen Buddhism*. 1934. Rpt., New York: Grove Press, 1964.

Swearer, Donald. *Becoming the Buddha: The Ritual of Image Consecration in Thailand*. Princeton: Princeton University Press, 2004.

Tanizaki, Jun'ichirō. *In Praise of Shadows*. Stony Creek, CT: Leete's Island Books, 1977.

Teiser, Stephen F. *The Scripture on the Ten Kings and the Making of Purgatory in Medieval Chinese Buddhism*. Honolulu: Kuroda Institute, University of Hawaii Press, 1994.

Trainor, Kevin. *Relics, Ritual, and Representation in Buddhism*. Cambridge: Cambridge University Press, 1997.

Tyler, Royall. *Japanese Tales*. New York: Pantheon Books, 1987.

———. *The Miracles of the Kasuga Deity*. New York: Columbia University Press, 1990.

Watson, Burton, trans. *The Lotus Sutra*. New York: Columbia University Press, 1993.

———, trans. *The Vimalakirti Sutra*. New York: Columbia University Press, 1997.

Weidner, Marsha, ed. *Cultural Intersections in Later Chinese Buddhism*. Honolulu: University of Hawaii Press, 2001.

Weinstein, Lucie. "The Yumedono Kannon: Problems in Seventh-Century Sculpture." *Archives of Asian Art* 42 (1989): 25–48.

Yiengpruksawan, Mimi Hall. "Buddha's Bodies and the Iconographical Turn in Buddhism." In *Buddhist Spirituality: Later China, Korea, Japan, and the Modern World*, ed. Takeuchi Yoshinori, 391–416. New York: Crossroad Publishing Company, A Herder & Herder Book, 1999.

———. "The Eyes of Michinaga in the Light of Pure Land Buddhism." In *The Presence of Light: Divine Radiance and Religious Experience*, ed. Matthew T. Kaplan, 227–261. Chicago: University of Chicago Press, 2004.

Yü, Chün-fang. *Kuan-yin: The Chinese Transformation of Avalokitesvara*. New York: Columbia University Press, 2001.

Zenrinji. "Zenrin-ji and Its History." [Brochure, n.d.].

Sources in Japanese and Chinese

Amino Yūshun. *Sensōjishi danshō*. Tokyo: Konryūzan Sensōji, 1962.

Bijutsushi Gakkai, ed. *Besson Kyōto butsuzō zusetsu*. Kyoto: Usui Shobō, 1943.

Bukkyō gyōji sansaku, ed. Nakamura Hajime. Tokyo: Tōkyō Shoseki, 1991.

Butsudan no hanashi. Butsugu: sono 7, ed. Gendai Bukkyō Kenkyūkai. Hiroshima: Daisō Sangyō, 2004.

Butsuzō monoshiri kojiten. Butsugu: sono 15, ed. Gendai Bukkyō Kenkyūkai. Hiroshima: Daisō Sangyō, 2004.

Chūyūki. DNKK, *Chūyūki* 1–5.

Dai Nihon Bukkyō zensho, 150 vols., ed. Bussho Kankōkai. Tokyo: Bussho Kankōkai, 1912–1922.

Dai Nihon Kokiroku, ed. Tōkyō Daigaku Shiryō Hesanjo. Tokyo: Iwanami Shoten, 1952–2001.

Daśacakrakṣitigarbha sūtra. T 13.

Dizang pusa penyuan jing. T 13.

Eiga monogatari. SNKBT 75–76.

Eigaku yōki. ZGR 8.

Eizan Daishiden. ZGR 8.2.

Enmei Jizō kyō. KYIK 49.

Eshin Sōzu zenshū, 5 vols., ed. Hieizan Senshūin. Kyoto: Shibunkaku, 1971.

Fayuan zhulin. T 53.

Fujii Masao. *Butsuji no kiso chishiki*. 1985. Rev. ed. Tokyo: Inshokan, 2001.

Fujisawa Takako. "'Hibutsu' tanjō no haikei o saguru." In *Hibutsu*, ed. Mainichi Shinbunsha, 149–171. Tokyo: Mainichi Shinbunsha, 1991.

———. "Hibutsu to wa nanika?" In *Nihon no hibutsu*, ed. Korona Bukkusu, 114–119. Tokyo: Heibonsha, 2002.

Gaoseng Faxian zhuan. T 51.

Geijutsu Shinchō Henshūbu, ed. *Kokuhō*. Tokyo: Shinchōsha, 1993.

Gekkan Kyōto 625, no. 8 (August 2003).

Genji monogatari. SNKBT 19–23.

Genshin Sōzu den. ESZ 5.

Gonki. DNKK.

Goriyaku Book in Kyōto, ed. Tankōsha Henshūkyoku. Kyoto: Tankōsha, 1990.

Goshūi ōjōden. NST 7.

Guannian famen. T 47.

Gunsho ruijū, 29 vols., ed. Hanawa Hokiichi. Rev. ed. Ōta Tōshirō. Tokyo: Zoku Gunsho Ruijū Kanseikai, 1939–1943.

Hana. *Chiisai butsuzō, ōkii butsuzō*. Tokyo: Tōkyō Shoseki, 2003.

Hanayama Shinshō, trans. *Ōjōyōshū*. Tokyo: Tokkan Shoten, 1972.

Hasedera. "Hasedera." [Brochure, n.d.].

Hasedera reigenki. ZGR 27: 2.

Hashimoto Shōjun. "Chōrō kikigaki 2." In *Tōdaiji omizutori: Ichigatsu Shuni-e no kiroku to kenkyū*, ed. Ōga Tetsuo, 223–225. Tokyo: Shōgakkan, 1985.

Hayami Tasuku. *Bosatsu: Bukkyōgaku nyūmon*. Tōkyō bijutsu sensho 30. Tokyo: Tōkyō Bijutsu, 1982.

———. *Jizō shinkō*. Tokyo: Hanawa Shinsho, 1975.

———. *Kannon, Jizō, Fudō*. Tokyo: Kōdansha, 1996.

———. *Kannon shinkō*. Tokyo: Hanawa Shobō, 1970.

Heike monogatari. SNKBT 44–45.

Hibutsu, ed. Mainichi Shinbunsha. Tokyo: Mainichi Shinbunsha, 1991.

Hibutsu kaichō: tokubetsu haikan no koji, meisatsu o yuku. Tokyo: Shinforesuto, 2002. NHK video.

Hōbutsushū. SNKBT 40.

"Hohoyake Amida engi emaki." In *Naomoto moshibumi ekotoba, Nōe Hōshi ekotoba, Inabadō engi, Hohoyake Amida engi, Fudō riyaku engi, Konda sōbyō engi*. Shinshū Nihon emaki zenshū 30, ed. Takasaki Fujihiko and Minamoto Toyomune, 75–78. Tokyo: Kadokawa Shoten, 1980.

Hokke genki. NST 7.

Ishikawa Jun'ichirō. *Jizō no sekai*. Tokyo: Jiji Tsūshinsha, 1995.

Ishiyamadera engi. DNBZ 117.

Itō Kokan. *O-Jizōsama*. Tokyo: Shunjūsha, 1972.

Itō Seikō and Miura Jun. *Kenbutsuki*. Tokyo: Kadokawa Shoten, 1993.

———. *Kenbutsuki: oya kōkō hen*. Tokyo: Kadokawa Shoten, 2002.

———. *Kenbutsuki 2: butsuyūhen*. Tokyo: Kadokawa Shoten, 2002.

Itō Shirō. *Heian jidai chōkokushi no kenkyū*. Nagoya: Nagoya Daigaku Shuppankai, 2001.

Itō Yumiko. "Hibutsu nyūmon: shinkō to tomo ni ikiru hibutsu." In *Hibutsu*, ed. Mainichi Shinbunsha, 50–58. Tokyo: Mainichi Shinbunsha, 1991.

Iwabashi Haruki. "Hohoyake Amida engi emaki." In *Naomoto moshibumi ekotoba, Nōe Hōshi ekotoba, Inabadō engi, Hohoyake Amida engi, Fudō riyaku engi, Konda sōbyō engi*. Shinshū Nihon emaki zenshū 30, ed. Takasaki Fujihiko and Minamoto Toyomune, 37–49. Tokyo: Kadokawa Shoten, 1980.

———. "Migawari Amida butsu: hohoyake Amida engi." In *Jōdo e no akogare*, Taiyō hotoke no bi to kokoro shiriizu 2, Taiyō shiriizu 34, ed. Satō Shinji, 128–134. Tokyo: Heibonsha, 1983.

Jizō bosatsu reigenki. ZGR 24: 2.

Jizō shinkō. Minshū shūkyōshi sōsho 10, ed. Sakurai Tokutarō. Tokyo: Yūzankaku Shuppan, 1983.

Jizōkō shiki. ESZ 5: 586.

Jōdo e no akogare. Taiyō hotoke no bi to kokoro shiriizu 2. Taiyō shiriizu 34, ed. Satō Shinji. Tokyo: Heibonsha, 1983.

Jōdo no kanata e. Ningen no bijutsu 5, ed. Yamaori Tetsuo. Tokyo: Gakushū Kenkyūsha, 2004.

Kagerō nikki. SNKBT 24.

Kawamura Tomoyuki. "Tōdaiji Nigatsudō no hibutsu jūichimen Kannon." In *Hibutsu*, ed. Mainichi Shinbunsha, 137–148. Tokyo: Mainichi Shinbunsha, 1991.

Kawasaki Yasuyuki. *Genshin*. Nihon no meicho 4. Tokyo: Chūō Kōronsha, 1972.

Kokuyaku issai kyō, 102 vols. Tokyo: Daitō Shuppansha, 1930–1933.

Kondō Takuji. "Gohonzon to enishi o musubu 'zen no tsuna.'" In *Hibutsu*, ed. Mainichi Shinbunsha, 123–129. Tokyo: Mainichi Shinbunsha, 1991.

Konjaku monogatari. SNKBT 33–37.

Koyama Masazumi. "Tōdaiji Chūshōin shozō 'Yokawa Shuryōgon'in Nijūgo zanmai Eshin Yasutane rinju gyōgi' no sai kentō." Bukkyōgaku kenkyū 53 (1997): 56–95.

Kuno Takeshi. Hibutsu. Tokyo: Gakushōsha, 1978.

Kyōto no makai o yuku: etoki annai, ed. Kasha and Kikuchi Masaharu. Tokyo: Shōgakkan, 1999.

Mahāparinirvāṇa sūtra. T 12.

Mainichi sahō. In Heian ibun, 13 vols., ed. Kodaigaku Kyōkai and Kodaigaku Kenkyūjo. Tokyo: Kadokawa Shoten, 1994, vol. 11.

Makita Tairyō. Kanzeon kenki no kenkyū: rikuchō koitsu. Kyoto: Heirakuji Shoten, 1970.

Makura no sōshi. SNKBT 25.

Manabe Kōsai. Jizō bosatsu no kenkyū. Kyoto: Sanmitsudō Shoten, 1969.

Matsuhisa Hōrin. Butsuzō o horu: aru Kyōbusshi no kaisō. Tokyo: Shin Jinbutsu Ōraisha, 1975.

Matsushima Takeshi. Jizō bosatsu. Nihon no bijutsu 239. Tokyo: Shibundō, 1986.

Midō kanpakuki. DNKK, Midō kanpakuki 1–3.

Mitsumori Masashi and Okada Ken. Butsuzō chōkoku no kanshō kiso chishiki. Tokyo: Shibundō, 1993.

"Miyako no roku Jizō meguri." Kyoto: Roku Jizō Kai, 1995. [Brochure].

Mochizuki Shinjō. Jizō bosatsu—sono minamoto to shinkō o saguru. Tokyo: Gakushōsha, 1989.

Mochizuku Shinjō, Sawa Ryūken, and Umehara Takeshi. Butsuzō: kokoro to katachi. Tokyo: Nihon Hōsō Shuppan Kyōkai, 1965.

Nakano Satoshi, "Reigen butsu toshite no Daianji Shaka nyorai zō." Nihon no geijutsu 249 (March 2000): 83–102.

Naomoto moshibumi ekotoba, Nōe Hōshi ekotoba, Inabadō engi, Hohoyake Amida engi, Fudō riyaku engi, Konda sōbyō engi. Shinshū Nihon emaki zenshū 30, ed. Takasaki Fujihiko and Minamoto Toyomune. Tokyo: Kadokawa Shoten, 1980.

Nihon koten bungaku taikei, 100 vols. Tokyo: Iwanami Shoten, 1957–1969.

Nihon no hibutsu, ed. Korona Bukkusu. Tokyo: Heibonsha, 2002.

Nihon ōjō gokuraku ki. NST 7.

Nihon ryōiki. SNKBT 30.

Nihon shisō taikei, 56 vols. Tokyo: Iwanami Shoten, 1970–1982.

Niiro Chūnosuke gojūkaiki kinen: butsuzō shūri gojūnen. Kyoto: Benridō, 2004.

Nishimura Kōchō. Butsuzō no koe. Tokyo: Shinchōsha, 1995.

———. Butsuzō wa kataru. Tokyo: Shinchōsha, 1990.

———. Hibutsu kaichō. Kyoto: Tankōsha, 1976.

———. Yoku wakaru butsuzō no mikata: Yamatoji no hotoketachi. Tokyo: Shōgakkan, 1999.

Nishiyama Atsushi. "Tōdaiji Nigatsudō to Omizutori." In Tōdaiji Nigatsudō to Omizutori, ed. Nara Kokuritsu Hakubutsukan, 4–11. Nara: Bukkyō Bijutsu Kyōkai, 1999.

Nyoirin Kannon: Ōsaka Kanshinji, ed. Ogawa Kōzō. Tokyo: Mainichi Shinbunsha, 2001.

Ōga Tetsuo, ed. Tōdaiji no omizutori: Nigatsudō Shuni-e no kiroku to kenkyū. Tokyo: Shōgakkan, 1985.

Ogawa Kōzō. "Hibutsu no nazo." In Nyoirin Kannon: Ōsaka Kanshinji, ed. Ogawa Kōzō, 60–67. Tokyo: Mainichi Shinbunsha, 2001.

O-Jizōsama. Kyōiku manga. Tokyo: Daidōsha, n.d.

Ōjōyōshū. NST 6.

Ōsumi Kazuo. Raigō geijutsu. Hōzō sensho 21. Tokyo: Hōzōkan, 1979.

Otera ni ikō! ed. Kojima Dokkaan and Mikami Ken'ichi. Tokyo: Fusōsha, 2004.

Rokuharamitsuji no kenkyū, ed. Gangōji Bukkyō Minzoku Shiryō Kenkyūkai. Nara: Gangōji Bukkyō Minzoku Shiryō Kenkyūkai, 1975.

"Ryōgon'in Nijūgo zanmai kesshū kakochō." In Hirabayashi Moritoku, Shoryōbu kiyō 37 (1985): 41–52.

Ryōjin hishō. SNKBT 56.

Ryōzen'in shiki. In *Dai Nihon shiryō*, 320 vols., ed. Tōkyō Daigaku Shiryō Hensanjo. Tokyo: Tōkyō Daigaku Shuppankai, 1922–present, vol. 2, no. 5.

Saddharmapuṇḍarīka sūtra. T 9.

Sagazaki Shirō. "Shōjū raigō no hi: nijūgo bosatsu nerikuyō." In *Jōdo e no akogare*, Taiyō hotoke no bi to kokoro shiriizu 2, Taiyō shiriizu 34, ed. Satō Shinji, 110–121. Tokyo: Heibonsha, 1983.

Sakeiki. ZST 6.

Sanbōe. SNKBT 31.

Sanmon dōshaki. ZGR 8.

Sannō reigenki, Jizō bosatsu reigenki. Zoku Nihon no emaki 23. Tokyo: Chūō Kōronsha, 1992.

Sarashina nikki. SNKBT 24.

Seiryōji. "O-Minuguishiki yurai." [Brochure, n.d.].

———. "Saga Shakadō, Godaisan, Seiryōji." [Brochure, n.d.].

Sekine Shun'ichi. *Butsu, bosatsu to dōnai no shōgon.* Nihon no bijutsu 10. Tokyo: Shibundō, 1989.

Seki Nobuko. "'Mukaekō Amidazō' kō I: Taimadera no raigōe to Kōbōji no mukaekō Amidazō." *Bukkyō geijutsu* 221 (July 1995): 100–132.

———. "'Mukaekō Amidazō' kō II: Taimadera no mukaekō Amidazō." *Bukkyō geijutsu* 223 (Dec. 1995): 77–46.

———. "'Mukaekō Amidazō' kō IV: Mukaekō Amidazō zōritsu no haikei to jōdokyō geijutsu ni ataeta eikyō." *Bukkyō geijutsu* 228 (Sept. 1996): 70–96.

Sensōji. "Asuka Kannon Sensōji." [Brochure, n.d.].

Shaji engi e, ed. Nara Kokuritsu Hakubutsukan. Tokyo: Kadokawa Shoten, 1974.

Shaka shinkō to Seiryōji: tokubetsu tenrankai, ed. Kyōto Kokuritsu Hakubutsukan. Kyoto: Kyōto Kokuritsu Hakubutsukan, 1982.

Shakuzōji. "Kuginuki Jizō engi." [Brochure, n.d.].

Shasekishū. NKBT 85.

Shichidaiji junrei shiki. DNBZ 120.

Shichidaiji nikki. DNBZ 120.

Shigemura Yasushi. *Shigisan engi to Kokawadera engi.* Nihon no bijutsu 2, no. 298. Tokyo: Shibundō, 1991.

Shimizu Mazumi. *Butsuzō to hito no rekishi hakken: taimu kapuseru ga hikarete.* Tokyo: Ribun Shuppan, 2000.

Shin kokin wakashū, SNKBT 11.

Shin Nihon koten bungaku taikei, 105 vols. Tokyo: Iwanami Shoten, 1989.

Shin Yakushiji. "Otama Jizō engi." [Brochure, n.d.].

Shiraki Toshiyuki. "Hibutsu o tazuneru." *Daihōrin* 1 (2003): 120–124.

Shōtoku taishi den shiki. DBZ 112.

Shōyūki. DNKK, *Shōyūki* 1–11.

Shūi ōjōden. NST 7.

Sifenlü shanfan buque xingshi chao. T 40.

Sokujōin. "Gokuraku jōdo, Kyōto no kosatsu, Sokujōin." [Brochure, n.d.].

Sōtōshū Shūmuchō Kyōkabu, ed. *Shōwa shūtei, Sōtōshū gyōji kihan.* Tokyo: Sōtōshū Shūmuchō, 1988.

Sukhāvatīvyūha sūtra. T 12.

Taishō shinshū daizōkyō, 85 vols., ed. Takakusu Junjirō and Watanabe Kaigyoku. Tokyo: Taishō Issaikyō Kankōkai, 1924–1934.

Takahashi Yoshikazu. *Kannonsama.* Kyōiku manga. Tokyo: Daidōsha, n.d.

Takemura Toshinori. *Miyako no O-Jizōsan.* Kyoto: Kyōto Shinbunsha, 1994.

Tanaka Hisao. *Jizō shinkō to minzoku.* Tokyo: Mokujisha, 1989.

Tanaka Takako. *Butsuzō ga kataru shirarezaru dorama.* Tokyo: Kōdansha, 2000.

Teishin kōki. DNKK, *Teishin kōki* 1.

Tōdaiji Nigatsudō to omizutori: tokubetsu chinretsu, ed. Nara Kokuritsu Hakubutsukan. Nara: Nara Kokuritsu Hakubutsukan, 1999.

Tōdaiji omizutori: Ichigatsu Shuni-e no kiroku to kenkyū, ed. Ōga Tetsuo. Tokyo: Shōgakkan, 1985.

Tōdaiji yōroku. ZZGR 11.

Uji shūi monogatari. SNKBT 42.

Ullambana sūtra. T 16.

Umehara Takeshi. *Kyōto hakken 1: chirei chinkon.* Tokyo: Shinchōsha, 1997.

Vimalakīrti sūtra. T 14.

Watsuji Tetsurō. *Koji junrei.* 1918. Rpt., Tokyo: Iwanami Shoten, 1979.

Xiyouji. T 51.

Xukongzang jiuwenchi fajing. T 20.

Yamaguchi Tsutomu. "Daimonji." In *Bukkyō gyōji sansaku,* ed. Nakamura Hajime, 210–213. Tokyo: Tōkyō Shoseki, 1991.

Yamanaka Yutaka. *Heian jidai no nenjū gyōji.* Hanawa sensho 75. Tokyo: Hanawa Shobō, 1972.

Yata Jizō engi. DNBZ 118.

Yatadera no butsuzō: tokubetsu chinretsu, ed. Nara Kokuritsu Hakubutsukan and Bukkyō Bijutsu Kyōkai. Nara: Bukkyō Bijutsu Kyōkai, 2001.

Yoku wakaru Zenkōji mairi, ed. Zenkōji Jimukyoku. Tokyo: Chikuma Shūhansha, 2000.

Yoku wakaru Zenkōji mairi 2: gokaichō, ed. Zenkōji Jimukyoku. Tokyo: Chikuma Shūhansha, 2002.

Yoritomi Motohiro. "Hibutsu no sekai." In *Hibutsu,* ed. Mainichi Shinbunsha, 73–120. Tokyo: Mainichi Shinbunsha, 1991.

Yume jūya. Gendai bungaku taikei, 69 vols. Tokyo: Chikuma Shobō, 1964, vol. 13.

Zenkōjisan. Nagano City: Zenkōji Honbō Daikanjin Kyōkabu, 1995.

Zenkoku jisha, butsuzō gaido, ed. Tanaka Yukiyoshi. Tokyo: Bijutsu Shuppansha, 2001.

Zenrinji. "Zenrinji, Eikandō." [Brochure, n.d.].

Zhunti tuoluoni jing. T 20.

Zōho shiryō taisei, 48 vols., ed. Zōho Shiryō Taisei Kankōkai. Kyoto: Rinsen Shoten, 1965-.

Zoku gunsho ruijū, 33 vols., ed. Hanawa Hokiichi. Rev. ed. Ōta Tōshirō. Tokyo: Zoku Gunsho Ruijū Kanseikai, 1923–1928.

Zoku zoku gunsho ruijū, 16 vols., ed. Kokusho Kankōkai. Tokyo: Kokusho Kankōkai, 1906–1909.

INDEX

Introductory Note

Works cited and terms transliterated from Japanese or Chinese are in italics. References such as "134–6" indicate (not necessarily continuous) discussion of a topic across a range of pages. A reference in the form "*12fig1*" indicates that Figure 1 on page 12 is relevant. Bold type has been used to highlight the most significant discussions of topics referred to in many places.